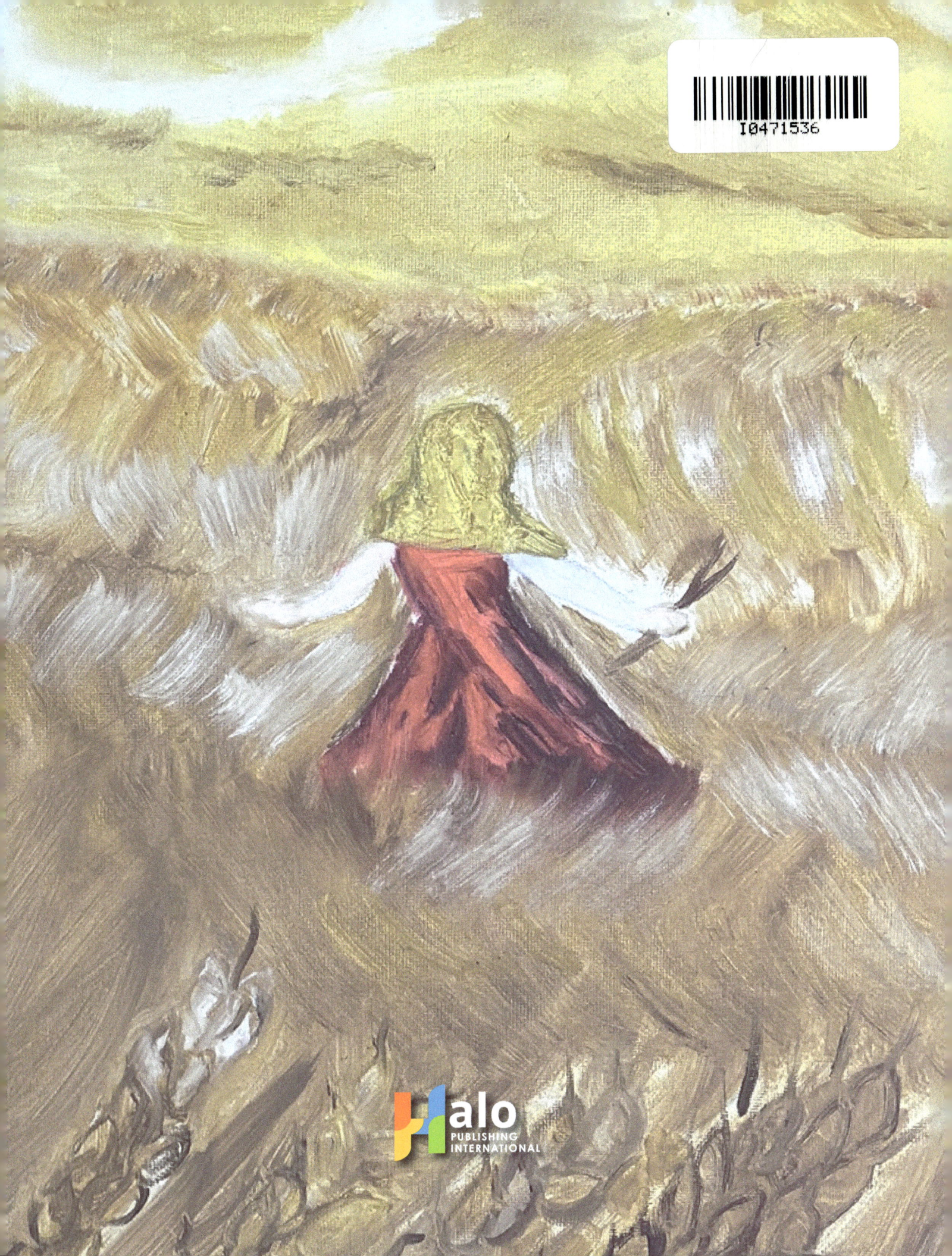

*Special thanks to Karen Bruso,
Katy Curtin and Susan Popper*

*Edition
Jullyen Matos
Nilma Lima Costa*

Copyright © 2022 Monica Septimio, All rights reserved.

No part of this publication may be reproduced, stored in a retrieval system or transmitted in any form or by any means, electronic, mechanical, photocopying, recording or otherwise, without prior permission of Halo Publishing International.

For permission requests, write to the publisher, addressed "Attention: Permissions Coordinator," at the address below.

Halo Publishing International
8000 W Interstate 10, #600
San Antonio, Texas 78230

First Edition, September 2022
Printed in the United States of America
ISBN 978-1-63765-230-5
Library of Congress Control Number: 2022907168

The information contained within this book is strictly for informational purposes. Unless otherwise indicated, all the names, characters, businesses, places, events and incidents in this book are either the product of the author's imagination or used in a fictitious manner. Any resemblance to actual persons, living or dead, or actual events is purely coincidental.

Halo Publishing International is a self-publishing company that publishes adult fiction and non-fiction, children's literature, self-help, spiritual, and faith-based books. Do you have a book idea you would like us to consider publishing? Please visit www.halopublishing.com for more information.

To my king, Richard Ruffin

Contents

Preface 7

Introduction 9

Chapter 1
The meeting 11

Chapter 2
The list 17
 When there is no door—Poem 20
 Slave of the past—Oil on canvas 21

Chapter 3
Broken compass 22

Chapter 4
Lost 30

Chapter 5
Why & what for 37
 I garden 43

Chapter 6
Repetitions 44
 Protection—Oil on canvas 52

Chapter 7
An oasis in the desert 53

Chapter 8
Spawned in the heart 57
 She sleeps—Poem 62

Chapter 9
Borrowed dreams ... 63
- The mess made by love—Poem ... 70
- Sweet comfort zone—Oil on canvas ... 71

Chapter 10
The rug pulled ... 72

Chapter 11
Under the rug ... 78
- Through the window—Poem ... 85
- Nice to meet me—Acrylic on canvas ... 86

Chapter 12
The mirror ... 87
- Between a comb and scissor—Poem ... 100

Chapter 13
Between a comb and scissors ... 101

Chapter 14
The gift ... 108

Chapter 15
Dreams ... 123
- Learning to float—Poem ... 141

Chapter 16
Learning to float ... 142
- Flowers blouse—Poem ... 150
- Path of no return—Oil on canvas ... 151

Chapter 17
Forgiveness ... 152

Chapter 18
No .. 167

Chapter 19
The reflection .. 179
 The real me–Poem 191

Chapter 20
Identity .. 193
 Blisse–Oil on canvas 200

Chapter 21
Choosing a King 201
 Autumn and the king–Poem 209

Chapter 22
The King and I .. 210
 King's New Path–Oil on canvas 225

Chapter 23
180 degrees ... 226
 Dancing the music of life–Poem 234

Chapter 24
Joy ... 236
 The Harvest–Oil on canvas 252

About the Author 253

Preface

I am on the last chapter of your book. I'm not quite finished yet, but I felt compelled to stop and address a couple of things. And I'm writing it all down before I lose where my head and my heart are.

Thank you for sharing it with me. It inspires self-reflection in me about where I am weak and where I am strong. That's a good thing. I literally have only read trashy novels for years because I no longer want to read about real angst. This is the first time in a long time that I have voluntarily read anything that I knew would hurt my heart. And your story hurts my heart. I've lived some of it, but not all of it. Thankfully. I'm not sure I would have come out on the other side the way you have. Please know that you are amazing and have much to be proud of.

As I was reading a few chapters ago, I imagined one of those blurbs people put at the beginning of books to inspire people to read on. This is verbatim what I scribbled on a piece of paper:

"When Monica first requested that I proofread her book, I blithely accepted, thinking it was a children's book. Piece of cake, right? I balked when I realized it was novel length and full of religious references. I am not a religious person, at all. And I was busy. And all my other excuses…

Now I find myself grateful for having read it. I have learned much about Monica, her life, and myself.

The lesson I take from this is not about God, or religion, or having a having a higher power watch over you. It's about learning to love yourself and learning from the situations you've found yourself in. I tell my children frequently that you can't control everything that happens to you, but you can control how you react. For Monica and I, this is a hard lesson learned.

This book is an honest, heartfelt, soul baring example of making lemonade out of lemons.

I've lived some of Monica's life, but not all. I would not wish her hardships on anyone. I am awed by her ability to put pen to paper and reveal just how hard her journey has been, and I am honored to have been invited to dip a toe in her dome."

"I would like to imagine this story and write it; however, I had to live it to tell it." This is a quote from the concluding chapter of the book.

If no one else ever appreciates the gift of your story, please know that I did. It is painfully authentic and yet redeemingly wonderful. You have much to be proud of.

I would add to the blurb:

"This book was written by a person who speaks and thinks in more than one language. Some sentences need to be read more than once to appreciate or understand the meaning. But it is Monica's authentic voice. The one you would hear if you were speaking to her in person. Believe me, it is worth the effort."[1]

<div align="right">Kate Curtin</div>

[1] Curtin Kate. English Major Bachelor. Natick, MA

Introduction

A few years ago, in a preaching class, I suddenly turned off the lights. It was something that I arranged to do at my signal. The general reaction was of fright and exclamation. Wondering what had happened, I calmed everyone down and communicated that it was part of communicating my message. Then I asked everyone to walk towards the exit door. As you can imagine, it was scary because they weren't in their homes. When people know the location and already have it memorized, it is certainly easier to walk in the dark. As they sat, I asked them, "Is it possible for me to get around and do things in an unfamiliar place with my eyes open in the dark?" The answer was a unanimous "no."

Soon after, I turned on the lights and asked them to walk toward the exit door, this time with their eyes closed. There was no difference; it was chaos. I repeated the question, "Is it possible for me to get around and perform tasks in an unknown place in the light with my eyes closed?" What do you think? Well, I personally still know I can't. My question to you is the same one I asked my classmates and my teacher. "What's the difference between being in darkness with your eyes open or in the light with your eyes closed?" The class responded, "None."

I told them, "Exactly!" I left them to ponder for a few minutes. In both cases, I need to be careful not to hit and knock things down so much along the way and not to get knocked down by them. Resilient to get up after every bump, fall, and pain. Determined knowing I have no other choice but to move forward. Brave for even being afraid of the unknown. There are phases in our lives in which we are like this, aren't there? I need to understand that I need to be aware, because in these phases, there will always be a driver. If I'm not mindful, I'll go unnoticed. If I'm not aware, this target will show up, and I'll go unnoticed. There is no darkness without light and vice versa. It is usually in the darkest place that a small light will shine the brightest! This light can illuminate me through a dream, art, or a person. Dreams can be a point of view to answer many problems. Art can heal and bring out my truest self: the person that can calibrate my compass. My dreams, my motivation, my spark and riposte. My art; the painting, the writing. My person; Joy!

This book is an illuminator, and it will undoubtedly bring direction to some part of your life. It is based on a true story with crucial issues that most of us face. Joy is a book that shows the reality in the practice of personal experiences and is supported by professionals through both scientific and spiritual. It addresses issues that you and I don't identify, know, and possibly will be afraid to act towards. My meeting with Joy was a turning point in my life. It was the endpoint of a story of failure and the birth of a story of resilience and healing. As a storyteller, I brightly learned to turn the twilight of secrets kept for more than four decades into galvanization. Meeting Joy didn't make me lose my fear. It made me lose my cowardice. I hope that opening my life is not an act of exposing my failures, traumas, disappointments, illnesses, and healing processes, but rather a witness to the aftercare and God's purpose for my life. I truly believe that when you read Joy, you will be looking at your obstacles from different perspectives, and you may write a new history in your life, as I did in mine. I hope this book will be an inspiration to you.

<div align="right">Monica Septimio</div>

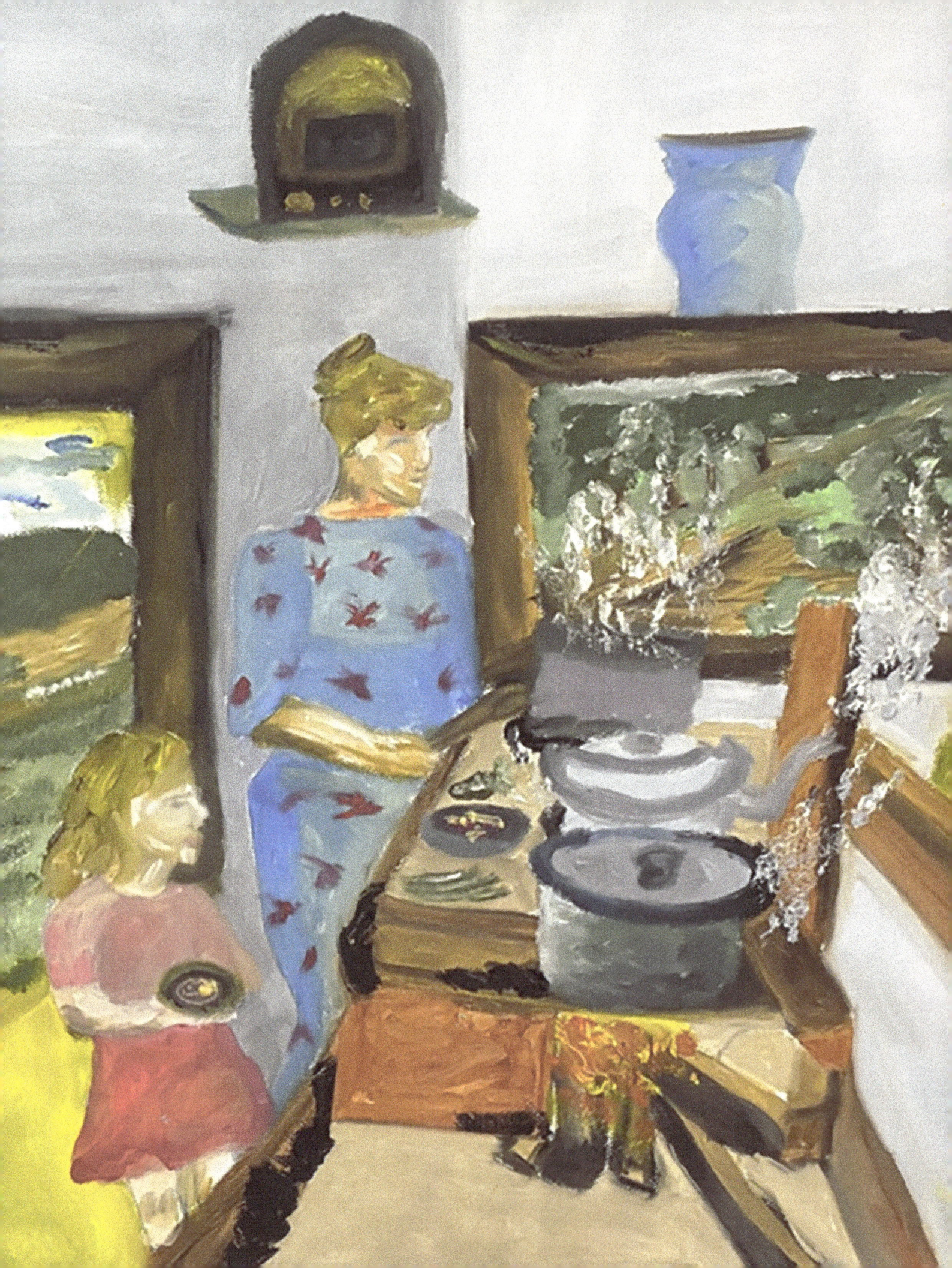

Chapter 1
The meeting

Let us inspire those who are afraid, not because we are brave, but because we have faith.

Storyteller

I am the granddaughter of a wonderful woman. My paternal grandmother was a true Amazon, except she was 5'5" and northeastern Brazilian. She was brave, like during the times I saw her chopping off poisonous snake's heads with an ax, dropping her head to one side while the rest of her body writhed to the other; she was fearless. A super artistic woman, she created beautiful blankets, rugs, and pillows of all the styles you can imagine from scraps of cloth. She was so ingenious that she went from raising chicken to pigs, from pigs to cows, and from cows to buying a farm. It wasn't just her—my grandfather was the same way. They could barely read. However, their wisdom and willpower made them reach beyond their dreams. Nothing was impossible for them; no problem impeded what they decided to do.

My grandfather was a dreamer. He said something he was going to do, and it seemed absurd to us, but even if it took a while, he carried out his project. With them, I learned to love, to be obstinate, to be committed to what I dreamed of, and, of course, how to tell stories. I believed that if I wanted to and God wanted to, it would be accomplished. In my teens, we installed electricity on my grandparents' farm. During my childhood, my family lit lamplight with kerosene, and the next day the nostrils had to be cleaned, as they were undoubtedly black. The most beautiful memories of my childhood were with my grandparents. Before we went to sleep, my youngest aunt, four years older than me, would listen to their tales. It was like a ritual, and I couldn't wait until that magical moment when my grandmother told old wives' tales. She told us almost all the ancient fables at bedtime in her own words. Today, I wonder how a semi-illiterate knew so much about these stories,

from the lying boy named Pinocchio, Little Red Riding Hood, the three little pigs, and so on. But my favorite story was "Beauty and the Beast," followed closely by "Cinderella."

When I traveled, I pretended to be the characters in all those stories. When all the lights were off for us to fall asleep, I kept dreaming of everything my grandmother told me. And for the stories that I didn't like the endings of, I invented my own happy endings. I have traveled in those tales narrated by my grandmother. She also loved to tell the Brazilian folklore that was passed down from her ancestors about sacipererê[2], mula-sem-cabeça[3], curupira[4], boi encantado[5], the boto cor-de-rosa[6], and so on. Some stories scared me, and I imagined different conclusions in which I always saved the day.

My grandfather told authentic and augmentative chronicles, narratives that he lived or heard about throughout his life. Some came from his genealogy, some stories were from the Bible, some were tales of saints who performed miracles, and some came from his travels and exploits. When I analyze this desire to tell stories, I realize that the spark came from those nights. I struggled to sleep with my imaginary travels in the stories my grandparents told. When I wanted to forget about some frustrations, I made up stories in my mind, running away from reality when I was alone. The state school Dionísio De Carvalho's director, Maria Lei, gave me my first book when I learned to read. *The Legend of Alvorado* was about a wild white horse that helped other horses. As a teenager, I loved acting and found it easy to write plays. I didn't know how much I should do academically, but my creative ability to make up stories was very good. I believe I also inherited from my mother the curiosity to explore books and the taste for writing. With the musicality of the suddenness of growing up, my father sang vaquejada[7] tunes, which are musicalized tales about the fearless cowboys of the Northeast and the simplicity of life in the sertão[8]. His deep, tuned voice is still in my mind, helping me with the rhymes. That style of music is called repente or aboio—it's improvised music with rims created about a theme of their choice. It's known for the alignment of words in sentences and the passion for parables

[2] Sacipererê: is usually a single-legged, very dark-skinned boy who smokes a pipe, wears a red hood, and transports himself on a mini hurricane. Comes from the Tupi Guarani language and can be interpreted as "the leaping evil eye": çaa cy means "evil eye" and *pérérê* means "leaping."

[3] Mula-sem-cabeça headless mule: The legend says that mula-sem-cabeça was a woman that had relationships with a priest, and then she was cursed and transformed into a headless mule.

[4] Curupira: The name comes from the Tupi word *kuru'pir*, meaning "covered in blisters." According to the cultural legends, this creature has *bright red/orange hair* and resembles a man or a *dwarf*, but its feet are turned backwards. Curupira lives in the *forests of Brazil* and uses its backward feet to create footprints that lead to its starting point, thus making hunters and travelers confused.

[5] Boi encantado: In the tales of Northeastern cowboys, this "enchanted ox" appears and disappears, and no one can capture it.

[6] Boto cor-de-rosa: pink dolphins in the Amazon River. They are enchanted shapeshifters that become young beaus at night and seduce women. The legend goes that the Amazon pink dolphins become attractive young men each evening to go to parties. They look for parties to go have fun at and pick up young ladies. After seducing them and staying the night together, the pink dolphins disappear and go back to the river.

[7] The vaquejada is a sport typical to the Northeastern region of Brazil, in which two cowboys ("vaqueiros") on horseback pursue a bull, seeking to pin it between the two horses and direct it to a goal (often consisting of chalk marks).

[8] Sertão is the "hinterland" or "backcountry." In Brazil, it refers to one of the four subregions of the Northeast region of Brazil. Northeast Brazil is largely covered in a scrubby upland forest called a caatingas.

and metaphors. A significant influence of my poetic side were the cordel[9] booklets that came with us from Northeastern Brazil to Pará (North). In my desire to live a full and westernized, productive life, I forgot about all that. I didn't even imagine returning to my roots in my adult phase. I never dreamed of what I'm living now.

For more than forty years, I never thought about being an artist, but my blood held my artistic heritage. I didn't know that my creative streak would influence my healing. However, God knew. He made my whole heritage become clear through a dream. Activated art became healing! Moreover, I didn't know how to do anything. I had to learn from scratch. The art worked to cure me: it branched out in countless directions, transforming my life, starting to put my emotions on a canvas, whether they made me feel inadequate or worthy. For many long years, I remained motionless in the corner of the board like a queen held by horses in a chess game. At forty-one years old, I was already in the middle of a game where the queen is not expected to move. The game of chess seemed over, and God urged the queen to start a new round. I painted a collection of artworks in my first art exhibition, which later turned into a book. Everything started to run fast. In addition to being an artist, the following year, I received the title of writer. However, like my grandmother, I am only a storyteller. And in this book, I will tell fragments of my tales.

Whose plans

We are born without planning, and so we die. But the future will see that we cannot control the objectives of those who planned us. When I reached this point, I started to live through my projects. We want to achieve the goals we have designed for our lives, but nothing is sure to succeed. And being young, most plans fail, or we change our minds. As adults, we have more control over our projects. Unfortunately, nothing exempts our plans. I imagine that we make God laugh with our projects that rely on his approval to come to fruition.

I imagine God saying, "Um…nope!" And off we go, back to the waiting list with our plans, kind of like a puppy with its tail between its little legs. Like me, right now, with a book ready to release and several events scheduled, including my fifth painting exhibition, and COVID-19 needing to stop everything. However, secure your plans are, nothing can prepare you for the unbelievable stage of life when the rug is taken out from under your feet! The loss of the rug, for me, was horrible enough, but on top of that, I discovered one colossal mess that I didn't know how to deal with it. The pain of loss is colossal, but the anxiety of discovery is even more frightening because that's what stays with you. Even if you are living with garbage, you can get used to it, but garbage is garbage!

[9] Cordel literature: From the Portuguese term "literatura de Cordel," Cordel is derived of the Portuguese name "corda," meaning hope. It refers to little books, printed booklets, or pamphlets. The contents of those books are basic songs, novels, or poems. They can be made and sold in street markets. They are hung from strings in stores.

Now, knowing that what was under the rug is dirty, it is time for confronting it. What is there to do with such colossal trash when you didn't even know you were used to it? Leave it or clean it? Leaving it will accumulate even more than we ever imagined existed. Cleaning seems like the worst option because I must remove the garbage piece by piece. It won't be possible to clean it myself most of the time, so I must ask for help. The worst thing about asking for help will be revealing my shortcomings to someone else. By exposing my shame, I risked being judged.

Since I have accumulated this trash for years and years, I decided I must ask for help from a person professionally trained to clean up messes. However, I feared even that might not be enough. That the rot from this garbage had stained too deep… Everything I knew was wrong.

Planning or not, I thought my life was in a straight line. Even without straying far, mistakes made more garbage come to the pile. Not just the plans have gone down the drain; there are still more surprises. And what is there to do when everything seems to have been swept away by a hurricane? Where should I start tidying up after everything has turned upside down? I need something that is not available to anyone. I need a miracle. Sometimes a miracle is not just attitudes and confrontations, or even professional help. Sometimes the miracle is someone who inspires you. My miracle was Joy.

The meeting

My tale begins in this incredible encounter between what was lost and what was created. Between the broken and the whole. Between the sick and the cured. On July 18, 2015, the fall of dominoes began almost six months before meeting Joy. The pieces were hollow socks covering everything in a cloud of lies. And I pretended not to see because I didn't dare to change. If I'm on the beach and don't jump over the wave, at one point, it rolls in stronger and knocks me down. Somehow, I need to get up, or I'm going to drown for good. This time was very dismal, as many waves crashed consecutively over me. Such gigantic and fierce waves pulled me to the bottom. And each time, I went down further and further into the dark heart of the sea. I was losing my strength, and death presented itself like seaweed wrapped around my neck. Then I could see someone pulling me up.

People are bridges between us and our dreams and must be loved. People are priceless, therefore, and more valuable than the precious things; both those who must be valued, from the happiest to the saddest, from the quietest to the noisiest, from the most chained to the freest. The ones that depress you the most, the ones that inspire you the most. Joy is that person for me. Hers was the hand that pulled me from the unknown sea where I was submerged under the waves.

I was drowning from mid-July until January, until Joy rescued me and gave me a gift that was like an oxygen tank when I could no longer breathe. Joy was the one who took me from deep in the heart of the seas and unwound me from the seaweed. Without her, this book would not be written. Without God, who arranged my meeting with Joy, I would

not be here. Of course, God had everything to do with Joy's presence. He provided this meeting. And without her, I wouldn't be here to write this book.

In Genesis,[10] the first chapter reports the process of creation. God made all things in five days, but on the sixth, He made people. God, in my view, left the last of His creation and still made it like Him in his creativity and ability. As He reigns over everything and is the supreme King, He made his creation like a vassal king, and everything on Earth would be under His authority. God affirmed that not only was it good like the other creations made by Him, but He said that it was perfect.

Do you know that person who surprises you and motivates you? That person who never leaves your head, for one reason or another? Joy came into my life to save me and propel me in a new direction. I met Joy on January 4, 2016, four days before my first art exhibition, which took place in Waltham, Massachusetts. She impacted my life in such a radical and unique way.

This was the beginning of our story. The day I meet Joy, I was on my usual walk. My thoughts distracted me and made me lost time, and I ended up on an unfamiliar side of the trail. I came across a field, and all my eyes could see were weeds so dry that they creaked in the wind. Incredibly, in January, the sun was so intense that it burned my skin. The bushes were almost up to my mouth and at some points were much taller than me. The yellow of the dry scrub and the strong sun gave the impression that everything was hazy yellow. I started walking to get out of there. Everything was the same, and no direction I walked in lead me to the exit. I continued to walk for a while longer and found nothing. I was already getting worried and nervous until I saw something moving in the distance.

I wasn't sure what I saw, and it scared me. Because of the sun, I couldn't identify what was moving. Everything was the same color. I walked a little further and saw it was a woman's figure. The sun was so bright that it blinded me, but still, I continued towards that figure. Heading in that direction, I walked for what felt like hours. I yelled some greetings out, but the wind didn't favor me.

Even though I was thirsty and exhausted, I didn't stop. When I finally approached, I saw by her movements that the woman seemed to dance. I was sure she was a woman because of her red dress, which, coincidentally, was also the color of my dress. Even this far away, I was sure she wasn't just walking, but dancing. How can someone dance in a place where I'm dying? She was lifting a mound of dry brush with her choreography. She was so distracted by her dancing that she didn't notice or hear me come. She couldn't even hear me or see the grass moving as I approached. Then I touched her shoulder, and she turned in her dance, showing me what she held in her hands. She didn't have dry weeds but a bunch of ripe wheat. And at that moment, my eyes opened; I saw that the whole field was ripe wheat. In my agony, I couldn't see it all extending to the ends of the fields. I understood that she was happy that the wheat was dry. It was harvest time. And that vast

[10] Genesis 1. NVI Study Bible version. Zondervan Publishing House. Michigan- MI US. 1995,2000

field was her plantation. She stopped dancing and faced me. I returned my eyes to her face, and she smiled in a way I could never smile in my life. Her smile was like freshwater that, at the exact moment, quenched my thirst after a long walk.

Her deep gaze was like arrows striking straight into my soul; Her expression was that of a person so sure of herself, it soothed my despair of being lost. The smell that came from her was wet earth, a very unusual smell. When she moved in her dance, her feet were so steady that she sounded like she weighed a ton. Her rising hands made movements of adoration. I was thonga,[11] but I didn't even need to speak.

I must have been looking at that woman for a long time, but it only felt like a few seconds. I understood her expression, as if she said, "Don't worry, your father never lost control of anything!" To this day, I don't understand how, even without speaking, I understood her message, and somehow, I managed to get out of that suffocation.

From that day forward, Joy became the most inspiring in my life. We never parted again, although in some chapters when I talk about my past before meet Joy, you will wonder, where is Joy? She was not there yet. Joy is the whole version of my original self. The amazing way I was created made me strong, fearless, and full of dreams.

My awakening came from the moment I met her. In my heart, a seed of hope was forged in our first meeting. When I left that place, the first thing I did was paint the scene I had just witnessed. But this painting couldn't express all that I saw and felt. At that time, I only painted in oil, and when I took the wet painting to the exhibition, my son, even after I warned him more than fifty times, stained his shirt all over with the paint. Several people wanted to buy the painting during the exhibition, but we didn't have time to catalog or price it, so we didn't sell it. It would become this book's cover. For a week, the image of the woman dancing was all that came into my head. At that time, I learned something fundamental from Joy: dancing in adoration and joy in times of despair.

Dancing in dry weather is knowing who is already waiting for me tomorrow.

[11] Thonga: wide mouth, numb, dumbfounded, shocked.

Chapter 2
The list

Lists allow us to prioritize goals and move towards them.

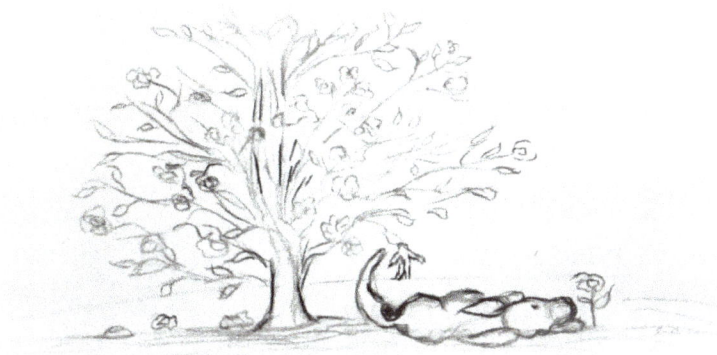

The power of the list

I spent a lot of time with Joy after we first met, letting the impact of her enlightened presence wash over me. She always showed up beautifully and unexpectedly in my worst moments as a compass and a mentor. She made me reflect on the evils I had collected and how I should discard them. I should never forget temporary things. So started my life after Joy. In the beginning, I was irritated by the symbolic way she spoke to me, as if I had to read her mind the first few times. But today, I realized that to understand metaphors, I must think. It's easier not to waste my thoughts, because reasoning takes work.

When analyzing metaphors, I ended up confronting them in one way or another. In these metaphors, there were many suggestions for changes in the way I conducted my life. One of the things that Joy suggested to me to keep in my life was my custom of making lists, which I had adhered to since my adolescence. Making lists was something I learned when I was seventeen. I can focus a lot more on my priorities when I make lists. The lists guide me to follow a particular order of importance. Lists on everything: grocery shopping, housework, personal care, scheduling time for my mental health, and projects for the week, month, or year. I even made lists of my long-term dreams. As soon as I put my wishes or even obligations on a list, I end up committing myself to fulfill them.

I inherited the importance of making lists from my heavenly father, as he created one of His lists to instruct us to walk in his ways and protect us from ourselves. After we inherit sin from Adam and Eve, God's list of ordinances keeps us away from the sin we inherited in our DNA. These laws insulate us from natural and spiritual enemies like a fence around us; they are called the Ten Commandments of God's Law, also known as the Decalogue.

According to the Bible, the Decalogue is the set of ten laws that God wrote in stone and gave to Moses to pass on to his people. Also, according to the book of Exodus, Moses broke theses stones, and God had to write others in their place. He divided it into two parts: the first part of the list was about the love of God, and the last six the love of neighbors. This list of laws that God left us is a protective bell to keep us close to him. We are close to Him; we are further away from our DNA of sin that we inherited from the fall of man in Eden. Those who don't believe can consider this practical advice and an excellent way to stay out of trouble. If the wisest being used a list, the idea must be adopted by us.

Writing your goals is a contract with yourself to make them happen. In my times of ignorance, I adopted the list as a fundamental part of my life. Lists for everything! But the two that matter most are the list of things I need God to do and the list I need to do for myself. After making the second one, I noticed that everything I put on my list happened. When I made my list, I put all my effort and dedication into getting what I had written. There's a quote that states, "Writing things down not only helps you remember, but it also makes your mind more efficient, helping you to focus on the things that matter. And your goals absolutely must qualify as significant stuff. Unfinished tasks than completed ones, and interruptions during a task helped people retain more details of the task itself."[12]

When I make a list, I automatically initiate a need to accomplish what I have listed, and if I stray from the list, my subconscious will remind me until I have finished the task. Carrie Barron created a list of six great benefits when lists are made. According to Barron, lists "provide a positive psychological process by which questions and confusion can be worked through. The real purposes arise."[13]

Also, lists promote the ability to select and prioritize. This is useful for avoiding an information overload situation. It separates the minutiae from what matters, which is good for both identity and achievement and helps you determine the necessary next steps. Write down what resonates with you, informs your direction, and helps you plan. Avoid confusion. Bringing the abstract to the concrete sets the stage for commitment and action, especially if you add self-imposed deadlines. It helps you organize and prevent a sense of internal chaos, which can make your load more manageable.

Maybe my creativity influenced my lists, or maybe it was my sense of commitment to myself. I had God's blessing to accomplish all the items on my lists faster, but God's list was totally up to Him. You have to predominate patience and prayer, and most importantly, you need his mercy if you want that to happen. I have been waiting decades to finish some items on my list, because sometimes His timing is different from mine. Although many I conquered solo, He granted me success countless times. I forget, but He never will. He even remembers the times of my ingratitude. As it is written in Proverbs, "Ask God to bless your plans, and they will work."

[12] Bluma Zeigarnik. Soviet psychologist and psychiatrist, member of the Berlin and Vygotsky School of Experimental Psychology. This is called Zeigarnik effect, as he was one of the first psychologists to examine lists.

[13] Barron, Caroline, MD. Co-author of *The Creativity Cure*.

Decades after adopting lists for my life, I still have my annual lists, which I start making in November of each year. If I put something on my list, I will be making a contract with myself to give one hundred percent to making it happen. The things I want or need the most are the ones at the top of the list, just as the first thing on God's list is to love Him above all things. The most repetitive lists are the habit-changing lists to make me a better person. Every year when I see what I could change, I always fall into the same miserable routine. How unfortunate am I? Paulo, the apostle, said, "What is right I don't do, but the evil that I don't want to do, I keep doing."

Bridge or Island?

Some people were disappointed in dreaming and trusting. Those who suffered, who struggled, who believed, who remained, and those who did not conform or change by rewriting a new history. It's beautiful to be resilient and, like cats, fall on your feet. It is like the difference between an egg and a potato in boiling water. The egg hardens, yet the potato softens until it disappears, even though they are in the same hot water. Which one are you?

These people did not have the opportunity of learning how to swim, but because they were sinking, they learned to float. Some were disappointed and closed off from life. Some have suffered and live isolated like an island protecting itself from the terror that invades life once again. Some were brave and decided to end the suffering because they lost hope, and their pain is so great that they could no longer stand it. Your pain is more significant than your love for people, greater than your dreams, more excellent than your faith. This person got tired of trying to swim and sank into the dread of what they were living.

Some are still afraid, perhaps because they don't dare to end the pain. They get used to it or seek healing. Others dare to end the pain by being brave enough to end it. Each leaves their memories in our lives. We all leave memories, and we live on in memories that others leave in our lives, whether the memories are good or bad.

What am I today after living—an island or a bridge? After having lived like a carousel that rotates but always goes horizontally, how do I identify myself? What have I become? An island that isolates me, surrounded by water, separating the people closest to me? I am an island because I cannot trust for long.

I am an island because I am hurt. I trusted, opened my clean waters, and just got pollution. Therefore, I am an island! I have been deceived with flowers that I took care of, but they abandoned me when they were beautiful and fragrant. I'm an island for being hurt by people that came with picnic baskets, ate the best, and left their trash on my land. I became an island to protect myself from all emotional harm. I have no bridge.

Or am I a bridge? Even wounded and despised, abandoned, used, betrayed, each piece built a bridge in me. I strengthened myself and got to know myself. I am a bridge between the good in me and the bad in others. I let good things come out, and I recycle the bad by learning. I don't stop being a bridge because someone tried to make me an island.

My life can have the shadows of my past, but my responsibility is to illuminate how I want to live for the future.

When there is no door

I crave life much more than the stage I reached; I want to get everything from it.

The truth is, my own life never offers me anything, but stubbornly I rip it off and make it mine.

I always took it by force because it was never given it to me.

I have been knocking on the door incessantly for some time, and it still doesn't open.

I even think about breaking it down, but this life's door is solid, and my strength is not the greatest at this moment. What if this door leads me into a dark tunnel that doesn't see the end? Will it be me who passes through it? At some point, I stopped thinking about how tight it will be, and how it will be an opportunity that might lead me to the same place I want to go. I will never know if I do not enter through it. Just try to go and not think about how difficult it will be, and it will be!

Not thinking about the discomfort, I will have, and I will!

It is so little to think about everything I will have to leave behind, and I will!

To fit into this place that I can barely get in. And I will go in! Because where I find myself, I can no longer stay.

There are times in life when the doors don't open, or worse, sometimes there is no door at all. It is taking from life what it has never offered you. Seeking courage where there is none, going in fear, making windows or breaking walls where there is no way out. Or even, in worse situations, having to dig with my own hands, deafening to criticism, and not speaking the language that will discourage me.

I have the improbable already. So, I am going searching for the probable through the role that I must make until the door remains closed. From life, I will take by force everything it refused to give me. No matter how hard I searched, begged, and insistently knocked on the door that never opened.

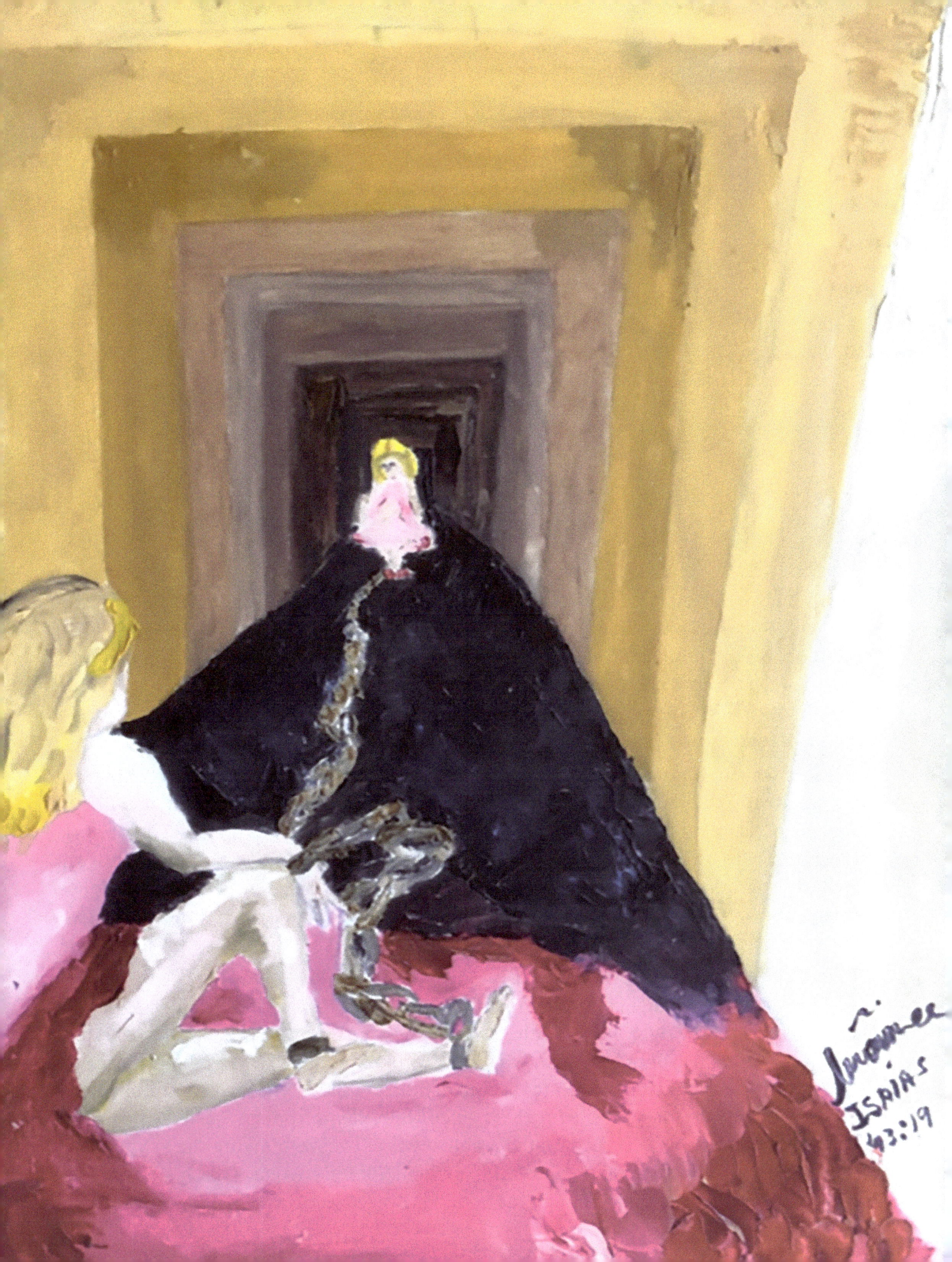

Chapter 3
Broken compass
Decisions are current, with their links reinforcing one after another.

Following one broken compass

Recalling the times before Joy, I was like a broken compass. I didn't hear anyone who I should listen to. I also didn't know the voice of God as I do today. And like every young person, the decisions I made weren't the best. I was raised in a different environment than the one I live in now, and the God I was introduced to was quite a different God than the one I know today. When I was nine years old, God presented Himself to me in a dream as the same figure I now know.

I was walking through a city of destruction, and I was lost and scared. I couldn't find my grandparents, who raised me. I couldn't find my parents. I didn't see anyone I knew, just people running in despair, their houses burned and some still on fire. The dark sky of ash grew from the fires that could be seen near and far. I stepped on the ground, and my little feet hurt from the rocks, making me limp. I was thirsty and looked for a faucet outside the house but didn't see any. My hair, almost white-blonde, then turned black from the ash blown by the wind. My wide eyes took in all the destruction where I walked. I was looking for some familiar faces.

After a lot of walking in places that had the same scene of fire and disorder, I felt a big man's hand grip my right hand tightly. He felt familiar, like my father's presence, but he wasn't my father. Holding His hand, we started walking together. I looked at the ground because His footsteps were heavy and it sounded like thunder, but I wasn't afraid. On the contrary, I felt safe. He was wearing a sky-blue shirt, clean from any ash. His scent was like a ripe pink mango. His breath from above was a breeze blowing the ash from my hair. I didn't feel lost anymore, and I didn't even look for anyone. That man's presence felt like a shield around me, and it was enough. Everything I saw no longer scared me.

He didn't say anything, not a word, and He didn't need to. Only His presence stopped the world for me.

I woke up with that smell of ripe pink mango in my nostrils. I knew that it was Jesus I heard talking, and it would be just like in my dream. Even when everything fell around me, He would sustain me. And so, I see today that He has always been there, and that during some of these moments I couldn't see Him, but He was there. But even though God is everywhere in life, I always ran from his presence and His plans for me. This made me an easy target for the enemy of my soul, the architect of evil. God doesn't leave anyone who believes in Him unanswered. My questions were always the same before Joy: why didn't He deliver me from so many things, since supposedly the devil didn't know the future? Well, the answer came after a long time.

In 2017, I had a dream where I was walking through a big city, but there was no one around. I was with my grandmother, and she looked around scared but stared when she looked back. She said, "Don't you see?"

I did not answer.

"Don't you see the legion surrounding us?"

I was so startled; I could not reply. She said, "Follow the angels who are opening the paths for you to pass. They don't know what will happen, but if angels are opening the paths for you and taking care of you in this way, it is because you are the target of their attention, and you need to listen."

Sometimes we hear a voice tell us not to do something. We obey the voice, but most of the time, we're so desperate to live that we don't even hear common sense, let alone the angel's voice. After having this dream, I look back and see how I was once the target, distracted so that I don't go where I should be. But the most beautiful thing about the Heavenly father is that no evil remains in His hands. He always makes everything good. In so many cases, we must wait years to see the results of the changes. Therefore, even if I take the wrong direction, it will cooperate in my maturation and in the testimony of my achievements.

If I hadn't gone through what I went through, I wouldn't have so many stories to tell. It was a long road of wrong decisions, forming a chain reinforced by other bad choices. It would not be a single good decision that would break the chain formed over a long time. I wrapped everything around me, and even if I weakened the chain with a good decision, I would still have many solid links for bad choices to be broken. I was putting together good decisions one after another. The good ones were the majority. Even when making a wrong decision, there were too many good ones for a bad link to destroy the chain of good decisions. One of my bad decisions was to strengthen the chain, and one of the links in this chain was coming to the United States. Deep down, I knew that I was already involved in this chain, and that the following links were stronger than the others.

> *The more an artist is a specialist in recycling trash, the more putrid, the more beautiful his artwork will be.*

It's a good thing that God smooths our paths, because after moving from country to country, my attitude changed from bad to worse. I cried a lot, then fixed myself for a few months, made my list, and worked through it. No longer was everything good; I was already putting new bad links in my chain again. One of these links was Felipe, my ex-husband. He never hid who he was and what he wanted from me, but I ignored the signs. The signs that this was another wrong link were like giant posters showing what was clearer than spring water. Stupid people always think they are exclusive. "It will be different with me!" People don't change character. God changes nature, not us, but we must accept and work in the changes. I was blind, and Felipe was, too. We were one blind leading the other is like a broken compass, he couldn't guide me anywhere.

People always show who they are in their present and past attitudes, but emptiness makes us stubborn. The biggest problem is that loneliness and despair emphasize other people's happiness. Viewing what is shown by the other person becomes meaningless in the face of the need to be loved. When someone is happy alone, another person will add to the relationship. But what if that person is unhappy and seeks happiness in someone else? I ended up subtracting my importance from my felicity and handing over the responsibility of my fortune to someone else.

Consequently, I would nullify myself to make that person happy and maintain my happiness. So, I was going to agree to things I wouldn't usually agree to, and whatever comes out of that person would be above me no matter how much he or she didn't impose. My unconscious fear of losing this person would impose on me. I am the most responsible for my happiness. Indeed, this responsibility does not lie with another person. But sometimes the traumas of life made me lose my self-love, and without my self-love, I would never be happy with myself. If I don't love myself, how can I be responsible for making myself happy?

> *Self-love is a compass that always directs me towards my happiness.*

The mistake is not in other people, but in me. We are not truthful in admitting that we need to love ourselves first and be happy on our own before placing this burden on someone else. Mexican writer and philosopher Don Miguel Ruiz wrote, "Don't expect people to tell the truth, because they also lie to themselves."[14]

If I'm not true to myself, how can I expect others to be? And even more foolishly, when I lose "my source of happiness" and force someone to replace that source, it can make the next chapter of my life even worse. The right thing is to fix the broken compass and take

[14] Ruiz, Don Miguel. *The Four Agreements. Don't take anything personally. P. 57.* Amber-Allen Publishing Inc. San Rafael, CA. 1997.

the time to put it in the right direction. If the compass breaks, it will indeed lead me down the wrong path. But if you believe like me and believe that God is the way, He will show it to you. When we trust Him, He changes direction, no matter how lost we find ourselves. It's as simple as that!

Heritage

Inheritance belongs to one person and is usually passed on to another person when that person dies. We inherit not only from our family members, but also from friends, leaders, and influencers, and so we also leave a legacy to our descendants. I may influence people who had cvzvzvvvvontact with me at some point; this is also a legacy. We inherit influences and material possessions and our DNA, which is our genetic inheritance. Many of us are like our grandparents or great-grandparents, both physically and in essence. We have attributes that are inherited from our ancestors. If someone who knew my ancestor saw their gestures or attitudes in me, they could discern the resemblance.

I am what I project for myself, and everything that has to do with my emotions can be controlled. By inheriting DNA, we also, unfortunately, receive hereditary diseases. As some conditions are genetic, it often skips a generation. Another unwanted inheritance is the way of being that is often discussed by experts. The temperamental attitudes are more for living than the genetic inheritance itself. For example, take the expression, "I'm nervous just like my father." Living with my father made me copy his gestures and attitudes. My life depends on me. What I am can no longer be influenced by the other things that I've lived and witnessed.

When we are children, we can make excuses for our mistakes because we are still learning. As we become adults and are responsible for our lives and actions, those excuses no longer stick. We cannot excuse our actions by saying that we're like that because our fathers were like that. I'm another person, and my emotions are mine alone. Knowing my roots is a path that will only bring me benefits. It will give me a deeper understanding of my true role in the world. I may be like someone in my family tree. In my life, I can try to fix what he/she couldn't do.

In the construction of the ego, of the personality, everyone takes their brand, their structure, their peculiarity. Paulo de Jesus Amorim wrote, "In this construction, the conscience of each one is structured by the conscience of the other or more than one. Thus, as we are animals raised in packs or, more specifically, in families, the psychic life of one member is transmitted to another within this family unit. This transmission can cross time, becoming transgenerational."[15] By making my gift better than those of my ancestors and accepting only the heritage that I want to perpetuate, I can leave behind an inheritance to those who come after me. I am what I decide to be. I won't be nervous like my father. I'll be fearless, or I'll die trying to be. Genetic inheritance is not reversible, but all other heritage is like a gift. Gifts are mine only if I accept them. If I don't want an inheritance,

[15] Paulo de Jesus Amorim, Ph.D. Clinical list flashes. Psychic and intra-transgenerational inheritances. Psicólogondo.com.br. September 2015.

I won't get it. I don't have to receive something in my life that I don't want, just as with blessings or curses, wealth or poverty, nervousness or calm. Everything is mine if I accept it into my life. My life can have the shadows of my past, but only I can decide how I want to live.

My cultural heritage is something I love. The beliefs and stories make people eternal. The desire to walk barefoot was a habit we inherited from the Indians, the originally Brazilians: Tupi (North) and Guarani (from the South). Usually, when we get home after a full day of work or school, the first thing we do is remove our shoes and spend some time barefoot. Many people are in the habit of always going barefoot when they are in their homes. My Brazilian cultural heritage is remarkably diverse, as the Northeast influenced me through my parents and grandparents.

Northeastern cuisine, for those who are unfamiliar, includes dishes such as acarajé,[16] vatapá,[17] caruru,[18] fish moqueca with dendê oil, and much more. The delights of buchada[19] de bode, sarapatel,[20] viúva,[21] and genipap liqueur go further to the Northeast. I was also influenced by the artistic heritage that I grew up learning, like the repente[22] and cordel[23] literature.

I have my cultural heritage from the state where I lived my childhood, adolescence, and my first adult phase, my Pará, which was the central theme of my 2018 art exhibition. I tried to show some of its infinite beauty through my canvases. I would paint like Ver-o-Peso,[24] and I painted Brazilian Indians from different tribes from my state, Pará, like Mundurukus and Kikateje. The state of Pará and the entire Northern region has an indigenous base in its gastronomy. All the wealth that the Amazon offers is used for consumption by its people. The biggest influencers on the culinary richness of the North are the Indians. Most dishes use cassava. The biggest wild card in Northern cuisine is tucupi. Tucupi is a yellow, aromatic, and acidic juice extracted from wild cassava after being peeled, grated, and squeezed with tipiti, a tool of indigenous origin. It is a food that is very present on the table of Brazilians in the Northern region. Tucupi has many health benefits. It is rich in Vitamin A, which helps the eyes and bones and is anti-inflammatory.

[16] Brazilian Northeastern exotic food as usual, vatapá, caruru, fish moqueca with dendê oil.

[17] Dish made with shrimp, dendê oil.

[18] Dish made with okra.

[19] Dish made with sheep intestines.

[20] Dish made with blood, kidney, heart, liver.

[21] Dish made with the intestines filled with the organs and bound with the guts. It was named because the poor Northern widows don't let anything go to waste.

[22] Repente: also popularly known as Cantoria, this is a Brazilian art style based on singing improvisation, alternated by two singers with their violas in northeastern tuning. Based on the alternate singing that takes place in the form of poetic improvisation—the creation of verses "suddenly."

[23] Cordel Literature: brochure folk literature in verse is a popular literary genre often written in rhymed form. The name comes from the way in which brochures were traditionally displayed for sale by hanging on ropes, twine, or string.

[24] Ver-o-Peso: one of the oldest public markets in the country, considered one of the state's wonders. It was elected one of the 7 Wonders of Brazil for being one of the oldest markets in Brazil. And it is the largest open-air markets in Latin America.

It is a great help for the immune system and hair appearance. No wonder why the Indians have such beautiful hair. The best-known dishes are duck in tucupi and tacacá. The açaí berry, which has become popular in recent years, grows where my people come from. The Northern region produces the richest coconuts from the skinniest palms of the Amazon.

Almost everything at the table comes from the rivers and forest, where the culinary and cultural wealth originated from the Native Brazilians. Age-old culinary recipes have been passed down for generations, like the burnt milk I made for my son last night. It is a simple recipe that tastes and smells like my childhood. I melted sugar and cinnamon and poured milk in at the end. It may be that he passes it on to his child and so on, or it could be forgotten. In the state of Pará, where I grew up, I consider myself a cultural heir. A state is rich in indigenous cultural heritage, from legends to cuisine. The typical dishes we inherit from indigenous cuisine are the wealth and pride of the people from Pará. In most recipes, the ingredients are plants and herbs that are native to the state of Pará and Amazonas.

I inherited the name of the Septimios from my maternal family. We are descendants of Septimius Severus, also known as Severus, the Roman Emperor from 193 to 211 CE. He was born in Leptis Magna, in the Roman province of Africa. As a young man, he advanced through the usual succession of positions under the reigns of Marcus Aurelius and Commodus. Septimio was born on April 11, 145 CE in Leptis Magna, Libya,[25] and died on February 4, 211 CE in Eboracum.[26] His full name was Lucius Septimius Severus of the House Severan Dynasty.[27] The richest heritage that came from the African peoples was not only a region or state—whole of Brazil was part of Africa's inheritance.

Everywhere I go here in the United States, I talk about these African culinary influences in Brazilian cuisine. Feijoada, the beans that the enslaved people planted, was the only food destined for them. Writers already mentioned beans at the time of the colonization of Brazil for being part of the diet of Brazilian natives, Grupos dos Guaranis. The slave masters ate the best parts of the pig with more meat, like the ham, for example. The enslaved people used everything else that the masters did not consume, such as pieces of pork like feet, tails, ears, muzzles, and skin. They cooked all of this along with the beans and herbs they grew. The rest of the meat that remained on the skin joined with the guts and made sausage. A recipe of oppression and neglect has become the best-known dish in Brazilian cuisine. How ironic, huh?

The first mention of feijoada was at the beginning of the 19th century in an advertisement published in n. 47 of *Diário do Pernambuco,* one of the oldest Brazilian newspapers in the city of Recife. On March 2, 1827, the newspaper reported that at Locanda da

[25] Leptis or Lepcis Magna, also known by other names in antiquity, was an important city of the Carthaginian Empire and Roman Libya at the mouth of the Wadi Lebdam in the Mediterranean. Location: Khoms, Libya. Founded: 7th c. BC.

[26] Eboracum was a fort and later became a city in the Roman province of Britannia. At its height, it was the largest city in northern Britain and a provincial capital. The site remained occupied after the decline of the Western Roman Empire and eventually evolved into the present city of York, occupying the same site in North Yorkshire, England.

[27] The Severan Dynasty was a Roman imperial dynasty, which ruled the Roman Empire between 193 and 235. The dynasty was founded by General Septimius Severus, who rose to power as the victor of the Civil War from 193 to 197.

ÁguiaD›ouro, on Rua das Cruzes, on Thursdays, the delicacy would be served—"excellent Brazilian feijoada, all for a comfortable price." Feijoada is born from oppression, evil, hope, and creativity. Despite the racist history of colonizers, a part of Brazilian heritage is remembered though the times of struggle that only proved to make us strong, creative, fearless people whose art flows through their pores.

Before the discovery of Brazil, native peoples already inhabited the territory. There are several indigenous groups in the country. Among the main ones are the Karajá, Bororo, Kaigang, and Yanomami. In the past, the Native population was almost 2 million people, followed by Africans captured from their tribes - many were kings and leaders. The names created by the interbreeding of Natives and Africans at the time of colonial Brazil formed several groups, called Mestizos, for mixing. The three that stood out were: Cafuzos,[28] Mamelucos,[29] and Mulatos.[30] But also, Mazombos, Curiboca,[31] Pardo, Cabras, and Crioulo.[32]

We are descendants of this suffering and strong people, as our hymn says: "But if you lift a strong club from justice, you will see that your son does not flee from the fight. Neither fear, who adore you, death itself." [33]So, we are heirs of great warriors and trailblazers. We didn't run away from any fight, and we got stronger with defeats. We came back more potent and more promising. Giving up is not an option for people who forge themselves in suffering and get up with wounds and continue because giving up is not an option.

Brazil is also known for its unique musical culture. The first recording of samba music was in a music studio in Brazil at the end of the 19th century. Samba is a Bantu word. Samba means navel in the Kimbundu language. This originated from the former Kingdom of Kongo, which currently corresponds to the two republics of the Congo and Angola. In context, samba means dancing with joy linked to the belly button—it's an invitation to rub a navel against the navel in binary rhythms. Capoeira is a martial art of dance fighting of Bantu origin. The practice of capoeira is with the hands, whose gestures such as ginga and quot [34]are some of its basic movements. Movements practiced by Maculelê[35] players and inherited today in Brazilian capoeira.

Historian Justes Axel wrote, "Originally, it was inspired by the fighting techniques of the armies of the Kongo Kingdom, which currently includes Congo-Brazzaville, the Democratic

[28] Cafuzo: people who are a mix of Black and Indian.

[29] Mamelucos: caboclo, caiçara—mix of and with Indian (the coppery skin coloring reminds me of the Egyptian Mamluks).

[30] Mulatos: mix of Black and white.

[31] Curiboca: the son of an Indian with a Mamluca.

[32] Crioulo: the Africans born in Brazil in the colonial period.

[33] Brazilian national Anthem by Francisco Manuel da Silva in 1831 and had been given at least two sets of unofficial lyrics before 1922. In 1909 official lyrics by Joaquin Osorio Duque-Estrada.

[34] The ginga (pronounced jeen-gah; literally: rocking back and forth; to swing) is the fundamental footwork of capoeira. Its constant triangular footwork makes capoeira easily recognizable as well as confusing, since it looks much more like a rhythmic dance step than an orthodox static fighting stance. Quot is also another dance movement.

[35] Maculelê is an Afro Brazilian dance where a number of people gather in a circle called a roda. Regarding the etymology, it seems that macu comes from the Yoruba language spoken by the Nagôs, while lelê comes from the Malês' language.

Republic of Congo, Angola, and Gabon. Art of bare hands for war was taught to the Bantu warriors of the Kongo Kingdom to face off the occupying armies and was called 'NGO-LO' which in Portuguese means the strength of the panther."[36] According to historian Justes, capoeira was widely used by enslaved people in colonial Brazil in defense against the so-called captain of the forest who oversaw the enslaved people. The "captain" had to make sure that the enslaved people worked and did not run away. If they did run, the "captain" would have to go after them. At the end of the working day, the enslaved people would gather and practice capoeira disguised as a dance to train for their defense and teach the youngsters about the cultural heritage.

Moreover, humanity's heritage is the burden of man's fall in Eden. On the other hand, we inherited from our creator, God, to be like Him, His image, and His likeness. This is similar to being like Him not physically, but in essence. First is our ability to love. This is not love that is expressed through emotions, but love positioned in front of what is real. The closest thing to the love of God is the love of a mother. A mother loves her child when it is conceived, and she loves him when she meets the baby, whether he is even ugly, handsome, or handicapped, and she just loves him. A mother loves her child when they disobey, lie, or steal. A mother continues to love because she chooses to love. But God's love goes even further: "Even if my father and mother forsake me, the Lord will take in."[37] "Is there a mother who can forget about her baby who is still nursing and not have compassion for the child she bore? However, even if she forgot, I will never forget you!"[38]

Even as heirs, we receive the ability to choose, change, create, and develop from something small to become great. We discern between right and wrong, leading and directing people with our vision, morality, sense of justice, mercy, and forgiveness. Like God, we forgive people even though we know they will repeat the mistake or perhaps do worse. And as His heir, we're able to give Him another chance. But as the inheritance is mine only if I accept it, in the kingdom of God, it is no different. He created everything for us, who are His creatures. We are all called His heirs. He gave us Himself as Jesus in His visible form. He descended, dwelt among us, and left us the inheritance of being not only creatures, but sons and daughters. And like any inheritance, I must accept it in order for it to belong to me. A legacy will only be mine if I take possession and become heir to it.

He knows we're going to do it again, or we're going to descend deeper into our flaws, into His omniscience. But even so, He gives us more trust credits not once, not a hundred times, but infinite and renewable in all our days.

We are waiting for a great miracle and keep forgetting that every morning is a miracle when we wake up.

[36] Axel, Justes. Historian and researcher from Congo Brazzaville in Brazil. Beginning of Kongo's history." The huge influence and the Bantu heritage in Brazil. Article. www.Wizi-Kongo.com. June 13, 2018.

[37] Psalm 27:10

[38] Isaiah 49:15

Chapter 4
Lost

Going back to the old path is back to fighting battles that we almost died in.

One blind leading another blind

Felipe once told me amid a fallacy of separation that "we must learn to be happy alone because your company will be a matter of choice, not a necessity." He said this to remind me that I was always a necessity to him. I was never his first option and knew that in choosing him. I was someone who helped him when no one else was there and who picked him up at a time when he was down. I wasn't someone he desired and chose to grow old with. I was a necessity. I learned a lot from it, but I only put it into practice after almost fourteen years, after hearing him repeat it. Foolish people hide excuses to continue in their vicious circle because making decisions and making them happen is very painful. So, I lived blind because I refused to see what was clearly before my eyes. How many pains would have been avoided if Joy had been with me at this time? And in addition to being blind, she guided another blind man who did not want to see the future and mature.

I grew up with a single dad. Unfortunately, someone like my father attracted me like a magnet to men with attitudes like my father. Both Felipe and some of my first choices were no different. This is nothing new. The theory was put forward over a century ago by the well-known father of psychoanalysis, Sigmund Freud, who dubbed it the "Oedipus Complex" in men. His contemporary, Jung, proposed an analogous theory, which created the idea known as the Electra Complex. Theories suggest that all boys between the ages of three and five sexually desire their mothers, and girls lust after their fathers. In Freud's theory regarding the Oedipus Complex, it is explicit that there is a desire to seduce the child by the opposite sex in childhood. The other phases are the rivalry after your disappointment in the face of denial and the destruction of the Oedipus Complex, forming out of that the identification and our psychic structure, which will be what will later attract

us. The daughter is always unconsciously looking for someone like her father; apparently, the son always looks for women who remind him of his mother.

I'm not blaming anyone but myself. After all, what I am and still will be was formed in my joys, pains, and healings. Today I am myself. To reach this conclusion and gain direction, I walked a confusing path strongly characterized by my first relationships in my first six years of life.

The feelings of a child's early life will always weigh heavily on their adult life. We shape our emotions through our discoveries as we grow up based on what is essential. In our first six years of life, the internal adjustment in search of our own identity is impeded by the influence of someone's most vital characteristics in the past. These influences reflect on our development as we grow up. The search for our identity will continue, but always with the shadow of our roots in our childhood assimilations. Self-identity will be achieved when we are mature enough, deciding to be what we want to be. Being free from the shadows and influences of what we saw in our early years of life is a choice. It's not because I saw my mother cheat that I must cheat. It's not because I saw my dad beat my mom that I must beat my wife. I am free to decide what I want to be.

Steady growth in research indicates that adverse childhood experiences are associated with increased risks of psychosocial neglect as children become adults. James Fosshage states, "Appropriately in its positive form, to a specific relational configuration in which the child experiences expansively the role of a heterosexual partner of the father of the opposite sex and feels variably identified and competitive with the father of the same sex."[39]

When we are with a limited vision—or why not say, blind—without our own identity, we are prone to choose repeated paths strongly marked in our development. In this moment of blindness, I insisted on guiding another person who was also blind based on their development and their unconscious childhood traumas.

This is not unlike the opinion of psychologist and psychoanalyst Beatriz Markman, who emphasized, "Physical and emotional constancy allows children to reach a healthy personality as a child, adolescent and adult future."[40]

Unfortunately, we suffer from our parents, and we still have no control over what we pass on to our children. If we are marked by trauma because of how our parents raised us, this will undoubtedly influence what we will do to our children. A good attitude for me to have is to watch what I do and explain that we all make mistakes and will continue to make mistakes. Trying to recognize my errors for my son and make him understand that I fall not because I want to. Showing that I have failed in many things, but his safety and happiness are paramount for me and will make a big difference.

Many times, when I don't talk and don't admit that I did it wrong, I'll be showing my child that it's okay to do what I do. So that goes unnoticed, and my son can be influenced

[39] Fosshage, James L. Psychoanalytic Inquiry. Early consequences of pre-Oedipal maternal deprivation. Vol. 30 Issue 6, p520-534. 15p. Nov/Dec2010,

[40] Markman Reubins, Beatriz,.MD, PhD. Child, adolescent and adult psychiatrist, psychologist. International Forum of Psychoanalysis. Vol. 26 Issue 1, p38-42. 5p. Mar2017, New York

by the bad image that he will think is right. However, as an adult, the form he saw and found normal will be involuntary and likely repeated.

I am thankful for the opportunity to be present in most of my children's lives, always expressing how essential their importance is in my life. I remain hopeful that among the traumas they may have acquired that are inevitable for all of us, maybe I could have been a constant figure of love and trust in their lives. Another opportunity is to be able to see the bad influence I am for them and redeem myself by showing my mistakes and teaching them that it is not okay to do so. There is no trauma or emptiness that God does not solve. In traumas, He loves, and for emptiness, He fills up.

When Saturday is on Wednesday

Life is art. We must take broken pieces and turn them into beautiful sculptures. Use the dark side to transform a deep part of our paintings. Collect thankful words in stanzas and colorful days in songs to be remembered. This art called life is fleeting when we are happy and long when we are suffering. Nevertheless, like any artist, we must turn simple days into beautiful happy memories, to celebrate midweek special occasions, turning this dark and rainy day into a colorful canvas-like baby mess art.

Like an image or painting that has more light on one side than the other, so is every relationship filled with good and bad things. In the dark part of my past relationship, the things I point out don't hit the hammer as to what went wrong. On the contrary, if they did, I wouldn't have struggled so hard to stay in it: "A few years after marriage, however, married people report feeling less romantic and more dissatisfied," wrote authors Karney and Bradbury[41].

But we couldn't continue some things, and we both needed professional help. Unfortunately, when we decided to search, it was too late. As much as my ex-husband had me suffer, I wish God's best for him because I also want God's best for my life. Besides, I had good days, too.

On one occasion, I drove down Main Street in Cambridge, Massachusetts, and saw a giant mermaid in a place that looked like a restaurant. I was curious what that place was like. I thought it must be colorful and mysterious, like the mermaid outside the front door. Will it be beautiful as it looks outside? Was it a special occasion to go there? It was a dark gray, rainy day that needed some color. The crazy, choppy weather in New England, a beautiful hot day, had turned into a day to want to be in bed. One beautiful sunny day, and the next I was waking up with snow. But our ninth wedding anniversary was approaching, and Felipe had booked this restaurant for a particular date. And we were going on Saturday. As an old Brazilian saying goes, "I'll rest a lot when I die." Wednesday is a perfect day to rest after work, but we decided to turn Wednesday into Saturday.

[41] Karney B.R., & Bradbury, T.M. *Trajetórias OD chance during the early years of marriage* pp65-96 Mahwah, NJ: Erlbaum. 2004.

We got ready and went; I didn't know I was going to the place that had caught my attention, it was a pleasant surprise. There was no parking, so we drove fifteen minutes to find if they have a valet. The valet disappeared with our car and made us think of those movies when the valet takes a crazy ride and returns with your car with just the wheels and the steering wheel. The area had street parking when it wasn't busy, but Cambridge is never quiet. When you have less than two hours to park and get a ticket in the city where Harvard is, it will never be less than fifty dollars, as is every area near Boston.

At the reception of the place, the environment already embraced us, with a well-paid hostess who was happy to be there; she was prettier inside. All the waitresses dressed like 20- to 40-year-old French cabaret dancers. There were lots of red feathers and fuchsia lipstick, a ribbon-like chocker or lots of pearls, and elegant high heels. They wore Fishnet stockings and sweet perfumes and greeted us with a big smile. Customers wanted to take pictures with them, and they were happy, as if they enjoyed their work. Working in a place like this should be paid well and tipped well because the waitresses look radiant.

The restaurant had rustic tables, the napkins like flying doves inside small plates. There was a table in the back for a big party with elegant, well-dressed people. On the side of this table were two large gift boxes on the floor that nearly made one of the waitresses trip. A male guest came in with a giant bouquet of red roses and a white teddy bear about his size; the gentleman was chubby and sharp-dressed. It made all the other women in the place jealous, myself included. One of the girls seated at that table had an afro hairstyle pulled to one side and held up with a beautiful shiny comb. She wore a yellow chiffon dress, which was a very nice outfit. Still, this restaurant just looked like a television show, but we were watching live on a rainy Wednesday night.

On one side of the restaurant wall was a geisha costume, on the other a mannequin with an antique French cabaret costume, like the waitresses wore. It was a mysterious environment with dipped lights, some floor lamps, and wall lamps. The walls were framed with wonders, flower arrangements, old Hollywood photos, concerts, and casino performances.

The drink menu was named after an original cocktail party, but with their flair. They had smooth, very creative, and beautiful cocktails—they even had a Brazilian Caipirinha with its peculiar touch of the establishment. Very good, but nothing related to the original Brazilian. Felipe asked for one called "Aviation." It was very delicate, gin, cherry liqueur, lemon, and cream, something that was precisely on the right path, and costly, too.

They served smaller dishes, more like tapas, but they don't like that word for their little food. The restaurant was so expensive and well-designed that you had to take a picture. It was so lovely that the camera or phone was the last thing to remember. The chef was a chubby, sharp-dressed man who created international dishes with an exquisite presentation. Many of the recipes were from different countries, but with their own creative little twist. I fell in love with the Thai mussels, a fantastic little soup with noodles and coconut milk. They had a grilled petite filet in honor of Argentina with a chimichurri[42] sauce that

[42] Chimichurri: traditional Argentinean sauce used for barbecue "Argentine roast" made with garlic, parsley, vinegar, oil, spices and lemon.

was very different from the original. All of the dishes were perfect and creative. The desserts were so artistic we didn't want them ruined, but were so good we had to. The tiramisu was a great end to share, eating slowly and pleasantly every minute.

After a while, a palm reader came to our small white table. The place wasn't full, but it created a commotion there. Many people paid even more than they did for those tiny, overpriced plates to hear them to read about their future. It was a mysterious moment. Some people were happy. Others were not very happy, with their expressions saying, "How can you spend my money like that?" But the one who read her hands seemed happy to have more money. She was beautiful and a mystical part of that place.

The unfortunate part was when the bill arrived. The prices were all above the size of the dishes but worthy of all the beauty. Felipe was still hungry, complaining about the size. "I loved it, but I wanted it to be bigger," he said after each course. He loved the fun cocktails. "When we leave here, I'll stop by Burger King," he said.

This restaurant was a glamorous adventure. It felt like we were in old Hollywood, enjoying every minute and money well spent, at least for me. Everything was small and delicious. When at this place, you need a good amount of money and a little hunger. But the art of life is living with the beauty and challenge of new things, turning a gray, rainy day into a new midweek adventure.

Noller & Feeney said, "The couple realized that they had different expectations for the wedding"[43] in their article talking about separation due to differences in ideas and expectations. Sometimes betrayal and character are based on traumas that are not treated. In my case, that was it, but it wasn't always betrayal and words to put me down. We had a lot of beautiful things, like our son, and that's why I didn't create any grudges for everything that happened to me. He tried his way to be the best he could for me and the family we made. With my eldest son, he was always perfect. My son loved him as a friend trusted him. But for all I suffered, Felipe created a lot of grudges for a time that were also forgiven. The days of ashes pass, and what you must remember are the beautiful things. He was very thoughtful and romantic, but unfortunately, it wasn't just me. If you have a spouse who is boring, who does not have an iota of romanticism, never gives you a present, or never takes you to dinner, that is not a defect. Lovingly make them change their mind by handling the situation wisely. It's better to have a boring partner alone than a beau who shares with several. Usually, those who are flirtatious are like that with everyone. Everything must be balanced, sometimes with a lot of effort and a lot of dedication. Some areas must be contained by some defect in another.

See, look & watch

Of course, it's not a statement or generalization. I speak from what I've lived. Everyone knows the shoe they wear. Or if you don't know yet, don't worry, nothing is hidden for a long time. When I see a situation, it confronts me, and I'm annoyed. I'm driven to take a stand or brood. For this reason, I opt to simply look and still not see. How many times do

[43] Noller, P. and Feeney, J. A. *Communication, relationship concern, and satisfaction in early marriage.* P. 129-155. Cambridge, New York. 2002.

you and I watch something, and we don't fully see it? But isn't that the same thing? Well, beyond the verbs being synonymous, the difference between looking and seeing makes a big difference. In some cases, looking is something that I involuntary observe. "See" means to notice or become aware of someone or something by using your eyes. "Look" means to direct your eyes in a particular direction. "Watch" means to look at someone or something for an amount of time and pay attention to what is happening. When reading a book, for example, we can say that when flipping through its pages, we only look at its pages; however, when we start reading its pages, we see and interact with the content. Seeing goes through an analysis of clear attention in which I need to feel, judge, ponder and sometimes decide about what I saw. My attention will be absolute as I learn or clarify and begin seeing and storing it in my consciousness.

I see situations that I am not prepared to change, or I just keep it as if I were just looking. Mostly it is because I want to hide reality, and I prefer not to see. Relationships prone to failure can tell us that I look when it is convenient, but I will not see. So continually, the one who loves the most suffers the most. A relationship with a person who looks but does not want to see is correspondingly a blind man who guides the another.

Minor traumas retained as treasures turn into rubbish, deeply soiling the soul.

In the eyes of the artist, everything is art.

In a time of great suffering, I read this fable by an unknown author. At that time, I thought that everything I experienced was wrong, as if my life had no meaning, and it seemed that I would live that way until the end. This fable caught my attention and was the theme I chose for the group painting that I led at MAPS.[44] Fania Resende was the director at the time. I volunteered with my Painting From The Soul work, and the theme was the one from the fable. The group was for women who had suffered domestic violence. After reading it, I taught the painting inspired by this message step by step. A certain Japanese King in the 16th century was named Ashikaga Yoshimirsu (achicagaotimisu). He had a porcelain vase to drink his tea out of that he got from a very special friend. One day he had a very important event, so he asked his servants to bring this vase, but this servant dropped it, and it broke. It was a tremendous silence, and everyone was terrified of what this king was going to do to his servant, but another noble Kesokorá drafted a poem that everyone laughed at and saved the servant's life. But what about the vase?

Another servant of the king was sent to China to fix it, but it didn't look good. Since then, all artists have started looking for some way to repair broken vases. Another significant man in Japan contemporary to this King named Se No rikiu went to a meeting, and the house owner showed a costly vase that he didn't even pay attention to. They spent

[44] Massachusetts Alliance of Portuguese Speakers

the entire night talking about the weather and how a branch hit the window, making a different sound. When the meeting was over, he left with the others, and the owner of the house was angry, throwing the expensive vase on the ground and breaking it. Some of his artist servants, hearing what happened, gathered the vase pieces and glued it with glue made with gold. Some time passed, and the same rich man invited the same group of influential people to another meeting. Se No Rikiu was among them. As soon as they entered the place, they were amazed by the vase glued together, and Se No rikiu said, "Now it's magnificent." Kintsukuroi is a very old Japanese art that consists of repairing pots, plates, and china in general that have broken. This art is formed by gluing broken porcelain with gold or silver. The Kintsukuroi (kisucoroi) philosophy is that everything we love transforms us into a different person after being broken.

Through this type of change, I decide whether to throw our pieces away or gather them and glue them together with love, forgiveness, hope, perseverance, and dreams—not forgetting what I went through, but remembering what I've been through and overcame. Before we suffered all these traumas, losses, abuses, betrayals, and all the things that tear us apart, we were ordinary people, but today we are extraordinary people. Picking up our pieces after each fall and failure, we become Kintsukuroi, and, like every work of art, we are unique. My broken pieces were soldered with gold and made me a work of art!

The group I told this story to was ecstatic; the paintings surprised me. This group had these paintings on display at the consulate general of Brazil in Boston. That led to many other opportunities as artists and authors. The past lesson inspired by this tale was surprising to them and once again proved to me that my scars from my falls only served to take me further and further than I ever imagined. My aches and imperfections are what make me better.

Being a broken vase glued with determination doesn't make me exempt from the marks. But they bring out the beauty of my strength.

Chapter 5
Why & what for
To persist is to exchange the certainty of a no for the possibility of a yes.

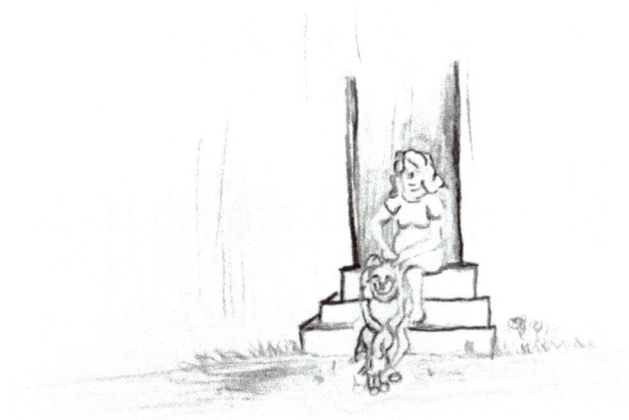

Why?

Usually, I can't remember dates, but I remember how old I was when this event occurred. 1986 is one of the few years I remember, as it was a milestone year for me. It is worth remembering that I only met Joy in 2016. I remember that 1986 was the year of the World Cup, and Brazil had a weak team, and they lost to France. This was the year I left my family and went with my youngest aunt to study at a nuns' college.

We had a quiet life—my grandparents were very financially stable, and they believed that we should go to an affluent town to get a better education. Through our cousin who was a nun, my aunt and I were encouraged to go to this boarding school where she lived. We lived for a year in Santíssimo Sacramento school in Alagoinhas in the state of Bahia, Brazil. It would have been a much better experience if we were older. I'm sure if my grandparents knew how we would be treated there, they would have never let us go.

I was only twelve and my aunt was sixteen; the school was aimed at orphans, girls who had a very precarious financial situation, or those who wanted to be a nun. Most of the nuns I met in the convent were impoverished and chose to become nuns to have a better chance in life, or they gave up fighting in secular life and chose the priesthood. I know there are cases of those who leave everything and become brides of Christ, but at least where I lived, there weren't any there. They ended up looking for their vocation in God or in making life hell for those around them. This is what I saw when I lived with the other inmates, as we sometimes felt we were. It is not an affirmation for the entirety of all the nuns in convents and schools. Furthermore, I have met people who have gone through the same, in different boarding schools for nuns, even in England and the United States.

My cousin nun, unlike the others, was always very loving and caring with us as much as she could; however, she was under a hierarchy and therefore could not do much. She decided to go on with her apostolic life after a disappointment in love thwarted by an evil aunt, as reported by the family. I don't know if that's the absolute truth, but she's still a nun to this day; my thought is that she has a true calling.

I also met another nun, Geisa. She was a beautiful Black woman, very skinny, and she was always thrilled, liked to sing, and always brought us joy, but the others were very bitter, mean, selfish, and hypocritical.

When we talked, my aunt and I said we lived in hell. There is no better name to describe the convent we lived in, but the Bible speaks of a similar place, and this is closer to how I can describe it. The girls who went there supposedly had no financial means and were treated very poorly. The school was "free" in everything; however, we paid our debt with a lot of work, keeping the school clean and washing the floors with wickerwork on the weekend, but I understand that part. We had to clean all the church toilets, piles and piles of dishes, plus our laundry. The food store was the most beautiful thing I've ever seen in my life. My aunt and I, when had the opportunity, stole the nun's amazing food, because it was a daily feast for the nuns, and our food looked and tasted like vomit.

At one time of year, the families would visit, and on this day the food was the same as what the nuns ate; there was even fresh fruit juice. All of us who lived in the convent would wake up at five in the morning to clean a certain number of rooms each. Before going to our classes on Saturdays, we would wash the floor of the classrooms with a scrubber. We worked in the canteen at recess, and I loved it because I stole sonho,[45] my favorite. I also stole pastries, kibbeh, esfiha, and I drank soda from the machine. We couldn't eat anything from the canteen—for us there, was bread with packaged juice. What was left of the nuns' food from the day before was always better than our food. On Sundays, we went to Mass and then cleaned up after lunch. The pans I washed were bigger than me. The second part of Sunday was reserved for rest, and I took the opportunity to explore the school. The building was beautiful and so big that there were three student playgrounds. The kindergarten playground even had a mini theater and toys more beautiful than I had ever seen. Many places on the ground floor of the building were stunning, with substantial diocesan meetings taking place there. I loved hearing my echo in the gigantic gym. The school auditorium had more than 300 seats, twice that of the cinema in the city where I lived. The city was beautiful with many historical sites, especially Alagoinhas Velha.

But something happened to my aunt and I in that place. It was something that ran over our emotions, because when we came home, we were different people. When I remember these horrors, I get scared because I always remember that the devil-possessed nuns. And I know that the devil only enters the body that gives him entrance; he doesn't know what's on my mind, but he sees by my attitudes, and if there's room, he enters. And that's how my aunt and I spent the year 1986, the year we lived in hell. I'm not apologizing, as

[45] Dreams: fried round donuts filled with jelly or caramel cream.

everyone is responsible for their own decisions. Moreover, the influence of evil emotions in that place made a mess of us. It caused us a huge hole. I started doing hidden things. I had sex when I was thirteen and, because the rumor spread around town, my father sent me to live with my mother. My mother wasn't prepared to live with me, and it was even worse than living with the nuns. I spent a year with her, which further damaged our relationship. Shortly after that, I returned to my city and soon became pregnant with my first child. My aunt had a relationship with a married man—that was the bankruptcy of his life.

Our greatest wish is for life to follow a sequence, like a TV series where everything fits and always works out in the end. But it's not quite like that. Sometimes we must go back in the middle of life to analyze situations, treat trauma, forgive people, forgive ourselves, and answer our questions about what we are experiencing today. For the most part, the answers to our fears, insecurities, and low self-esteem are in the past. After all, everything has a beginning, and most of the time, it is in the beginning that the problem is germinated. At some point, this question is unavoidable. Why did this happen to me? In my case, it was because of my first pregnancy so early in life. Was I still a girl? What happened on my fifteenth birthday, when I could have been having my debutante party, dating, traveling, and seeing new places? Could I start thinking about entering a university? What courses should I study? What about the changes that resulted from bringing a child into the world? What would I do with a child? How will I take care of someone else if I haven't even learned to take care of myself?

Today, amid four and a half decades of life and a bucket full of many storms, I have learned to control my hunger for life. But thirty years ago, with my broken compass and all the emptiness I had in my soul, it was very different. Like most teenagers, I didn't listen to anyone, and I was perpetually looking for a boyfriend. The other girls had them, and I wanted to have one, too. And for that reason, I tried to fit in among young people my age and even older people. I needed to be pleasant and acceptable to other teenagers, and it was at this time that I did unthinkable and unusual things to be part of a group. This need causes isolation in the family environment, and whatever the desired friends say or do is right.

The transition is difficult for a teenager with a structured family; now imagine those who don't. All of my education up to this period taught moral values, and they were taught even more rigidly to girls. The period in which I lived my teenage years and the community to which I belonged generated a terrible scandal. My desire to be part of a group of people I admired was far greater than anything else. It was larger than the values they taught me, more prominent than saving myself for my marriage or even finding someone who loved me. Yes, they taught me, but I did things knowing I was running away from the values and instructions that were passed on to me. I didn't pay attention to these ethics because what mattered most at that moment in my life was being accepted by the group I wanted to belong to.

Something I learned and passed on to my kids when they said they didn't know something they were doing was wrong was to ask, "Is this what you intend to do? Something that makes you ashamed? Do you have to hide it? If so, it's wrong!"

Dr. Lynda Warwick wrote, "Adolescence is a period when, although much moral thinking is developed, we may not choose to follow the voices in our minds just because of the decisions made by our peers. Studies have shown that while teens have a set of patterns, they can cross them to fit the crowd."[46]

The absence of my father and mother caused something that was built in and was never addressed. Today, I know that acting unconsciously was the biggest reason why my compass was broken. My dad was always there, but he was more like an older brother. My parents were my grandparents. Without direction, I got pregnant at fifteen from a boyfriend who was twenty-three. He was living in a tiny town where everyone knew everyone else's life, and his neighbors were his family.

I had to stop studying out of shame because my friends were forbidden to talk or hang out with me. Some colleagues and family friends who knew I was sexually active persecuted me to take advantage of something, like saying, "Since the cake has been cut, I want a piece, too." They didn't see it the same way as me. I didn't assume that there would be a separation from girls who had not yet had a sexual experience. After a pregnancy, everyone knows what you've done.

Warwick said, "Going back to school is a disgrace, in addition to the contempt of many of the teachers and administrators, the jokes and harassment of my male colleagues. This was not just restricted to happen thirty years ago. A team of scholars in England carried out a large survey in 2019. In that survey, it was found that some teachers and administrators ignored the provision of equal opportunity for teenage mothers by stigmatizing girls in front of other female students and did not give the girls the same chance to learn as other female students. Instead, teachers utter offensive words to discourage them from attending classes for fear that allowing teenage mothers at school would encourage immorality at school and that by doing so they want to protect the school's reputation."[47] This research is based on several factors, but the main one is the teen's return from school after pregnancy. The support that is given by the community, school, teachers, and peers is much worse after the return. What caught my attention is that what happened to me still happens.

These scholars have done phenomenal work interviewing twenty-four schools in Lusaka, Zambia. The young women, in general, reported their experiences on their return to school: discrimination, mockery, sexual harassment (because they have already had sex), gossip, nicknames, and titles that they should not have. Also, regarding their psychological states, they were shaken by the omission of support and by persecution, thus causing a

[46] Warwick, Lynda L., Ph.D. Everything Psychology Book: Origins of the human brain. P. 262. ISBN. 13:978-1-59337-056-5, United States. 2004.

[47] Shama, AKnwem, S., Jacobs, C. N., Mweemba, O. BMC public health [BMC Public Health. Vol. 19 (1) "They say that I have lost my integrity by breaking my virginity," P. 62. Date of Electronic Publication: Jan 14, 2019.

disorder in their personality and development. As such, they are forced into unwanted marriages, rejection of babies, running away from home, drugs, drinking, prostitution, postpartum depression, and of course, low self-esteem. They concluded that they should still train teachers to have more lectures in terms of helping their peers and, of course, psychological support from the school for the reintegration of these girls. The reality isn't different in countries like mine and many more. God saved me from greater risks in this process when my body was just developing.

According to Lynda Warwick, "Pregnancy among teenagers has decreased since 1991, but they still face many problems today. An average of 1 million teenagers still gets pregnant."[48] And about 3 million teenagers contract sexually transmitted diseases. Worse still, a teenage mother with an STD puts the health of herself and her child at risk. Some STDs are prominent among teenagers and particularly harmful to mother and child, like chlamydia, syphilis, and AIDS. Due to a lack of information, fear, the taboo on sex, and STDs, it is still not as straightforward as it should be.

My neighbor across the street, Edilene, had three daughters. The eldest had very severe autism. Even though Edilene's bucket was overflowing with problems, she noticed me crying one afternoon when I was six months pregnant. I was crying because of the pregnancy, and she came over to comfort me. Ignoring her problems, she told me, "Don't cry, because your son will be everything for you. He will be your helper when he grows up and your strength in sad days. He will be your pride." And it came true, as she had said.

For what?

My question for several years has always been, why? Maybe because I didn't think or didn't have anyone to instruct me better. Teenage pregnancy can be devastating. It can cause harm to both one's physical and psychological health. It can delay or cancel the projects and dreams of many teenagers. It's not about wanting to get pregnant or looking for it, but the lack of education and the taboos about sex. Even today, with so much information, teenage pregnancy is still common.

I stopped asking why. The question really is, what for? This happened in my teenage years; for what purpose would I have to go through these experiences so early and so unprepared? My son and I grew up together. He always loved me unconditionally. He was always a very sensible child. I always said that he was born old because of his responsibility and maturity, no matter what happened around him. I hope I was five percent of what he was and is to me. Today I know why I had to go through something as complicated as a pregnancy at fifteen years old. When did I ask why? God already knew why He sent my first child so early. As is written in Jeremiah, "Before I formed you in the womb I knew you, and before you came out of the womb, I sanctified you; to the nations, I have given you as a prophet."[49]

[48] Warwick, Lynda, L, Ph D. Everything Psychology Book: Origins of the human brain, P. 266. ISBN 13:978-1-59337-056-5, United States. 2004.

[49] Jeremiah 1:15

Making your child a priority when you are a teenager is difficult. Being irresponsible, staying out late, and over-socializing could hurt you and the child. But as difficult as it may have been, abortion was never an option for me, even though my mother suggested that I abort the baby. I understood that in her way, she wanted the best for me. My mother had suffered when she became pregnant with me at age 19. My son's father didn't offer it to me, but he suggested putting the decision in my hands. I already had a trauma bag, and I didn't want another one in my luggage. As my grandfather said, "Where you eat one, you eat two," and we became two. I know that I would never recover from an abortion, and my soul would have an incurable hole.

According to a thesis of group psychology students, "We adjust for abortion, but data on abortion rates come from thin estimates. Therefore, we also adjust state policies that are likely to affect the ease with which a teenager can obtain an abortion. Thirty-four states require women and girls to obtain counseling before abortion, and there have been some policy changes over the years."[50] The research points to abstinence as prevention, but especially to sexual education, instructing teenagers in practically every way not to get pregnant and not to contract any sexually transmitted disease and leaving abortion as the last option. The greatest difficulty for some countries is funding the prevention of teenage pregnancy by investing in education as initial prevention. On the other hand, abstinence as prevention only had an effect in more conservative states, which agreed to add abstinence as an educational option. And because the most liberal states do not support the idea of abstaining sexually in adolescence, only births in conservative states, reduced the effectiveness of sex education. Unfortunately, it all depends on each state's policy, which dictates how easily a teenager can get an abortion. Of course, there are always policy changes, and this research has been conducted for years in the United States, where education is much better than in countries like mine. And what about cities like the one I grew up in that, unfortunately, are still stuck in time concerning sex education?

Schools can help the most because there are still families where information about sex is forbidden to talk about. When I was thirteen, my grandmother went to live on the farm. Me and my aunts were left alone without direction, like broken compasses. I'm not an accident, nor are my kids. God planned our arrival before he called us into existence. Among the trials I faced until I got here, my oldest son was the first one who had everything in his favor. God favored of both of us. I no longer ask why. The purpose of my son's arrival is innumerable. He is my best friend and the first person I trust with my eyes closed.

I bear many scars from the paths I walked, where I saw many giving up, and some dead.

[50] Fox, Ashley M. Himmelstein, Georgia. Khalid, Hina. Howell, Elizabeth. *American Journal of Public Health*. March 2019. Vol. 109 Issue 3, P. 497–504.

I garden

I am a large garden, plants that bore fruit grew from me.

Flowers that are born in spring show their beauty.

From my soil, three seeds germinated, and beautiful flowers were born.

My flowers have the same scent that refers to jasmine.

The colors and shapes are distinct but equally precious.

They were born and blossomed at different times.

Wet them with the same constancy and love.

One like water a lot, one likes it moderately, and the other doesn't even know what it likes.

A flower that wasn't mine was added as a bud and blossomed; I have been taking care of it.

A lot of work and pain gave me this flower, but its perfume is still soft.

These four beloved flowers grew to exude perfume, beauty, coloring, and making me proud in my fertile soil. I'm fortunate to be a garden.

Chapter 6
Repetitions

We can repair everything until the last breath; after that, if lucky, they're just memories to some.

Repeating cycles

Unconsciously, we keep cycles and repeat mistakes that we so condemn. Perhaps for criticizing the person, we ended up paying with a curse. We unconsciously keep judgement in our hearts if we ignore the other person's perspective. Only those who live the story can report it, as no one sees it from the outside. It is one thing to narrate a fact that has only been seen; the experience of having lived it is another thing. Or maybe the repetition of something we think is wrong is a spiritual cycle we know as a hereditary curse that needs to be undone and broken.

Something that hit my mother has come upon me, and if I don't stop it in the spiritual world, it may reach my children. In this case, I must break the curse, but the Bible says that for those who believe that Jesus took the curses upon himself, there is no more condemnation to the one who receives the sacrifice of the cross from it. It wouldn't be karma because I didn't do it to pay with my life. I can't say what it is, but in Buddhist or Hindu religion, it's the sum of good and bad deeds that someone performs in one of their lives that can determine what will happen to that person in another life. So, it's going to be a past life like a domino crash. It will happen if I believe it. I make real what does not exist through faith. The human being is subject to moral causality, and his or her actions, good and bad, have reactions that return to them with the same form and intensity in this or another life. Everything you do in this life is like a boomerang effect. What I do comes back to me. Mistakes and situations are transformed with changes in attitudes today. I must stop this cycle and put it behind me. I cannot believe that stories repeat themselves

hereditarily. The life and the choices we make sometimes look like the same ones my parents made. However, this is my time, my life.

According to Santrock, "Daughters of teenage mothers are at risk of having children, thus perpetuating an intergenerational cycle. A recent study using data from the National Longitudinal Survey of Young People revealed that a teenage mother's daughter was 66% more likely to become a teenage mother."[51] As we've seen, not only do guesswork and cheating show that we're likely to repeat what we think is wrong, there are studies that show that we are.

I lived this repetition. I did my best to clarify, directed my children not to repeat my wrong story, but to look at it as a model of what should be avoided in their lives. I admitted my mistakes during long conversations with my youngest son, still only a teenager. My work is not finished yet. When you want to fix an error, you must first admit that you did it. Before, I couldn't even approach the subject without it hurting or angering me. The wound no longer exists, only a scar that stays forever. Unfortunately, I repeated in my life something that caused me a lot of damage in my formation as a person. Since my adolescence, I took up my adult life and tried to forget, saying as they say here in the United States, "It is what it is."

According to Psychologist André Lima, "When you don't agree at behavior of your parents, this disagreement is at the rational level. But what counts is what you keep unconscious. That is, your emotions and beliefs. The conscious is very small, maybe 10%, of our mind, while the unconscious is vast, it represents 90% or more."[52] Why do we repeat behaviors we disagree with?

This is a story about my mother, my birth, and our misfortune. In my second month of life, my mother was insecure and unstable. She lived with my father in my paternal grandparents' house. According to her, my grandfather did not agree with this union. To make matters worse, some of my grandmother's relatives, out of great envy, wanted to take my mother's place. With all the pressure and lack of support, she had to leave the house at the age of just nineteen. The arrangement was for her to settle down a little in life and then come back to get me. After four years she came back, and my grandparents didn't want to give me to her anymore. They had already fallen in love with the baby who was once given to their care. They ended up going to court to fight for custody of me and won. My mother lost. I didn't understand anything; I just felt over the years the crater that abandonment makes.

No matter the circumstances, those who have been abandoned suffer something that will cause a lot of damage. Most mothers don't leave their children because they don't love them or don't want responsibility, but unfortunately, it's something they think about fixing and then come back hoping that the world won't stop, and everything will be as it was left. Nothing stays the same. Every minute that passed, everything went on in its motion, just

[51] Santrock, John, W. "Adolescence *Pregnancy*" Adolescence. 13th ed, ch. p6. p216. New York. 2016.

[52] Lima, Andre. Why do we repeat attitudes that we don't agree with? www.somostodosum.com.br. November 26, 2014.

like people's minds, and what was once hard to find became lost. Unfortunately for me, the first few months of a baby's life are when the connection of mother and baby is created and formed for life. The misfortunes that both my mother and I suffered will be paid for over a lifetime. As much as I told my mom that I was okay and that I was where I had to be, as much as I had forgiven her for having to choose to leave me in a better place, she never stopped feeling pain. I felt that pain when I made the same decision to leave my son behind, in my own country, to come to the United States.

Laura Berk says, "A child's feelings developed in the first few months of life, and all the fear, anxiety, anger develops as the child grows, so also like the good feelings; safety, well-being."[53] A child feels safe next to someone they deeply trust who teaches them to not fear new things that are frightening to them. The person the child creates this bond with must approve of the child's achievements so that they can continue to develop. Dr. Berk further states in her book that "the increase in fear after six months of age keeps the newly moved babies' enthusiasm for exploration under control; as development progresses, infants take the family caregiver as a base of safety, or point from which to explore, venturing into the environment and then returning for emotional support."[54] In all my life, I didn't miss much, being surrounded by the love of my paternal family. After all, it was only my mother who wasn't there. The others I knew continued to live in the same house. I knew that I had to achieve financial stability of my own since my mother is gone. She let me know that I was safe and surrounded by people she was sure loved me and would take care of me, and they did. I can't even imagine a child being abandoned in an orphanage.

Freud said, "The worse a child is treated, the worse it feels." The child does not stop loving their parents, but they cease to love themselves, feeling unlovable, feeling like rubbish nobody wants. The biggest problem with abandonment is the eternal feeling of emptiness. The endless quest to fill this void creates emotionally unstable people, eternally in need of a feeling that never fulfills them. The worst point of this situation is adolescence. Adolescence is the most challenging point for individuals, as it is when they are looking for their own identity. Imagine those who no longer have any identity in the family you live in. I knew several teenagers who went through more significant abandonment than myself. I'm going to share two of the stories of my time with these girls. As such I shall not use their real names. For the sake of their privacy, I will refer to them as Maria and Martha.

Maria's parents separated in her early childhood; she stayed with her mother, who was still very young. Her mother would leave her alone at home to go out and have fun; sometimes, she woke up in the middle of the night and cried alone until dawn. She always saw her mother with different partners. Her mother never kept a steady job or any kind of stability for her. When her father sent support, her mother used it for herself and not

[53] Berk, Laura. University of Chicago Ph.D. in Child Development and Educational Psychology, infants *and Children: P256. 1993.ISBN-13:978-0-205-53161-4. Pearson Education Inc.*

[54] Berk, Laura E. University of Chicago Ph.D. in Child Development and Educational Psychology, *infants and Children.* P. 257. 1993.ISBN-13:978-0-205-53161-4. Pearson Education Inc.

Maria. Her mother went to live with her boyfriend and, when they had more children, Maria began to be despised. She witnessed her stepfather beating her mother, and Maria began displaying behaviors to draw attention and be a little more loved. Her stepfather didn't want her around; the easiest way was to hand her over to her father. Maria was living with her father and his family; her adaptation was challenging, as she received love and attention but didn't know what to do with it. The problem is that she brought along her bag of traumas; she continued to see her father's disregard for the family. Her father cheated on her stepmother and abused her brother and sometimes her, too. In adolescence, her father abandoned her, her sister, and her stepmother, and she suffered through an emotionally and financially unstable. Maria began lying compulsively, tried to commit suicide several times, cut herself to relieve the pain of her soul, and turned to boyfriends to cover the emptiness caused by her traumas. Maria was a victim of her own story. She had several follow-ups with psychologists; however, they no longer had control after she was abandoned for the second time.

In the first year of her life, Martha was abandoned by her father when he left her in the care of his friend who operated a brothel. A widow learned of what had happened and took her home. When Martha finally started to feel more emotionally secure with the widow, her father improved his financial situation and came to get her. Not too long after, her parents were out of work again, and they handed her over to a couple who wasn't able to have children. This couple turned Martha into a princess. She had her own bedroom in her own house and was shown love like never before.

Already with her little trauma bag, she began to show some behavior that made the new mother return her to her birth mother. At this point, Martha's birth mother handed her over to the same lady who took care of her first. This lady did not have the same financial condition as the couple; she was a widow and already had two children. However, she shared what little she had with her biological children. Everything was missing but love. Martha soon learned that the couple who returned her was this widow's family, and they took another little girl and raised her in her place. Sometimes they looked for her to help take care of the child she adopted.

Like Maria and many more girls who were abandoned, Martha began to lie compulsively and seek men of any age to fill the eternal need caused by abandonment. Martha invented stories and situations that, in her mind, made sense and gave her a feeling of joy. At thirteen, Martha's stepfather tried to seduce her. The widow believed her, but as many of her lies surfaced, they no longer kept her. She was given back to her birth mother, who lived in a room with more than five people. There, she started doing what she wanted, prostituting herself and using drugs and everything she could to fill the void caused by the disruptions in her life.

Martha went to live at a friend's house with her parents. Her friend's parents helped her for two years with food and housing so she could get a job, save money, rent a room, and move out. When she was offered a good time, people would get tired of her attitude, then migrate to another place. She would think she had a better solution and then play

the victim. Whenever she found herself in despair, she looked for her father's wife, who always believed in her. But she sunk deeper and deeper, falling victim to her own sad story. Hopefully, she remembers what she has been told and changes her life.

Our parents never took anyone's advice and direction. Thus, we are generated, and so we develop in the same way. If the abandonment cycle is never broken, we will continue to form as emotionally unbalanced people. In Martha's and my case, we had no access to professional support and continued to live with our trauma bag. My pocket of trauma was continuous until my forties. It wasn't until I was forty-two that I had my first encounter with Joy, my traumas rotting my emotions and deeply wounding my soul, making something harder to resolve.[55] My solution was my will to be free from this emptiness. And my cure came from myself, from a professional follow-up and, of course, from my God.

I stayed in the same family. I had the stability of having a family that loved me every day. And my mother came to visit me whenever she could. She brought gifts and took me with her for walks. Still, the abandonment left behind some pain. I thought this was never a problem, as I was loved on all sides. My grandparents, my father, and my uncles ensured that I was protected and loved. Whenever my mother had the opportunity, she made me meet members of her family. I thought it didn't affect me, but unconsciously I developed a feeling that has stayed with me for over forty years. It's not my mother's fault, but each chapter of life has a sequel dependent on it.

I developed feelings that I had to identify and eliminate for good. The biggest problem is that when these feelings become untouchable habits, they become untouchable because they are old companions. Such habits acquired by small and large wounds in the soul, which were taught without treatment or attention, become chronic and show in your personality. It becomes a trait of yours, as with all my rebellion, envy, hatred, the envy of those who had a father, a mother, the desire to have a standard family. This emptiness and wish to get what you don't have seems common. We all want what we don't have. Envy is a feeling that sometimes comes unwanted, and we must control it, by not paying attention or giving back blessings that belong to someone else. But when you can't do that, it's already an illness.

According to the article by child psychologist Mariana Cardoso, "The suffering of abandoned children can cause deficiencies in their mental and social behavior for the rest of their lives, in addition to health problems."[56] I went back to repeating the same mistake as my mother, abandoning my son to come to the United States. Although I managed to make a better life for my children, it doesn't exempt me from abandonment. My intentions were the best, but I don't know if I made all the right choices. I didn't experience the best of life with my second child. I didn't know him, although I've never walked away from him, and I've never gone more than a week without speaking to him. I've never let go of his hand, and he knows he's everything to me, but I hide an immeasurable pain of

[55] Difficult to resolve: Genesis 18:14, Jeremiah 32:27, Matthew 19:20, Mark 10:27, Luke 18:27, Luke 1:37

[56] Cardoso, Mariana. "Affective abandonment, harms the child's education." www.terapiadebolso.com, February 21, 2018. Mogi das Cruzes, SP.

having repeated my trauma. My son and I have already talked about it, and I was able to explain how my mother's absence unconsciously made me make the same mistake. My son has certainly had more contact over his entire life. I feel guilty for fear of having caused something unconscious in him, but his response to that was always different. I was always within reach of him, even if geographically far away.

My relationship with my sisters was always a terrible thing. I love them; it wasn't about their relationship with me, but their relationship with my mother and the envy of what they had, the way they were loved, and the security of their relationship, which my sisters gained from the bond I couldn't form with my mother. When you're in the middle of it, you hate being there. You can't express what you feel, so you just swallow hard and feel sorry for yourself. The person is not part of anything. It doesn't belong to anyone. My mother was very angry with my paternal grandfather for having fought in court over my custody. Her financial instability made her lose to him. And all the wrong decisions I pursued in my life made my mother frustrated that she didn't raise me. She always made a point of showing the world that she raised my sisters better than my grandparents raised me. She repeated that the garbage I had become was the absolute fault of not being raised by her. When I came to the knowledge that something was happening to me, she would appear overnight, and if she could, she would go out announcing with a megaphone the big "merda" I had done. She didn't do it to hurt me, that's for sure, but to take her frustration out, and she did that by throwing it in my father's family's face that they didn't give me away when she came to pick me up. Now I've become the "bagaceira no caminho da feira."[57] After all, she came back four years later, and they didn't give me back to her.

Today I understand that in the few opportunities she had, she was throwing her poison created by years of frustration over what had happened. It happened whenever I did something bad, like my first pregnancy at the age of fifteen, or minor things that others told to her. The problem was that I couldn't see that this wasn't for me. After many years, we reconnected and even saw each other in person. We spoke almost every week via video calls. When she passed away on Easter 2021, late at night after complications caused by the COVID-19 virus, I felt blessed to have had this opportunity to reconnect with her. I cried a lot and felt like walking down a rocky path and losing one of my shoes. Once again, I consoled myself in my paintings.

Less than a month later, on the nineteenth of April, my sister came to me to share the house and car that she owned. In conversations with my mother, she told me that she wanted to keep the house and that we would do the same until the house had a better value to be sold and shared between the three of us. She also told me about the help and renovation that my sisters had done in the house. I clung to the house because my mother had told me that my sisters and I should keep the house. But they didn't want this at all. Since I couldn't be convinced, they revealed something overwhelming. I was told that it was my luck that my mother died during this time. She told them and other family

[57] Mess on the way of the open market: expression used to say that everything is useless, because they are the thrown and lost on the floor of an open-air market.

members that she wanted to pay the house quickly to change the ownership to her other daughters because she didn't want me to inherit her house. After all, I wasn't worthy.

My first reaction was to pick a war. My sister tried not to tell me the entire history, but the disgusting old hole of my mother's emptiness came with the romanticism of my mother's death. For the first time in my life, I felt that all those judgments and dramas were only in my mind. I thought she left me behind something because I was important like my other sisters. I would have been put to the side if it wasn't for my sister and for my mother's death. I might as well have given it all up after knowing that once again, I didn't matter. My sister suggested that if I thought my mom didn't want to leave the house to me at all, I would let go, and she was right. With difficulty, I worked through the situation and all of the pain and romanticism that I felt when she passed. Everyone makes the dead saints, forgetting all the bad things they did when they were still alive.

I have been working since I was 16, and since I was 21, I have been living on my own. Therefore, besides judging me, my mother was never able to help me in any way. I understand that she could barely handle herself and was supported at many stages by my sisters. Besides, it wasn't her heart to leave anything to my kids or me. In her last months, she talked a lot about spending time with me so that she could have more contact with my youngest son. I remember crying when my sister found a picture of him in her wallet when she got my mother's stuff after her passing. I want my kids to have a memory of a grandmother who cared about their mother. I will not repeat the same stories that my sisters do—that my mother was someone who would have once again shown me that I was unimportant to her, had it been in her power. I really will make the little good memories live; besides within this book, I won't talk about this subject anymore.

Glory be to God that He didn't let her wishes happen, or my old scar was going to be even more terrible. "Many are the plans in man's heart, but what prevails is the Lord's purpose."[58] I must understand that she was very grateful for all the help and support my sisters gave her, though my old wound of abandonment is struggling to prove me wrong. It's not about money at all; it is about be rejected again. Yet God knows that my poor mother who had a very strange way of loving me. She gave me only what she had, both financially and emotionally. I'm only going to keep the attributes that I can help me win in this life as my heritage—resilience, creativity, faith, and hope. Forgiveness is the release from all pain, so I am forgiving her and myself. I will not add one more guilt and pain. I chose not to do so. I will remember to love, that's all.

My dad also had a lot of times that were tough. He was rarely called to do something about me, as it was my grandparents who always did. I got tired of hearing from my father that I was a disgrace in his life, that I would never change, that I just gave him problems. I felt unworthy of being loved because the first two people who were supposed to love me didn't. I was a nuisance to both my father and his parents. I wanted to belong. It was like I always sought the love I could never have. And so I went through my development,

[58] Proverbs 19:21

"bate que eu apaixono,"[59] until Joy and I were standing in front of a mirror, and I said to her, "All my life I've always wanted to belong to someone," and she replied, "You always belonged to God! He is your mother! He is your father!" After this entered me, the awareness of knowing that God has always loved me, I could learn to love myself, and so ended the rest of the trauma that tried to cling to me.

With my second child, I had to make up for my absence. I always made a point of prioritizing him more than others, giving more gifts than others. I know it's not right, but I also said no when it was necessary.

"Parents end up compensating for the absence, giving gifts, allowances, traveling and even having a more permissive attitude towards inappropriate behaviors, such as addiction to the internet or games. They end up turning a blind eye,"[60] says psychologist Arim Rohula Neto. After Joy, I chose to forgive my mother and close this hole, asking her forgiveness for not being an example of a daughter either. I reflected that it was the same mistake with a different version, but the same miserable attitude. I had to acknowledge my hypocrisy and close this chapter of my life. I asked God every day that my mistakes would not cause my child the same harm that it caused me.

My mother's absence in my second month of life left an unconscious hole for decades. My family's love could never fill the void of abandonment. I had to completely lower the level of my emotions. I had to be totally broken and exhausted to be able to put the pieces together. From this point a new life begins.

Abandonment was the root of all the evil in my story. I spent my adolescence fearing rejection, and so I did my best to keep people who showed me a little affection. I became an immensely needy and insecure person. I desperately loved others, depended on their affection to make me feel better, and suffered deeply when I was hurt, betrayed, and abandoned, as if I wasn't worthy of being loved. But the cure for this evil, I found, was the love for myself. The root of healing the emptiness caused by abandonment is the self-love that is the basis of a person's life. As a child, the first love is maternal, but when we grow up, it is self-love. Self-love healed me from the inside out and created in me a dome.

Nothing is impossible when we are humble to recognize our mistakes and wise to fix them.

[59] Bate que euapaixono: hit me and I fall in love. This is an expression to say that the most despised person, the more he seeks love from the one who despises him.

[60] Rohula, Arim Neto, in an interview by Katia Michelle. Rohula, Ari, Ph.D., 02/13/2017. wwwgazetadopovo.com.br

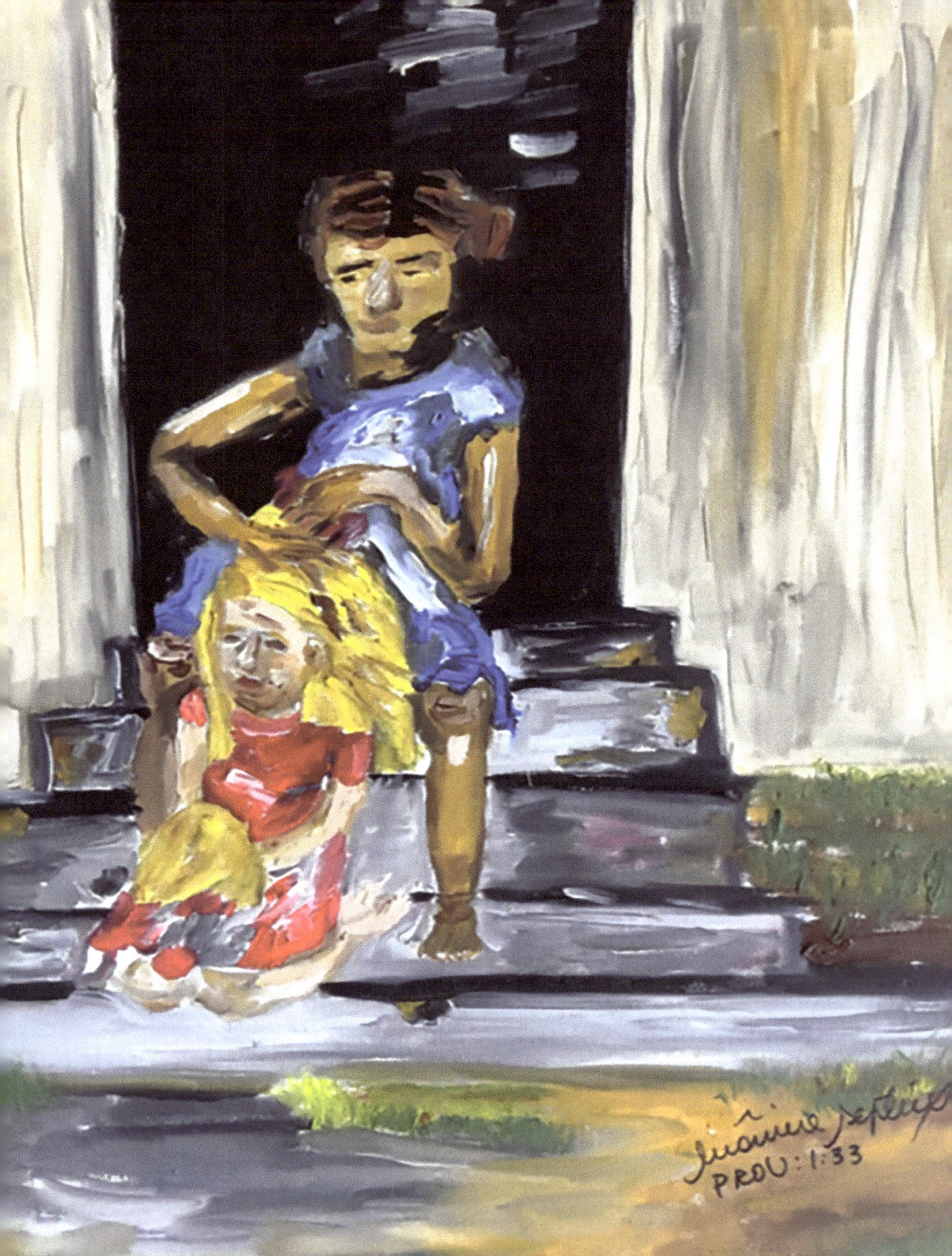

PROV: 1:33

Chapter 7
An oasis in the desert

We are waiting for a great miracle, forgetting that we live it every day.

My little oasis.

It's never so dry that it doesn't drip a drop, even if it's a teardrop.

It's never so dark that a star doesn't shine, even if it's shooting.

It's never so cold that it doesn't get a little warm, even if it's a hug.

It's never so alone that you don't have company, even if it's memories.

It's never so sad that it doesn't make you smile, even if it's one of hope.

It's never too late to start, even if it's a new life.

It's never so deserted that you don't have an oasis, even if it's a child.

It was a very uncertain time; I lived through many fights at the beginning of my previous relationship. My compass is broken, and each link that my chain added was heavier than the other. I lived many lies and betrayals. One month everything seemed to stop. I lost one of my two jobs here in the United States. My car broke down within the same week. We lived in a kitchenette where the two-burner stove was in front of the bed, beside a small table with two chairs. The building was full of kitchenettes; many students and single people lived in it. I was alone, with no family at the age of twenty-seven. Already in despair, I cried to the Lord and asked my aunt in Brazil for help in prayer. She listened to me and prayed with me. Later, she gave me the phone number of a lady who had helped her in prayer. This lady helped me a lot. I called and didn't say anything that was going on, and we prayed for a few weeks. I was in a situation that needed help. She prophesied,

and everything she said happened. In the third week, the lady said that I would live for many years with the person who had just closed the door.

That person was Felipe. He had recently left and ended our relationship. This lady also said that I would have a child with him and that he would look for me with his thoughts changed at the end of the week. She ratified it, saying that I would have the baby in my womb in six months. Everything happened exactly the way she told me. The problem is that I had cut my tubes ten years ago after my second pregnancy. However, I got pregnant after six months and went into despair, even though everything that she said would occur, did. I couldn't believe that I was pregnant. I was heartbroken—the last thing I wanted in this messy part of my life was another child. I prayed for things to get better, not for more problems. But trouble kept coming like snow in wintertime in New England. I already had two children, and they were far away from me. My life with Felipe was very insecure and troubled, but this oasis in the middle of the desert changed everything.

Felipe gave me the option for the baby to come, saying he would support me in deciding whether to have the baby. Only for me, it was never an option. I believed that he had changed, and we could do a beautiful job with this little gift that was to come. For a while, we had peace. A little angel with peach cheeks and a toothless smile arrived. He was born in the coldest month of the year, where there was no longer any place to put the snow. My life was full of peace. I had been a mother very young, but I received my third child at the age of thirty, and my vision was different. Now I could enjoy it more; I had patience, experience, more time, and another chance to do for him everything my youth and stupidity didn't allow me to do for the first two.

As much as he brought everything beautiful with him into my life, both his father and I were emotionally sick. We just followed and never thought to ask for help for our emotions unbalanced by our traumas. Even so, I enjoyed every bit of the pregnancy, the preparation for his arrival, and every bath. I nursed for more than six months. I nursed the first two, but it was my last child, the one who didn't even have a chance to come but did. And the experience of being a mother when you're older is different.

In an interview with Carla Leonardi, Tânia Schupp, a gynecologist and obstetrician, reapplied the importance of having children later and the risks. I was still 30 years old, and I didn't take any risks, but I enjoyed it a lot more than before. She says, "Apart from the maturity that comes with years, this is usually an age when there is no longer that feeling of 'losing' something when having a child[61]." In this age group, women are much more mature. They tend to have a stable life and can dedicate themselves more to the child, having more time available because they no longer need to study or work as much. Even though I was personally much more prepared to receive my third child and was living in a country that is easier to support one in, I had to deposit my traumas in dark box at the bottom deep cave.

[61] Schupp, Tânia PhD," *A diferença de engravidar aos 20,30 e 40 anos de idade*" 07/20/2017, São Paulo,SP.www.bebe.abril.com.br.

My mind always struggled to erase bad things that I survived until I got to this moment. The problem is, things like that don't go away if I just keep them in a cave. Sooner or later, it will surface and be stronger than ever. It must resolve and not be hidden, but unfortunately, that's what I did. And I know I'm not the only one to keep an open wound bleeding unhealed for years and years. This time, I was distracted by all the light that the presence this little creature had brought to me.

My son came at a troubled time like the others, but I had more time and help from my ex-husband to raise him. Ten years later, this cave was exposed, and inside was what had never been treated. From the bottom of this hideous cave, I died, succumbing to the mountain of garbage accumulated in my soul. It was my ten-year-old son's voice calling me, and that was one of the biggest reasons for me to leave the place I was entering. He needed his mother to send him to school, make him lunch when he arrived, and do his laundry, as is expected of every responsible mother. I couldn't get out of the deep hole I'd entered, as much as I struggled to try to get back up. My son's voice called out to me like a light guiding me to the other side. The question about having another child became once again, why?

I was living in a relationship where I refused to believe that sooner or later it would end up as I expected since it started. This failure came ten years after my last child was born. Today I know why; however, I asked myself the same question at least five times a day: why? Why did another child have to come into a troubled relationship? This child made me walk, even when I couldn't get up. God gives us weapons and teaches us through life how to use them at some point and will reveal to us the skills to wield them the moment we need to. God, Joy, therapy, art, and my willpower were essential for me to reach the other side. Even though I saw my son suffering because I was succumbing to my dark feelings and the accumulation of everything, I had been saved without being cured

A life with a child becomes full of joy, pride, dreams, and achievements, but also fear, doubt, and worry. Learn from the bad and enjoy the good in everything! During the pandemic in 2020, I took time to give my young son classes in Portuguese, painting, and some cooking. Unfortunately, sometimes something bad must happen for something good to be born. Each day comes with new opportunities to fix or create something while we can take advantage of them, in or out of the crisis. After all, crises bury everyone, but the difference is whether we die in the rubble or come out stronger and more experienced.

Opportunities are not second chances but the first chance at a new story.

The world stopped

And He stopped the world...

And we were doing what in our omniscience we thought was right. We exchanged everything, inverting values because they were wrong, and we knew everything. We ate

new and exotic things, drawing attention to the emptiness it could complete. We were omnipotent to create without asking if it's wrong or right. Nothing could stop us.

When we dawn on a day where the enemy is not known, it doesn't stop killing; it doesn't need to hide. All the powerful and most brilliant strategize against it, but it still wins by knocking down some and exterminating others. From God, we inherit creativity, intelligence, the power to build and love and manipulate; we are creative in corrupting ourselves and building weapons and strategies to destroy each other; we use our intelligence to dominate, and yet we enslave ourselves in deep solitude. We spend time fleeing our homes that had become fortresses to hide from this mighty enemy; almost two years passed, and we were still surrounded. The family that is already unknown is now the only safe contact.

The creator must stop a world, make some look for him in remission, being delivered from our own evil to show His sovereignty. We recognize our insignificance, but we don't learn anything and still fight for insignificant matters.

The world stopped to wait for an answer from Him. All the giants became small. So wisely, the great thinkers and doctors still had to wait for Him to imprison the enemy once for all. All wealth cannot pay for the lives lost. Our democratic enemy doesn't choose between racists, bigots, rich, good, bad, fat, or thin.

The alienation became even worse; those who didn't create started to believe in something, the blind got even more blind in the dark. Everything stopped because we were allowed to think about what we were doing. What are we looking for? For us? Every day is more miserable and self-sufficient, thinking that we are in control of everything with the power we think we have. Knees had to bend for ourselves and the world. Those like myself thought we were strong. I fell like everyone else, waiting for God's grace to survive or perish in the ceaseless attack of what is unseen and still has no known weaknesses.

One day, I was thinking about what it would be like if His grace had not poured out. Could we bear it? Never! By the request of the Father of faith, God spared Sodom and Gomorrah for the tears of those who still cry in prayers. Without knowing, many will have one more chance. We'll wake up and move towards our purpose at once, when our time is clearly up. The world will stop to wait for your word, like in the beginning of everything. One word is all we hope and all we fear. Yes, through a word all is created, and with one single word, the world stopped. In one single word, everything can exist or extinguish.

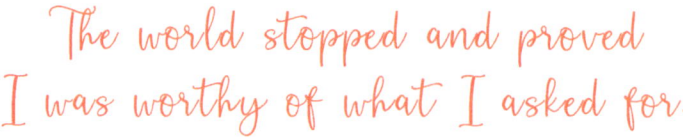

The world stopped and proved I was worthy of what I asked for.

Chapter 8
Spawned in the heart

Being a mother is like keeping a garden with different flowers. Some need more water than others, but they are all watered.

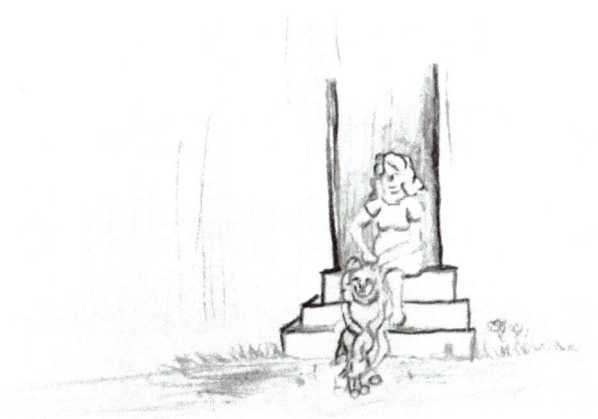

My little flower

Life comes with its challenges and lots of decisions to choose from. Depending on what I do, I'll learn or not. At some point, I will come across people who provide those challenges with them. Some will be in the same situation that I was in before. These situations can make me sympathetic because I can relate. I become apathetic because I have suffered without any help. So, my line of thought can be, "If I suffered and survived, you can do so, too." In most of the cases, I see that God allows me to choose to make a difference for some people.

This is what I wish someone had done for me. I wish I had someone to be sympathetic to someone who's suffering. I adjusted myself in the role of mentor to show what I had dealt. However, being apathetic can lead to being a poor mentor. I wish I could have been a better mentor, and I sincerely hope I didn't trigger more traumas beyond what the people I tried to help already carried with them.

When my oldest children were still small in Northern Brazil, I met a fifteen-year-old girl. Her name was Kelly. She was beautiful and sweet, but also very confused. This was twenty years ago, when I was not yet ready to be a mentor. I had a small company, and she came to work with me. I don't know if she just wanted to run away from her house, and I assumed she had problems that she must face like every teenager. I also felt she was more comfortable with my kids and me. She started to stay longer until she sometimes slept at my home. I tried to guide her and help somehow, but it wasn't enough. Once we disagreed, she never returned, and I didn't go looking for her. I regret not having done more for her. I never took the blame, even though I had no experience to guide anyone.

I should have been even more sympathetic given that I had lived in a very similar situation. This was the time to do it very differently, and I didn't.

Many beautiful people embrace the cause of young people who are bewildered. We try to pay things forward by helping these lost children. We want to help and embrace the cause and don't let go of whatever the situation is. Unfortunately, when they are someone else's child, the story is not quite like that. I loved that girl, but at the same time, I let her go without doing much. Today she is fine, we have an excellent relationship, and she holds a special place in my heart.

My grandmother had an expression that goes, "like God created potatoes." It was a phrase used for those who had been left to their own luck. For a few years of my life, that's how I had been. Many years later, I had different opportunity. A second chance came when I married Felipe. He had a daughter from his first marriage, almost four years older than our son. She certainly was raised as God created potatoes. Her mother was very young and neglectful. My ex-mother-in-law asked us to bring her to live with us. I embraced the cause, as I didn't have a daughter. However, I still didn't have direction and was still at emotional war with myself. I set up her little room, we bought everything, and she arrived when she was nine years old. When unpacking her suitcase, we had to throw all her old and rotting clothes away. I had to buy everything new for her. She wanted everything to be different in this new life.

She had to adapt to our style of food, and she had problems urinating in her bed. Maybe was because she wasn't used to having plenty of food before she went to sleep. When I washed her clothes and tidied up her drawers, I would find empty food containers and packages among her clothes. Things that were meant to be shared with the family just disappeared; most of the time, she blamed her brother. We also had to fix her cavities and rid her of lice. The smell on her skin and the dirt took some time to get out. She came with her traumas and hated her mother for being young with two small children. Because she felt insecure, she needed to get her mother's attention, and she ended up doing what she could to get it. I don't understand how a mother can neglect a child like that. I had my first child at fifteen years old, and he never went through half of what this girl went through.

She told me about a time when she was four when she woke up alone and began crying out of fear. Another time, her mother forgot her on the bus. She didn't know what to do with all of the attention on her and always wanted more. It was an endless nightmare, and I often ended up in horrible fights with my husband. She started countless fights with her brother, and it made Felipe angry when she lied about my young son. Our marriage was no longer the best. Felipe would go out with "his friends" and arrive the next morning. There were so many fights that I didn't even say anything. After this gesture of embracing his daughter like my own, I thought he would see me as someone worth changing for. I hoped for the family's sake that he would have a little more consideration and respect. We talked about the changes after his daughter arrived. I would no longer accept these outings at night when he wanted to go. He listened; he just went out in the evenings instead of at night. God reminded me that his daughter could have grown up like me. That's when I decided that since he wouldn't change, I was the one who had to change.

I started to generate it in my heart to try to understand moving forward. I taught her to cook and talked about the things my grandmother, aunts, and stepmother taught me that

reminded me of when I was her age, when the only thing I wanted was a family. I tried to be an example of a reputable person who showed more than she spoke. From this point, I tried to offer more words, to teach more than command, and to love more than criticize.

"When morally behaving role models provided, teenagers are likely to adopt their behavior... When teenagers' impulses acted responsibly and are praised by parents for doing so, they are more likely to remain safely adapted," wrote John Santrock, who also said, "If the teenager sees his parents' taking responsibility, they are more likely to follow the same standards...the effectiveness of modeling depends on the characteristics of the model."[62] Through the trials of my life, I hope that my children understand that my actions speak louder than my words. Unfortunately, my stepdaughter's pains came, and one way she had to express herself was cutting herself, which was very sad.

The first time I saw cuts on her wrists, I asked what had happened. She told me she was coming home from school and saw a kitten, and when she touched him, he scratched her. When we planned a trip near the water, she did not want to go so that her cuts would not be seen. Due to her carefulness, the cuts on her legs wouldn't be seen. Self-harm is sometimes a way of expressing anger or pain and manipulating how people care about this person. Some people use it to keep people around with a constant threat of suicide. Especially when they are under pressure and feel like sleeping, they self-mutilate to feel something. There is a lot of attention, love, and dialogue involved in the healing process. If possible, it's helpful for teenagers to open up to those they are close to. Of course, there is professional support and occupations or hobbies. According to Dr. Luiza Vieira, "Self-inflicted violence is one in which a person provokes himself and involves suicidal behavior and self-injury."[63]

Another time, she told me that she had a lot of pain in her stomach and wanted to go to the hospital. I was stupid and made her some tea and said if it persisted, we would. In my defense, when you go to the ER, they only give Tylenol. God cared because she'd taken nearly half of a pain medication prescription. I learned this a long time later. When someone talks about killing them self, it's because they feel already half-dead inside. Nobody decides to take their life overnight. That person already has a history of pain. "The teenager may have a long-standing history of family instability and unhappiness. Lack of affection and emotional support, total control, pressure to win over parents during childhood will likely appear as facts in suicide,"[64] Says Santrock.

She came from an unstable life and fell in the middle of my disastrous marriage. During every fight we had, my ex talked about separation. He carried his own trauma bags, but he never knew how to handle himself. She already understood a lot about her situation because she had to grow up in a hurry to take care of herself. My youngest son didn't understand what I was living, and I wouldn't let him see it. My crying was on the sly anyway. My stepdaughter's changes had a lot to do with my children because they loved and shared everything with her—especially her little brother, whom she had a fight with

[62] Santrock, John, W. *Adolescence Pregnancy. Adolescence.* 13ed. chp6. p216. New York. 2016.

[63] Vieira, Luisa Jane. PhD in Nursing. Full Professor at the Health Sciences Center and Master's Degree in Public Health, University of Fortaleza - CE, Brazil. janeeyre@unifor.br

[64] Santrock, John, W. *Adolescence Pregnancy. Adolescence.* 13ed. Ch. p6. P. 216. New York. 2016.

when she arrived. He always supported and loved her unconditionally. Similarly, my older son always made her feel like his own flesh and blood. Four years after the divorce came, my eldest son had already adopted her as a sister.

Although many people often told me I should give her back to her mother, my ex-husband also made this same decision. He had no way to take care of her because his life at the time was a roller coaster in his new relationship. If he thought our relationship was a disaster, his new relationship showed him what a true disaster was. The situation was very delicate because she was not to blame for what her father did to me. At the same time, I had no emotional stability, much less financial stability. So, I prayed and asked God to tell me through my oldest son what I should do. I would follow whatever advice my son would give me about my stepdaughter. My son told me, "What kind of Christians would we represent if we delivered her into her mother's hands again?" And so it was. So, to me, what my son said was God's answer to my question. Our house didn't have money, but there was peace and unity. She sang and played in church, she ran the house, and the boys adored her. She learned how to cook and organize the home as I taught her. Saturday night was our day to eat out of the budget and watch movies together. We laughed and fought together and got to know many new places. What a blessing this time the four of us had together was. Nothing lasts forever, so this time of peace was close to being over.

Close to her eighteenth birthday, I demanded some accountability because I was financially alone in maintaining the household. My oldest son helped a lot, but he also was earning his master's degree. We needed more help from another adult in the house. I couldn't convince her; she wanted to be an adult in one aspect, yet not receive any responsibilities. I thought that she'd be the first to help the family more since we stood up for her, but unfortunately, that didn't happen. An article written by Eliana Barbosa stated, "Remember: nobody changes anyone, except yourself. Each person has their nature and free will to choose whether to wake up for life."[65] So don't waste any more time trying to change your kids. We should remain firm as a good example for them and decide today to seek their inner resources to be happy without ever conditioning their happiness on anyone.

When she turned eighteen years old, she decided to go visit her mother. She decided on a new path and never came back to live with us. Shielding her head from the raindrops, she still threw herself into the lake because she needed to feel the water herself. I kept her away from the fire so the flames wouldn't cause minor burns, but she skipped the fire anyway because she needed to feel the heat on her own. Driving for days out of fear of flying, she still parachuted. She teaches herself the way but shows that every person has her own vision of the right way.

In my heart, I raised her, but I hoped that everything I could share and use would one day benefit her future. I bless my children in the same frequency and intensity and pray for them as I do for her. Too many times, I find myself crying over another failure. However, I know that I did my best for her, and it was not what I wanted. She learned a lot, and that age is our time to hit our head and find it hurts. When we tell ourselves that it

[65] Barbosa, Eliana. www.wjonline.com.br. November 11, 2011. Uberaba MG.

hurts, we don't believe it, but we want to have our own experience. But she's trying and slowly getting up in whatever way she can. Little by little, she is maturing and finding her place. She works, she's honest, she doesn't have any addictions, and I know that what I spent years teaching her hasn't been lost. She is a bright, talented artist with a huge heart. I know she will be great in her time and will win and reach her place in the sun. Today, even though she is chasing her path, we are always connected. What brought us together became a love that nobody can take away. She was not spawned from my womb but loved because she developed in my heart.

Hear and listen

Every mom or dad asks their children, "Did you listen to me?" And the answer is yes. But did they hear us? Or listen? After all, what's the difference? Hearing is the physical sense of hearing, as animals also hear. Hearing is involuntary. Listening, however, is related to processing the sound that is emitted. Listening is physically receiving sound, processing, and storing it in a useful way. I can hear a door closing, but I can listen and reason about what possibly made a door slam. Maybe someone would come if I left it open and the wind came in. The big difference between hearing and listening is what follows the sound that is emitted. In psychology, hearing and listening are distinct, and there is context to their usage. In a session, a professional not only listens, but also performs analytical listening on what is reported by the patient. Freud developed a "speech space" theory, placing the patient's word at the center of the therapeutic process. After the psychologist hears, then he listens, analyzing what is said so that he can help. Then he will make you not only hear what you said, but listen to what you reported to him for a change of thinking to be affected.

Hearing is no longer just about listening, but the attention paid to the subject, including the availability to understand it, through analyzing the meaning of what was said. The lack of communication starts not only by not having a dialogue, but by not listening to what was said by the other person. People often say something crucial that sometimes is a call for help in an area in which they are hiding. Out of shame or fear, we sometimes just hear but don't listen. Our reception of the message is garbled, which can cause specific contentions. Most of the time, it can be avoided if you listen.

Similarly, this is what the Bible tells me about so many things that bring me closer to God. It's possible that I hear but don't bring it to my life, because I wasn't listening, and this way I don't change like God wants me to. I don't often listen to what God wants me to do, and what I find most sad is that I never heard what the elders said. I hear only through one ear, and it quickly escapes through the other. I can tell from many experiences that I just heard and never listened. I do not absorb, at least not to reflect. The sad thing is that eventually, I will remember when my life worsened when I heard but didn't listen to what I was supposed to. The act of listening is a deep analysis, and it will undoubtedly confront me. It's not enough to hear. I must stop and listen, significantly transforming me into a better person.

The creatures hear the voice of the one who created them, but the children listen because they know the father's voice.

She sleeps.

Chained, comfortable sleeps.

The shackles on her arms and legs no longer bother her. If she wakes up, she goes up, down, exercises, cleans, cooks, and even goes for a walk in her chains.

The noises from the movement of the chains have already turned into a pleasant sound, she starts to dance. She is then vexing a little.

She is her executioner.

Isn't she blind?

And the chains?

Or have they become heavy? Or the extension of her body?

She feels slightly sorry for herself. Some hot tears fall between her eyes and burn her delicate face.

At this moment, she fantasizes about flowers like vines in the shackles that bind her.

At dusk, she is distracted by the lives of others since hers is just circulating in her prison.

As night falls, she looks at the key in her hand from the chains and slowly tries to recall where the keys belong.

Remember by pressing a small smile in the corner of her mouth, showing out the dimples.

She softly puts the chains keys in her jewelry box.

Not knowing what it's like to live without the chains, she takes a shower, moisturizes her skin, makes herself a comfortable bed, and goes back to sleep in chains.

Chapter 9
Borrowed dreams

Dreaming other people's dreams is like a country using a foreign flag.

Borrowed dreams

An old Brazilian proverb says that anyone who expects shoes for the dead walks barefoot all their life. It is a way of saying that each person must seek what belongs to them, and to never expect to get what you want. I grew up wishing for a bunch of things I didn't have, like a lot of people did. It's common in human beings to alway want more, especially what they don't have yet.

Personally, what I wanted were not material things. I was never a materialistic person. All I wanted was my family, affection, education, and so on. During a certain period of my life, probably before I was twenty-eight years old, I had my dreams and fought for my ideals, but it wasn't always like that. My unique need to have a family was so unconsciously strong that it overrode everything I had acquired. And finally, I had it when my third child was born. What I had in my head was my opportunity to have a family with a husband and children. Having a family became the only thing I wanted in my life. There is nothing wrong with wanting a family badly and fighting for it, but I forgot I was still alive in my case; I forgot that I'm a person.

Erich Fromm said, "Love is only possible by respecting the separation and uniqueness of us and the other."[66] I forgot that I was a person with yearnings and the ability to acquire them. In my normal individual state, I had an enormous number of friends and colleagues, like those I knew from afar only for celebrations, and those who had become close. We would go out, get together at someone's house, talk, eat, or celebrate something.

[66] Erich Fromm The Little Book of Psychology. p81. Ed Gillian Andrews. Penguin Random House. New York. 2018.

But when I got the family I desired so much, I started to drift away from my identity. Only what related to Felipe was important. I waited so long to live like this that I didn't want to live with anything else besides my family. It's like when you discover your favorite dessert and eat it until you feel sick. Unfortunately, that was me. His friends became my friends. The songs he listened to became the most listened to by me. I cut out of my life everything he possibly didn't like, even if I never imposed them on him. I did this because I wanted it so badly and had the fear of losing it. The biggest problem with all of this is that I gave up my independence, happiness, and strength, and my entire personality disappeared.

I spent nearly thirty years trying to fill a void I imagined would be filled with someone else. This person was always me. I always thought I was half, and the other person would complete me. Love is never complete if I am not filled with love for myself. Assure me, love me, know me, because being different from the person is the shine that will attract this person. If I start to be like the others, their interest goes away because my charm was that I wasn't like other people. My creative interpersonal ability needs to be developed as part of my personality. I must maintain and conserve my shine and everything I am, what I've achieved individually, and what will make my partner admire and respect me. I should be the person who needs to be the same until the end, because what I was is what made the other person interested. In my relationships, I made many mistakes trying to please the other person. All those changes made me lose my identity as a person. What was light and reflecting an irresistible glow, attracting them, has now become shadow. The shadow of the other person was where I lived. I can never continue to shine; the light is gone. We are what we have, and that attracts people; beauty is in individuality and complementing each other.

According to clinical psychologist Roberto R. Fernandes, "It's the way children find their parents' attention. We can say that people who act like that are regressed, act like a child who tries to please his parents," he says. The psychologist says that, by creating a "false self" to captivate the object of love, the person runs the risk of "erasing" the characteristics that aroused the partner's attention."[67]

If this is not adjusted during infancy, it can continue into adulthood, which is exactly what happened to me. I stopped growing as a person and hid my personality. I had no passion for life in an individual way, not to mention that my self-esteem was getting lower. It was not because of something he did, but because I failed to see what I really was and what I could do.

True love comes from loving a person's authenticity. I must maintain my authenticity to grow individually, not become a shadow of the other. My identity is what makes my partner love me in first place. I could try to be all that he isn't, but that wouldn't complete my partner.

I didn't love myself not because I didn't like myself, but because I lived my mate's life. Joy made me come out of the shadows, but at this time she wasn't in the scene. An

[67] Fernandes, Roberto R., Ph.D. uol.com.br. May 7, 2015, São Paulo.

illustration that is perhaps a little heavy but is the clearest for this time of my life is about a saltwater fish called remora. Remora, also called a shark-sucking or flying fish, is any of the eight species of marine fish in the Echeneidae family. This fish is known to cling and walk over sharks, other large marine animals, and oceanic ships. Remora adheres via a flat oval suction disk on top of the head. This glued fish starts to feed on the remains of food that fall from the shark's mouth after its prey is devoured. Several researchers have also found that the larvae have distinct hook-shaped teeth protruding from the lower jaw. This can be an indication of how the fish hitchhikes as a baby before developing the disc. The first lesson is that remora does not harm the shark. If she harms anyone, it's always the shark's shadow. The relationship is supposedly beneficial to the remora and indifferent to the shark. The shark is indifferent because it has an identity and does not need other fish to eat, move, and so on.

This relationship is called commensalism, which is an inter specific ecological relationship. This happens between two distinct species that usually live together. The second lesson is when the remora chick is not born with its suction disc fully formed. You must wait for the thing to develop as it grows. When the remora is young, the sucker's development starts where a dorsal fin is found and then moves to the top of the fish's head during development. The lesson is that a remora is not born ready to stick to the shark, but with time it is able to do so. It must surely be a painful process for such a change. I wasn't born codependent, but over time I ended up sticking my sucker on someone else. I didn't harm my host, only myself. I've slowed down my life, but I've made these people's life slow down because I became a burden. Third and last is the saddest thing. The remora will always glue to something. The remorse for not letting go will be dependent on the other creature. You will always go where the other goes and live other people's dreams. That was me. I dreamed what my ex-husband dreamed. I wanted what he wanted for the future. It wasn't like we dreamed of separate things. We also had a common dream for the family. I didn't have my dreams. All I wanted was to be a wife, but God didn't create me just to be someone's wife. To be something to someone, I first need to be me. I needed a reference, a personality, a vision for the future, and my own dreams.

Conjugal love is formed by two people of different opinions who decide to stay together. People fall in love with individual characteristics, pride in individual achievements, fulfilled dreams, and differing opinions to find the common good. In this period of living the dreams of others, I lost my individuality and my self-love. Having spent so many years living like a remnant in someone else's shadow, I forgot to exist on my own.

Joy arrived when I finally let go and had to learn to swim by myself. All I wanted was for this relationship to last until the end of my life so that I no longer had the feeling that I didn't belong anymore. I saw the relationship going down, but I covered it with my love. I dreamed for both of us a dream that wasn't even mine for almost fourteen years. I know it was love, but that's not what pushed us both. What kept our relationship going was not me trying, accepting, forgiving, and giving myself for both of us, but the fear of having another child raised without a father. Once again, I was afraid of having the family dream

destroyed. I know that many people pretend to be blind and keep a lie for several years just like me. It's not because we don't see the situation; it's the fear of change.

It's horrible to admit failure. It's easier to keep it up; it's like mending an old garment and ripping on the other side. When only one person wants it, two don't fight, as they say in Brazil. Sometimes one wants a family, and the other keeps the family waiting for emergencies because of a lack of options. He doesn't want the family. He only stays until something more interesting appears. Everything must start through a choice. As I said in chapter 2, a teenager may not care about his parents, but something happens if he runs into something he doesn't know how to handle, and he rushes to his parents. I was support for a need. And for me, it was my last chance to have a family and a husband. When I hold a rope pulled from the other side and can't hold it, it will undoubtedly hurt my hands, but instead of letting go of the rope, I wrapped it around my hands and got stuck.

The most considerable blindness is the illusion of covering what it wants to show itself.

The art of lying

Who doesn't know the story of Pinocchio? Pinocchio is one of the many stories from my childhood told by my grandmother. I loved it when she told me stories. Pinocchio was a wooden doll who wanted to be a real boy; the carpenter Geppetto created him. Not having children, the carpenter wished that the doll he created was a real boy. So, it happened because a blue fairy heard him. She gave life to the puppet and told him that he could not lie, because lies always come with consequences and are not always good. Well, for Pinocchio, who lied to avoid going to school, to hide something he was ashamed of, or to defend himself with, it had a consequence—with each lie, his nose grew. At the very end, he repents and changes, and in return, the fairy turns him into a real boy. Pinocchio is a symbol for a lie; even the phone has an emoji with the Pinocchio doll's face when you write the word lie.

According to Alex Lickerman, "Most of the time, most of us don't lie out of the spirit of compassion. And even when we do, we generally assume that people are essentially fragile and have egos that are likely to collapse, or at least get hurt, if they hear nasty comments."[68] There are many expressions about lying in Brazil. Some that I have heard the most in my life are "the lie has a short leg", "hairy lie," and "the devil's daughter." However, lying can also be an art form. The art of lying develops from a broken toy in the first years of life—doing something wrong and blaming a brother, skipping school, saying you were with a friend while you were with her boyfriend. People lie to get the job they want, to get a spouse, to maintain a broken marriage, so that they don't make a child cry. With time, it starts to change with the experience if it is not corrected. I lied like an artist,

[68] Lickerman, Alex, M.D. Happiness in this World. Psychology Today. **www.psychologytoday.com**. March 08, 2010.

and for that reason, I made a point of passing on to my children the problem of getting used to lying. The worst part is that when a lie is discovered, trust is never restored. The word of the person who is discovered lying never carries weight.

A lie often comes from the absence of things we don't have, so we fantasize them. We lie for fear of losing something or someone, not to be punished. We lie to be popular, creating a character that we are not to please our ego. We lie to protect people we love, hiding the truth that will surely make them suffer. Or we lie out of malice, even hiding and manipulating important facts to get what we want. We lie to make someone feel bad, sometimes just because we don't like the individual, or to get revenge on someone who harmed us or someone we care about. We also lie to hide our frustration, anger, sadness, and depression so that we don't expose ourselves. "It hides low self-esteem, insecurity, lack of self-confidence, fear of rejection, shame, fear of punishment and criticism and, in many cases, the desire to manipulate the other. There are brains that, due to their structure, are more capable of lying than others: lying is learning that begins in childhood."[69] According to psychologist Sandra Farrera, the lie is not necessarily just in words. It can also be in gestures. Anyone studying bodily communication can read lies. And therefore, practicing the lie sometimes makes the lie real in our mind from repeating it so much. There comes a point where we deceive ourselves from the truth.

Lying has become a feature of everyone living in this world. Since the little lie of Eden, everything on Earth is cursed. "And to Adam He said, because thou hast heeded the voice of thy wife, and he ate of the tree from which I commanded thee, saying, thou shall not eat of it, cursed is the land because of thee; in pain, you will eat from it all the days of your life."[70] From then on, even the animals fell on the roller. The lie became something simple for all the inhabitants of the Earth. Soon after, when the Ten Commandments were written and given to Moses, the ninth commandment helped us to understand the gravity of speaking a lie, which is to harm another person: "Thou shall not bear false witness against thy neighbor."[71] As the lie is "acculturated" on Earth and God is the truth, to be close to Him, we must be far from the lie.

You might be asking yourself: why do animals lie? To get what they want from animals their own kind. To protect themselves, to mate. "Some birds imitate the sound of other birds to confuse them away from their nest,"[72] wrote Adams Eldridge. A beautiful "liar," for example, is the butterfly, which lies to attract another for breeding. Some brightly colored ones have toxins in their wings, and when predators taste them, they know they shouldn't eat vibrantly colored butterflies. Other types of butterflies that don't have toxins in their wings but have similar colors use this strategy to "cheat" their predator. Camouflage is

[69] Farrera, Sandra Ph.D. Why do we lie? www.psychology.bch.com. October 25, 2018.

[70] Genesis 3:17

[71] Exodus 20:16

[72] Eldridge, Adams. *Do animals "lie" yes, even to their own kind*. The journal of theoretical Biology. University of Rochester. Www.rochester.edu. Sep 25, 1995.

also another "lie," deceiving the butterfly's predators by disguising itself in the color of the environment, as does the chameleon. And some do not lie, but consent to it by remaining silent. Some of the most deceptive animals have created some popular expressions that we use in Brazil for those who do something and hide, such as "making breeze face," "João without an arm," "a washed face," and "a dog's face that fell from the moving," among many others. Maybe in another language this doesn't make any sense, but most Brazilians know those expressions. Even if trying to cover up the lie, it is a considerable possibility that lying is noticed through bodily expression. Currently, many scholars can detect a lie by examining the body, face, and hands.

The silent ones are even worse than those who lie; the omitted destroys the only opportunity to save two people with his cowardice. A lie has to participants: the one who is lying and the one who is receiving the lie. Who doesn't have that friend who bought a piece of jewelry and said it was her husband who gave it to her, and then one day she forgot and said where she bought it to someone else in front of her? Who hasn't shared a place where her husband took her to a romantic dinner, and one day someone tells her husband about the place, and he has no idea what that place is? That's when the lie has a short leg. The liar does not feel guilty when he believes the lie is legitimate: a salesperson considers it his job to emphasize the favorable aspects of the sale product and will not feel guilty about doing so. "A liar will also feel less guilty when he feels that the negative consequences are not serious for the person he cheats,"[73] according to a research article.

On one occasion, my ex-husband went to work in the morning wearing a uniform like every other day, but he arrived home in shorts with wet hair. It was summer, and the day was beautiful for the beach. He told me he made his deliveries, and the last one he stopped at was right by a beach. The streets were busy, so he went to a store near where he parked. He bought a pair of shorts and went to the beach until the traffic cleared, and then headed back home. Months later, a mutual friend of ours asked me why I didn't go with the kids to the beach. Apparently, they were organizing for a long time to go with everyone from his work. I confronted him, and his answer was another lie, and that wasn't all. A year later, I learned of the mistress who worked with him, and that day at the beach was a day she was with him. This was a hairy lie.

In that same year, a coworker in the salon I worked at burned a client and pretended like nothing happened. It passed over the weekend; the burned woman appeared very angry because the hairdresser did not even apologize. Many Spanish and Brazilian people use the expression "menina"[74] to refer to Brazilian women. The burned person exposed the case to the salon owner. When the client reported the accident, she said, "The menina burned me." My boss instantly thought the person who disgraced her was Brazilian, meaning that she thought it me. So, the owner came to me furious, because the Brazilian who was burned left open the possibility of opening a case against the salon not only

[73] Albert VRIJ, PH.D., PÄR Anders Granhang. PH.D., and Samantha Mann *Good liars. The journal of psychiatry & Law.* 38. Spring/summer 2010.

[74] Girl

because of the burn but, above all, because of her neglect. At the end of the story, what happened was that the hairdresser who burned her didn't notice, and when she called her, she didn't answer; consequently, she didn't even ask for an apology.

My boss gave me a hell of a scolding. She got even angrier when I said I didn't remember anything like this happening with any of my clients. I started looking at my phone, and my messages didn't find anything. It was a good thing I asked another hairdresser, who always worked with me, if she had overheard the conversation between the owner of the salon and the burn client. She said the client had said it was the other hairdresser. She told me that it was the other one because she had witnessed the fact when it happened. I wasn't working that day, so I asked her to speak with the salon owner. She said that when she heard the Brazilian client talk about the subject with the owner, she said that it had been the other hairdresser who burned her, but the salon owner made a disbelieving expression and still came to talk to me. We were swamped that day, so when we had some time together, I asked my colleague to speak to the salon owner in front of me, and she did. Although she was doubtful because of the other hairdresser's burned client, she never assumed that it was her fault. My boss never liked to confront people because she did not want to upset them, and she let the situation go. She was scared and admitted that I was not the one to blame. That was the devil's daughter.

I worked in this place for five years and am so grateful to God for that time, but it was at this point that I realized it was no longer time to stay there. Lies out of fear or defense are the most common. The problem with a lie is that it always causes harm to the person who spoke it. Sometimes you forget something somewhere, and when you come back, the person you found is wearing it, and when you say you lost it, they tell you they bought it. That is a hairy lie.

When someone says you're never going to get something, you try tirelessly to achieve it. When your child doesn't obey you, you think he's never going to change. When you talk about God to a person for years and see them getting worse, you think it was a waste of time. When you look in the mirror after a bad day and think how old or ugly or fat you are, you will never be happy again. That's the lie, the devil's daughter.

God is beautiful and creative; everything you see and feel, He called to exist, but the only thing the devil created was the lie, the deceit, the omission, the manipulation.

A liar's silence lets the innocent shed the weight of their omission.

The mess made by love

I loved despicable people,
I loved people who despised me,
I loved the people that I despised today.

I begged for someone's love,
someone begged for my love,
My love was not enough for someone.

We all may fall in love,
we all may fail to love too much,
Some don't love anyone.

Many are loved by none,
many had a great love,
few had a lifelong love.

Several pretend they love many,
many can't love anyone,
few don't have any love to give.

Some who only love money,
some the only wealth is love,
few believe that can buy love.

I lived times when I wasn't loved,
I lived times when love was all I had,
moments that love was just what I wanted.

Chapter 10
The rug pulled

The truth is always before our eyes, but over and over, desire makes us blind.

The rug pulled

During life, people and situations pass us by, helping to develop our character. Some people are role models for us to be better or lead us astray even more with their evil influences. Some situations will create beautiful memories, others will teach us, and those that become traumas will make our behavior change. These situations cause damage that, if in childhood, we cannot express. In adolescence, we get lost; we forget, and the wound is profound in adulthood. As adults looking to heal, it is necessary to remember everything we spent our lives trying to forget. Traumas produce attitudes and decisions that most often compromise the whole of life. For many, it compromises character. This shift starts at the point where we hurt people we care about. Some people realize this, but some can no longer see it. I can get used to the feelings of cheating and getting away with it. The other may be hurt, although it doesn't bother me anymore. I hurt and feel a little better; even for hours, I lie, cheat, and betray. The biggest problem is the destructive to the side that suffers because of trusting. Lying may be commonplace, but the damage is not minor. Betrayal is like a path we have never taken and are afraid to go on, but we lose the fear when it passes for the first time. And when fear is lost, it becomes customary, even if I'm aware of the evil. The trust is deceived and will be destroyed no matter how much I apologize for the act. The betrayal causes harm when it comes from those we love and trust blindly.

 The first betrayal I suffered in my past relationship was before we decided to be a couple, Felipe and me. The excuse was that it happened before our connection was exclusive. "The practice of infidelity may be related to certain personality characteristics and

even to a genetic predisposition,"[75] according to Dr. Peixoto. He explains that there is a permanent conflict between the biological, the psychical, and the cultural determinants. After all, monogamy isn't in the biological essence of the human being; it is a cultural and social imposition. Still, he does not fail to warn that preventing a betrayal is possible, and he sees infidelity as a decision of the people involved.

Years later came the first separation. Felipe revealed that for five years, he had been cheating on me with the head of the bakery where he used to work. He said that their relationship was back and forth, and the saddest thing is that I realized when it started: a Halloween party where the situation was so ridiculous that I felt ashamed of myself. Felipe and his coworker danced around for six songs in a row. The songs were upbeat, and they danced very slowly, talking "work" stuff in that deafening noise. It was so clear that his friend's wife came up to me and said, "Aren't you going to do anything?" I had to get up and talk to him, and still he made me feel like it was nothing, and I was just being jealous. From then on, I forbade him to dance with her. I couldn't believe something like this was happening to me. I was willfully ignorant to the situation, even though he invited her to our celebrations, and she always brought my favorite food. In the friends' meetings, she was always there, of course.

We often choose not to go after information so as not to lose confidence with the person we live with, but sometimes we don't go after certain things. Why? We choose not to see what has already been revealed because we want to remain blind. We are not deceived in a betrayal; it has already been desired or even planned countless times before the act happens. In the beginning of a relationship, we are presented with the flaws of our partners. To maintain the relationship, we choose not to give importance to things that will create contention. So far, so good, but what about when it comes to cheating, domestic violence, sexual abuse, and verbal abuse? Do we do the same things?

Unfortunately, we close our eyes and push with our stomachs. No one should be unequally matched, as respect, commitment, fidelity, and companionship must be on both sides. To love the other is to love ourselves first and believe that this person loves us as we love them. I had a husband in my head like a child's dream. As much as my ex-husband tried, he wasn't this person. My lack of self-love made me feel that what I had was what I deserved. I don't know for sure why, but I became blind by choice. Today, I realize that everything was in front of my eyes until the rug was pulled out from under me and I had to face what was under it. I no longer had the rug to hide the dirt collected during all those years. How many times have I heard that the neighbor's grass was greener! That apples from each other's tree had better fruit! Or worse than that, with each fight, it was said that there was no love but a need. There was something better that hadn't come up, so he stayed with me. "The moral and learning reasons associated with cheating have almost always been associated with cheating, rational conclusions about consequences

[75] Peixoto, Manuel Ph.D. Porque Traímos. Revistasaberviver. wwwlifestyle.sapo.pt. Sept. 06, 2016. Portugal.

and punitive outcomes could also be a reason for cheating."[76] The punitive results associated with poor performance and failure can offset the threat of punishment for the act of betrayal as a way of getting revenge on the other for the way they were treated. The revenge is suitable for the character caused by a trauma that has never been treated. During this time in our lives, our house was often the meeting spot for all the parties we and our friends had. Everyone knew of Felipe's betrayal. Those parties were another way I tried to please him. To think that I thought all those people were my friends. It was customary to receive these people in our house, although most didn't even like us. Felipe couldn't bear to spend a lot of time with our family. He was always looking for a reason to not be with us, even when he came home from a long day of work. For him, the house was just a place to shower and eat. The family was needy and not his choice.

When he confessed to five years of treason and decided to leave the house, I died of pain from my "failure." I forgave him, even though he didn't regret it. At the same time, when I was going to file my income taxes, I ended up finding several bills for hotel rooms in the middle of the day. And some were during times when we were in severe financial crises. He thought that he had it all figured out. Once again, out of necessity, he ended up returning home, swearing that he learned that family was everything to him. He started going to church with me for a few months. I accepted him not because I believed in his change, but because I didn't have enough self-esteem to let go of this relationship. Before I met Joy, Felipe preferred to hide in my cowardice rather than face it. He needed to relax with his friends, and since he wasn't part of a band anymore, started going to karaoke. In the past, he participated in some bands, as he sang very well in three languages. On his last birthday that he spent with us as a family, he invited two old friends and some new ones, and his new lover was one of them. Within a week, his friend's girlfriend was upset because I had his lover in our house, so she called me and told me what she had seen. I confronted him, and he denied everything until his lover accepted him. Then, everything became public.

More complex than the attitude of betraying is the breach of trust. The human being tends to betray the harmful things that are most beneficial. Men can become tired quickly and become attracted by the eyes because they are visual beings, and they forget what they should prioritize.

The message that remains is that the person betrayed was not enough. "The betrayal manifests itself in every possible way, depending on the age of the traitor, the circumstances and customs of the collective conscience that builds the cultural environment in which the betrayal takes place."[77]

Betrayal happens long before a person decides to betray. Before I knew about the cheating, Felipe wanted to us try therapy to save our marriage. I went to see the therapist as he suggested, but when I booked our session, he didn't want to go anymore. In any

[76] Taylor, Susan L. Moral Reasons for Betrayal, Vol. 24 Issue 11. P. 73. March 1994.

[77] Miller, Barry. "On the analysis of the cheating." Journals od Analytical Psychology. vol58. Issue 4. P. 530, P.17. 2013.

situation when I use this kind of excuse, it's because I already have made my decision. The excuse is only a bad way to say that something has been tried.

He was never fully committed to our relationship. I was alone for years. But instead of me getting angry at being betrayed and humiliated once more, back inside my home, I raised not only our son, but his daughter as well. My self-unloving didn't wait for regret. Once again, I begged him to rethink and fight for the family that I alone tried to keep. Before he moved out, he said that didn't want to be married anymore and that he was going to live with some friends until he could rent something. I found myself in a deplorable situation of humiliation, as low as a person can go. Only someone who is emotionally ill can do something like I had repeatedly done. I'm so ashamed of myself for the times I crawled around begging for the permanence of someone who didn't deserve to stay the first time.

It wasn't about love. It was about a lack that I had been carrying like a disease since my childhood. It was an emotional imbalance that came like a cancer, rotting me to the point of no longer being cured. I totally depended on this person to be happy. It felt like I was going to die every time I had the chance of him leaving. I changed my life, I changed my plans, I stopped being me, but nothing worked. But it wasn't just him. This happened before in some past relationships as well. The sentiment was the same in the breakups. Since I was a child, I was obsessed with having a traditional family because I didn't have one. It was my childhood dream, and as an adult, whenever I tried, I failed. I clung to this relationship, terrified of another failure.

Obsession is part of mourning something or someone. Those who go through this mourning tend to relentlessly repeat history, as if they must convince themselves of what happened. There was notoriously a sign that something was wrong with me, as if I was trying to manipulate the situation in my favor so that it wouldn't take me away from reality. I tried to force a wish that wasn't real instead of accepting what occurred. Obsession is something very difficult to stop because the feeling controls and imprisons emotions in favor of desire. It is something that doesn't leave your thoughts, even if you try to distract yourself. It is an involuntary reaction that dominates what I want more than the reality I live in does. It bothered everyone around me, and my emotional instability was remarkable.

Obsession causes suffering and lack of control, and if it isn't treated, it will drive people away. With unreal desires projecting things weren't there, I was refusing reality. A dungeon of illusion and obsession kept my mind occupied in a fictional direction. Melody Beattie said, "Obsession is the expression of a passion that we want to keep alive."[78] Obsession comes from loss and pain and is the emotional expression accompanied by anxiety and fear. A good obsession, on the other hand, revitalizes life-bringing aspirations. It makes us quickly reach the goal of pleasure.

[78] Beattie, Melody. *The New Codependency*. P. 138. Simon & Schuster. New York. 2009.

Today I understand that I wasn't the one who wasn't good enough or pretty enough for Felipe. However, the betrayal happened because of his character, which was formed by traumas he acquired. Before Joy, I blamed myself for a lot less, let alone something that big, like a breakup of a relationship. But my actions were not understood by me as a disease, but as love and the struggle for a family. I would only come to understand that later. That was my debt. Everything I lived for was because of the path of traumas, followed by my choices. The happiness and well-being of each are the exclusive responsibility of everyone. Happiness is not defined by the other way a partner can add to my own happiness or to try to overthrow it.

When I had the opportunity to talk to a psychologist, I told them that we wanted help as a couple, so she made the first appointment, and I ended up going alone. I explained the situation and that I needed help with our marriage, but he didn't come and seemed to have asked for more therapy as an excuse for trying. The psychologist told me that she doesn't have much she can do at that stage. The couple must seek help at the beginning of the problems, not when they are already in the separation phase, but she would try to help us. Nothing was okay, but the situation reached the point where my rug had been pulled, now I was on the floor not knowing what to do. The help of a professional was my second option. My first choice was God.

The rug

I started my painting group, Paintings From the Soul, in 2017. The idea was to pass a message of one determinate theme to the participants. The group applied the suggested theme to the canvas as an illustration. Those messages can be emotional or spiritual, depending on how the group wants to work. I believe that in the day of despair and doubt, they will look at the painting and remember the message stamped on it. The central idea is mainly written by me, using metaphors, comparisons, and stories; the messages can be my own, from legends or tales written by other people, or based on the Bible. This book has some of these messages from my stories in this chapter and the previous one.

Once, a lady who lived alone was invited to a birthday party. During the party, the birthday girl introduced her to one of her friends. In the conversation, they decided to exchange phone numbers. After some time, they became very friendly, and because they were very close, the lady told her friend a big secret: she went to live with her aunt when she was young, and the house was the same as it was in those days. This lady's aunt gave everything to her with the condition that she never moved the rug from its place unless she was going to move out.

The carpet was a great treasure of incalculable value in her room and shouldn't be sold unless the lady desperately needed money. She never needed it, and she never moved. The rug belonged to a Persian king, and the lady's grandmother worked for one of his descendants for many long years. Her boss had graced her grandma with the rug, and now it was her inheritance.

After several years, the women were invited to a party, and at this party the lady's friend met a handsome man. They ended up getting involved until eventually they got married. After a while, they moved away, and the two ladies' friends lost touch. One day, the lady returned from her grocery shopping trip and found her door open. The rug was stolen! She was distraught, went to the police, and did everything she could do. Everything she had of value was gone, and she was already at a certain age at which she could never make the same money the rug was worth by just working. After days of crying and moaning, she decided to clean up the dirt under the rug that she had never moved, as it was one of her aunt's requirements for receiving the inheritance. When she started to clean up the trash, everything became more evident, and she found in the middle of that mess a ring that the king used to identify himself. The ring was among the dirt inside a tiny floor piece, spoiled and covered with dirt, dust, and sand. When the thieves removed the rug, the garbage was left because whoever stole it was only looking for the carpet. The rug was worthless, and she was now more prosperous than she could ever imagine!

What can we learn from this?

1. The occasion makes the betrayal

2. The secret is secret!

3. Preciousness in the middle of the dirt.

We are humans subject to lying and betraying, as well as being betrayed and lied to. Secrets, when shared, can be revealed or used against or in favor of the person who knows a secret. We have a great fortune hidden under the years of dirt that we have gathered in our souls, but how can we see it? It's all the rubbish we acquire from our traumas, or all the rubbish we hold onto for fear of changing, deciding, and going for what we deserve. We find willpower because courage will not come. We must pursue happiness in life because it will pass away, and nothing is found when it dies. We are alive, and now is the time to see what's hidden behind the accumulated dirt. God has given each of us one of these hidden fortunes. If we don't find it by looking, we will be driven one day to see it one way or another. Hopefully, it's not too late to enjoy it.

The current that confines me in the child from the past is no more potent than the adult I have become.

Chapter 11
Under the rug
My hands always had the keys to the chains that imprisoned me.

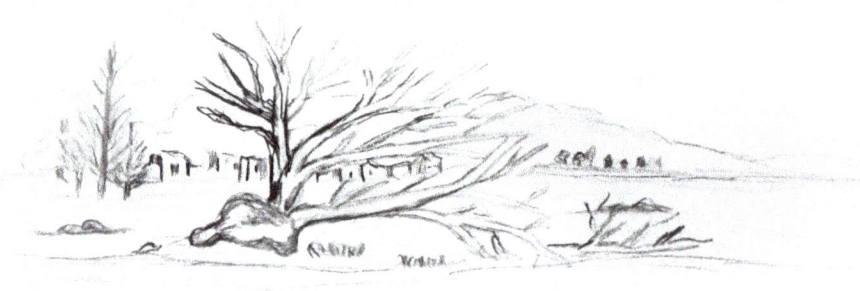

Buildup under the rug

My third bilingual children's book, *White Dresses,* is a narrative of two young girls playing in a beautiful garden, where they discover delicious berries. The two of them wore beautiful white dresses. They loved their dresses, but the berries gave them such an inexplicable sensation that they didn't even care that they were dripping berry juice on their white dresses. The stains grew as they continued to eat. They had to ask for help from a person who knew more about cleanliness than they did to help them get rid of the stains. The girls forgot all about their dresses as they ate and realized too late that they were completely stained.

Felipe wanted to leave, but before he did, he suggested we try therapy. It wasn't his intention to attend. In my second session, I was distraught with my therapist's analysis. It made me angry; it was the fact that she said that if I was looking for help, I was the one who needed help. I went to the third session to help us and again heard unpleasant things, like, "To desire the other to be cured, first we have to heal ourselves." I left and decided never to go back. However, the pains in the subsequent sessions were getting worse and worse after she gave me the diagnosis. She said, "You have a very high codependence of many years without treatment. Your stage is the last one."

She told me that I could get better with years of therapy but that I had no cure because it had been years and years of being at this stage. I was dissatisfied with this diagnosis; first, I disagreed, then considered, "how come there's no cure?" The pain I felt needed to stop somehow, and therapy was what I could cling to. So, I started to read more about it. The more I read, the more I identified myself in various aspects. I noticed that long before this relationship, I could recall another codependent relationship. Since I started the meetings, I have studied a lot about codependency. Perhaps I became sick with my

emotions early in my youth, and abusive and unhealthy relationships developed even more. I had no follow-up to cure the damage, and I became codependent without realizing it. The codependency never presented itself during the years I was with someone who had their emotions balanced. Remember chapter three, when I talk about chains formed by good links and bad links? I have added the good ones in seven years of my life, and my chain had been strengthened with good connections until I started adding more links and making the chain run the risk of corrupting again.

"Codependency is not a problem in romantic relationships between couples. But from self-denial, obsession with what we've lost, guilt, bargaining, control, anger, and sadness… we may not be aware of how much we've lost something we never had,"[79] said Melody Beattie, referring to how codependency is akin to grieving for what we never have, like feeling protected and loved. Many people feel lost with no place in the world. Codependency has several levels, ranging from the behavior to make decisions that please your partner, to being extremely possessive and manipulative with the same goal. Regardless of the level of codependency, the ability to decide and change is always around the other. It's an emptiness caused by a sequence of traumas, and when faced with something that seems to fill the emptiness, we become dependent. It usually occurs with a chemically or emotionally dependent person.

But what really is codependency? Codependency is a peculiar situation in behavioral psychology that is attributed to an excessive dependence from one person to another. This is made possible by the coexistence in which one person waits for another. An individual with codependency has the extreme desire to be needed, and to great lengths, they will sacrifice their own needs and wants in favor of the other person. Often, someone who is codependent bases their self-worth on being needed. On the other hand, a dependent person is emotionally shaken and characterized by neediness and reliance on others. Independence in any area of life is absent, and they will depend on the other person to make daily decisions.

Emotional dependence is formed in several ways, but the best known are by avoiding pain and suffering and maintaining pleasure. The dependent person evades past suffering caused by trauma. These people need a person more substantial than them to depend on. These things can be both emotional and economic needs.

According to Dr. Elizabeth Zamuel in an article on emotional dependence and codependency, these are some characteristics of a person who has this disorder: "Living oscillating between heaven and hell, dysfunctional communication, sexual difficulties, involvement with complicated people, excessive care for the other, low self-esteem, repression of emotions, unhealthy jealousy, compulsive control and also denial."[80] The person lies to himself and pretends that the problems do not exist or are not serious. He thinks that one day everything will improve from nothing.

[79] Beattie, Melody. The new codependency. P. 16. Simon& Shuster. New York. Jan. 2009.
[80] Zamuel, Elizabeth. Ph.D. Emotional dependency and codependency.www.elizabethzamuel.com. São Paulo, 2018.

The codependent believes that she depends on the other. She desperately seeks love and protection outside herself. She cannot be alone, feels threatened by the loss of the other, and thinks that she needs the other to be happy; she is usually a person who appears to be strong, so she attracts weak people who need her help. She will always be strong even though she is the one who needs help but will show strength to keep the other with her. It will always make the dependent person rise and grow in life. Her love is excessive and limitless, but she also wants to be loved on the same level.

The big problem is that the dependent person usually seeks someone to hold on to who is emotionally ill and does not precisely love them. So, when she thinks she's fine, she can stand up on her own when she decides on another path that doesn't include the codependent. The codependent is lost because she no longer has her own identity, as she is spending all her time nullifying herself and prioritizing the dependent person. This is when she forgets self-love and pours everything into the person who needs her help and support. This instability in the relationship holds the codependent, because they always have pity on the other person, thinking that because of their traumas, they need help. She thinks that help comes from her, making her sick as well. Often the addict falls again and comes back as if they had regretted asking for help. The codependent, still sick, welcomes the dependent, and the cycle repeats itself endlessly. Not to mention that she will permanently hide her mistakes and her addiction or illness from the other person, no matter how evident it is.

According to Leilanir Carvalho, "The psychological treatment of codependency focuses on the difficulty of the individual who suffers and clashes with their emotional and behavioral changes to improve their relationship with the other. Some remain in codependency all their lives, so they don't have to go through the harrowing process of separation."[81]

On the other hand, codependency was analyzed in psychology based on people who had relationships with alcoholics and drug addicts. But today, emotional codependency is very common and goes. You know the case of "one bad apple rots the others" and so on. My example of codependency is based on old traumas that my ex-husband suffered and which ended up pushing him towards depression or a shift in his mood. I ended up gathering more garbage and putting it under my rug. For years, I had this rug under my feet accumulating the new dirt with the old ones without cleaning anything. When the rug was pulled away, I figured out that I needed help. I never looked for help because I thought the problem was his character. I tried to cover by understanding his attitudes. I was always forgiving and hoping that everything would change somehow. What came out was beyond love; it was an emotional illness.

In an American Journal of Psychology article, Andrew, Jacobson, and Carlson state that "certainly used psychological systems are well grounded in all of us and established during

[81] Carvalho, Leilanir S. Negreiros, Fauston.co-dependence from the perspective of the sufferer. Psychology Bulletin, Vol. 61, no. 135. São Paulo- Brasil. July 2011.

early development. Dependent behaviors are associated with an unhealthy dependence on other people to meet emotional needs."[82] This overdependence on others often leads to dysfunctional interpersonal relationships. The person the codependent depends on is a person they will forgive, and they blame these attitudes for the evil the person is afflicted with. Imagine a case where a child is dependent on drugs. The mother or father will cover everything the child does, and their life will be dependent on the child's emotions and actions for them to be okay. The family of an alcoholic father will depend on how the father is doing and will pity and fix everything he does as a fault of alcohol. A codependent wife is stuck in her husband's mood and uses it to base her mind on what her day is going to be like. And in some worse cases, she lives in the hope that she doesn't wake up to him breaking everything, including hitting her. Many end up putting up with everything to save their marriage, and they end up getting sick, too. Now that I have studied codependency to understand myself, I can see codependency miles away. I have many friends who are codependent, and they just feel sorry for me. Moreover, the way they handle their relationships is totally codependent.

Unfortunately, we became codependent with friendships, too. With everything the other friend has, I will buy the same just to satisfy my friend, even if I don't like it. Even the car is the same; sometimes, I'd change the color so as not to look jealous. This is relevant to all life lessons, experiences, spirituality, and so on. Who doesn't have a codependent friend? Do you remember anyone in your life who has been codependent on someone? According to Darlene Lancer, "Codependency is a disease of the lost self, depriving us of vitality, spontaneity, and self-fulfillment."[83]

My uncle's father's wife was codependent on her sister. Everything her sister ate, she started to like it. If the sister had a piece of furniture in the house, she would buy the same in a different color. Opinions about everything were her sister's, not hers. If she talked about a certain subject, she needed to bring up what her sister had done related to the topic, even if she didn't have much to do with it. The codependent not only lives for the other, but also lives the other's life, aspiring to become like the other person in everything. People like me who lived with depressed people have a huge possibility of being or becoming codependent.

"The person who depends on the dependent, needs the other because he/she needs to feel loved and safe. They blame themselves for problems the other may have and take responsibility for themselves, acquiring problems that are not theirs, to maintain a harmonious relationship and the well-being of the other, to feel loved, thus delaying their emotional maturity,"[84] says Tatiana Torquato. The pain of detachment from the codependent to the dependent is compared to a surgery where a large tumor is removed. The longer the tumor has been growing and taking root, the greater the pain and focus it

[82] Daire, Andrew. Jacobson, Lamerial. Carlson, Ryan. G. American Journal of Psychotherapy. Vol. 66, Issue 3, P. 259-278. 2012.

[83] Lancer, Darlene J.D., L.M.T. *Conquering Shame and Codependency*. P. 30. Hazelden Publishing. Minnesota, 2015.

[84] Torquato, Tatiana. Talking about emotional dependence and co-dependence. www.tatifalandosobre.wordpress.com. May 2019. Brazil.

leaves after being cut. Anesthesia is the thought that the dependent person will regret it and come back, but time begins to pass, and despite all the humiliation there is no turning back, and the hollow will hurt immensely. Months or even years go by, and the pain still lives, possibly causing shortness of breath. Most of the time, the codependent needs to find another dependent to continue their life. For that reason, they will act strong and will certainly attract another person to depend upon.

The first psychologist I went to scared me immensely. I became obsessed with reading all about codependency, and at the same time, I was desperate to find a cure according to her diagnosis. The knowledge I had on the subject made me hopeful. Her analysis of me was lurid, and my view of myself became horrible, as if I were Hitler's successor. As bad as I was at the time, when I discovered what lurked within myself behind my shadow, I wanted to heal. The desire to be freed from this evil was fundamental to the process that started until I was cured.

My first psychologist had to take a leave of absence due to her partner being sick. Thus, I had to find someone new. I met with a new psychologist who I was not happy to spill out my traumas on. At the end of the session, I said what the other person had diagnosed me with, and she asked, "Do you want me to treat you only as a psychologist, or also with a Christian perspective?" As I am a Christian, I said that I wanted both things. I asked her what she thought and if I was cured after all these years of codependency. She said, "We serve a healing God! There's nothing our God won't heal!" After a year, I had an aversion to the first psychologist. Just saying her name made me afraid because I had hit the hammer with the diagnosis. As she was a known speaker and preacher in the community, I ran away to avoid her. Seeing her was like remembering what she said about me. Not everyone can withstand a harsh confrontation and a definitive diagnosis like the one I received.

In a Science and Business article, a group of psychologists stated that "codependency has been defined as a pattern of relating to others characterized by an extreme focus outside of the self, lack of overt expression of feelings, and attempts to derive a sense of purpose through relationships."[85]

A metaphor I use in my painting groups is about an empty vase or container. Throughout our life, we are filling it up. We are putting knowledge, experiences, and traumas within ourselves. How should a vase should be cleaned or stained? Like a vase, we can be broken. Like a vessel, we can be full of both good and bad things. The cleaning of the toilet must be maintained. The things that are not to be retained must be taken away. Anything that can cause damage to the vessel has to be removed. But if this maintenance is not done, the vase becomes corrupted. The codependent is a vessel that is not maintained and is always absorbing. Therefore, it is compromised. Codependency is acquired not only by the current state of life, but by a series of factors that in the past have overloaded the vessel. The codependent vessel is poorly maintained and therefore vulnerable to being what it is.

[85] J. Lampis1 · S. Cataudella 1 · A. Busonera 2 · Elizabeth A. Skowron. The Role of Differentiation of Self and Dyadic Adjustment in Predicting

This emotional handicap is not caused by a single relationship. Codependency is a vessel that from childhood becomes emotionally affected.

Codependency is a behavior that disguises itself and goes unnoticed, but it is a disorder in emotions. I needed to know what I had to get help with. Even without accepting this, I continued my therapies for over two years. A few years later, I donated my painting to a women's seminar. I knew that the psychologist who saw me first would be there. I didn't want to go because I was afraid of seeing her. The day came, and I wasn't going. Hours after starting, Joy told me, "You need to stop hiding like a kid! God did not give you a spirit of cowardice!" It had been a long time. I had not yet become a writer, but I had already done some exhibitions and performed live paintings. I went towards the end, not hiding, but feeling hopeful about the possibility that she would be gone before I arrived.

When I arrived late, the raffle of my painting was about to start, and there was such an uproar. Thayse from Maryland won the painting. Cecilia, the event leader, spoke of the painting's message as she handed to the winner. Then, she wanted to introduce the artist. I ended up talking a little about my work. Towards the end, a cocktail was being served and I tried to sneak out, but they called to me from both sides. I tried not to be seen by my first psychologist, but as I was leaving, she called my name. She was amazed to see the change in the person she diagnosed. At that time, I heard God speak softly, "Nothing is impossible for me."

At that moment, I realized that all the feelings I had towards her were gone. I'm grateful to God for this psychologist, because if she did not expose my weaknesses, I would never have known about them. I would have continued in the same way, looking for someone else to be codependent and continue with the cycle. Change needs a confrontation, confrontation needs a decision, and a decision will only flow with changes in attitudes. After this event, I encountered her at my presentations of live paintings or art shows; she was thrilled with what God did to me.

Trauma causes unbalanced emotions. The imbalanced emotions make me look for the wrong exits to get some personal satisfaction as a relief from escaping the "regular" situation in which I find myself. I adapt to what I can get without expectations of anything better than what I have. The direction of this escape will make me buy unnecessary things to fill something in myself, take extreme care of my appearance, feel the compulsion to eat, drink, or do drugs, degrade myself as a person, and so on.

The probability of change is entirely remote. There must be some struggle forcing me to transition from unwanted change. The emotional imbalance will drive me into a deep, dark hole. The more time passes, the more decadent I will become. Unfortunately, sometimes conflict happens and change doesn't. The struggle will lead me to two extremes: making it go down so deep that it won't give me any option but to go up, or dying down there. Conflicts cause someone who is already emotionally bewildered to pass, or they lead to life. It will never stay the same. I don't have those things in life anymore, and I still lose everything I have! The exit from the pit will depend solely on me. Whoever helps me get into that pit never helps me get out. If I don't try to leave, I've gone to the side of

death. Emotional death is not overnight; it comes slowly, with words, thoughts of defeat, and isolation. Like a satellite that revolves around the Earth, this is me. Anyone can be the Earth but myself, dispensable, unwelcome, replaceable. Hence, my self-esteem is already in the pit, and I lose the only thing I thought I had, identity. Emotional insecurity makes me unnecessary in my mind. At this point, emotional death will happen. Whoever enters in the hole should cling to something they love, like children or parents, so that they can strive to get out of the hole. Life breaks down in the same way for anyone; some have the resilience to be reborn emotionally, and others will unfortunately die.

Change is a new, tight shoe that will bother you until you realize how good it was to buy it.

Through the window

The sun goes down and I look out the window. Next to my bed, the glass allows me a beautiful view. Comfortable I adjust my pillow and go back to lie down.

I think about those who go from one side to the other and the cute boy leading his dog for a walk.

I sometimes reflect on my idle day and the nothing I did. In sighs, I complain to myself, lifting my shoulders and twisting my head. Tomorrow, I'll do it; tomorrow maybe I'll start.

For letting it go, I feel sad, and I go to bed regretting it, but the other day I repeat the same, leaving life behind.

 I was looking for some encouragement to get up from my bed. I think about everything I can do; I settle in and go back to bed.

Looking at the ceiling, I dream awake, I dream sleeping, and once again, I let another day pass.

Another day awake, looking out the window, I imagine all that changing.

What if I put a flower in my hair?

What if I start dancing?

Hmm...but today the day dawned so gray; soup and movie day, better in my warm and comfortable corner to stay.

My hair is very tangled. Not even a flower would go in. I don't comb it because I don't even go out of the house. I don't see anyone, and no one comes to see me, only to look through the window.

Ah…I could dance, I don't have music, and I don't even know how to sing. I just need a little flower. I'm not going in the garden to get it.

From my window, unstimulated, I see life passing. Another year gets closer.

Congratulations! For nothing. It depresses me that day, my born day. There it comes again, inevitable and always charging me.

The life I let pass by my window, my dreams I let crumble. So small that I don't remember, and I don't want my memory to strain.

That's when I remember them, and with bitterness, I start to cry, I hum that old sad song, and through the window, I look again.

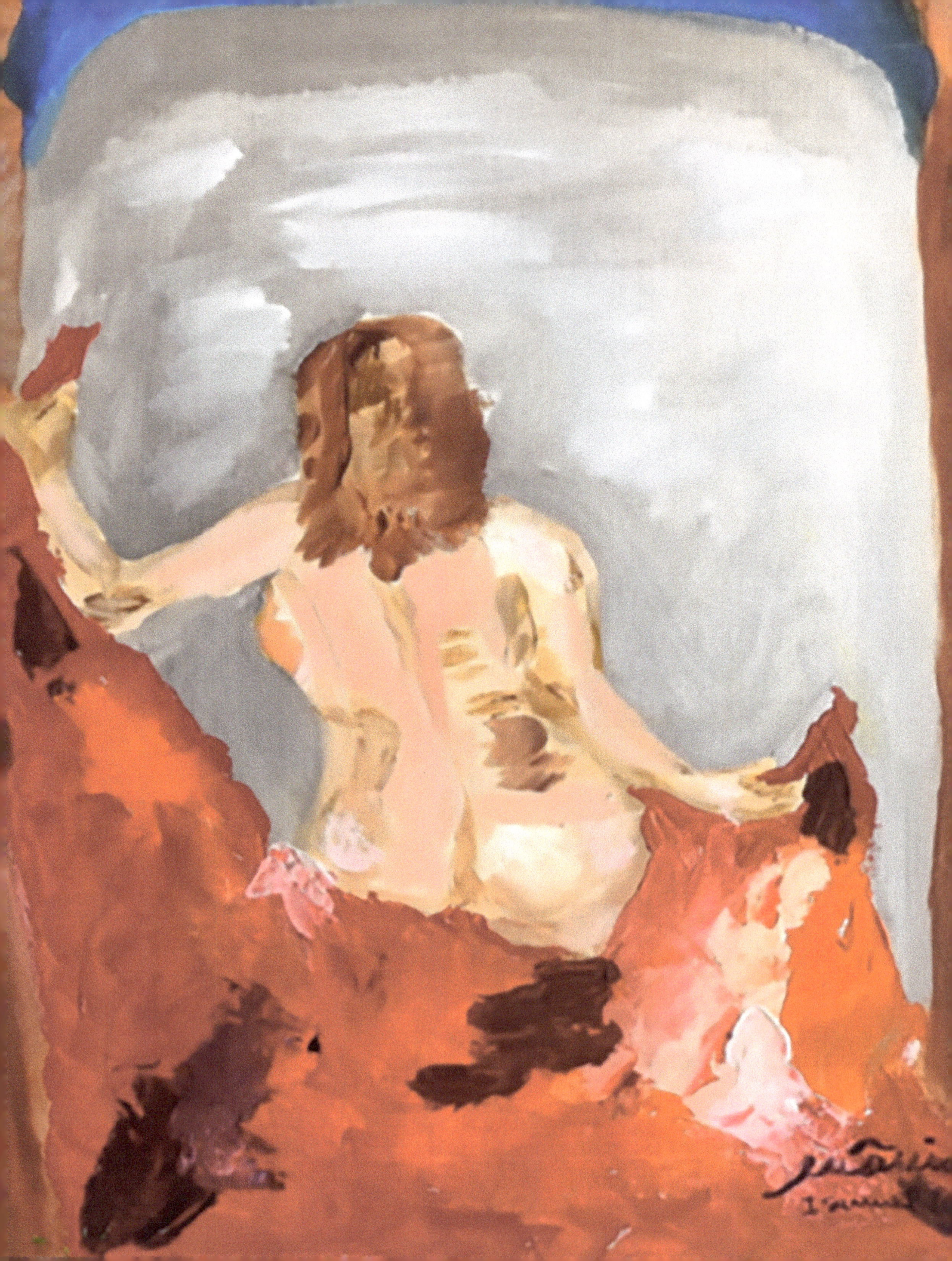

Chapter 12
The mirror
Testimony is a mirror that reflects the truth.

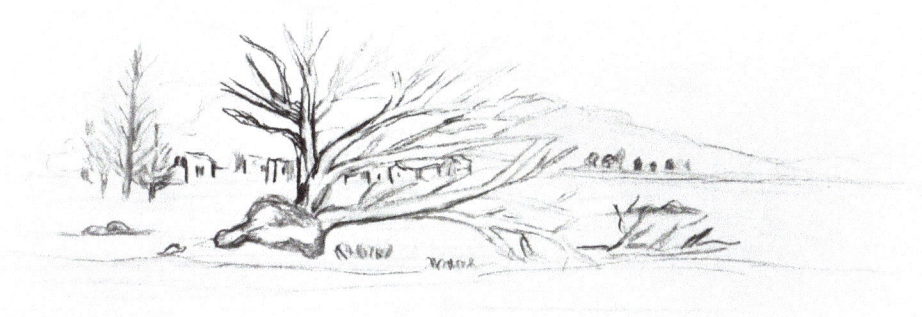

The beautiful

What is beauty? The characteristic of being admired causes a feeling of pleasure and satisfaction that transmits peace and joy. Beauty comes in many forms. It is in what is seen, felt, tasted, heard, and smelled. The beauty of memory, like the smell of leite queimado[86] that my grandmother used to make for me on cold, rainy days, smells like my early childhood. The flavor of the milk brings vivid memories of when my days were beautiful, as does the feeling of the shower and then old pajamas after an exhausting workday. Listening to an old song brings happy memories that touch my soul. Even today I can remember this song anytime; my grandmother used to sing as she combed my hair when I was a child, "My dream, oh my dream. Go look for someone who lives far away, my dream."[87] Beauty is a reencounter someone who I couldn't imagine seeing more in this life. The beauty of my dream is hugging my son who I haven't seen for many years. The beauty of a family man is finding work when all his bills are overdue. It is when you are sure that even among multitudes of people, like grains of sand, you are seen, heard, and loved by such a great God. Seeing beauty in all of this is much more, because today I see beauty in everything. I'm full of beauty in my being that spills over my sensory organs, surrounding me without even realizing it. When in this headspace, everything was a matter of exchange, not because it was past time for something to change. Where once I used to see only myself in the mirror, reflecting patterns dictated by a distorted vision of beauty, now I see identity. According to research carried out by a group of university students, "The literature on disordered eating found support for the role of self-esteem as a mediator of the relationships between several variables and disordered eating behaviors. For example, it was found that the

[86] Leite queimado: burnt milk (pour sugar in the pan, let melt, add cinnamon, then pour some milk and let cook for five minutes in low heat.

[87] Sonho meu. Alibi.1978. By Carvalho Dercio. Lara Ivone. Maria Betania. Performance.

relationships between restriction and disordered eating and autonomy and disordered eating are mediated by self-esteem."[88]

For a time, I felt that everything in me was terrible; the desperation for a better body and appearance began, which now is the question of bankruptcy and not character. Many women become addicted because of low self-esteem and get a little more serious about their appearance. But no matter how beautiful I am, when I look in the mirror, I feel ugly. How many times has the mirror lied to me? What it tells me isn't the truth, even though it is how my soul felt.

The ugly

Crisis is a sharpened scythe that cuts everyone like pristine bushes, but some seem to have not only been cut, but they also seem to have been pulled out without any possibility of renewing themselves. The cut was cauterizing, preventing the sprouts from growing. Some will continue to grow as if they had never been cut before. In all areas, from the simple to the most tragic, every cut we take in life hurts, and it's tough to get over it. From a small debt to the loss of a best friend in high school, the death of a loved one, the breakup of a marriage, or bankruptcy, everything hurts, regardless of its size. It is small for those who see it or huge for those who feel it. Perhaps because we are just starting, we overcome loss more quickly than adults when we are children. I'll never be prepared because I cannot be surprised by crisis and stress. According to my mental resistance, the physical and emotional strain comes with problems, or "cuts" intensified. The more emotionally overwhelmed I got, the greater the pressure and difficulty was in getting up.

When the rug was pulled out from under my feet, a lot of dirt had accumulated over the years. Along with codependency, there was the pain of losing my marriage, lost self-esteem in being exchanged, and loneliness for not knowing how to be with myself. When this was exposed, I had to deal with myself and the awful thoughts I had, realizing that Felipe was not able to fix everything in me. Here comes the escape from the reality of the codependent thinking that everything will be fine without treating the cause. Everything has a reason that triggers a story. When there is a need to fix something, I must go straight to the cause, not the factors. If flies are flying over the trash, should I kill the flies or take out the garbage and clean the rubbish? The solution to the problem is to solve its cause. In my time deciphering what ailed me, there were so many answers to fix my problem and not the cause of the problem. We generally look for the easiest solution—which, in its entirety, is not the most efficient. When I had to move on after my rug was pulled, I did several things to deal with my problems.

The first and most comfortable of these is going into depression.

Second, becoming bitter and hating the world.

[88] Ertl, Melissa M. Longo, Laura M. Groth, Gabrielle Hoover Berghuis, Kate J. Prout, Jeff Hetz, Maria C. Martin, Jessica L. *Running on empty: high self-esteem as a risk factor for exercise addiction.* June 2018, Vol. 26 Issue 3, P. 205-211. Educational & Counseling Psychology, University at Albany-State University of New York, Albany, NY, USA.

Third, going back to my country and getting away from it all.

Fourth, going out with "friends," dancing, and drinking to forget.

Fifth, handing over his daughter so he can get by.

Sixth, getting someone else to replace the one I lost.

Seventh, seeking God and becoming fanatical and paranoid.

Eighth, feeling all the pain, going through grief, and seeking healing.

Ninth, taking time to get to know myself.

Tenth, learning to love myself.

Eleventh, knowing my life purpose.

There is a long process to get to almost every option, **except for the third, fourth, fifth, and sixth**. I will descant only the ones I had to go through in my healing process.

The first: I went through a state of depression. The depression I experienced was like entering the last place where the door behind me closed and in front of me, there was nothing left for me to get out. But I'm so thankful to God because I know He painted a door for me to get out, and I didn't stay at this stage very long, with prominent, deep depression. According to Robert Feldman, "People with major depression experience similar feelings, but the severity tends to be considerably greater, they may feel useless, lonely, they may think the future is useless and that no one can help them. They can lose their appetite and have no energy."[89] Also, they may experience these feelings for months or even years. They may cry uncontrollably, have sleep disturbances, and are at risk of suicide. Sadness eats from the inside, and when it consumes to the degree of depression, such destruction of the soul has no limit.

I had various symptoms: I cried, I couldn't sleep, I couldn't eat, and my mind wouldn't relax in blaming myself for not doing more to save a broken relationship. I spent hours looking out the window at dawn, waiting for a change of mind in continuing living a disgraceful life of betrayal and disrespect, but suicide never crossed my mind. All I thought was that my youngest son needed me. I needed to stand up for him. The two older ones were raised, but the younger one still depended on his mother. Deep sadness caused by a major trauma has two critical sides: depression caused by deep sadness and self-pity, and depression caused by sadness, bringing isolation and self-harm. Most of the time, we don't know when someone is like this. The person with deep sadness often only hurts themselves. It is true that when it is noticed, it shakes the people who love them. In general, it is the sadness itself that it destroys. I felt self-pity in thinking that without me, the world of the people I love would be better. This is a burden and blames me for everything, but unfortunately, I can't do anything about the enormous sadness.

[89] Feldman, Robert S. *Understanding Psychology- Mood Disorders- Major depression.* 9th Ed. P. 529. University of Massachusetts, Amherst. Mc Graw Hill. Boston, MA.

On the other hand, a person with bitterness lives in a personal hell, but also contaminates everyone around them. And now, with social media haters, they can pour out their bitterness to anyone they can reach. Here in the United States, there is a popular saying, "misery loves company," as every embittered person can't just poison themselves; they need to go out and destroy everything that their sick eyes can reach. Its toxicity is caused by great sadness, the emotions are affected, and the insight will multiply until they undergo a healing process. The wounded and bitter soul hates to see others achieve what it cannot or did not dare to achieve. They complain about everything they have acquired and are ungrateful even for the good parts of this existence. As their wounds hurt, they need to hurt someone. They repeatedly conspire against everything, even against themselves, for everything comes and goes.

Without emotional balance, envy predominates gossip and complaints. Worst of all, everyone who lives with this person will be intoxicated by such bitterness. If I curse, everyone close to me will end up getting into the habit of cursing. If I complain, all will complain about everything, too. If I speak ill of others, all will soon be doing the same. Not to mention that I can poison everyone when I feel angry and manipulate those who allow themselves to be controlled. Who doesn't know someone like that? Or do you have someone like that in your family? Or worse, you may be surprised when you least expect it. It's challenging to raise self-esteem surrounded by people who have the same imbalance as me; it is unavoidable for the negativity not to get into me if the breather tank is contaminated. The same goes for living with people whose self-esteem is disguised, but in fact they are a totally narcissistic person. What's the difference? I put myself on a pedestal and think I'm superior and so low-key that my self-esteem doesn't put me on the level of others. My selfishness doesn't allow it. My mind is so close around myself that everyone can't have what I have.

I want to talk about my problems, but when others want to talk about them, I change the subject or say I don't have time. When someone is sad, I feel sorry, but I don't like them anymore if they fix themselves. I always judge the attitudes of others based on not agreeing with their thinking. If they do something and don't communicate, it's already a reason for fights and innuendos. What do these three emotional imbalances have in common? The ingratitude. Jealousy is characteristic of narcissists, envious people, and haters. Narcissists are jealous to see me get up, as I may be fine, but no better than them. Haters, in turn, are in such constant inner hatred that nothing pleases them.

Besides being constantly jealous, people who are envious are also bitter. The one who has low self-esteem finds themselves unworthy of everything, and for that, they cannot be grateful. The narcissist finds nothing quite good enough to get to their pedestal. Haters will think that if someone offers them help, they should not do it because they are better than them. The envious wants everything just for them. Gratitude is a characteristic of inner joy and emotional balance. I have lived, and I know what it is to be ungrateful. After healing comes and the emotional balance is set, gratitude is a continual state. Gratitude is a constant act of the person who feels good about themselves. Everything is a succession; gratitude is one thing that pulls another. If I am grateful, I will develop new goals to be

achieved and elaborate conclusions to improve my life. That will come accompanied by joy at the benefits of my actions. I will recognize the gain of good things for my life. I will also be valuing good intentions and will appreciate them more. And once again, God will make me grateful!

Likewise, ingratitude is related to bitterness. It will always frustrate me, and I'll leave everything unfinished because I can't see the positive of getting what I hoped for. I can't get a vision of what I can achieve. I will find myself powerless and blame people, be miserable, remain bitter, and always view everything with a bad thought and remain ungrateful. As stated by Elaine Fox, "Several factors contribute to increased well-being and happiness. Having friends and social networks, expressing gratitude to others are ways to increase our happiness."[90]

Living alongside people who are grateful influences you and encourages you to be grateful like them, just as with living with the ungrateful. Not only did I experience my emotions out of control, but I also had people around me who were totally out of control. As I was no longer well, some made me worse. The good thing was that it was only in certain situations, so I didn't have to live with them. There is no way to avoid them, but I needed to get away from this toxicity in my daily life. Otherwise, it would affect me. I directly experienced two sad and unexpected situations; the first was a few years ago when I was leading the children's ministry at my local church. I had a lot of energy and was always inventing new things. I formed a great team with beautiful people who supported me, which made me create even more.

On one occasion, I decided to raise money for the children's ministry to have its own fund so that they would not have to use the church's money for their needs. I started to promote two groups of paintings with them as I do with adults in "Painting From the Soul." Some parents and the church helped me with money for paints and canvases. I took my work brushes, easels, and aprons. I chose the theme according to the age of each group. Children came from outside the church, and the spaces filled up quickly.

At that time, a family began to gather. It was a husband and wife, with a daughter who was pregnant. This lady came to church and changed overnight. She started to help and participate in everything to fit in. She came to me and was very excited for her daughter to participate in the painting group. She wanted to help the children's ministry by paying to sponsor more kids. So, on the last day to sign up, I posted the announcements on social media, in groups, and at church. After the service, I stayed at a table in the cafeteria, where some people signed up.

When I finished, a lady saw me and made an expression of displeasure, shook her head in denial, and turned away. I got up and took the money to buy the materials and left. When I started to leave, she started yelling at me. Surprised by her attitude and never having experienced something like this inside a church, I tried to sneak out as if she weren't yelling at me. I walked and she screamed that I had no education, how someone

[90] Fox, Elaine. *Emotion Science*. P. 340. Palgrave Macmillan. New York. 2008.

like that shouldn't lead something, and so on. After I left, she spoke even worse. As a result, she spent some time congregating and fighting with three others after I disappeared.

Elaine Fox states that "emotion is cognitive processing that results in a decoded signal that an environmental event (or memory event) is reinforcing, along with the mood state produced as a result."[91] The person reacts according to how they are formed. If your emotions are unstable, you will surely explode over things you should be able to control. However, something small that may not even be relative to them will bring out frustration and bitterness generated by emotional damage, sometimes causing curiosity to those who witness it without understanding the reason for such a great offense. The person was not really aimed at, but the emotionally unstable one cannot control themselves as someone who is stable.

The other story was recent and passed on social media. My aunt launched her pre-candidacy for councilor in my city in Brazil. I was very happy that she made this decision, not that she got involved in politics. I rejoiced that she came out of her box of hopelessness and met this experience. I posted on my page a poster of my aunt and said how happy I was, and that if I could, I would vote for her not just once, but twenty times. Many friends commented with good things. Two pastors, mutual friends of my aunt and mine, commented that "it is from God." This means that her attitude is blessed, and I commented again, writing, "From God." Then a hater appeared out of nowhere! It was a girl who lived down the street from my grandmother's house. She was added to my contacts on Facebook with several others. She never commented on my page. But on this occasion, she wrote: "all people are from God, friend." I was surprised. For starters, she called me her friend. If you are called a friend or a flower, you have already given the signal. I called my oldest aunt and asked if that girl had something against my younger aunt who was a candidate for councilor, or against me. My aunt said she was so bitter that she had a stroke that left her side paralyzed for a long time, and that the answer was coercion, since her brother is also a candidate for councilor. Then I could understand how miserable her reaction was to something that had nothing to do with her. My answer was: "I respect your opinion, 'friend.'"

Second: like in the example I just gave, envying people for their happiness poisoned me in acridity. Most of all, I started to hate myself because I blamed myself for having lost the fake life I was living. I began to hate to leave the house, and when I saw families and couples together, I felt angry and started to cry. I canceled all my social networks and hid in shame of my failure. "Self-esteem stability is generally identified and measured based on temporal changes or fluctuations in self-esteem,"[92] states Kernis and Grannemann.

There was an episode that I never told anyone about. I was at one of my jobs in a bakery. An old friend from when I arrived here in the United States showed up there. She

[91] Fox, Elaine. *Emotion Science*. P27. Palgrave Macmillan. New York. 2008.

[92] Kernis, M. H., Grannemann, B. D., & Barclay, L. C. (1989). Stability and level of self-esteem as predictors of anger arousal and hostility. Journal of Personality and Social Psychology, 56, 1013–1022.

was with a friend and came to buy something at the bakery. When I saw her, I hid until she left. She was a simple person, and she would never show off like she was better than anyone else. But because she had a good life financially, studied, was still married, had her own house, and didn't need to work, I felt ashamed to be in the situation I found myself in after these years living here. I was jealous of her for being well while I was miserable. It's not that I wanted her life and what she had, but she was way above me, as far as I was concerned at the time.

Third: I thought about the possibility of returning to my country, but my older children didn't accept it. It was necessary to think about my youngest son, about the opportunities he had here and the ones he wouldn't have in Brazil.

Seventh: I prayed a lot and constantly read the Bible. I listened to worship music that soothed me and gave me peace at that stage. At this time, there was an episode in which a very close and very loved friend disappeared. For about five months, she didn't call or text. After I got through this period, I called her and pleaded to for her to return. I asked why she had disappeared in this sad time of my life. She replied, "I can't stand to see you cry so much, and you look crazy with the Bible in your hand and talking about God all the time." But thank God, He always raises someone to the time of despair, and it won't always be the same person. On the other hand, another friend who is also very dear lent me her ear. Even with small children to take care of, she attended to me almost every day for years.

Eighth: I couldn't find any of the remedies I was referred to until I gave up looking. I had to stop screaming in pain in my room, as my youngest son suffered a lot when he saw me cry. My grief for my failures was long lived. It took years before he came to seek comfort from me. And by tempting his friend, he renewed my hopes of rekindling a marriage that never worked. When you're not cured, it's better to stay away from what could possibly cause you to relapse.

Ninth: I took God's promises seriously—that He is Yahweh Raph'eka,[93] and there is no pain and illness that He does not heal. I took therapy seriously, going once a week, following the recommendations. I continued to struggle to get out of the deep well I had been sinking into. In the beginning, I told everything I did to my "friends" because, like all co-dependents, I looked for approval.

"This means that people whose self-esteem is more contingent are likely to only feel good when they receive approval, praise or success in terms of social standards, or objective goals,"[94] according to Deci and Ryan. I counted to show my evolution, and some said that I only needed God. For the other, the therapy didn't feel right. It's hard for me to discover that therapy is a secret. After two years of my therapy, some people saw changes in me, came to me asking about the therapist, and even went a few times. But maybe they didn't need it like me, and that's why they didn't proceed. It is challenging to **admit that**

[93] Jehovah Rapha - I am the Lord who heals.

[94] Deci, E. L., & Ryan, R. M. (1995). Human autonomy: The basis for true self-esteem. In M. H. Kernis (Ed.), Efficacy, agency, and self-esteem (pp. 31–49). New York, NY: Plenum Press.

you are sick, but this is the first step. This is the worst part of the healing process, but it is essential. It is easier to hide from others and yourself when you have an emotional disturbance. Seeking healing takes a lot of work. You expose yourself to people. They judge you and are sometimes even sicker than you. But by not admitting it, they will remain sick.

The second step is recognizing that you need to be healed and want to be healed. If I don't want it, not even God will make it happen. Committing every week, driving for almost an hour, paying to be "criticized and with your mistakes pointed out" is a confrontation to recognize the need to change. Besides, what would I be if my God wasn't always watching over me? How beautiful He was and is with me. He also pointed out to me where I should improve to be a little like Him. Because of Him, I've had the biggest inspiration of my life, Joy.

Tenth: I had a time of silence, a time when a lot of people had to turn their backs on me—not because they were bad friends, but because God Himself allowed them to walk away from me. As a codependent, I needed to feel secure in myself. I needed my company and to get to know myself. Unfortunately, I didn't know who I was or what I could do. I needed to depend on myself and God. As bad as it seems, my experiences at this time were accurate for my healing process. In this part, I have three episodes: A, B, and C:

Episode A: a friend of many years made me an excellent offer. She worked for many years in a business with a lady, and that lady wanted to work less and have time for her family, so she offered my friend the whole half of the company. My friend thought of us working together. The only money I had was a little less than two thousand dollars, and I had my car to help her with because she didn't drive, and it was necessary to drive to clean houses and work. However, my friend disappeared for a while and never talked about it again, but I heard from another friend that she was driving, and then she showed up at my place with her new car. I was pleased that she started to be more independent. And after a few more months, I learned that her boss had given her half the job and not sold the company. So, she finally decided to learn to drive, bought her car, and went to work alone. I never mentioned the subject. I confess that I was outraged by her attitude at the time; moreover, I know it was necessary. It was God Himself who did not allow it. If it had worked, you wouldn't be reading this book today. I understood that it was my time alone and that I only needed God and myself, and that He made a point of teaching me that. Looking at my entire process, I remember a part of the Bible where Abraham didn't accept help from the king of Sodom because he just wanted to be dependent on God: "And I swear I won't keep anything that's yours, not a thread or a sandal strap, so you'll never complain: 'Abram got rich at my expense!'"[95] At this time, I needed to know my strength, heal myself from any human dependence, and be dependent only on the Divine.

Episode B: Another friend I called to pray with, cry with, and complain about my misery, often cut me off and said, "I'll call you later, my husband is calling me," and it would take days before I called again. Once I called several times, and when she didn't

[95] Genesis 14:23. Updated King James Bible.

answer, it seemed like I heard a voice saying, "Leave her alone!" But I ignored the voice and kept calling. Then she answered and said to me very angrily, "You have nothing to do, don't you? Look for something to do." It was hard to hear this and continue to love my friend. I know God wanted me to know myself and lean on myself and Him alone.

Episode C: God has time to put us in certain places, and for a while, we learn, and then he takes us elsewhere, just as the people of Israel had to wait in Egypt for four hundred years until the wickedness of the Amorites reached the limit of evil, and God with all his patience decided to fix them, vacating the land: "After four generations, your descendants will return to these lands; for I will not drive out the Amorites until they become so evil that they deserve to be severely punished."[96]

Sometimes we stay at one stage until the other is ready to be handed over to us. These things that happened before I went to the salon I work at now are prepared for me. Someone offered me a space in another hall for rent. I had no products, let alone a customer and money to pay rent. Cecilia, a lady from my church, went with me to buy hair products; she paid for her stuff and mine when we were at the register. She said that she had already had a similar situation and some people helped her, and she wanted to do the same for me. It turned out that I didn't even need it, and I offered to return the money to her, which was around one hundred and twenty dollars, but she didn't accept. Later, she turned out to be a dear friend; she also edited the Portuguese version of *White Dresses* and edited the speech on the launch of this book. Another friend from my hometown, named Cecilia, offered to lend me the rent at the salon, and then I would return the money to her. It didn't work out to rent the space, so I didn't have to take her money. After I trusted my God, I went through horrible financial straits, but I never had to borrow. I even had no electricity for two days because I couldn't pay the bill, but then I made a payment plan, and they turned it back on. Luckily it was spring, and it wasn't cold anymore.

From above, learning to love myself was a highly complex job because, in my humiliations begging to reconsider marriage, I heard repeatedly, "You don't have self-love, do you?" The truth is, no! I love everyone, even my dog, except myself. I had to learn that, and it started when I met Joy. Self-esteem is at the center of self-love. Unfortunately for me, I had never known either of these two things. But when I saw my resemblance to Joy, I started getting to know myself and liking myself a little bit.

Eleventh: for the first time, someone told me without knowing me that I was called to introduce God to those who don't know Him, to talk about Him and show what he did in my life. And this time, it was spoken through a prophet, so I believed it and began to prepare myself. Then, confirmations started through many people when and where I didn't expect it. So, I asked God for three things.

The first thing I asked for was braces to fix two spaces in my front teeth. This bothered me my entire life. I once heard, "You need to get those teeth fixed because Halloween isn't every day." That unfortunate comment made me stop smiling for years. I hated smiling;

[96] Genesis 15:13 Updated King James Bible.

my photographs were without a smile. If possible, I would put my hand up to cover my mouth. The problem was that I couldn't pay or make a down payment, so I bargained with God. God blessed me, and I made more money; it seems minor, but it was a miracle at this stage of my life. For some reason, the payments got smaller, and at the worst financial time of my life, I could pay for my treatment.

The world is constantly changing: everything we knew yesterday becomes obsolete today, everything evolves very quickly, and every minute there's a new thing to learn. I'm not just talking about the evolution of fashion, health, computing, or even the weather, but about the most crucial person in our lives: ourselves. We keep wanting things, and when we get something, we already have another item on our wish list. These are material things and changes that we want in our life as a person. We already know that we need to step forward to change our lives. We are being pressured by life or by the surprise option, which is when everything goes wrong.

The second thing I asked was to learn to speak about God and study and get to know Him. First, I couldn't afford a seminar. The seminar I had in mind was a four-year bachelor's degree. Classes were on Saturday, and as a hairdresser, I couldn't attend them. A month later, they opened a class on Monday and Tuesday nights, and I had the time to go, but as far as the payment was concerned, if you asked how I paid for the seminar, my answer is yhaweh-yi'eh.[97]

The third thing I asked for was a different romantic ministry that spoke of him as he is to me, my loved one, my husband, my father, my friend. I wanted to have things for me to present, something like singing with that cracked bamboo voice of mine. Maybe He would do something about my voice, and in no time, I would appear there singing like Shakira. I wanted something different to draw the attention of many to what He did to me. And then it happened two months later. I was raised not just to be a mother and wife, but to talk about the kingdom my father has prepared for us all.

The real

With all this process, I started to have a purpose, to prepare for my calling by studying and working. I used to use the expression, "I lost my family!" My family has always been my children, and I never lost them. Another thing I loved was to show how unhappy I was, maybe so that people would come pray for me or lick my wounds from the life I thought I shouldn't miss. People ran away from me, and I thought people liked to hear crying. Nobody has the time and patience for this—maybe a month, but if nothing changes, people start talking about their boredom. I was the talk of the moment, the ridiculous crybaby. I became an example in my community of eternal sufferers. Nobody wants to hear problems for free.

[97] Jehovah Jireh - You will provide

Currently, I was in therapy with the person I call God's compass on my path, Pastor Iracema. After I had stopped therapy, I met her cousin through a friend of mine. Pastor Angela from Brasília listened to me very patiently and scolded me when necessary. She does a beautiful job of counseling women torn apart by their losses. Pastor Angela wasn't a person to ask for prayers, because I prayed. She was not a person to go to therapy with, because I had my therapist and my art that helped me with my emotional healing. She was a friend and a helper, someone who saw in me what I still cannot see. She went through a process of pain, and everything was restored to her life in all areas. As people were close to denying listening to me, because they were tired of my lamentations, she was steadfast.

Another person I can never forget in this process was Pastor Jacinta, also in Brasília, whom I met through Angela. She was a wise woman who understood pain and how to get over it. She always encouraged me to stock up on everything God gave me for inspiration. She wished that all my ideas be carefully executed and that I would never be invincible to my dreams. Through Angela, I met a doctor in education, Nilma, who has been walking beside me and diagramming my books. During this period, I also met Pastor Flávia, who never let go of my hand, even on days when she didn't believe I could be cured. Nobody can stand people who are never well, and many people ran from my presence because it seemed that I was repeating an insane move. He always returned to the same place and kept showing others how much it hurt. I looked more like a child who got hurt and wanted to show the injury to everyone she met. I sadly learned that I was the mockery at the time; they talked about my crying, my self-pity.

My self-pity wanted to draw attention to a pain I thought would kill me. But that was all good; it was a confrontation for me to change. I no longer wanted to be a mockery in my community. I wanted to be remembered as a strong person who survived it all. I wanted to be like Joy, but she wasn't there yet. For those who don't have friends like I had who also helped me spiritually, you will certainly have special friends to help with during your difficult period. Also, you will have the ones who will walk away from you—the sanctimonious, super-spiritual people who say that all you need is to be like them. People know everything when they have everything better than anyone else. The best news is that in time, there is always someone who will make you cross the bridge out of nowhere or will be a bridge—like Joy was for me. If you who are reading don't have a spiritual side to hold on like I had, just hold onto all that is good, like children or direct family members in general. These people love you and suffer to see you suffer as I did.

I also had longtime friends like Ivonilde, who never stopped lending her ear and always listened to me when some didn't even answer my phone calls anymore. I also had Cecilia and Gislaine. Some had more patience than the others, like Iva and my dearest cousin Renata, who lent their ears although they could no longer see me in the same way. In a spiritual view, God used people to train me, putting them closer or further way depending on the circumstances of my needs. People are powders that connect us to steps, each in their own time. And at this time, I needed Joy, and soon she came. However, I needed to be isolated from many people for her to play her redeeming role. I came to understand that not all loss is loss, and not all gain is profit. The land must be cleaned, cared for, and

rested to plant something new. If the land is dirty, neglected, and not rested, it will lose the plantation.

This reminds me of a fable I presented to my themed painting group. I found an old Chinese fable of unknown authorship, and it tells the story of two monks, one very wise and the other an apprentice, who passed through an impoverished place where a family lived. This family had a cow that was their main source of food. In the short time they remained there, the monks were treated very well. The poor family had shared with them what little they had. The eldest monk told the apprentice that he should do as he asked without question.

This family consisted of a couple and three children. They were poorly dressed and clearly in need. The eldest monk then asked the man what they did to survive. As the monk expected, the poor man replied that they had a cow that, despite being skinny, provided the necessary sustenance to go on with their lives. The monk thanked him and said goodbye to the family. As they left the house, the wisest monk told the apprentice, "Take the cow and throw it off the cliff." The apprentice opened his eyes wide and tried to reiterate that the cow was the only means of survival for that humble family. However, upon noticing the master's gaze, he complied with the order, disapproving of the action.

After a few years, the younger monk passed with his apprentice near that site. He was curious and decided to see what happened to the family. Once there, he noticed flowers blooming in the garden several animals, including several cows. Upon entering the house, he realized that everything had changed, but it was the same family. So, he asked, "What happened?"

The father of the family replied, "After you left a few years ago, our cow fell off the cliff and died. We thought it would be the end of the world, but we had to adapt and discover skills and competencies that we didn't know in ourselves. That accident forced us to look for opportunities and new sources of income that we hadn't thought of while we were satisfied with the cow. After my cow died, I had to reinvent myself. And the person I was, was not quite what I wanted to be." "Human beings are addicted to suffering at different levels and to different degrees, and we support each other in maintaining these addictions,"[98] said Don Miguel Ruiz.

Before the cow, I lived like a leaf in the wind. But the cow's death made me see that I was alive. And I didn't want to live as I did for forty-one years. When I met Joy, I noticed that she lived with the promise in the Bible: life in abundance. And I wanted to live that promise. I never had an abundant life. I had to listen to Joy confronting me to see where she found me. She always repeated: "A life of emptiness and trauma is not a life of abundance. A life of codependency is not a life of abundance. A life without self-esteem is not a life of abundance."

[98] Don Miguel Ruiz, MD. *The Four Agreements. Breaking old agreements p57*. Amber-Allen Publishing Inc. San Rafael CA. 1997.

"You really need to be born again!" Joy said. And I needed to put a stop to everything I had lived to reach this life. I was fighting with my "poor me" mindset tirelessly every day. Self-pity left me trapped; I wanted to escape.

In my church, there was a girl who inspired me, Dani. I never saw her sad; she was always smiling, and every time she arrived, there was a party with her. I envied having that joy. I told God that when I grew up, I wanted to be like her. I started to smile more after I got braces put on. I began to have a little more self-esteem with the braces on my teeth. And above all, I felt better knowing that I was special, that my God chose me for an important job, and that He did his part when it came to my bargains. He gave me all. However, each situation that we face to win, changes happen, and we cannot achieve what we so much desire. It doesn't work to advance to a new goal in life; at least it will make a difference in how you view the experience. If the trial experience is not successful on the first attempt, it will be helpful, but it will either make us stronger and specialists in retrying or make us a block in a shell, crying out for our failure.

Thomas Crum wrote, "Be willing to change. If we are unwilling to change, we find ourselves stuck in patterned reactions that we use repeatedly, even though the situation may change drastically."[99] His statement is a reality; I am very afraid of change, and many people I know are also afflicted by the same evil as me. On most occasions in my life, I have been forced to experience drastic change. The turn is one hundred and eighty degrees, it never moves just a little, but it comes like a hurricane and then leaves everything upside down. The key to change the echo we no longer want to hear has always been in our hands. The key to opening the door to a new life sometimes doesn't work because it has been rusted by the waiting time, and the door no longer opens. We must try another way until someone can open it, even if it's by force. It is necessary to recognize our own weaknesses and decide to do something to fix them. Stop going around in circles repeating things that don't make us grow. Put a stop to our mistakes when we can see them. Many times, I looked in the mirror and hurt myself with adjectives that diminished me as a person. But what the mirror revealed to me was not the absolute truth about me. What the mirror showed me was not what my God saw of me. I wanted to look in the mirror and see the greatness of what God created to grow, win, and never stop except for Himself. I wanted to believe that what He made is good—actually, **"very good,"** as He said Himself.

When you know which is the right way to go, you'll never go around in circles.

[99] Crum, Thomas F." *Be willing to change*. "The Magic of Conflict." p168. Touchstone. NewYork. 1988

Between a comb and scissors
Cutting hair, creating poems.
Describing pain, dreams, dilemmas.
Turning aversions into sweet themes.
Between razors and scissors, solving problems.

With pen and paper emptying the mind.
Turning wounds into permanent art.
Writing rhymes between scissors and comb,
from a suffering heart to a contented soul.

I was studying, writing, learning a little.
Coming out of a hole, towards the top...
In space of time, between hair color and haircut.

As a hairdresser, I was healing as a painter.
As a painter, I turned into a writer.
I am now risking being a poet between a comb and scissors.

Chapter 13
Between a comb and scissors

The decision is a battle between the comfort of the known and the discomfort of change.

Between one haircut and another

My passion for working in the beauty area, especially hair, dates to when I was very young, when I cut my hair against my scalp, on top of my bangs. I hid from my grandmother, but when she found out, she told me that I would never cut my hair again. One week later, my cousin Mirela came to visit us, and I cut her hair. My grandmother despaired because my cousin's mother was the oddest person I have ever seen in my four decades of life. My grandmother covered up for me; my cousin's mother never dreamed that I had done it, no one noticed, and it was our secret. I got beaten up again, and my grandmother asked me why I disobeyed. No, I hadn't disobeyed her order, because she had told me not to cut "my" hair. She hadn't said anything about my cousin's.

When I was fifteen years old, I started cutting my hair, my cousins' hair, and sometimes my children's hair, and so it went on. I went through many salons. I learned from many people. I invested in my hairdressing career, attending many classes on cuts, makeup, and coloring, getting expensive scissors, and learning how use razors for dry haircuts. I participated in numerous seminars in different states in the United States, preparing for good opportunities. An opportunity arose to rent a lounge chair in the town of Framingham, and shortly thereafter, I was offered a position in another salon of the same owner where I rented a chair, but in another location, in the city of Ashland. This salon was very far from where I lived, and I would stay out very late with an eleven-year-old and a teenager alone at home. I stayed there until the day I got a call from the beauty salon owner in Waltham. I forgot a copy of my license on the board in the old hall in Ashland. After a year, I went back there to buy a skincare product from an aesthetician working there. I was leaving when I looked on the salon's wall and saw my name in one of the cosmetology licenses. They kept my license displayed with the other professionals at the place.

I realized that they were using my license for another hairdresser. I imagine that it was convenient for them because some Brazilian salons have a hard time finding people with cosmetology licenses to work, as those who get them end up looking for a better position. I decided to not mention it, and they didn't even bother to let me know or take it away since I no longer worked for them. During this period, I was numb in the middle of so much annoyance and pain that when things like this happened, I would go through them like jumping over holes in a video game.

While I worked at the salon in Waltham, I took advantage of the opportunities that were presented to me. There was a lot of work doing makeup on brides in hotels through the salon I worked with. This salon was a great learning experience in this part of my life. I am so grateful to the owner for having been half of my livelihood for nearly five years. May God tremendously bless this lady for the opportunity to have worked for her. I believed the salon was always my dream; however, God had other plans for my life. I could live what I wanted while preparing to live what God dreamt for me.

I wrote my first book, *Nothing is Impossible*, between one haircut and another. I wrote it when I was still fighting; when I was learning to float, it was the impossible thing I could do. When there was a space between clients, I wrote *"Be Thankful."* I wrote this book around the time I discovered that I was the most ungrateful person I knew. My low self-esteem and self-pity did not let me see how much I had to be grateful for. Because I wanted so many things that I didn't have yet, I was ungrateful for not having them. Nothing pleased me because I wanted to live in the future, longing for what had not yet arrived. In this, I lost the beauty of my gift and was always grumpy with my ingratitude.

One day, I woke up from a dream where I lost my children in a hideous place and couldn't find them, and I realized how rich I was. I must wait to live the fullness of each awakening and not live waiting for what is yet to come. This thought made me paint the images in the book and, after a long time, inspired me to develop the text. During one of these paintings, I heard a song inside my mind that said God was telling me that when I was grateful for what He had given me, He would see that I was ready to receive what I so asked for. So, I started to see everything with different eyes.

Resilience

I would write and draw what I felt while waiting for hair dye to set in. I wasn't the best at speaking; instead, I put it on paper in writing and drawing. I created many ideas from paintings, poems, reflections, sermons, and sayings in the intervals between one client and another. I developed other books, such as *White Dresses*. First, I drew the main idea between my clients' appointments; after work, I worked on the painting in my house, followed by the text. My clients loved to hear about my books and see my latest artwork. *White Dresses'* message about codependency is not to lose focus on good things. That could hold you back from getting something even better.

At this point, I was in complete peace, as Joy was already walking with me. I was enjoying it so much that I started to relax. I began to allow some people who shouldn't be

getting close to me into my life. Letting down my guard with Joy made me create a dome and then a boundary system. I started to give up on things that made me complicated. The message fell on me like a cold shower. When something is delicious, I want to enjoy it, and sometimes what's good ends up taking me away from the purpose I was called to in the first place. He sighed, analyzed, decided, and made it happen! Stopping can happen as life goes by quickly, but what am I leaving behind me? To make things happen, I must act, not just yearn for them. There comes a time when I must put it into practice or spend my whole life dreaming without knowing what could have been. As absurd as it may seem, your dream is worth trying to fulfill. Mine was being a hairdresser, and what I live today are God's dreams for me. Between one cut and another, I often cried in the hallway bathroom, hiding my bitterness. In my salon time, I lived in my cocoon. It is inside the cocoon's mind that challenges occur. The cocoon is tight and sparse. In the cocoon, you must reinvent yourself.

We spend a lifetime undergoing changes and improving our knowledge. We often ask, why so much learning? Will I ever use this? Everything we absorb into our life will have a purpose at some point. Many of us go through more suffering and struggles, and when the best time comes, it goes by so quickly. A butterfly undergoes several drastic changes between when it is an egg until its glamor phase, which is its time to shine and live what it has spent its entire life preparing for. Before this beautiful phase, the butterfly spends most of its life as a caterpillar, preparing itself for transformation. The caterpillar's lifespan lasts from one to eight months, depending on the species. This time, no one sees it, it goes unnoticed, and it does not attract attention. However, it continues to work for its confinement inside the cocoon, possibly from one to four weeks. After the transformation it has been preparing for most of its life, the butterfly will live from one day to nine months. The less cocoon time, the less time of life it has to take advantage of the cycle of its descendants. The sacrifice is substantial until complete metamorphosis. That's why this time must be enjoyed: to make all the waiting time worth it. The transformation goes through a stage of learning and preparation, keeping unnoticed the beauty that will reveal itself.

According to Elaine Fox, "We are often much more resilient than we think, it's a key fact that has emerged is that there are significant individual differences in the way people respond to stress."[100] Like the difficult phases of metamorphosis, life is very adverse. Confronted with situations that seem impossible to overcome, the shock tends to stop us. But the vast majority of people, like me, develop immunity rather than disease. I suffer like everyone else, but instead of prostrating indefinitely, I grieve the loss and then go on to fight.

To transform into a butterfly, you must be strong. I was a caterpillar for forty years. I didn't choose much because I felt that the little people offered me was what I deserved. When I was a caterpillar, I accumulated all the emotional fat. I became big on unloving and fat in my miserable comfort zone. My soul ate what it saw, and it was full of what hurt me. When I met Joy, I had to stop being a caterpillar. I couldn't be the same after meeting

[100] Fox Elaine. Emotion Science. P. 309. Palgrave Macmillan. New York. 2008.

her. Only a beautiful God like mine could bring me a person like Joy. I couldn't meet Joy and still be a caterpillar, because she is a beautiful butterfly, and caterpillars don't follow butterflies because they can't fly.

How could you meet a butterfly like Joy and not be inspired by her, or not stop to listen if her voice conveys security? I had to change. The butterfly is a great analogy about resilience. It grows and eats to be trapped in a cocoon. Tight without eating, just quietly waiting and waiting. Many die inside the cocoon. Others are so comfortable that they no longer want to leave the cocoon. The resilient ones learn inside the cocoon. And when they emerge, there is no one left for them. The butterfly gets to know itself while it is still in the cocoon. Its strength is measured by everything that cannot kill it. Resilient people who are like butterflies surprise everyone. Shortly after its worst moment, when it should have been down, it flies away. It was almost destroyed, but because of the cocoon, it still has life. It takes advantage of how it must live and transforms this stage into the best time of its life from this time forward, forgetting the evil that will come and improving. It does not become bitter; it leaves the past in the past and shines in what is to come. It will live better than it has ever lived before, as it now knows how important it is to have the opportunity to start over after the cocoon.

The butterfly solves what she has a solution for and says, "Patience, that's what it is!" for the unresolved. The butterfly is you and me! I cannot afford to be bumped in the ground. I wish we were like cats who fell on their feet. The reality is different: I fall apart with the falls of life, and then I go to the cocoon and transform myself so that I don't die inside of it. When everything was at a standstill during the pandemic, I was planning for one possible opportunity: I will have to go through it. Being alive, I must enjoy the sweetness of the transformation and be grateful that I went through it and didn't stay in it.

"A person who hasn't fallen so deep in a crisis suffers less. But they often don't experience positive things with the same emotional depth either,"[101] said Christina Berndt. The moment they manage to get out of the crisis, this person will see everything with different eyes. If another crisis comes to ravage the maturity of having overcome it, they will see the positive in chaos. Priorities are changed, and things that were important before didn't mean much after a post-crisis transformation. They reflect more, knowing that life becomes more enriched with new possibilities.

When the rug was pulled out from under my feet, it not only took the rug off the floor, but it showed me what's under it. What was hidden under the rug was rubbish for years. Once I accumulate lots of garbage, I either get used to it and live in pain for the rest of my life or clean it. A caterpillar can be in the trash, but a butterfly will be intricate. When something like this happens, it's two extremes. It either kills you or makes you stronger. This killing is not always disincarnating—stamping your boots, stretching your shins, having your mouth full of worms. Dying is conforming to what the world has given you and not dreaming of a better life. Dying is having a disgraceful life and tolerating it until

[101] Christina Berndt. Resilience the secret of psychic strength. P. 89. Editoravoz.Petrópolis-RJ. 2018.

the last day of it. Death is discovering that I am codependent and accepting it by masquerading as strong. Death is burying my dreams for not having the courage to try to achieve them. Death is spending a lifetime waiting for God to do the things I can do.

The other extreme is being resilient. My theology professor, Oliveira Wellington, said, "A resilient person does not look at the process, but at the proposal,"[102] in his preaching about resilience. The preaching is based on the book of Hebrews, where it speaks of the resilience of Jesus enduring everything he endured. Because of the proposal of what he would receive, he endured his martyrdom. He pointed out that what most intrigues the life of a resilient person is their way of seeing. She has a different view of failure. Failure for the resilient is learning. The interpretation of defeat is totally directed towards the proposal. The process of change is painful, but it can stop. But the proposal makes you move forward, taking your eyes off what you're experiencing. The second greatest pain is that of childbirth, followed by death from burns. The woman ready to give birth does not look to the pain, but to the joy of having her child. "To be resilient, you have to take your eyes off the process and look at the result."

As a resilient person, I look forward to quiet time as a time to regroup. The time of failure is the time of silence, not of whining. Life is a war, and battles are fought day by day. The difference between war and battle seemed very confusing to me. I used to use the two words interchangeably. Battles are between soldiers, while war is between countries or nations. Battles can be won or lost, but they cannot determine the end of the war. Battles are usually short-term, while wars are long. If we live, we are at war, and each day is a new battle. We often lose the battle, but the war continues in the courtyard. The time of failure in battle makes the resilient person more prepared for war. In my time of several lost battles, my friend Michelle Pezente told me something that I treasured with love: "You lost a soldier, but not the war." We were in a pool with the kids, and I was whining about my failure. In our war, we will lose many soldiers and supporters. Some will disinherit and abandon us amid chaos. But the war is mine. It depends exclusively on me. I must regroup in every defeat and strengthen myself, hoping to win in the end. I must use my flaws to overcome the weakness that made me fall, or delete traitors and every distraction from the target. I must make lists and worksheets with priorities to follow. Experience in battles makes the best soldiers. Resilient soldiers stay alive and come back stronger. Some soldiers surrender, and others die from the wounds of battles. The one who survives must learn from the fiascos in some battles in order to win the war.

Her name was resilience

Speaking of resilience, I could never just refer to my own example. I have met many people who have worthily earned this title throughout my forty-seven years of life. My mother recently turned sixty-six and is the benchmark of the most resilient person I have ever met. Much more than me, she suffered disagreements and, like a cat, fell on her feet.

[102] Welignton Oliveira, Ph.D. Reverend Focus on Results, Resilience. Vol.1 www.bit.ly/PrwelingtonoliveiraYt. Framigham, Ma. Nov 2019.

At nineteen, armed with envy and malice, she had to leave her two-month-old daughter. She was separating from her love and the blessing of the fruit of her womb. She was surrendering this baby's life and ways to the God of her parents and letting God Himself bring them together. A set trap followed a path, and my mother was thinking about what was best. She was helpless and hurt for having left a piece of herself behind. Four years later, she felt that time might still let her fight back. However, my poor mother lost in court. She always came back hoping to gather her leftover piece. Falling other times, she became pregnant and had another loss. This time it was an abortion, as there was instability in her relationship with the father of her first daughter. Years later, she was able to find a new love and conceived two daughters. This was filling a massive chunk in the big hole she had in her heart. It also allowed her to close a book that was a story of pain.

This was very good for her, an adult; however, the girl could not see it the same way, becoming a teenager full of anger at the misunderstanding and the pain that life had imposed on two destinies on two sides. Then came the grandchildren that she couldn't pamper. And when she had the opportunity, she didn't do it, either. The distance created an abyss. The God of her parents, now your God, and of her daughter gave a new opportunity to reconnect. They were mature enough to forgive and bless each other if they could find each other again. Well, the story was much sadder and deeper. I will remember a queen as a symbol of resilience. I will keep this part of history. This is my inheritance. I'm already healed; the true version couldn't hurt me anymore and won't change anything. Weekly or monthly, my mother and I talked for hours and saw each other on camera until she went home. She left a legacy of wisdom, a love of writing, a passion for gardening, traveling, and faith, and a devotion to God. She never surrendered to any misfortune. She was constantly adapting and learning to heal wounds by force, as she didn't allow herself to bleed.

Her last years were ones of joy and gratitude for having seen a beautiful ending in a story of a lot of struggle and multiple victories, but it was a story of excellent weight worthy of a queen. This vassal queen returned to the Overlord King's house on Easter 2021. One day I will meet her there. However, she moaned for her fallen pieces without stopping to look at what was lost along the way. What could be acquired while she went on? Her resilience made her a happy person. And who is a happy person?

Happy is the one who accomplishes most of their bucket list. Happy is the one who can have enough time in this life to plant a tree, and write at least one book or poem, even if it's about pain. Happy is he who has had a child, and happier is one who raises them well. Happy is the one who settles scores with the past. Happy is being forgiven and asking for forgiveness for your immaturities and poor choices. Happy are those who have given their mistakes an opportunity to be corrected. Happy are those who live and grow old. And happier are those who see their children having children and their grandchildren growing up. Happy is the one who can achieve wisdom, can share it and is able to regroup with their wreckage, see what's left, and from there continue a one-way hand with no option to return. Happy are those who take the weight of hurts off their shoulders, writing a story in a clean notebook. They are happy that the lightness can give pardon. Happy are those

who start peace in their own family and spread it throughout the world, not making personal the revolt and misfortunes of others. Happy are those who do not serve God only at the altar. Happy are those who can love a neighbor, even if they dropped puppies at their door. Happy are those whose testimony of their lives speaks more than words and, on the contrary, is noticed in everything they do. Happy are those who hope in God and can reach with a faithfulness that may be full in us. I guess the queen of resilience was happy; I'm happy, are you?

While we live, we are at war, and each day is a new battle in which the resilient one does not surrender.

Chapter 14
The gift

The greatest gift offered by life is being able to dream, and it is the most beautiful thing to do.

The gift of art

Art has the power to go beyond our physical capabilities. In synchrony with the subconscious, art expresses what consciously would be impossible to describe. The unconscious synergy in an art project makes the unknown possible. Art, with its delicacy, brings out the best and the worst of me and exposes me without causing pain. He was giving possibilities to clarify what cannot be said but is expressed through art. Many years ago, Carl Jung discovered that imagination and creativity were ways to help us heal. His descriptions of it brought us very close to the possibility of art as therapy as we know it today. Although not mentioned in his work, he made explicit references to art and healing as his preferred psychotherapy methods. He continued to use it as a basis for treatments throughout his career. Influencing future generations by recognizing art as therapy and healing, his attention went beyond images, extending to movements and the poetic process of personifying ideas. Thus, he was one of the pioneers of art as therapy as we know it today, just as Freud had much of his work reflected in analyzing dreams. However, Jung was the basis of the creative process for understanding patients and their therapeutic methods.

Emotions in art are like a giant magnet. Without us realizing what the soul hides, it can be revealed through numerous art forms, such as dance, painting, sculpture, music, drawings, poetry, and so on. For three years, without knowing anything about art, I was treated and cured by one painting.

According to Alain Botton and John Armstrong, "Art is a resource that can lead us back to a more accurate assessment of what is valuable, working against a habit and inviting us to recalibrate what we admire about love."[103] The painting took me out of the shadows

[103] Botton, Alain. Armstrong, John. *Art as Therapy*. P. 5. Phaidon Press Limited. London NI 9PA. 2013.

and gave me identity. It made me look inside myself and analyze what should be balanced. I could only bring what I had inside my personal shadow by flowing through the painting as if I spilled onto the screen. I didn't understand what was happening. I didn't know the power of art as a cure. However, it happened to me.

In this period, which I now have much more understanding of, I surrendered. Everything I did was an essential tool for healing my wounded soul. During the worst time of my life, I needed a refuge to ease my pain, and I found myself in my brushstrokes. I wasn't inspired by artists or friends, nor did I get tips from anyone. I never had this artistic inclination to organize in my original form. I was created to be what I am today, but it was hidden and surfaced in my dark moments to give light to my life. In every chapter of this book, I present what I experienced before I even knew I was on the right path. When big things started to happen, I had to understand what I was going through in my lack of preparation. I reported when I had to that I was emotionally ill and at the beginning of traumas; after this discovery, I reported what I did to be healed and what happened after being cured. This was strongly structured in my encounter with Joy, a unique person and a crucial supporter of art, healing, and evolution in my life. People who knew me before Joy came into my life do not recognize me for these emotional and spiritual reasons. Those who knew me before this process may have noticed my evolution, but only Joy has the credit. Clearly, my willpower and the God I believe in were the center of it all. Without Him, Joy would never have come to me. Art wasn't just a healing channel, but a compass directing my transformation.

According to Michael Samuels and Mary Rockwood, "Art and healing lighten the spirit…art heals, promoting spiritual experience. The story of your spiritual journey will help make your own light brighter. Your spiritual journey is your life's work."[104] When it connects with art, we elevate it to an imaginable level of peace. The whole process related to my learning, with painting connecting me more with myself. My pains and fears are being exposed, being with myself. In a way, that didn't hurt, but it confronted me. It successively connected me more with my spirituality, as my artistic awakening came from it. I started to study the importance of all the events I was experiencing in relation to art as a healing tool. I was ignorant about this subject, but because I was feeling relief in my soul, I clung tooth and nail to this gift to get out of a terrible sea of mud. Without knowing it, I was entangled in many methods recommended by many professionals as tools for psychological help. As an extension of myself, the artistic side was like an instrument that my unconscious found as a bridge to help me. Certainly, psychology and neuroscience would say that it was all my psychics who strongly projected my artistic side during the crisis to save me. My subconscious brought the help I needed in my original form, agreeing with my temperament. My hidden artistic side was boosted by my unconscious self and brought out at the necessary moment.

[104] Samuels, Michael, MD. Rockwood, Mary Lane Ph.D., RN. *Healing with the Arts*. P41. Beyond Words. Hillsboro, Oregon. 2013.

That's the most rational way to explain what happened to me. It's not that I painted and wrote and stopped, and in a moment of crisis, I took refuge. I didn't know anything about painting! I learned from scratch. What really happened to me cannot be explained naturally. I was gifted by God with an uncontrollable desire to paint. He made me an artist, although my talent was hidden for many years. Even without a trace, the creator knew the time to come out. It gave me the uncontrollable desire to paint and to interpret my dreams as a message of encouragement to my sick soul. I painted everything I could remember of my dreams, both good and bad. After the painting was done, I could better understand what my mind wanted to reveal about myself. With a purpose greater than just painting, He gave me painting to heal me and change my life. The change was such that I barely recognized myself.

People who knew me before can't recognize me, either. The change was drastic, both in the speed it happened and in the surprising way that I became an artist and author. My view is clear regarding science. Five years ago, intrigued by what I received through art, I started researching what happened to me. I came to understand the role of art for emotionally shaken people like myself. According to Elinor Ulman and Penny Dachinger, "Therefore art has a special value in treating the mentally ill, but on their own, they cannot repair severely damaged sublimation capacities."[105]

In psychology, sublimation is a mature type of defense mechanism that can result in a long-term conversion of the initial impulse. The psychoanalytic theory of its founder, Freud, defined sublimation as a process by which negative impulses and behaviors are directed towards more socially acceptable behaviors. In medicine, it can be the act, process, or an instance of sublimating a chemical. It can also be the process of converting and expressing primitive instinctual urges into a form that is socially or culturally acceptable. Examples of sublimation are channeling inappropriate impulses into positive behaviors such as exercise, therapy, or other physical activities. Sublimation is the replacement of evil that starts with good distractions. This moderates the impulses or even extinguishes them. Sublimation with the help of art is an emotional purification. Assisting precisely with the other methods according to the seriousness of each case, however, any type of art is an indispensable tool. Obviously, therapy and my faith in my God played a big part. Without this partnership, as I've mentioned in other parts of this book, I wouldn't have such an achievement.

Without a clue of what I was doing, I continued to follow this path and induced several openings toward the artistic way. I know who persuaded me to make even a misunderstanding on the subject: Joy and God. I was now understanding more about this whole subject and being able to give credit to science by referring to the magnitude of my unconscious. Even so, my faith is greater, giving certainty that what I experienced was a gift from my God to transform my life. I am convinced that art as a cure worked in practice.

[105] Ulman, Elionor. Dachinger, Penny. *Art Therapy in Theory and Practice*. P. 4. Schooler Books. New York. 1975.

I decided to go back to college to learn the theory of what I lived through. I see God as the great psychologist who has already used my dreams to direct me. He instructed me how to get the message I dreamed of, directing and healing me. What I was living was inspiring my paintings and, consecutively, my books and Painting From the Soul work. What I believe faithfully becomes real to me. The absolute truth is nothing but what I come to think. And what I think was that God, through a dream, gave me the will and inspiration to paint. I had to improve, I'm learning still, but the choice and the motivation continue unabated and came from Him. That's what I really believe.

Receiving the gift

In the middle of the biggest crisis of my life, I had a dream that was the beginning of my entire metamorphosis. On August 25, 2015, I dreamed that I was at my grandparent's house in Rondon do Pará, Para, Brazil. I was packing up my things for a permanent move. It wasn't just suitcases, but boxes for a significant change—a change of life. I came across a beautiful, turned, thin wooden shelf.

In this dream, I saw a man who wore a cloak of peace, like someone illustrious. Wherever he passed, people changed their faces with a singular expression of peace. In the place of my childhood, He was seated at a table. In his hand, there was a golden pen; it seemed of great value. He wrote on a blank sheet of paper. I couldn't read what he wrote because it wasn't a language I knew; however, I could understand that it was an order like a decree, which was also my duty to fulfill. I stopped in front of the hardwood shelf and started packing. Already with the change, it was tidy, with many organized boxes. I saw a lot of shoes on this shelf, shoes from my childhood that my innocent little feet ran in. I recognized shoes I wore in my teens. Some I had in my youth, boots I used on the vaquejadas, those who walked in circles around my messy life, with big holes. I saw the sneakers I wore when I crossed some border, and I saw shoes I didn't have yet. Each of them was a different gift, each in different colors and shades. There were models that made me sad and others that made me happy. Shoes represent the dispersed past and a prepared future. On the last shelf were sandals made with leather and blue beads, with a spotlight on them from the lamp at the top of the rack. I knew they were the most important things I would wear, and somehow, I knew my feet weren't ready to wear them. I know that shoes mean preparation. While I prepared for a project, I still had no idea what it was. I packed everything I was supposed to put in the boxes. I took the paper from the man's hands without seeing his face, although his smile splashed glory on me. He reminded me that everything reflected on me came from His hands.

I woke up and went to work. When I arrived, I needed to remember the dream somehow. My stepdaughter had three colors of paint, two brushes, and two canvases leftover from some school project. I made a sign at the entrance of my house that said, "My house and I will serve the Lord." Another time, I tried to paint a woman with her hands up. I ended up doing just the arms because I didn't know how to paint hands. I painted my own hands and put them on canvas as little children do. Other people couldn't understand

the painting. My son thought it was an upside-down insect that the hand was trying to reach. The following week, I bought more paints, canvases, and brushes to paint the shelf and shoes that I dreamed of. From that day onwards, I needed to paint my dreams by applying the messages that I felt brought me to the canvas. When I painted, my anxieties, pains, and sorrows passed onto the canvas, and I felt at peace. It was the worst time I could remember going through. I had been through so much perrengue![106] I had a war inside me. Only when I prayed or painted did I feel relieved. I also painted the things I faced that caused pain. It felt like everything I put on the canvas left me. I wish the good things happened soon in my life. Some would say there is a spiritual connection through the paintings, and others would say that it was the force of my will. All I know is that within four months, I had already painted over 100 canvases.

Each one of them I understood was a message for my life, so I started looking for a biblical quote that corresponded with them. In my opinion, as my pains relieved in each brushstroke, I concluded that the feeling of painting was a gift to heal me. I received the art as a gift; I decided to return it to the kingdom of God. I have donated some of them, and when people received them, they reacted to how the imagery impacted by the message that the images brought. I started selling canvases on January 9, 2016. It was my first painting exhibition here in Waltham. While that was happening wonderfully, however, I asked God for two signs that he was with me in this. I knew my paintings were too raw for learning by doing. They needed something bigger than just my hand and paint.

The first question was about how I met Joy days before the art show. I asked him if he was in the middle of this. I needed to see Him acting in someone's life and react with tears from seeing the painting. As I asked, he did it. One person who said words of dismay to me stopped in front of one of the paintings and began to cry in great pain. Her cry was one of sadness and gratitude. She pulled me by the hands and cried incessantly with sobs; she said, "You painted my life! This screen is my life! Did you paint thinking of me? But how could you know?" I started to cry over the answer God gave me through her. It was an unforgettable moment, and for me, it was the first confirmation that He gave me this gift not only for the purpose of healing me, but to bring Him to those who would never go to the church but would go to an exhibition of mine. The scenery strongly impacted other people, and others were impacted by seeing the change God had made to me.

For years, many who didn't see me couldn't believe how I had painted all those canvases in a few months. My friend brought one friend with her, and this person told her that she wished to be like me. My friend started crying and replied, "You don't know what you're asking. Because I know what she went through. I don't want to go through what she went through."

At the show's end, I was in front of one of my painting collections and realized that they had a history, so I had the idea of turning that story into a book. When my youngest son started reading, I looked for bilingual children's books in Portuguese and English and

[106] Perrengue: endless difficulties that bring physical and emotional exhaustion.

never found them. That was always a frustrated wish. So, from these two points, the idea for my first book was born. I had no idea how to publish a book. It was very difficult at that time, and people who had already published books seemed to be afraid to help. My son and I had to do all the work. My oldest son and I started looking into how to make this possible. The next year, on January 14, 2017, the second exhibition also featured the release of *Nothing is Impossible*, a bilingual children's book illustrated with oil paintings. Several paintings were sold on this occasion, as well as paintings that were illustrated in the book.

The cure for the present

Here I could already see some of my wounds stop bleeding. I understood that my art moment was like a spiritual time where I disconnected from the world and connected with my soul. The difficulties of expressing what we feel represents a substantial figure that we are not. You and I have things we cover up so that we don't remember them, and sometimes we must deal with them. I needed to deal with the things that hurt me. Are they no longer in my life because they still hurt me? The answer is that I haven't healed yet. Forgetting is not the way; I needed to face and close accounts with what hurt me but didn't kill me. Today, I'm here because I went through a painful situation, and it didn't stay with me. So why do I give so much importance to something that is no longer part of my present life? I need to deal with my emotions and heal to proceed with the beautiful things I can do with my future. It starts today in my present.

According to Alain Botton and John Armstrong, "To discover the purpose of art, we must ask what kinds of things we need to do with our minds and emotions, but what do we have problems with."[107] I must put an end to what ails me and make room for infinite possibilities. For that, I need inner peace. There comes a time when not everything is money, and peace is more important. I didn't give up my time to heal myself. I needed to keep some priorities straight. It's not that I became selfish; I shared my time with my kids and with friends beyond work and church. I had to spend more daily time with myself. Here are some things I had to do that I can share with you if you need a "solo" moment.

1. **Don't be negligent with your "solo" time.**

I worked two jobs. I came home and organized what I had to organize. I usually cooked, washed clothes, and had time with my children. My time alone was paramount. I did everything that was required and told my family, "I'm going to paint." They already knew they shouldn't bother me unless it was an emergency. And so, until today, I noticed that if I'm going to my studio, they avoid interrupting my "solo" time.

2. **Choose your corner.**

No matter where the size or space, let it be yours! May it be your refuge, your place of disconnection from the world. Make it yourself, and decorate with love as best you can, but

[107] Botton, Alain de. Armstrong, John. *Art as Therapy*. P. 5. Phaidon Press Limited. London NI 9PA. 2013

let it be your face. I've set aside a corner in my room with a small table and an easel. At the end of the day, I would let me my family know I was going to take a shower and stay in my solitude for an hour. Afterward, they got used to it, and I applied my time. The paintings were already increasing; I went down to a corner of the room, and I needed a bigger space. My children also required their corner to play games and watch television—my two noisy children, my louder stepdaughter, and my dog who barked even if a fly flew by the window. I still used one of the rooms to do hair, makeup, and waxing at home.

I worked at a cafe called Dorset three times a week from Monday to Wednesday. From Thursday to Saturday, I worked at a salon, on the weekend afternoons after my other job, I would take some clients that I already had and who didn't want to pay the price of the salon. After my salon clientele grew, I disbanded my beauty parlor in my house and set up my studio. I came home exhausted from the salon and needed my time to disconnect from the world. I spent forty years without knowing myself, and that was just my time. I never had my own time; perhaps that's why I didn't know myself. I spent all my time taking care of the family and working outside the home, and even when I got home, I attended to beauty clients. When I left the beauty parlor, it was like choosing money versus mental health.

My corner is my face! It is also my point of meditation, prayer, and study. My students love it. People who come to groups at my house don't want to leave and neither do my friends when they come to my house. They are delighted when they come and I'm painting. When the small groups happen in my studio, the favorable atmosphere of poetry and peace transforms the participants' faces. In my corner, I enter in bad shape and come out well; I go in well and go out better! I'm suspicious about the peace corner in my studio or any space that can be set aside for art or hobbies, as painting for me is therapy and a disconnection from the world and creates a connection with God and myself.

 3. **Create a list of your projects. Write them!**

Everything in an artist's life becomes inspiration sooner or later. Everything is essential: dreams, images, thoughts, and memories, both good and challenging. List dreams even if they seem crazy. Our artistic side is not logical. List what you want to do short-term or long-term. Remember, Chapter 2 says that by creating a list, I help my future self. So, commit to your dreams and projects.

 4. **Embrace your cause.**

If I don't take my time, no one will do it for me. When I discover what will give me my moment of peace, I need to embrace it and make it primordial. Make it known what you are creating. Consider writing cards for people or letters. If you're gardening, send what you harvest to someone. Cook something you like and innovate your recipes. Start singing music at family gatherings. Give away paintings, crochet, and so on instead of buying presents. You never know the possibility of your hobby becoming your business or inspiring someone.

The most important thing is to start now, whatever you choose to do. If this is not what you expect, look for another hobby until you find something that will be your connection

with yourself. Spend time on what you choose and improve by learning more for yourself. We always do what we love with pleasure.

While researching the benefits of art as an aid in healing emotions, I had to delve deep into this topic. It is not difficult for me, because it's also why I chose psychology and art in the university's program. Art used as therapy has a highly practical function in every area of health, including both in recovery and during the treatment of adults and children. I witnessed art being effective in the emotional area because that's what I lived; however, many professionals provide art therapy cures much more than just regular medical treatment. According to Anya Beebe, "Art therapy is an effective way to significantly reduce anxiety, improve the quality of life and strengthen the self-concept of children with chronic asthma."[108]

With the emotional condition more stabilized by the shock of the illness, both the adult and the child will be more likely to treat their physical weakness. Most books I used in my research are collections of professionals reporting on art therapy, treatment, and the end results. Art therapy gently makes patients more comfortable to follow traditional medical treatment. Art activities make patients create art, and art therapy techniques help them regain their self-esteem, be more confident, and increase their understanding of their health condition. Several diseases are improved, including asthma, epilepsy, physical and psychological trauma, cancer, head trauma, AIDS, Alzheimer's, and much more. The soul of art is to help to heal, period.

Painting dreams or dreaming paintings?

Some neuroscientists who study dreams claim that the busier and more stressed we are, the less able we are to remember our dreams. In my case, it didn't work like that, but I'm less dreamy. I rarely forget what I dreamed and take what my subconscious is showing me in my dreams. I haven't known myself for most of my life, and since I discovered myself in my dreams, I needed to pay close attention to them. I was already writing my dreams, but after this dream, I started to paint what I dreamed of. I found the main message that my unconscious reveals to me and passing it to the screen. The biggest challenge not only for me, but also in the classes I took, was that I couldn't show the teacher what I had dreamed of, and I didn't know how to present it. Most of my paintings are dreams. Only a few were inspired by my daily life, my childhood, biblical passages, the culture in my state, or Brazil. The landscapes that inspire me are a message for my life. My dreams are my most incredible inspirational wealth. I still can't tell if I paint dreams or dream paintings. I say that life gives us a message, and this message is at the heart of my paintings. Every screen has its message that I get for myself, and it always becomes a message for someone else. It could be natural because we humans always have the same problems and dreams. Or spiritually speaking, God teaches me that something can be in dreams or when awake, and then someone else will receive. I don't claim one or the other. What I affirm without a shadow of a doubt is that what I paint transcends me to another level. That was

[108] Beebe, Anya. Art Therapist and Health Care. P. 79. Edited by Carthusian A. P79. Malchiodi. The Guilford Press. New York. 2013.

the biggest reason I created paintings from the soul. I knew that that the message applied on the screen works not only by listening to the message, but projecting it in an image so it won't be forgotten.

The experiences I had in these groups are extraordinary. It is beautiful to see how people feel when they are surprised by this method. It's marvelous to know the power of art manifested in their lives as it has been in mine. As I dream a lot, I have many messages to pass on both on canvas and in my art groups. In those groups, I use the theme from my vision and create metaphors and stories to apply the idea as a painting. I also use other people's stories, giving their copyright and biblical passages if required. I believe the message must be behind the painted image. I was then placed at a strategic point to remember one day. A therapist has one of my artworks. She heard what I said about a strategic place to remember the message in the painting. This therapist told me that she placed her canvas in front of her desk in her office. When she comes across cases in which she thinks she can't help the person, the image says that she can do it! That she is called to direct lives! So, in moments of her doubt, her painting reminds her of her ability and mission. It happened to me, and it worked.

The most incredible meaning in life is to walk towards our dreams.

The purpose of the gift

Art has many functions. The most important for me is emotional healing, but it has infinite uses. The purpose of art as a gift to my life was not only to heal me, but to give me an identity.

According to Michael Samuels and Mary Rockwood, "One of the healing goals through art process that we guide you is to help you find your essence, your authentic self, and your gifts."[109] The purposes of this gift were numerous, and today, I see that all the gifts led me to a single path: my personal peace, my bliss. My self-therapy through art had a purpose and continues to do so. Art has brought to my life numerous benefits. I certainly will bring it to yours, too. Here are some of the remedies art brought to me that I would like to share.

First, pass messages:

The messages passed through art are messages from the artist's entire life, not only in happy moments, but in moments of weakness, anguish, and even illness. Art captures the message of the soul, and the soul does not lie. It is difficult to make something original without inspiration, but creating is impossible. The battle to get out of these moments of chaos will certainly be a source of inspiration, exposing the suffering. After the artist survives, and the soul is illuminated, then messages are conveyed of gratitude and conquest. I wanted to help people who suffered like me and bring them messages of hope, faith, and

[109] Samuels, Michael, MD. Rockwood, Mary Lane Ph.D., RN. *Healing with the Arts*. P. 149. Beyond Words. Hillsboro, Oregon. 2013.

self-esteem. All my paintings have a message, especially the ones that inspire me in my dreams. Some dreams are so special that if I wake up in the middle of the night, I record them on my phone in detail so I don't risk forgetting. They are messages for me not to forget the crisis I overcame and the victory I gained over it.

Second, bring back memories:

Unfortunately, art reveals bad memories, but the foundation of them is for emotional healing. Once the beauty of dark time is expressed, it turns to sheer splendor. It converts the sad to shine and brings the best of me to be shared. And the best part of the memories for me are a big part of my childhood, places I've seen, the culture, my land, and all the unforgettable moments presented in visual art, music, or a poem. I love sharing happy fragments of my story and how to relive them. It happens both when I paint and when I review the canvas again.

Third, therapy:

Art allowed me to do self-therapy in moments of deep sadness when my best ideas flowed. Many of my most beautiful canvases were when I couldn't speak because I was so sad, so I expressed myself with a brush and paint. The frustrations and crying turned into profound poetry. With art, pain turns into beauty and inspiration. Only those who feel know that pain is when we no longer have the strength to speak. The soul is so sore that expression can only be revealed through art. And like a prayer of tears in the silent moment, I mainly lived in moments where my painting was like talking to God, where my prayer was the painting. I showed with my brush strokes how I felt even though He already knew. In many of my paintings, only God knows what it means. Art therapy was so influential in my life that it redirected me to college and inspired me to enroll in an art and psychology program. The possibility of art therapy wherever I go has already helped me create this book.

Fourth, resilience:

Having experienced turbulent moments and irrecoverable traumas, I entered a very dark path, and I wanted to stay there. I looked for remedies to ease my pain and couldn't find it. I had no peace. There seemed to be a war inside me. I couldn't see a future for myself. I was tired and hopeless. I wanted to stop. Then I met Joy. She's the biggest inspiration of my life—my muse, teacher, and influence, after God. My art made me resilient and began my transformation into a new life. The creative spirit that cultivates art for soul healing transforms it into freedom and gratitude.

Fifth, gratitude:

I was so blind to getting out of what I was living that I became an ingrate. I was getting out of my efforts in the war I lived in, and my heart was closing. I was angry at people who hurt me, fake people, and people who just wanted to benefit from something I could offer them. I was running to present my talent as a hairdresser and makeup artist. I ran to show that I was still standing, no matter how much they threw me to the ground. Then one day in the salon, something happened that made me very frustrated. So, in my "solo"

moment, I started drawing a story, and it became paintings, and these paintings turned into my book *Be Thankful*. I saw that I had achieved so much that if I didn't earn more, I could be happy with what I had. And that's what the book is about. That slapped me in the face. I have so much, and I don't enjoy it because I always want more. When I don't get what I want, I suffer more because I always like what I don't have.

Gratitude came with the art and humility of leveling land for ongoing construction. I do not have such a well-founded expectation of getting more, however, so enjoying what I have would not disappoint me because I am already fine. Gratitude made me whole and content with the beautiful things I acquired and lived with. However, I have had unexpected success with the sales of my canvases in the first six months since I started painting. This was followed by the exhibitions and then with the books that became much more popular than paintings, although the paintings are the basis for the books. Anyway, since I did my public artwork, it was abrupt. Indeed, I am very fortunate for that; however, my most tremendous gratitude to art was the cure it provided for me.

Sixth, identity:

I didn't have an identity, so art created an unshakable position in me. What I survived to get here and became wasn't anything financial or for recognition, but truly knowing myself. Understand that a group of people like me price their ailments and aspirations as a brand. I always had a unique and incomprehensible form amid my family. Many made unpleasant comments about my behavior and how I dressed. I didn't follow what everyone else did. I thought I had bad taste in things that everyone chose but me. So, I tried to copy people who followed what I expected to do. Art helped me understand that each person has their style and their fingerprint. Being original is beautiful; creating is not crazy, and neither is imbalance, as I heard it in the first half of my life. Today, I can understand that this is a brand of person who has an identity, and identity brings freedom of expression and emotional stability. This is someone who can have peace even when everything is upside down. I was sure of myself as a person and believed in what I wanted even if it seemed impossible. God called each of His ways of being to represent Himself to an audience that identified with the one He chose. Pastor Fernando always says that my originality is the mark of my calling. Nor does God want me to change the way He created me because people want to change me. They want to change my style, and they want to do it because they don't dare to be spontaneous like me, so I shouldn't be. Art gives the artist permission to be what they are and value it for its uniqueness.

Seventh, cure:

The emotional imbalance caused at a certain point in my life made me lose the original way I was raised. Art brings the answer to where this happened, as well as the confrontation, the relief, the understanding, and the overcoming. It was a long process with determination to improve myself as a human being and, most importantly, improve my relationship with myself. Healing through art starts from the awareness that we must do something to stop the pain in the soul. I usually say that I paint because life hurts, and the relief for the pain in life is its disconnection from art. It cleanses the soul and prepares it

for whatever comes the next day. In my experience, my imprisonment by the pills acted depressive, and the routine that adhered to a long time of treatment became perpetual. Of course, I can't speak in severe cases. After all, I'm just curious about the subject because I don't know the depth. I'm no scientist; however, I speak from the perspective of what I survived. All this is necessary, but there is no abolition without occupational therapy. Art is the broadest path to an effective cure for what I have experienced myself, then researched in articles and books by neuroscientists and psychoanalysts. In severe cases, when a cure is impossible, art eases the ailment with great benefit. Shaun Mcniff said, "Artistic expression has a unique and timeless ability to touch every person in the region in times of personal crisis and collective anguish."[110]

Art is not just a healing path for individuals, but for groups as well. I see emotions in my groups from the moment I present the theme to the application of the text on the screen. The expression of feelings provides rest during work. As an artist, I can contemplate the blossoming of immediate peace, and as someone who has been healed by art, I can identify the feeling in people who share the same evolution.

Everything outside of the pattern shocks those who aren't outside of it, and because I ran away from the "normal" standard in Christ by not being accepted as "normal," this psychosis of distorted thinking does not exist for me. There is no abnormality when I am involved with art; there is style. No matter how small or insignificant it may seem, what I do to express myself through art makes me unique. For a time, I was isolated because I didn't want to talk, write, dance, sing. I wrapped my fingers in the carriage and counted the points. They protested and declared their passion or indignation through poetry. They projected thoughts and emotions onto screens and so on. Healing through art brings messages from the subconscious, unearths the most profound memories, and eternalizes new ones. The therapy empties the mind by turning all dirt, rejection, or happiness into color. Resilience and gratitude come from being free to express yourself. And most importantly, they give you an identity!

Eighth, be an inspiration to others:

Witness the magnitude of the transformation that art has provided. Witness what was faced and learned the process. This part is shown not only in my canvases, but also in the poems and reflections that I wrote, like what you are reading now. I recorded everything that I experienced, including the difficulties and doubts of continuing. I had to face the past to have a peaceful present and a future of many achievements. I use my art to express the power of God and His mercy in choosing me to show through my perspective how good He is. I am the physical testimony that art heals. I cannot retain myself alone. I can't hide the glamor that art has provoked by allowing me to have a great story.

Dreams are the light of life: living without dreams is living in the dark.

[110] Mcniff, Shaun. *Art Heals.* P. 4 Shambhala. Boston, MA. 2004.

Reverse path

In the beginning, I painted what came into my head with no idea what I was doing. Despite the rustic paintings, people identified themselves, and sales were impressive. So, I decided to learn more and improve. I went to a cafe, and there were some paintings on the wall with the artist's contact details. I decided to contact him and ask if he would be interested in giving me some private lessons. His name was Dana, a gentleman over 60 years old, adorable and thoughtful. We agreed on the price, and he would come to my house for two lessons per week. The first time Dana came home was the first time a professional had seen my paintings. He was impressed by the quantity and the intensely expressive style. His analysis was that my style was impressionism, and his recommendation was never to change the already defined style. As I was always very original, I continued to follow his techniques to improve my work. He came from far away and had to contend with a lot of traffic, so we only met for a short time. He also painted in watercolor, and I painted in oil, which made a difference. They were assorted styles, but all I learned from him after six lessons.

After the first exhibition, I did make-up for a bride, and she was an art teacher who ended up giving me some lessons. She was very methodical, but I also absorbed her help: everything is something for those who know nothing. I heard from her about an art center in a nearby town and signed up for six weeks of one-hour class per week. Then, I did six weeks of illustrations in children's books, which was a massive help to my second book, *Be Thankful*. It was released on January 20, 2018. This book's message came from paintings inspired from dreams that taught me to be more grateful. Everything that happened led me to a door, and when I passed through it, another one opened. Because I'm open to opportunities, they always come.

I once made a live video on Facebook, and a pastor saw me and invited me to a seminar named "three hundred" to paint live in front of more than 800 women. I had done live paintings at several gatherings before this day, but no more than 150 people attended. I went to a Brazilian Festival fair in Boston. From there, I was invited to Brazil at Greenway, another Brazilian fair promoted by the Brazilian consulate in Boston. After this event, I volunteered to do paintings from the soul at MAPS to a group of women who have suffered domestic violence. It was beautiful work. This action led me to their exposure at the consulate, and I received an Honorific recognition of volunteering to the community.

God's dream

If you've read this far, you can already see that my biggest dream was to have a family with a stable marriage. I succeeded to make a living from my profession in cosmetology and had this dream come true, but it was just what I wanted. Maybe I'll open a tiny salon to work in after I retire. After entering this dark period, I continued with my old dream; however, God dreamed something different. In addition to what I already was, He wanted an artist, a writer, an idealizer, an influencer, and an evangelist. The big turning point in my life was during darkness, but even in the dark, the light will shine. In the beginning

of 2020, I was exercising my old profession, aside from my work as an artist and writer. The shutdown during the pandemic was when I experienced a significant change. I took this time to create another children's book. Pressured by my husband and eldest son to write *Joy*, I started borrowing books from my college and local library. Also, using many psychology textbooks from my son's college, I began to conduct research to further understand the theoretical side of how I lived in practice. Nothing seemed to move until the invitation to Focus Brazil New York came, followed by the opportunity to be a member of the International Academy of Brazilian Literature. Many posts of my work and everything that seemed to have stopped started to surprise me. I wanted to settle down with a small dream, which I had already achieved. What God dreamed is incomparably greater. God's proposal seemed impossible, but I kept doing my part, since He is the God of the impossible. Even though I'm afraid, I go, and with every step, I take a door that opens, and the one that doesn't open isn't for me.

I remember during my four years of seminary, my professor always hit me harder than anyone else. I was the first in the class to be asked. The first class of the week was for me; he asked me to recap the previous week. When he delivered the jobs, he invariably demanded more and more. Nothing I did was okay with him. He said, "Okay, but I want you to do this and this!" His pressures often irritated me. At the beginning of the third year, I started to understand that he expected more from me. He could see in me what I didn't notice: the ability to go beyond my. Today, I am indebted to him for coaxing the glow he saw behind a rough stone. So, God did the same with me; He got me out of my comfortable position with a good shake. I was completely transformed, and in less than a year, I was a different person and had other dreams.

I once did a person's hair, and as our conversation progressed, we talked about how I started to paint; she commented on the book of Exodus[111] that in building the temple, God gave artistic gifts to be used in ornamentation. I had already read the book of Exodus but had never paid attention to this part. God called two artisans from Israel to lead the artistic project of the Tabernacle of the Lord. In the wilderness, the Spirit of God came upon Bezalel, Aholiab, and other Hebrew men to make them inspired artisans of the Tabernacle. They already had some knowledge of Egyptian craftsmanship, which was much devoted to the production of objects for idolatry, stamping the faces of Egyptian animal gods.

The call and the divine training that rested on them was to elaborate drawings and work in gold, silver, and bronze for the cutting of setting stones and for all kinds of craft work, such as the structure of the Tabernacle. However, those who were specially chosen would not only do the manual work, but also the intellectual and pedagogical work to teach the others. This is because the congregation of Israel would not have Bezaleel[112] and

[111] Exodus 31:4,5 e 35: 32, 35.

[112] Bezalel means under the God's shadow

Aholiab[113] forever, nor did the Spirit of God come upon them to form a distinct professional or artistic elite among the Hebrews. God did give the skill to create a true school to train male and female experts in the art of craftsmanship, which would serve future religious, professional, and social purposes for all. They became known in Israel as the first two art teachers among God's people.

God would have already troubled with his spirit the hearts of artisans and artists to play their roles and teach others. The artistic gifts given by God are nothing new, but He gives according to the purpose He has for His kingdom. Everything I'm living today was never my wish. There was not a day when I was forty-two where I imagined walking on this path I walk today. Everything was projected while I slept. While I slept, He already had a different story for me. God does that to a lot of people. The only difference is the sensitivity to discern and the madness to go even at significant risk of being a laughingstock. But those who don't know what God dreams of for me cannot understand the improbability.

Another memory I have is from my first grade at school. I hated art education classes. I remember once the teacher told us to draw a horse. I made a black ball in the middle of the paper. When we went to show the drawings, I was the biggest reason for the laughs in my room. The teacher asked me, "Didn't I tell you to make a horse?" And I replied, "And I did! Only he went to eat grass behind that big rock, can't you see it?" I'll never forgot this day! After that, I started to hate everything related to visual art. Many of my classmates continued in the same school from elementary to high school, and they all turned into professionals in different areas. What we are today does not define us forever! A big turnaround can happen, and sometimes it's at the worst time that the best can come.

The persistence of going against logic and the fear of regret for not trying is far greater than the fear of the disappointment of not making it.

[113] Aholiab means father's tent

Chapter 15
Dreams

The light of the human being is His dream.
While dreaming, this light will remain.

Sleeping dreams — fragments of the day, compensation

This chapter is hugely inspired by what I believe about dreams. This is not just what I believe, but the research from psychology books and the professional opinion of doctors on the subject. It also reports the personal experience of people who lived to see their dreams come true. The messages and experiences in their dreams had a significant impact on their lives. Joy's arrival made me take my dreams even more seriously, to the point that studying more about the subject was helpful in answering many questions about myself, like explaining specific anxieties and traumas. I learned to decipher the dream messages to use as inspiration in my paintings. There are many theories and studies elaborated by great psychoanalytic minds about dreams. This is something so mysterious that intrigues everyone and leaves us with the answer to this magnificent topic. Some people tend to say that they don't dream; however, science says we all dream. We may not even remember when we wake up, but we did dream.

You will never see your dreams the same way after reading this book, especially this chapter. You will surely start to give more importance to your dreams. They will be able to help you much more than you think. Because I am not prioritizing my dreams, I may be discarding a great help because it is the work of my more cultured side, my subconscious. My subconscious picks up everything about me that I can never consciously see. My subconscious projects all the important facts that I don't put my attention on when I am disconnected without an outside interference. Every dream must be credited, no matter how much I think about discarding it.

Each dream has a message for the dreamer's life that is extremely important with their current life situation. No matter how much I dream about the past, it's always related to something I'm living now or something I have lived but needs closure. My subconscious

analyzes me in all spheres, and the answers I seek are usually in my dreams that I discard. In his perfection and His magnitude, God made our subconscious help us know ourselves in our silence. He doesn't need to keep bringing messages; He made our subconscious to do this job. I complicate it by seeking answers with clouds of glory and trumpets, though they are silently clear. I believe in spiritual dreams against science. Even though I cannot prove faith, there is no way to explain it to those who do not have faith. Even though I believe in and experience changes after spiritual dreams, 99% of my dreams are natural. These are messages from my brighter side for myself to use and improve my life. My subconscious is a system analyst, like a computer. It examines everything that needs improvement in me, and He maps every virus and broken part, doing all the work. When I dream, my subconscious exposes and analyzes me. "Psychologists often implicitly assume that all dreamers share their naturalistic dream model, while ethnographers often emphasize the spiritual explanations of dreams in the dreamer's worldviews,"[114] stated Shaynea and Rogerivar in their doctoral thesis.

God gave us all this unconscious system analyst, but spiritual dreams are rare. Everything has a balance, but anyone believes what they want. Most dreams are about me, and almost everything I dream is about my emotions and what I live. My mind projects on me things I don't even consciously know. In fact, throughout the book, I talk about my personal experiences, voice, vision, experience, and what I believe in my sleep and when I'm awake. I try to show three angles: mine, what I experienced, and what psychologists or other professionals say about the subject. I also show what God did for me through dreams.

Since I was very young, dreams have had great importance in my life. My dreams guided me, gave me hope, corrected me, made me forgive, revealed things about myself, inspired me to paint and write, and much more. The mind continues to function even more when we sleep, reports everything we do during the day, and often goes by without realizing it. Many professionals confirm that if we sleep without preparing, without being relaxed, and to disconnect from the daily rush, all of our stress accompanies us in our dreams. The first type of dream I will cover is the dream of fragments of the day, or the first stage of sleep. Usually, these dreams bring back everything I experienced during my waking state. I fear not waking up in time and dreaming that I was arriving late if I'm worried. When I have a necessary appointment, I dream that I arrive at the place, and something is missing. I don't have a shoe, I forgot an important document, I have dirty clothes, or something else bizarre, according to my level of concern. The physiological dream is linked to the fragment of my day but related to what my body is feeling. Dreams relate to my physical goals, physical pain, senses of hunger and thirst, and sexual desires.

My recurring dream could be related to my day of stress and worries about something I must do. Whenever I need to do something, like work on Monday, I dream of arriving late or already working. Recurring collective dreams can be ancestral dreams that we

[114] Lohmann, Rogerivar. Dahl, shaynea. *Sleep, Dreaming, and the Imagination: Psychosocial Adaptations to an Ever-Changing World*. Article. Vol 42. Jun–April 2013.

inherited from our ancestors. Most of us have this kind of dream, like flying or falling out of a building. Our collective unconscious projects them. Remember that unconsciousness is formed by psychic facts and mental activity that escapes consciousness. Everything done without consciousness reacts, and it will not go unnoticed by the unconscious; it will reveal it to you. The unconscious becomes what happens spontaneously, automatically, and instinctively. The founder of analytical psychology, Carl Jung, said, "The collective unconscious is common to all of us; the ancient foundation called the sympathy of things."[115] The collective unconscious is the substrate that makes it possible to understand that people who live far away, do not know each other, or are from another culture, have some psychic characteristics in common. In his experimental travels around the world, he saw that people had dreams with aspects of myths and religions that they didn't know, but when they remembered them, they could describe them in detail, even without knowing what they were. "That was passed unconsciously from past decades and was stored in his mind of his, your unconscious."[116] How energetic charges emitted by waves of people from before that time were inherited as energy does not follow the same linear time pattern. Information is a cloud in which the essence of our human experience is stored, which we all have in our unconscious minds.

The recurring dream can also compensate for what I don't have, can't have, or desire in my waking life. I repeatedly dreamed about my husband a year before I met him because I was looking for someone with those characteristics. I always dreamed of a tall Black man with an athletic build, who brought me a lot of peace when talking to me. I was yearning for that reason; my brain gave me compensation in my dreams repeatedly.

The dream of compensation for psychic activity is vital to reorganizing my mind. It brings to the surface the emotions I went through when I was awake: waves of anger, fear, anguish, desire, and so on. What I couldn't accomplish when I was awake, I rewarded in my dreams. During a dream, I compensated for everything I experienced during the day—that word I had to hold back and couldn't speak, the punch in the person's face that I couldn't give, the candy I couldn't eat. What about that famous dream flying, or having superpowers? How about dreaming of the perfect person, or a dream with a lot of money? My unconscious works for things and situations that I yearn for or fear to live with during my waking hours.

Even my sex life is caught up when I dream. Sleep acts as a dream guardian, filling in the incomplete and desirable things essential to organize the mind. I assume my dream ego is the personality that I can't live with while I'm awake, so I live in a world of dreams.

I usually say that when I'm pleased, I live more and dream less in real life. Busy people typically don't remember their dreams because they have so many other things to store and don't have space to remember their dreams. To remember dreams, meditation and yoga are recommended under the suggestions by many professionals in the field. A long

[115] Carl Jung *Memories, Dreams, Reflections*.Switzerland1856.Translate Richard and Clara Winston. P. 139. Vintage Books. New York. April, 1989.

[116] amenteemaravilhosa.com.br Psychology. Collective unconscious. December 23, 2018.

prayer followed by positive thoughts and a good reading unloads the mind and prepares the unconscious to play its role in our dreams.

And nightmares? Nightmares are common dreams like all others, accompanied by feelings of anguish, threat, anxiety, and insecurity. Usually, everything I fear and can face when I sleep is illustrated as nightmares. Like other dreams, nightmares result from brain activity, and the emotional fragments of my day will be reflected in my dreams. Nightmares are scary dreams that result in repeated awakenings from sleep. They are very frightening dreams most of the time, but sometimes they can also be dreams of anger, sadness, disgust, and other unpleasant emotions. Nightmares often occur during REM sleep. Repetitive nightmares often occur as a symptom of Post-Traumatic Stress Disorder (PTSD), where they may include a partial repetition of a traumatic event. Nightmares often reflect psychological stress and conflict. When I am awake, all my phobias identify with the truth; however, my brain activity is free of time and reality in my sleep. In dreams, everything seems to be accurate. In my case, in my past relationship, I always dreamed of being abandoned and betrayed. All my daily fragments were the threat that always haunted that moment in my life. I haven't had this kind of nightmare for many years.

Everything we fear comes to haunt us in nightmares. Which mother has not dreamed that something was wrong with her child? That's any mother's biggest fear. Too often, I had nightmares about my two oldest children when they were kids. I remember that I dreamed that my middle son was killed by a car. When I went to work, he stayed with his grandmother, and she lived on a bustling street. Now with my two children already with their master's degrees and fully independent, the nightmares about them have stopped.

The recurrent personage dream occurs in different scenarios, but this is not the same as a recurring dream with repetition. A recurring dream is the same dream that repeats itself without changing anything. My dream was always something terrifying happening to my youngest son. My last nightmare of this recurring theme was that I found him thrown in the trash, like a baby, but he looked like he is now, a teenager. I woke up at two in the morning scared, prayed because prayer never hurts, and went back to sleep. I had another nightmare about being a massive old house almost without end, and he got lost in me. I woke up desperate, shaking, and crying, then I remembered that I was projecting my fear towards my son. I had to remind myself that nightmares are the projection of my worries.

After studying a lot about dreams, I used my knowledge to my advantage. I was already awake, I told myself that it wouldn't happen, and my fear made the nightmare happen. It was a constant nightmare that never happened again. An excellent remedy for ending nightmares, along with not sleeping with an overfull stomach, is facing fear.

As we are constantly struggling with something that ails us, we will always have nightmares. Nightmares are more frequent in times of both personal and global tension, such as this time of pandemic caused by COVID-19. The nightmares become repetitive until the phobia I'm facing changes.

Quite different from nightmares are sleep disturbances. There are more than 100 types of sleep disorders, and I will highlight the ones that call my attention the most.

Parasomnias include disturbances with undesirable behaviors or experiences occurring during sleep or partial awakenings from sleep. The following sleep disorders are overlapping types of parasomnias, often grouped as "arousal disorders." They occur during partial arousal states of deep non-REM sleep, usually in the first third of the night. People are often disoriented and unresponsive during episodes and typically don't remember the episode.

Confusional arousals - these include states of confusion or chaotic behavior during partial awakenings from sleep, usually on the first third of the night, but sometimes upon awakening in the morning. This disorder is more common in young children.

Sleepwalking – this is a partial awakening from sleep and includes walking in a state of limited awareness, decreased awareness of the environment, reduced responsiveness, and impaired judgment. It is common in the second stage of childhood and may persist into adulthood.

Night terrors – these are sudden partial awakenings from sleep with intense fear or terror, often beginning with a scream and often with increased heart rate and respiratory rate, confusion, and lack of response. Dreamers cannot remember episodes.

REM sleep behavior disorder (RBD) - a disorder in which dreams are enacted due to the loss of muscle paralysis that often prevents people from realizing their dreams during REM sleep. Enacted dreams can be violent and can hurt the dreamer and those who sleep with him.

Sleep paralysis (isolated recurrent form) – this can last from seconds to minutes. Although sleep paralysis can occur as a feature of the sleep disorder called narcolepsy, it also appears as an isolated symptom.

When I'm asleep, measuring my brain's electrical activity shows that my brain is quite active, producing frequent electrical c that look like waves. These electrical waves change height. If noted in science books, the waves get lower and lower. Imagine a ladder instead of waves. This one has four steps, and I'm at the top. These steps are very thin and shallow, and I'm going down them. I step on the first and start to sleep.

On the first step of REM sleep, I transition between awake and asleep. My eyes start to move slowly. There is no longer any eye movement to the second step, and dreaming is rare. The third and fourth steps are deep sleep. When I get to the bottom of the ladder, there is a very high, drastic step. During REM sleep, brain activity is like that of an awake person, suggesting that it is not a dormant period and has a specific function. During this sleep phase, lived dreaming is likely to occur, which is proposed to be a mechanism for repetition and mental process stimuli to extract meaning and create memories. "Paradoxically, while all this activity is going on, the main muscles in the body seem to be paralyzed. Also, most importantly, REM sleep is often accompanied by dreams,"[117] according to Robert Feldman.

[117] Feldman, Robert S. *Understanding Psychology-Mood Disorders-Major depression*. 9th Ed. P. 144. University of Massachusetts, Amherst. McGraw Hill. Boston, MA.

In REM sleep, rapid eye movement occurs due to the action of the thalamus. REM sleep is called the sleep that supports the body. The brain activity is like the waking state; It usually lasts for ninety minutes in adults. The most real dreams occur in this sleep phase. Here it is shown clearly; however, you must go down to the fourth and last step of sleep to go back up to REM sleep. Here, my unconscious works to bring me unknown dream information. During REM sleep, the brain is free from influence and does not allow itself to be influenced from the outside. The mind brings the great ideas created for my best self in this sleep. From REM sleep comes the theory of precognitive dreams. During this state, you begin to collect different signals of energies that I, being awake, will never be able to identify.

Psychological dreams

I remember that in my two years of therapy, my therapist would always ask me if I dreamed. I was in the habit of writing down my dreams after I took the parapsychology seminar. I have a notebook in which I write my dreams beyond my reality. During the two months of quarantine for COVID-19, I had a lot of time to study. My husband and oldest son pressed me for a book with my story. The idea came up to talk about my relationship with Joy and its importance in my healing process. I couldn't leave out the dream. The dream was the beginning of my emotional healing. I wrote down my dreams and didn't understand them. My therapist helped me decipher some; however, the responsibility was mine. In Daniel Goldin's thesis, he wrote, "In the psychoanalytic situation, analyst and patient are often involved in the process of capturing the patient's actions and sufferings in a story that they elaborate together in a way that makes sense to both."[118] The dreams of the person who undergoes therapy or counseling are doors to understanding what he experiences. Analyzing their patients, both Freud and Jung unraveled the puzzles that plagued them.

At the beginning of my healing process, I commented that I was doing therapy and heard rivers of criticism that I would eventually find out about. I have been called stupid, even unbalanced, in conversations between people who need treatment themselves. I had a big mouth, exposing my life to untrustworthy people. I would talk about what was happening to get to know "someone" that I thought I could trust. This time was different; I would share my discovery, healing, and transformation. Although I believe therapy should be continuous, which would be fantastic, I already had some knowledge of dream interpretations, but I wasn't in my best state and I wanted to know more for my self-help. I dreamed a lot, and most dreams were challenging to understand. I would speak with some people who seemed to understand the subject. They said things about it that usually came with their guesswork and judgment for the turbulent time I was going through.

At this point, I started to read a little about the subject. I tried to find out about the dreams of the biblical characters and what it meant for their journey. So, I asked God if He wanted to exhort me, prepare, advise, and direct all I should reflect on—not only to make

[118] Goldin, *Daniel Dreams as Fictional Remembering*. Article. Vol. 8 P. 12. April 2018.

some repairs or heal me on my spiritual side, but also on my emotional side. I needed Him to give me insight into my dreams. After a while, when I woke up, I understood everything about my dream. Not every dream is a direct connection to God. The truth is, most of it is our minds rearranging our accounts of our waking life. It was God who gave us this for our self-analysis and studying. I realized that it was a door to my unconscious. I started to retrieve more memories at this door, understanding a large part of my behavior. Allan Hobson's theory suggests that "the specific scenario a dreamer produces is not random, but is a clue to the dreamer's fears, emotions, and concerns. Therefore, what stands out as a random process culminates in something significant."[119]

Learning to analyze my dreams made me realize that most of what I dreamed gave me hints about things I didn't know about myself. My dreams are significant in my emotional healing process, as if sleeping were wiser than waking up. The first psychoanalysts already stated this question, and it seemed that my dreams analyzed me more deeply without pitying me. My dreams showed me things I could never admit to or see, as if sleeping told me something about myself that I had forgotten because I was chasing things and forgetting the most important thing: me. Being awake, I see it from my perspective; however, asleep, my dream can reveal the true me, as if I were out of my mind with a notebook, reading my life with a universal view of myself. It's like someone much more capable than me were inside my mind. I started receiving revelations from my unconscious mind about the root of my traumas and recovering memories, even those I didn't want to remember.

And in understanding myself, I was able to help myself with what my mind exposed in my dreams. Freud, in his psychoanalysis, realized that he could understand more of the person he helped when the patient was unconscious than when he was conscious. People who didn't know the reason for what was going on couldn't express themselves. Through hypnosis, he realized that he could access a door that not even the patient was aware of by tapping into the unconscious.

These dreams connected with a moment I had lived. I must analyze my dream by reading what I'm going through when everything is related. Freud said, "Every dream reveals itself as a psychic structure that can be inserted at an attributable point in the mental activities of waking life."[120]

Another type of dream related to the moment I am going through is an emotional event in a group called a collective dream. In the collective unconscious, ancestral memory inhabits the individual, which operates through the collective unconscious. A collective dream is an event that shakes a group of people who sometimes don't even know each other and have either the same dream, or a dream with many similar elements and the same meaning. Collective precognitive dreams are also related to events that have not happened yet. These dreams are based on energy formed, even if it has not yet passed,

[119] Hobson. Allan. PhD. Psychiatrist. Dreaming. P. 29. New York. 2005. *Understanding* 9th.Ed. pp147 McGraw Hill. Boston, MA.

[120] Freud, Sigmund. *Interpretation of Dreams*. Vol. 3, English ed. Chap 1. Vienna. March 1931.

but as fuel is not time-bound, it affects people with more sensitivities. They start dreaming about the same thing before an event that hasn't happened yet.

In 1986, I was twelve years old, and I lived a year in a boarding school for nuns and attended a week-long seminar on parapsychology. I lived inside the convent, and the Catholic Church had a line of studies and universities dealing with parapsychology. I was very excited and even got a pendulum as a gift from one of the people who conducted one of the lectures. I had kept it for many years. I spent about six months trying to hypnotize people who would allow me to do it. From this event on, I started to have more curiosity related to dreams in general, but it was only in my forties that I would study them more deeply. In this seminar, several scholars taught me how to interpret dreams from the emotions and daily happenings of my life. One of the lines of the study stated that all the characters in my dream have only one artist: me. I am everything in my dream, from the crumbling door to the dragon, to the snake that everyone is afraid of. I am representing myself in my fear of the sneakiness and cunning that the snake represents. That's because psychology and parapsychology have a fine line of understanding. The symbolism of my dream has nothing to do with me. Another exciting thing is the time I dream about. If it's sunny, it's because I'm prepared to decide what my unconscious showed me. If there's a lot of light, my unconscious is clear, and if it's dark, I still haven't had complete clarity of what my unconscious has brought to my dreams. According to Peter Hancock in his doctoral thesis, "It has been claimed that dreams are the royal road to the mind. Dreams and associated brain states such as memory, attention, flow, and perhaps even consciousness itself arise from various conflicts over time control in the brain."[121]

The division of sleep is also very similar to what psychology explains about dream analysis. If it's the first step, it's related to the shallow side of memory and has to do with my day. If it's the second step, that's where my unconscious shows what I don't know about myself. The third stage is when I'm about to wake up, and my unconscious suggests acting on what it has revealed to me. As I studied for this part of this chapter, the color of the pendulum that I got from one of the doctors present there came to mind. Parapsychology is not only Catholic; it is a science that studies inexplicable phenomena. Its purpose is the scientific research of telepathy,[122] precognition,[123] retrocognition,[124] clairvoyance,[125] projection of consciousness,[126] telekinesis,[127] reincarnation,[128] mediumship,[129] and even

[121] Hancock, Peter. *The Royal Road to Time: How Understanding of the Evolution of Time in the Brain*. American Journal of Psychology, Spring 2015.

[122] Telepathy: direct communication between two minds.

[123] Precognition: feeling, thinking, dreaming, seeing, etc., of what is about to occur.

[124] Retrocognition: past memory regression and parapsychology. This also refers to past lives.

[125] Clairvoyance: according to parapsychology and the ability to obtain knowledge without any human sensory channel.

[126] Projection of consciousness: out-of-body experience. The mind detaches itself from the body to the point where it can go elsewhere.

[127] Telekinesis: movement of objects at a distance without physical contact and only with the power of the mind, suggesting a paranormal power.

[128] Reincarnation: to live again in another physical body, according to some sects.

[129] Mediumship: the communication and/or manifestation of spirits with humans, as some sects believe.

near-death that occurs when the individual's heart stops for a while and starts beating again, among others.

This line of science takes everything to the energy side of the universe, and since we have energized bodies, everything in the universe is automatically connected. Despite the controversy and not being recognized by science, the historiographies of psychology and psychiatry in general pay little attention to this, and some researchers support studies on supposed paranormal phenomena and brought an outstanding contribution to the formation and development of several scientific concepts. These concepts related to the functioning of the mind, such as the subconscious, hysteria, hypnosis, dissociation, identity disorder, and automatic writing. The parapsychological side treats unconscious dreams as a gateway to supernatural phenomena.

Psychologist Stanley Krippner explains how quantum physics could justify precognitive dreams. "Quantum events happen on a different timetable than most people in the West know,"[130] he explained. "Our idea of 'time' is divided into past, present, and future. But quantum physics brings a different concept of time." He also reports that in his numerous surveys of indigenous peoples who don't believe in quantum time, some Native Americans believe that the body is not attached to the skin, but extends, projecting itself onto other people and everything alive. The dream of the future for the indigenous people does not seem absurd, since everything happens simultaneously. For some natives, they are in a pure state of mind in their dreams, in which everything is seen from all angles. Dreams have the same intensity as an unknown language for the well-known Carl Jung. It takes training and knowledge to decipher them, but putting effort into this practice will be highly rewarding.

Another phenomenon with a lot of intrigue between science and parapsychology is the astral projection, which is the exit of the spirit from the body. Parapsychology reports long journeys to a point where natives of some tribes attribute the projection of consciousness. The projection happens when we are sleeping. The mind detaches from the time and space we live in and travels to the present and the past, near and far. Many other Christians call it a vision. On the other hand, science sees it as a projection of thoughts caused by mental factors. Science does not prove consciousness travel or astral travel. It claims it's a hallucination triggered by a neurological mechanism.

I agree and disagree at the same time. I've had two experiences; one I wish was spiritual, and one I wish wasn't. My first projection of consciousness, vision, hallucination, or whatever it's called, occurred during a night when I got up from my body and went to the other side of my room. I was leaning against the window in front of my bed, then saw a shadow of a man. The shadow was coming out of the wall on top of my headboard, looking at me sleeping. This shadow was as if crawling towards my body lying on my bed. When the shadow saw me from the other side of the room, it stopped, looked at me, and tried to get back into the wall. The shadow, unable to get back into the wall, disappeared

[130] Krippner, Stanley, Ph.D. Psychology professor in Saybrook, Pasadena, CA.

like smoke. It was terrifying, and I was terrified that I wouldn't be able to move. That shadow raised what would be its head towards me when another shadow, like a light, covered me like an umbrella, and the other shadow came out. I stared at the light above me, walked over, saw myself, and laid down again. I wish it wasn't spiritual; I hope it was thought projection, anyway.

During the other, I felt something big under my body pulling me up. Then, I was almost to the ceiling of my room and looking down at myself lying on the bed. This day was beautiful, with a peace that smelled like jasmine in my room. Around my body was the shape of a substantial hand that held me, and I wasn't afraid. I looked at my body, and a surge of energy came like a voice saying, "I take care of you always." I recognized my Holy Father's voice. It doesn't matter to me whether it was a hallucination, as science says, or a cosmic journey, because my faith is not in it. The Bible reports a paranormal situation that triggered many discussions among theologians who have not reached a consensus. By mentioning parapsychology, I could not leave this subject out, but it is not about a dream; it is about the possibility of seeing the dead, which is something linked to parapsychology.

The event in question is in the book of Samuel. The story is about Saul, the king of Israel, David's predecessor. Towards the end of his life, he sought a medium. The medium was from the city of En-Dor and was asked to invoke the spirit of Samuel because Saul was too afraid of losing a war against the Philistines. Samuel[131] was the prophet offered to God by his mother after receiving the miracle of reversing barrenness. The Bible reports that he was a prophet of tremendous reputation, both with men and God. Even what Samuel spoke of himself, God made happen. The medium invokes the spirits to answer King Saul and was sure the spirit that appeared to him was Samuel. When the medium found out that the spirit was Samuel, she was scared.

At this point she recognized King Saul, who was in disguise. King Saul disguised himself because the people who served the God of Israel could not speak with the dead. The medium feared that the king would have her killed, for God does not allow his people to seek necromancy, and he was ashamed to have sought her help. This controversy is enormous, but the Hebrew translation of the Septuagint says that the woman saw Samuel. If the Bible tells this, who has a higher authority to deny this claim?

This text was super controversial in seminary, and several pastors from different denominations argued over it. The debate is over, and there have been more studies to show there is a probability that what is explicit in the text must be what happened. The biggest problem is prohibiting it in other parts of the Bible. If God allowed this to happen, He could do it; why can't we? Because He forbade it, and it's over. God forbids us to pursue what is not our concern. He knows that we are not competent to master the matter. This theme is in a single part of the Bible, and more important things like loving God, forgiving, and being vital are much more repeatedly shown. The most important things

[131] 1st Samuel 28: 1–25

written several times should be paid more attention to than the appearance of someone who died and did not rise like Jesus.

Spiritual dreams (prophetic, warning, comfort, exhortation, concert, reflection, preparation)

Spiritual dreams are not just a message from God, but also from my spirit to myself to heal my soul and body or help me align my waking life. Clearly, like every good Christian, I believe the Spirit of God uses our dreams to help us. And with dreams, I think we are more prone to the spirit world than when we are awake. Believing in dreams is now part of my universe and becomes much more of an experience when dreams turn into reality. Walking with Joy, I had to reinforce my position on the importance of dreams in my life. It wasn't difficult, as I already believed it. I think dreams are my connection to myself without the interference of other voices. I think dreams have an immaculate spiritual connection where there is no other intermediary person; it's God and I emphasizing that whoever believes will understand what I say much more than those who do not think so. I forget those who do not have a formed opinion that can displace them from their position, either to one side or the other.

Some people like me believe prophecies were given by prophets.[132] Let us not forget those who dream of events long before they happen. Carl Jung said, "Dreams can sometimes reveal certain situations long before they happen." I think prophetic dreams are more direct between God and me because there is no third-person intermediary. I dream without my emotions interfering with what God wants to say. And, when I'm awake, I know that as much as the prophet is a person of integrity and obedience to God, he can get confused. I can also let my desire interpret what God wants to pass on to me. However, in the case of dreams, I am disconnected from reality. Kelly Bulkley said, "What fascinates me so much about the dream is precisely its ability to bring energies to the 'further' side of waking consciousness, not only during unique revelations on the top of the mountain, also during our regular nightly sojourns, in the realm of nocturnal imagination."[133]

Of course, for the Christian, the first prophecy is the word left to us by people enlightened by God to give us direction. It interferes with the writer's style and vision, but God inspires their mind. There is a lot of controversy on the subject that most of us already know. Men wrote the Bible for this reason, so many doubt it. True! It was written by men for men but inspired by the Holy Spirit of God. "Many cultures believe that dreams are prophetic and contain messages from the spirit world. Therefore, dreams elevated to a high level of importance are interpreted very seriously. In this way, dreams can have a direct impact on the lives of many or all members of the culture,"[134] said Lynda Warwick.

[132] People used by God to deliver a message.

[133] Bulkeley, Kelly. *A Response to the Readers of Big Dreams*. Article Pastoral psychology. Vol 66. Oct 2017.

[134] Warwick, Lynda, L, Ph.D. Everything *Psychology Book: Origins of the human brain*. P. 93. 2004. ISBN. 13:978-1-59337-056-5, United States.

In this chapter about dreams, I will expose the experiences of people whose dreams warned of some future situation, preventing them from preparing for a moment that they would need to face. As a result of what they dreamed, they could prepare for a confrontation when it happened. Many people affirm this connection with God through dreams if the link is biblical. In several episodes, God connected with people who chose to do certain feats by receiving directions from God in their dreams. Others dreamed, and the events of their dream happened. Usually, when God allows these dreams, he gives us the understanding to interpret them. I know many people who claim their dreams turn into reality—not something they just wished for, but a dream repeated in the waking world. I have some reports of experiences in this chapter. In biblical times, God allowed dreams to guide, reveal, discern, correct, inspire, confirm, and even give children to some. He continues doing this today to those who believe, because everything is a matter of faith.

Dreams are the draft of reality.

Vanna[135] was married, had two children, and lived a normal life. She dreamed that she had traveled to a city to see someone important to her. Upon arriving in the town, she walked through narrow streets as if she were in the past. The houses were decorated with antique tiles. She entered a building and went to the reception to check in before moving forward to the next room. Although she went down to an underground entrance, she had to jump over a small wall to continue. Upon entering the room of the person she was going to see, both the floors and walls were dirty. The people were dirty and frowned upon, and the place smelled of dirt.

The room she entered was small, with a tiny window and a bed with a big block of cement that looked like a bench. She was afraid to be there, and then she heard the noise of a door closing behind her, and she woke up. Years later, something horrible happened: her husband was arrested, and he was transported to another state. She had to visit him in the capital of the state of Maranhão, São Luís, a historic city from the time of the colonization of Brazil. As she walked through the historic city, she identified the houses and streets that passed. Arriving at the building, she thought that this place looked as familiar as if she had been there before. Entering the penitentiary building, she was afraid of the review and the entire procedure. At this moment, she remembered the dream that she had years ago. She was so bewildered that she had dreamed of repeating herself that it surpassed the fear she felt. In those days, she didn't think much about the dream related to the event. However, today she believes that the dream was a preparation, consoling her for a challenging situation that she would face.

Iracema[136] was the fourth child of a family of sisters; she always dreamed of having long hair; since there were four girls, her mother didn't allow any of them to let their hair grow. Her mother said it was a lot of work to take care of the hair of four girls. Even as an

[135] Cardoso, Vanna. Rancher. Surubiju- Rondon do Pará- PA. Brazil. May 2020.

[136] Anastacio, Iracema. Reverend. Family counseling. Marlborough- MA. June 2020.

adult, she got used to keeping her hair short, just like her sisters. When she was fifty-two years old, she dreamed that she was around seven years old and running through a vast, green field. She was wearing a baby pink dress with short, fluffy sleeves and buttons on the back. Her hair was long and swayed as she ran. Because she was running, her dress was unbuttoning some buttons. At the end of the field, she saw a tree where a man sat in its shadow. She approached, and he had the feeling of care and protection, like a parent. He buttoned up her dress and fixed her hair. He smiled and said that he would always take care of her. When she woke up, she did not cut her hair for a year.

Her hair grew impressively fast, and everyone asked if she had extensions. Her dream while sleeping brought the reality of a girl's frustrated dream. Today, Iracema the woman does what Iracema the child could not. Even though she spent most of her life wearing short hair, it was difficult getting used to it being long. In a way, the long hair felt like protection, and she remembered this beautiful dream, which was a meeting that she had with God.

In 1865, US President Abraham Lincoln[137] had a dream in which he walked around the White House amid screams and funeral chants. He made his way to the West Room, where he saw a coffin protected by soldiers who informed him that the president was murdered. Over the next few days, Lincoln shared his dream with his wife and some close friends. Thirteen days later, he was assassinated.

The president grew up in a Baptist family, despite being skeptical in his youth. As an adult, he referred to God and quoted the Bible, according to many scholars. However, historian Mark Noll states that "Lincoln never joined a church, nor made a clear profession of the standard Christian faith." He attended the Protestant church and was seen by many as a true Christian, but friends like Ward Hill Lamon and William Herndon did not confirm this idea of him believing in Christ. However, he published in a pamphlet that he "never denied the truth of the scriptures,"[138] referring to truth from the holy scriptures, the Bible. Lincoln's case was not necessarily something revealed by God, but certainly a case of a precognitive dream.

Gislaine[139] was in her third pregnancy, and everything seemed to be normal. She, her husband, and their children were delighted and looking forward to the arrival of a baby. Gislaine dreamed that she felt a lot of pain, and when she woke up in the dream, she saw she was bleeding. She told her husband, who quickly took her to the nearest hospital emergency room. When she arrived at the emergency room, her husband filed the papers, and the nurses took her for an ultrasound. She passed the nurses, watching the white walls until she reached the room. She was taken to a radiologist. The nurse did the ultrasound, asked to wait for the doctor, and left. After about ten minutes, the nurse returned

[137] Abraham Lincoln (1809-1865) was a president of the United States.

[138] Noll mark PhD. American historian specializing in the history of Christianity in the United States. Professor of History Research at Regent College. *Visões religiosas de Abraham Lincoln* -https://en.qaz.wiki/wiki/Mark_Noll

[139] Silva, Gislaine. Christian Missionary. Preacher. Belmont- MA July 2020.

with the doctor. The doctor sadly said, "I'm sorry. Your body rejected your pregnancy, and you are losing your baby." She started to cry and woke up. A week later, that dream happened. She was nervous, and when she entered the ultrasound room, everything she was experiencing seemed to repeat. In the ultrasound room, when she saw the same nurse, she remembered a dream. With great sadness, she also found comfort. Gislaine believed her dreams were a premonition from God, showing that He was with her, and everything would be all right.

Ana Moura[140] was still learning about autism from her oldest son, who was nine years old at the time. She is still afraid of the church, because everything would have to have a certain kind of fit for her child. For several months of her life, she dreamed of beans almost every night with different plots. One night she dreamed that she was swimming in a sea of black beans. She was with her son, and after a long time, they reached the beach. The white sand contrasted with the sea of black beans.

She noticed that her son was playing with a white ball in the sand, which she later saw was made with socks. She called her son to her side, but he didn't come because he got distracted playing. At this point, she heard a soft voice that sounded like her pastor saying, "Don't be scared, I'll help you!" She then turned to the sound of the voice and saw a statue of her shepherd, which looked like white porcelain.

After a few days, the children's ministry leader invited her to work with her. Ana accepted, started working, and always took her son with her. By being at his mother's side, he began to be socially included. Her pastor, over the years, has done an excellent job with children and youths, particularly those with special needs. Today, her son is an assistant in the class that teaches children on Sunday. He loved joining the youth group and thanks his mother for taking him there. Even though he stays in his world many times, she believes that her dream was a sign of peace continuing in this church.

Ana's most fantastic emotion was seeing her son get up, walk towards the table, and get a piece of cake for himself. Even though it seems simple, she can see that he feels included and comfortable doing something he would never do anywhere else. Ana believes this was a prophetic dream consoling and directing her to stay in this church, a place where she would receive help for her son. She keeps this dream as a gift of love from God for her life and her child.

Ester[141] was in the city of Marabá in the State of Pará, Brazil, at her brother's house. Her brother, Ruben, had three daughters; they were young children. Her sister-in-law started a conversation, a very delicate request to Ester. The proposal was that Ester would raise her three daughters in the event of her death. She had an excellent relationship with Ester and trusted that she would be an ideal mother for the girls in her death. Ester was very flattered by the trust and affection; however, she already had three daughters and

[140] Moura, Ana. Broadcaster, Consultant. Framingham MA. Nov 2020.

[141] Septimio, Ester. Author, Teacher, Master's degree General History, and Religious Education. Belem do Para. April 2020.

would not like three more. She loved her nieces, but she wanted their mother to raise them, and nothing would happen to her.

After some time, she learned that her brother and sister-in-law would travel to Belém do Pará. She dreamed that they were traveling in a white pickup truck the night before the trip. The truck overturned, the couple would die, and she had to fulfill the promise made to her sister-in-law and raise the three nieces. She was terrified and wondered what she would do if that happened. She began to pray and ask God not to let anything happen to them, as it would be complicated for her to care for and educate these children. She also asked people she knew to help her in prayer. She called her sister-in-law and told her about the dream when she woke up.

The only thing that didn't seem like her dream was that her brother's car was yellow. They left home and started the journey; however, the other brother's farm was in the next town, and they went there first. They told the dream to the mother-in-law of the other brother they were visiting, and she prayed with them again. Although, without anyone noticing, when he stopped at his brother's farm, he exchanged his car for a white pickup. Approaching Bethlehem, out of nowhere, the truck overturned three times and stopped at the door of a church.

It seemed impossible for anyone to have survived the accident; however, they were unharmed. Esther believed that God delivered them from death beyond a shadow of a doubt. She didn't really know the purpose of that dream, but she was tremendously grateful that her brother and sister-in-law survived to raise their daughters. Today, their daughters are adults and have given them grandchildren.

Celia[142] has lived in the US for over twenty-three years with her husband and two daughters. Célia grew up in Itamaraju, in southern Bahia, Brazil. In her childhood, she ran barefoot around her little wooden house at the top of the hill. She soiled her little feet with yellow clay from the unpaved street in her neighborhood. Her house was painted lime green, her mother's favorite color, and they reinforced the paint before Christmas. Behind her home was a very flat and narrow street where she used to play. Many years passed, and Célia had a dream in her little house where she spent her childhood. The house still exists, but her family no longer resides there. Celia saw the window inside the old house, and her mother was at the door and said to her, "Did you see? Does my daughter have a white car that keeps going around the street above?" Celia, however, had not seen it. When the mother finished speaking, the car stopped in front of the house. A man got out of the car with gun in his hand. Celia's mother screamed, "He's coming!" Celia replied, "Don't be afraid; the God I serve is greater than any armed man." As she spoke, the man shot her, and she fell to the ground woke up from her dream.

Startled by the terrifying dream, she dropped to her knees and began to pray. When she looked at the clock, it was 3:00 in the morning. When she finished talking to God, He comforted her, saying that it was not for her, but that she should ask about her brother. So,

[142] Cannavino Celia. Writer. Life master coat (positive psychology behavioral/ profile analyst/ interpreter. Wayland MA. June 26, 2020.

she continued to intercede and asked her family to pray for her brother. Eight days later, her brother was robbed. He confronted the thief, who was his co-worker. Revolted by the shame of being discovered in the robbery, the coworker shot Celia's brother three times. Luckily all three shots were in his leg; nothing fatal occurred. Celia firmly believes that dreams receive attention, followed by supplications, mainly for those who have a life of commitment and connection with God. She believes that God speaks through dreams, so we must be careful. This dream was a warning for her to prepare for this future situation: someone would want to kill her brother and seek deliverance in her prayers. Celia's family stood by her side in prayer; however, lots of people have dreams without telling anyone about them. Many prefer not to speak because the fear of being ridiculed. We should not be afraid of dreams, but they do need our attention.

Fernando[143] and his wife assembled at a church in Brighton, Massachusetts, and were unsure whether they would go to the same church where their parents and other family members congregated. That night, he had a dream about a friend from high school. His dream was to go to the church where his parents congregated together, where he thought of going. A girl was at the church door and said to him, "Don't come here! Stay where you are, because it is in this ministry that God will honor you." He felt a lot of peace and security in the dream and was sure the girl embodied a message from God to him.

After two years of this dream, he dreamed that he was in a wonderful place and heard a voice saying that Fernando would not stay long in that church; he had to get ready because he and his wife were going to pastor a church. The next day, on Thursday night, they went to church, and at the end of the service, the pastor asked to speak with him. In the conversation, he asked to Fernando be a pastor of their congregation in Waltham, Massachusetts. That moment, doubt and fear wanted to prevail. After all, he was too young to be pastor of his own church. It would surely be an enormous weight on his shoulders, but he remembered the dream and felt peace. He was twenty-four years old; his son had just been born, and shortly thereafter, he was consecrated as a pastor. Fifteen years have passed, and he continues to pastor this church with his wife. Their teenage son has been a drummer since he was three years old.

I believe in dreams because of the ways they help me in many different situations. I'll let you know how my dreams changed my life tremendously. After my youngest son was born in 2004, I dreamed that I had four children at once, and the last one was a girl; however, I only gave birth to three children. They were placed on me by a doctor, and I wondered what that fourth baby meant. Maybe it was my unconscious desire to have a girl that I never had. It could be something new, like the birth of a child.

In 2011, my ex-husband's daughter came to live with us, and from that point, she became my daughter. I understood how I gave birth to four babies from the dream. I had three from my womb, and one from my heart. I repeatedly dreamed about my husband a year before I met him, because I was longing for someone with those characteristics. I always dreamed of a tall Black man with an athletic build who brought me a lot of peace

[143] Oliveira, Fernando. Reverend of the Cathedral Baptist Church of Adoration. Waltham, MA. July 2020.

when talking to me. That was my yearning; for that reason, my brain gave me compensation in my dreams repeatedly.

One Sunday after lunch, I was listening to music when I started to feel like taking a nap. During my fight not to sleep, I had a dream, but I felt the same sensation as when I saw the images through my window in front of my bed. I found myself entering a field; the grass was very green. Even at the entrance, I saw a man almost in the middle of the field. He was someone very well-known, so I was pulled to meet him. As I walked into the field, the grass seemed to grow, and so did the man. After I got close to him, he was so tall I could only get my head close to his hip. I walked over and hugged him tightly, grabbing him by the legs. It was a long hug, and I didn't want to let go of him. He smelled like fresh lavender. As I grabbed him, afraid to let go, he pushed me away from him and pointed me in another direction. I started crying and screaming, saying, "Daddy, I don't want to go!" At this point, my voice was that of a child, and I looked at my bare feet. Then he said to me in a voice that exuded peace, "You need to go! I raised you for this time." He pushed me gently, and I clung to his legs with all the strength of my little arms. He bent down, kissed my head, and turned me in one direction, and I didn't look back anymore. The grass diminished as I walked. When I had been walking for some time, I started to play over the grass, and when I looked at my hands, they were those of an adult.

On the way out of the field, I had a more panoramic view that was taller than the grass. I got scared. Everywhere I looked was a huge green field; now everything was dry. The road had a cloud of dry dust, and everything was ugly and sad. The loose dust started to get under my sandal, making me realize that I was no longer barefoot. I was wearing shoes! I didn't know what to do, and I stopped, petrified. The sound of dry grass started to come out, and I turned to one side and saw children leaving. Then I saw children appearing on all sides; children of all ages came towards me as if they were expecting some direction. Then they started to approach, holding my hand in the hands of the others. So, I started walking, and they followed me.

Two days later, on November 17, 2014, I painted a canvas of my dream message. Eight months later, I took over the children's ministry of my church in Waltham and stayed for a little over three years, leaving it well structured. In my second year of leadership, I witnessed the dream I had in the very rustic painting. I thought the central message of that dream was for the children's ministry only, but in 2016, I published my first bilingual children's book. By writing this book, I could see that children are Christ's children because everyone, even the elderly, is His child. My artwork has directions that I should pass to God's children of all ages—that is, all those I can reach. The painting of the encounter with Christ is in my first book, *Nothing is Impossible*, on page four.

Dreams in the Bible

In the book of Joel, the prophet calls the people of Judah to repent for their vision of a cloud of locusts, which was God's judgment for the wickedness they lived. The prophet calls for repentance to get deliverance. When he speaks of the blessings, the dream is among them. God promised to pour out his spirit upon them, that sons and daughters will

prophesize, the old will have dreams, and the young will have visions. Then he said that they will show wonders. The dreams are within a promise that includes prophecies and visions to see the wonders that God wants to show all people.

In the book of Acts,[144] the day of Pentecost[145] refers to the feast that took place seven weeks (fifty days) after Passover and the beginning of the harvest. It was a party to celebrate and thank God for the first fruits that the earth produced. That same day, the Holy Spirit came, and the first fruits of the Church were reaped. Through the outpouring of the Holy Spirit came the fruits conceived by transformation as a person and follower of Christ.

"Dreams have a prominent role in religious literature…In ancient times, dreams, primarily those of Kings and priests, were believed to convey messages from God. In the Bible, dreams are prophetic in nature," states Ronald Youngblood. "Since the Old Testament and also in the New Testament, God communicated with those who believe in Him through dreams.[146] God spoke often through prophets, but dreams were used directly with some biblical characters, like Laban,[147] the uncle of Jacob,[148] who became Israel, Joseph,[149] the son of Jacob, Gideon,[150] Abimelech,[151] the king of Gerar, Solomon,[152] Archelaus,[153] the king in Judea, Joseph,[154] husband of Mary, and the wife [155]of Potiphar.

In addition to dreaming, God also gives the gift to interpret, like in the case of Joseph, son of Israel, and Daniel. After Jesus's resurrection poured out his spirit on everyone who believed, as the prophet Joel said, the gifts are not just in the past. For those who believe in this promise and have a personal relationship with God, the promise is extended, and dreams are in its midst. It isn't every day; it's not about things I can work out myself. "The prophet who has a dream counts it as only a dream; but he in whom My word is, speaks My word as truth. What is the straw with the wheat?—says the Lord" (Jeremiah 23:28). Both the context of this chapter and this verse allude to the seriousness and the danger of misrepresenting what is divine and what is mine. I'll point out again that my dream is about me. I am a natural being, and therefore everything related to me is genuine. What is divine can happen, but it is not to make me fanatical. The Bible is for my everyday revelations. If you want to know more about God, read the Bible, listen to it in audio, and

[144] Acts 2: 14-17

[145] Pentecost means 50 days. Pentecost was also called the Feast of Weeks or First Fruits.

[146] Youngblood, Ronald Illustrated Dictionary of the Bible. P. 1359. Ed. New Life. São Paulo. BR. 2004.

[147] Genesis 31:24

[148] Genesis 31:11

[149] Genesis 41:15-16 and Genesis 37:9

[150] Judges 7:13

[151] Genesis 20:3

[152] 1 Kings 3:5

[153] Matthew 2:22

[154] Matthew 1:20 and Matthew 2:12

[155] Matthew 27:19

always reflect on His word. As much as I want to receive a message from God every day, it only happens when it has a specific purpose for His glory, not mine.

Spiritual dreams are for discerning a prophecy, for giving warning, comfort, exhortation, concert, reflection, preparation for one person or for a group. Never forget that it is very important to remember that dreams are entirely natural. Dreams have to do with what I'm living now or something that my unconsciousness wants to reveal about me. "The attitude of attributing the origin of all dreams to God is religious and always seeking a special meaning for its content is hazardous,"[156] said Pastor Alberto Timm. The dream has a primordial part in my spiritual and secular formation. On the spiritual side, dreams can be an answer to prayer. On the secular side, a re-analysis, either personally or of some situation, is not always about me but involves me somehow. Most of the time, it is a correction, direction, warning, comfort, and preparation, because I can't see clearly when I'm awake. As my mind's dream is free of distractions, I can see my mistakes in a more focused way. As science says, a decision, direction, or simply a better idea in the subconscious is from the more innovative version of myself.

> *"It will come to pass after I will pour out my Spirit on all flesh: your sons and daughters will prophesy, your old men will dream, your young men will see visions."*[157]

Learning to float
In life changes, to good,
Others to make it worse.
Sometimes finding something suitable,
Or to destroy.
Walking in a long desert,
Or be in a storm at sea.
I fell in a river,
Oh, me who couldn't swim.
But because I'm sinking,
I soon learned to float.
Giving up is suffering twice,
I prefer not to retreat.
The intensity of my will is what makes me arrive.
On the other side of the bank,
Where I want to be.

[156] Pr. Alberto R. Timm, Ph.D. How to discern dreams. bíblia.com.br.
[157] Joel 2:28

Chapter 16
Learning to float

Even though you are uncertain where to go, continuing is better than going back through the old painful paths.

Floating

There are good changes in life and others that make it worse. I fell in a river, and I didn't know how to swim. I had to learn to float, or I would drown. What made me survive this far? And why can't I afford to give up? It would have been easier to give in to my depression rather than paint more than 350 canvases in five years and publish four books in four years. Of course, the easiest is convenient. As my oldest son's friend Mike says, "I'm going to cry until my problems go away." Tears should wash away problems or drown them, but it is the movement of attitudes that makes them disappear.

I've been through perhaps worse experiences, such as in the chapter "The Pulled Rug," or when I fell into the river. I think every lie I was living was true, and when I saw what was under my rug, it was all sorts of dirt and lies I had forgotten. I lied to myself because the truth about myself hurt immensely. Anyway, these two metaphors are just announcements of chaos on the way. Giving up is suffering twice; I prefer not to back down. I couldn't back down because my kids were looking at me, and they needed an example of strength in their lives. I don't need to be an inspiration for a community, a city, a state, or a country. But I need to be an inspiration in my home to those I love the most in the world. I was not thinking about showing my children how to stand up. I didn't have the option of drowning when I fell into a river. I had to learn to float and survive when everything seemed like death. Learning to float is an arrow that the more it is pulled and tightened, the farther it goes. The intensity of my will makes me reach the other side of the bank where I want to be.

When I worked at one business for three years, someone committed suicide. First, a lovely and cheerful man always received me with a "good morning" and a smile from side to side. But only he knew how his soul was in pieces. Only he knew that he could no longer continue across the bank. I never thought that someone suicidal was weak or cowardly. I think this person has more courage than anyone who lives by inertia. The pain of a person who gives up is unimaginably more significant when they feel they can no longer take their broken soul.

The second person to commit suicide was a very beloved nineteen-year-old; she studied marine biology at one of the best universities in the South of the country. She had it all, financially speaking, always smiling and making everyone laugh. But inside, she couldn't stand to cry anymore.

The third was a woman in her late fifties with five children, two under twenty and just entering college. She was delightful, but she could not keep going on, either. To these people, I leave this paragraph of regret for the people who miss them. Because their beautiful existence left those who they loved many happy memories, but they didn't want to feel pain anymore. An external wound hurts, but one on the soul is unbearable, and many of them are incurable to the point of making the person who is carrying the wound want to end their own life. Never criticize those who couldn't stand it as I did. We don't know how much pain their wounded soul suffered in silence.

Changing with an injured soul takes years and has a purpose far greater than the pain. Because I was sinking, I learned to float, but many feel so much pain that they surrender to the bottom of the river and stop fighting. At a liberal arts graduation, David Wallace said, "There's no such thing as an atheist, everyone believes and loves something."[158] Maybe it's not a god, but something moves them forward, and they rely on their beliefs for the path ahead of them. On this day, he inspired many young people. Possibly, he keeps his words of encouragement, but unfortunately, years later, he surrendered from his painful soul and took his own life. You must make it work! I must make my time in this generation count for something, somehow. I must honor the gift of life given to me by God. He invested in a person as miserable as me, and He called a worthwhile daughter to walk with Him side to side. However, when I discover my purpose in this life, a "compass" will show my direction. Many people come and go and, unfortunately, never find their goal.

"Listen to your life! It's the most important work of your life. Know what's working well for you and what's missing. Be aware of where and why you might be hurting or feeling dissatisfied; knowing what you need to release and what you need to get more of,"[159] states to Brenda Wade. Finding out what I came into the world for is a priceless question. Some spend their lives guessing, and others don't even think about it. The moment when I finally discover what the purpose is on this road of life is a long way away, but in knowing the right direction, one is no longer lost.

[158] Wallace, David Foster. Speech Kenyon college graduation. Gambier, OHmaio 2005

[159] Wade, Brenda, Fear of Abandonment, Vol. 25 Issue12, P. 79. 6p. Articles 0014-0880. Apr 1995.

Am I?

To find purpose in this life, I need to get rid of many things—mainly the ones that add pain and dark feelings to me. Envy is the biggest war I have fought. To be a resilient person, I need to go in one direction. This harmful feeling makes me compare myself with people I'm not, things I don't need, and paths that took me away from what I need to focus on doing. For drastic changes, I need to do a deep analysis of myself, but not with judgments that blame everything bad that happened to me. I lived in times when I was hostage to stories and people who controlled my life. Today, as an adult, I need to learn to float. In other words, I need to be resilient to what I wanted to deteriorate. Envy comes from the frustrations of everything I couldn't achieve. To learn how to float, I need to be light, and envy will weigh on me in this mission and can take me as deep as possible.

In chapter 12, I spoke a little about envy as a seed of bitterness from unusual trauma. In this chapter, where I had to live with what was left of me, I couldn't leave envy out of it. It was tangled in with the problems I lived with day after day until I could overcome it. When traumas are suffered, the fatigue of losses will certainly bring bitterness, which in turn will always make envy speak louder. I confess that I have had to deal with envy my entire life. I always treated it with a "breezy face," as if it wasn't me. Everything was designed out of my frustrations at not getting a lot of things I wanted.

After I met Joy, I was confronted by her, and I had to rethink this feeling that came with me as a legacy. I remember that the first time I cut the legs of envy was at lunch with friends. I had just split up, and one of the two friends commented on something beautiful that her husband did for her. My bitterness came bouncing around in the form of envy, and it wanted to eat me up inside like a snake with its venom. That day, I had had enough! I replied with a forced comment: "How wonderful! I'm very happy for you." I didn't want her life, let alone her husband or her happiness. I felt jealous that I couldn't be happy like her. And instead of poisoning myself, I countered my feelings with a good-for-life wish for her. My fight with envy was not in the past. I admit to suffering today. I may not control it in myself, as it sometimes unwittingly catches me off guard.

What I don't allow myself is to let this feeling manipulate me. I am the boss of my feelings and not the other way around. The key for those who discover that their purpose has envy is not to be envious. The feeling is something involuntary, not chosen but imposed. Envy comes as a reminder of past failure. Envy spawns when you have a target to reach and a defined character dynamic. However, having priorities other than chasing is perilous when there are deep roots of unrecognized and untreated bitterness. At this point, the fury takes a stand and attitude, like that known phrase, "If I can't, neither can you." This is already on another level; you will be envious if you know you are and don't want to fight against it. The feeling of envy is the master of the person when they can no longer act, and they let envy flow. I was often envious of women's nice dresses, jewelry, and expensive bags in my church parade on Sunday service. But later, I put myself in a dome and isolated myself from things like that.

It didn't shake me anymore after I understood that I must continue towards what I believe is more important than that kind of thing. Envy comes, I admit it, and I move my thoughts. Controlling what wants to dominate me is a daily struggle, and envy does not surrender. I obviously have my priorities, and I can't let anything stop me. I need to get to the other side of the bank, where I want to be.

Thomas Crum wrote about clarity of vision, and to see clearly, we must first find our life purpose. "If you're going to use the power of visualization, it's important first to discern your true purpose."[160] These words in Portuguese have a precise meaning. Moreover, envy and jealousy are semantic ambiguities, but not the same emotions. As unpleasant as it can be, envy usually doesn't contain a sense of betrayal and resultant outrage. Jealousy does not need to include an acute sense of inferiority. Lamentably, when I feel jealous, I frequently feel envious as well. Among many explanations on how to find bliss or complete happiness, we need to find out what brings us peace. When our happiness is found, we want to share with the world what makes us so good.

The way to follow this path can be very difficult. I was called to learn to float. In times when you can no longer fight and flee, it is impossible, and reality must be faced. "As it usually doesn't work for fighting and it usually doesn't work for running away, it flows." [161]Here is the critical point for acting and not surrendering when you can no longer run away: the intensity of our will is what keeps us reaching for the other side of the bank, where we want to be. Or perhaps our will isn't as strong as our desire to be on the other side. Three things will happen: we will try to return even at the risk of dying on the way, we will die in despair, or we will learn to float

Rediscovering the superpowers

We are born with superpowers to be happy by doing things we love. When we grow up, we let go, but we must follow a path to discover or lose at some point. Be aware that recovering these lost powers is the way to "follow my happiness." To pursue my happiness, I must break all the chains that prevent the opening of doors or windows that close my mind and heart, destabilizing my soul. The destabilized soul creates chains, and I cannot go anywhere in chains. An unstable and hurting soul creates emotional currents that will prevent me from finding perfect happiness. I must be free of grudges and have a clear heart and mind to initiate joy from the inside out. According to Joseph Campbell, "Follow your happiness and the universe will open doors where there were only walls."

Joseph Campbell's father took him and his brother to see a Buffalo Bill movie about in the wild west. Everyone was paying attention to the lead actor instead of paying attention to the cowboys. The Indians took Joseph's full attention, and from that moment on, he sought to learn more about the Native Americans. He found a passion for stories about differences and increased his knowledge. Thereupon Joseph Campbell wrote, "They were

[160] Crum, Thomas F. *The Magic of Conflict*. P. 196. Touchstone. New York. 1987.

[161] Crum, Thomas F. *The Magic of Conflict*. P. 202. Touchstone. New York. 1987.

fascinated, apprehensive, obsessed with the figure of a naked Native Americans, with his ears to the ground, a bow and arrow in his hand and a look of special knowledge in his eyes." In an effort to find out more about American Indians, he would read every book in his neighborhood library on the subject by the age of ten. The passion of Campbell is just beginning for history, culture, and myth behind the masks, beliefs, stories, and ways of life. He was forwarding his studies on mythology and the continuous search for his purpose and complete happiness. He aimed to influence many writers and film directors, and he inspired many with his passions and by looking for total satisfaction. In his journey to discover his happiness, he found a word written in Sanskrit Ananda that means happiness, enjoyment of joy, and bliss.

The ancient Hindus believed that you must be honest and aware to find happiness when you face the end. In Sanskrit, "sat" means "being, existence real, real true, good, right or that which is, existence, essence, true being, really existing, good, true." Cit means "awareness." There is a word, Ananda, which means "pure happiness, other scholars translate Ananda as 'bliss.'"[162] According to Campbell, "They try to interrupt an experience through their ability. But three concepts are those that approach this emptiness: Sat-Cit-Ananda, being conscience and happiness." In his study of myths and expert history, Campbell says that the hero's journeys are the same. At all times, entomology or faith can relate to something, no matter where or what it is. Campbell calls it "the journey of a hero," and he found that every hero (you and me) lives the same saga. It starts when everything is apparently alright, even if something is missing. It's alright but incomplete. Then begins the journey to seek "bliss," and the need for this full joy makes the hero move from good to magnanimous. According to Campbell, there are three main stages: departure (or separation), initiation, and return. During the story, the hero is introduced as he is trained and prepares for his journey.

In Campbell's examples of initiation, the hero leaves his city and goes into a dark forest searching for the unknown. In the initiation, he must find the monster he needs to kill on the path to conquer victory. After the monster is defeated, the hero returns with his identity and the potential to destroy all monsters that appear. Separation is when the hero lives in his known life and is removed from this reality by an unknown adventure. Initiation is different from the hero's reality, and the hero's return is when he wins his challenges and returns transformed. The hero faces his call on his journey into danger. On this journey, he encounters terrible things that he must struggle with. Overcoming all the obstacles in his way, the hero brings his conquest to his people and shares it with them. It is not enough just to find the hero's identity and have victories over monsters, but his victory ennobles his king, people, and family. It doesn't have to be an incredible story to find our happiness, and it may be expected, but the way to find it is the same. We all must see all the tasks with "the hero's journey." This journey can begin with a simple snap of the fingers or in complete chaos. The hero needs to wake up and find his identity, whether in an intense or a soft way; regardless, the journey has to happen.

[162] Joseph Campbell. *Pathways to the Bliss*. Vol 16. Readhowyouwhat.com. 01.02.2004 - Finding Joe. Patrick Salomon. September 2011.

We will be selected or pressured into situations where we are dying or transcending. My journey start when I decide to leave my grandparents' house to my first union. There, I start see monsters, although I just hide from them. In the middle of my hero's journey, I found Joy, and she taught me how to fight, open my eyes, and see my potential. Later, my journey to become a hero was outside my country. The monsters continued to appear, and I confess that I kept hiding until the biggest one appeared. This monster wanted to devour me. It was a disguised monster called codependency. It took years of struggles until, with the weapon of art and strategy learned in countless defeats, I finally won. I bring this victory from my journey to share with you my dear reader.

This fight allowed me to see my superpowers and discover my strength and creativity, which allowed me to paint what I dreamed of when I slept, as well as my dreams, failures, anxieties, and pains. And painting was a door not only for healing, but also for aspirations. Through paintings came books successively. I had no idea I was capable of all these things. This whole process gave me the emotional stability to meet my "bliss," or complete joy. My total happiness came from my total awareness of the absolute self-love that is the basis of full joy. It is worth mentioning that my victory points to the king that I am below.

We are born with superpowers to be happy doing things we love, but on some occasions, I learned how to be miserable, following whatever makes me lose that power. Losses, like that of my superpowers, come when I try to find an adult place. Our lives are more dangerous and less dangerous, to the point where we miss something and need to start looking for a way to find what has been lost. Comparing a story of superheroes, like Batman and Superman, it's curious how Batman uses a mask to transform himself into someone he isn't. Superman is born super. Still, he needs a disguise to transform himself into someone he already is. They are opposites in this comparison. Even with Batman's technology, when everything goes wrong and he almost dies, Superman, who is the one who has superpowers, must come to save the "allegedly powerful" from being destroyed. My superpowers have been within me since I was created. However, the cover that situations create for me to wear throughout life makes me forget that I am super. Something needs to happen for our hero's journey to begin. I need this change to ennoble my people and my king, if I have one.

Fear is a comma, and love is the period.

I grew up listening to metaphors and fables as a life lesson, and in the same way, I did it with my children. Fear cuts me from growing up not because I'm cautious, but because I'm afraid I'll suffer the disappointment of failing. Even today, at forty-seven years old, I still don't know about anything, but my sixteen-year-old son knows, "according to him." I can leave out good things that may come into my life out of fear. Out of fear, I keep decisions that can improve my life and that of others. Out of fear, I won't change after a conflict.

I continue to live in my comfort zone because it is risky to change out of fear. Fear is a comma that keeps me in the constant motion of inertia. It keeps it day after day with no different path, because the insurance is to stay with the team that I think is winning. To

write a new story, the old one must have an endpoint. Something must end for another to begin. For fear of the unknown, I conserve my life through inertia, which, according to chemistry, is a substance that does not react when it meets another. I will never write a new story if I get stuck adding commas in this same story. I lived in fear; I postponed my life to a new era of development. I was too scared to put an end to my old account. However, my children needed a leader, a role model as a mother. My love for them was more powerful than my fear, and that love put an end to my fear. My self-love helped me because it was bigger than my fear of change. Thomas Crum said, "Let's understand how all people are operating in one of two ways: fear or love."[163] I strongly agree because I have lived in fear for many years, continuously adding commas and living incessantly in the shadows. The love for myself and my children when I lived in the shadows became light.

Love enables me to make decisions and get out of inertia, both for myself and for others. Love itself makes me someone without limits. When love is related to who I love and who depends on me, I will remember my superpowers. This is mainly in stories of conflicts where change does not occur, because fear seems more powerful than anything. If importance is given to fear, this feeling will continue to place commas in the same cycle. I've been in a situation where love for my children put an end to whining and pity and made the mask created by the various sad circumstances fall away. This was a moment when my self-love (my superpower) was greater than my fear. Only then did I start to notice my evolution. Love is a period, the final punctuation that ends one cycle, making me change.

Discovering the power of self-love

Self-love and selfishness can be confused, but they can often come from the same ground as trauma. Shocks can lead to two extremes: self-love and selfishness. They may be confused, but when the person in question tries to disguise the selfishness of self-love, it is elementary to notice the difference. Self-love is healthy, not selfish. Egocentrism arising from trauma puts the injured person on the alert in case of attack. Having gone through many discomforts, she always tries to protect herself in a costume of loving herself too much. It comes from the narcissism that always has been around her. Going to the extreme of selfishness will always make her see everything related to her. Love for others has to do with who she thinks she is—that is, a good person. This person, shrouded in selfishness, will always give and expect to receive it back or will wait to be shown that she made the other person what he is. I felt in my skin the entrance of selfishness in me caused by the trauma. For a few years after the shock of learning about my codependency, I armed myself in the guise of self-love, but walking with Joy didn't allow me to continue the mask; it had to fall.

I learned to love myself and not allow anyone to hurt me; I was becoming selfish. After my first art exhibition, some people got inspired and started to paint and do small shows.

[163] Crum, Thomas F. *The Magic of Conflict. No Boundaries.* P215. Touchstone. New York. 1987.

After doing live painting presentations at conferences, people started calling me for ideas. Those who lacked the courage asked me to investigate, and much of what I created, they began to copy. They had already stopped just as it started because the ideas that passed on had already been exhausted. That started to annoy me, but even so, I gave some information and ignored others. After my second book was published, it was the same rain of people wanting to know how to print, illustrate, value, and so on. I got mad because I remembered that nobody helped me, and why didn't these people try to do their thing without bothering me? Annoying, envious people! Why don't you look for your means like I did? Well, I went to complain to God, and the answer was, "I'm creative, and my clever daughter doesn't keep for you what you've got, because I'll always give you plenty of ideas. New things won't be lacking for you. Don't be worried about being copied, but be happy to be an inspiration to others." Today it doesn't bother me anymore because I live without time to carry out the many ideas, and I know that my God is the basis for them. The same passes on to you: don't worry, because what you copy will always be copied, and what you create will continue to be made.

As for self-love, I love not only myself but also my neighbors, wishing them well and rejoicing in their achievements. As for love and freedom, I will not judge those around me. I respect the other's freedom of choice and that love leaves the door open. After all, the world can criticize me if I'm less than one; I'm already playing my role of love. When I discovered self-love, I was surrounded by a feeling of great peace, knowing that what happens outside does not take away my peace and does not corrupt me or make me selfish. Selfishness is replaced by empathy, remembering that someone was projecting what is inside behind every attitude. I love to continue helping those who want to be supported and loving those who want to be loved, particularly forgiving those who don't even think they need to be pardoned.

Complete joy comes from my absolute awareness, knowing that my self-love is the basis of it.

Floral blouse

The closet is full of clothes, a blouse I loved.

Special to me.

Vibrant, cheerful colors, floral print, delicate fabric on my skin.

The model accentuated my body with high-quality stitching.

Light, soft, perfect! Matched everything.

There's nothing that won't go away with time...

Time doesn't forgive; it punishes all.

Buds of it started to fall out.

The colors of it overshadow.

Needed patches.

I sewed threadbare holes as if they were small embroidery.

I am trying to hide the damage of time.

My blurry eyes can't see the needle whole anymore, not even seeing the beauty of the blouse.

My glasses helped, assisted by the thread.

I mended and mended the old blouse.

I didn't want to give up the beauty I had once had.

It takes up space in the wardrobe, not giving room for a new blouse to come.

So many repairs hid the wonder.

Faded, you couldn't even see the color of the past.

It hurt to wear it.

Badly fell where it no longer had curves in my aging body.

The fine material went rough.

With pain, I bid farewell to my old blouse.

Time has taken my silhouettes and my favorite floral blouse away.

Sadly, I am finally aware some old things must go.

Thus, making room in my closet, newer, happier flowered blouses came.

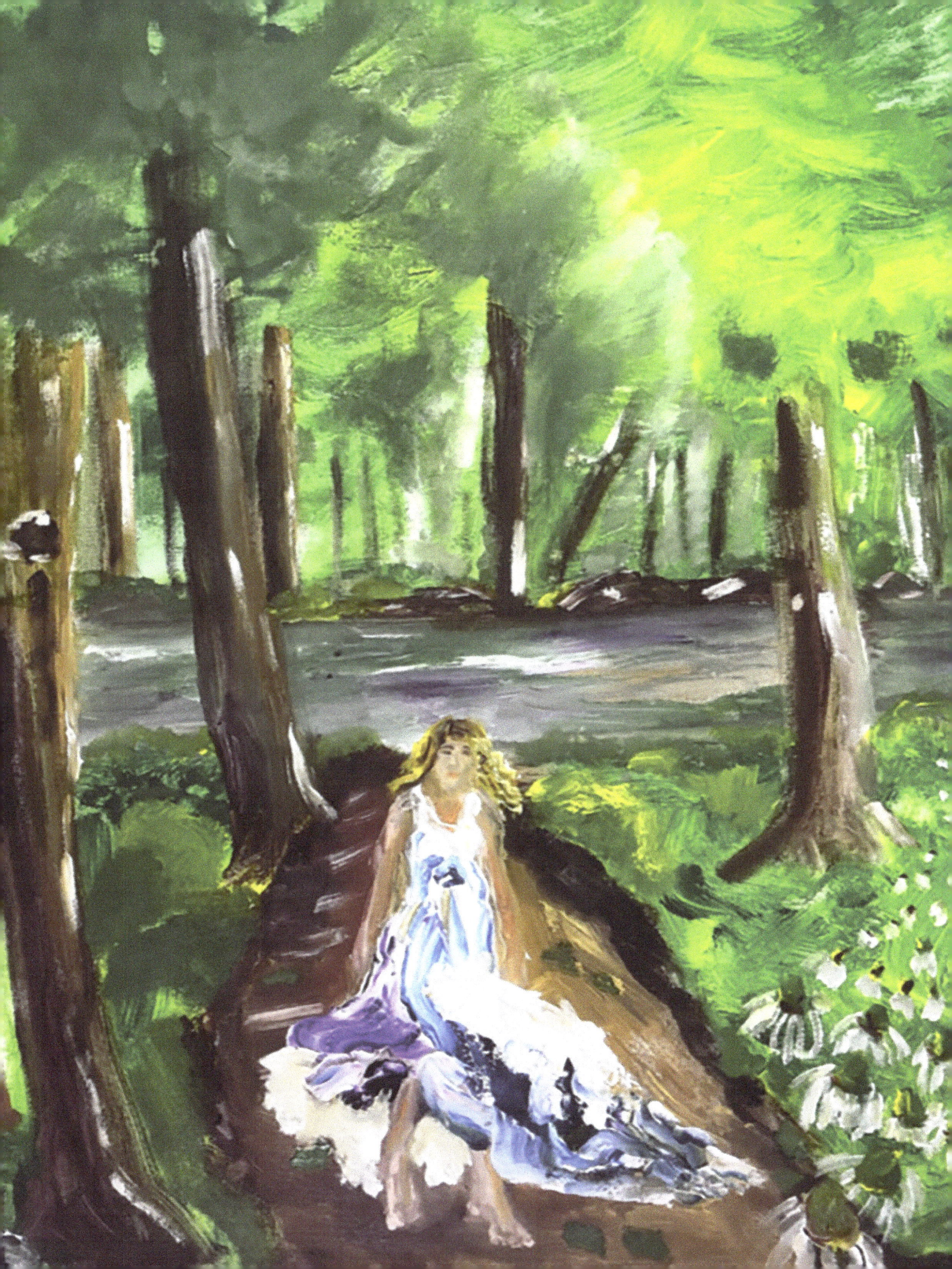

Chapter 17
Forgiveness

We are waiting for a great miracle, forgetting that we live it every day.

The act of releasing the anchor (forgive others)

If the world were all ocean, my life would be a boat and my emotions an anchor. The heavier it is, the less I can move. I must have a propositional anchor, according to my ship, but I am not free from the anchor. When it hurts, pains that I accumulate affect me and end up making my anchor heavy, which concerns my boat. If I don't get rid of the pain, I could be affected or destroyed. The destruction depends on the amount of weight and the size of the anchor I carry. If my anchor controls me, it must be cut or replaced. Forgiveness is the act of cutting the heavy anchor and replacing it with one that doesn't affect me. Forgiveness is the cut in the heavy anchor that puts my boat in danger—in danger of getting stuck in storms, at risk of never moving to better places.

According to Alexandre Versignassi, "Action and reaction the water displaced by the vessel will sustain it. If a boat has a thousand tons, its volume must be large enough to displace the exact weight of water. The liquid will react with a force equivalent to thousand tons but opposite the ship's weight. This countervailing force balances things and makes the boat float."[164]

The sea of life will play its part, and the boat will follow my course. Without the heavy anchor, I will be light. It's not just about forgiving others; it's also about forgiving myself. The worst of the anchors are the ones that cannot be cut by me. Someone else's grievances are carried with me. I become their anchor. When I release forgiveness, I am also free.

[164] Versignassi, Alexandre. Super interessante. super april.com.br. Jul 4, 2018, 8:13 PM - Published on Apr 18, 2011, 6:54 PM

I even forgave others for a good part of the time, but I held myself hostage to my heavy anchor with no idea how to cut it. The need to forgive ourselves causes us a great emptiness, and we don't know where it comes from. His complete joy fills man's vacuum in general. It is challenging for anyone to find their absolute happiness when they feel empty. This emptiness can be filled with self-forgiveness and God. Not necessarily in this order, most of the time—we can't forgive ourselves without God. And forgiveness empties me of hurtful feelings towards other people. With self-forgiveness, I empty myself of all the harm I've caused to myself by opening myself and allowing God to fill me with his peace.

It is exceedingly difficult to forgive those who have deeply hurt us, like those who have caused us traumas that wrought even more destruction. One of Jesus's ordinances seems simple to 100% man and 100% God. I am 50% of the totality that God created in Eden, or less, possibly. Although the first man, according to the Bible, lived close to 1,000 years, and I am forty-six years old, I already have one foot in the grave and the other on a banana peel. Maybe I should lower this 50% man percentage a lot more. I believe that not forgiving those who have wronged us is the worst thing we can ever do.

Upon meeting Joy, I was able to understand more about forgiveness. Speaking of percentages, forgiveness would be 80% for my benefit and 20% for the person who hurt us, or 100% for those who will never acknowledge wrongdoing or will never know that they have been forgiven. Forgiveness is an unnecessary burden that we carry for years. It's an enduring bond with whoever caused me harm. By ignoring it, I sever the connection with the one who hurt me. I become light and free from my imprisonment of the damage done to me. I release the person, and they have no pain in me in the past anymore.

Forgiving sick people

Pedophilia

Traumas are caused by people's actions and our forgiving actions to rid ourselves of traumas. It doesn't matter how hurt is unconsciously generated by traumas that we can't avoid. When you know yourself as a person, you are more merciful to others. It is important to note that I have already gone through an unfortunate situation and survived. I cannot allow whoever caused me harm before to continue doing the same thing to this day. If I don't let go of that anchor, the case remains with me. With the anchor of this evil attached to me, it will undoubtedly continue to haunt me. I understand that it wasn't my fault and that the person's act had to sink into the sea. For this, I need to drop this anchor, getting rid of the person and the harm she caused me. After all, I don't live anymore in this time, and she can't do any more damage to me. So why do I keep giving it importance? Why do I keep allowing her to haunt my present if it belongs in the past? This would never happen if this anchor was cut!

It's necessary to search my memories for what binds me to them to solve traumas and to destroy what is required to face them. Unfortunately, some traumas are like shadows. To meet what is obscure must be brought to clarity. If they generated moments, we were

aware of, it's easier, but unfortunately, some happened in a time of innocence. These only leave deep marks and the memories hidden for my self-protection. My consciousness is still very innocent, but the memory in a shadow protects me. The problem is that what's in the shadow can't be treated if it doesn't come into the light. And this shadow will not go away if it's not identified and faced. I also had to find out why it turned into a shadow to free me from this shadow. And to understand more about the subject, I had to look for specialists, study to understand better what I was facing, and search for memories that turned into shadows. I needed to dig a little deeper. By learning to read several expert opinions, I could understand a little more about my case.

The brain is like a building; the library within that building is the mind. The books are the memories. In this library, new books arrive, and old ones are stored. And outside the library are the people who may access the books and give their opinions about them. They watch and contemplate what's in the books, but they're not part of the library. These people are the conscience. They can't see in the library, but they will find the archives sooner or later. This information cannot be read, observed, or enjoyed, because they are outside the mind, not stuck in it. People (consciousness) are on the outside of the mind in order to view the reason.

The library has three floors that we call the mind. At the entrance of the mind on the first floor, the information enters, which is divided into separate sections. The new ones are further ahead, and the older ones are further back. Memories can also retrieve memories. For example, if I read a book, I might remember another. Scholars' theories on memories propose a memory system divided into three sections (like the library floors). The memory system is divided into sensory, short-term, and long-term memories.

Sensor memories (or sensory memories) last for about a few seconds. The sensor memories are kept for a short time, and then there is no way to recover them; they will be lost forever.

Short memories are the ones I must work on keeping—for example, learning a song. However, they will pass to the long memories section because I am working on them. Sometimes memories seem to fail me because they are not processed well. Following the library metaphor, a book can become lost because it is not kept well, perhaps because it didn't matter when it was received. Short memories are saved by being trained, worked on (rehearsing and studying), and forced to remain.

Long-term memories are procedural and declarative. Process memories are skills and habits, such as riding a bicycle. Declarative memories that provide information are episodic and semantic. Episodes that remind me of events and semantics are the facts I learned from birth to the present.

Some memories are stored when I am not conscious. They are explicit and implicit memories; the way to retrieve the long memories are to separate them into explicit ones, which are the intentional ones we want to keep. Explicit memories are retrieved or recognized when related to them. We renew our memories when we remember a date, an image, a song, or even a smell or taste.

These are different from the implicit memories that I unconsciously store, which later affect my behavior and performance. I may be inattentive, medicated, or not understanding, like a child. Those memories are lost and can only be found by some stimulus. Implied memories can also get lost by affecting me at some point. If they become recognized as needed, they will appear. And as long as the people identify me, this is where I want to go. A kind of temporal amnesia is hidden by a traumatic situation, both emotional and physical.

The autobiographical memory is the one that is most related to me concerning what I'm going to report. These are long-term, episodic memories that I hide from myself. It's a psychogenetic theory that amnesic memories are forgotten because we need an escape. According to Robert Feldman, "Autobiographical memories are our reminders of circumstances and episodes in our own lives."[165] Adults retrieve memories that their memory has hidden. We tend to forget those memories to protect us from situations that we don't want to remember. These memories can be retrieved through a stimulus. Most adults have memories of episodes from early childhood, some even as young as six months old. And most of these memories are hidden by us.

They are related to shameful pain. The library in my brain keeps these memories in the back of my mind so I don't remember them. The library of my mind keeps these memories in a dead archive section. These memories could be retrieved to work on emotional healing. They are forgotten for our well-being and were acquired most of the time in a state of unconsciousness. Your recovered memory will usually bring pain. Disgracefulness may be the only way to treat an unconsciously acquired trauma.

Traumas are formed unconsciously and can take years to resolve. I compared people to consciousness and a library to the brain. The brain depends on consciousness, but it is outside the brain (the library). Just as there are different types of people, there are also different levels of consciousness. Thinking about awareness and being aware of what happens around us creates memories. But there are several existing levels of consciousness: consciousness, preconsciousness, subconsciousness, and unconsciousness. In this chapter, I want to highlight three of them.

First, consciousness is when we are aware of what is happening. Second, pre-consciousness isn't used very often, but we remember when that memory is needed, or it is activated by things we hear, feel or taste. By hearing a song, we remember some occasion, or when we eat something or feel the same way, we will activate the pre-consciousness. And the third thing I want to highlight in this chapter is unconsciousness. The unconscious is one of the observational levels of memory where I am not aware of what is stored. It may even seem non-existent, since the information deposited can often be unknown to me. Or it may have been acquired when I wasn't so aware in my childhood, for example. "The unconscious is the object of constant study with Freud. He thought that the unconscious

[165] Feldman, Robert.S. *Understanding Psychology- Mood Disorders- Major depression 9th.Ed. pp529.University of Massachusetts, Amherst. McGraw Hill. Boston, MA.*

stored all the memories, thoughts, and emotions too disturbing to be aware of. He considered it a realm of secrets that held the key to unlocking an individual's identity, desires, and personality,"[166] wrote Lynda Warwick.

This warehouse is visited when I am in an altered state. Like in hypnosis, something alters my emotions in a way that I end up pulling up a deposit that I didn't even know. These memories are in this archive to get rid of events I shouldn't remember most of the time. By doing this, my mind defends me from episodes that will bring me stability without repairing power. In times of trauma, I really can't keep dates anymore, but I can remember how old I was. For dates like the month or day of the week, or even the year, I need to do the math on how old I was.

My most considerable burden came disguised in a dubious memory, stored somewhere hidden from myself to prevent further pain in the future. But the biggest problem with this is that you have a wound caused by something because of your self-defense mechanism. When we face moments that we don't want to remember, the mind helps us by erasing all memories related to the event. According to Josiane Moura, the mind "remembers that it is convenient that uncomfortable representations, evoked in the subject's acts, thoughts or behaviors, are considered as not having existed."[167] For this, the subject puts on other acts, thoughts, or behaviors designed to erase everything linked to uncomfortable representations.

I have no memory of anything that happened in my childhood from the ages of two to seven. Some fragments came to my mind, but I denied them and made them remain hidden. When I painted for long hours, I started dreaming about fragments of the past. I tried to put it back into the occult, but the more I cleared my mind in my time painting, the more the memories came to life. Here begins the first anchor-shaped pardon that held me for forty years.

"Although those who commit sex crimes against minors are often described as 'pedophiles' or 'predators' and considered adults, it is important to understand that a substantial part of these crimes is committed by other minors who do not fit the image of those terms,"[168] according to an article by Finkelhor, Ormrod, and Chaffin.

When we moved to Pará from Eunápolis, Bahia, my grandfather built a small house on the farm until he built his dream house on top of the hill. We had a huge, very comfortable home in town with two big bathrooms and four bedrooms. My grandmother would take us all to the farm on the weekends. The first house was a tiny yellow house with blue windows and made of mud with chipboard tiles in front of the corral; the floor was very fresh with burnt cement. After mopping the house, my grandmother brushed the floor with steel wool until it gleamed.

[166] Warwick, Lynda, L, Ph.D. Everything *Psychology Book: Origins of the human brain*. P. 89. 2004, ISBN. 13:978-1-59337-056-5, United States.

[167] Moura, Joviane Aparecida de. The Ego Defense Mechanisms [online]. Psychologist.com.br. May 23, 2020.

[168] Finkelhor, David Ph D. Ormrod, Richard Ph D. Chaffin, Mark Ph D. *Juveniles Who Commit Sex Offenses Against Minors*. US Department of Justice. Washington, DC. ncjrs.gov. December 2009.

Through the front door was a small room with two small red sofas and a third large one that could turn into a bed. In the corner of the room was a vase with peacock feathers created by my grandfather on his farm. Even today, I hear the peacocks singing. To the left side was a small room with three beds: my father and uncle's room. A few steps further on the left side was a bedroom with two double beds and one single. In this room, I slept with my grandparents and two aunts. There was a small kitchen with a gas stove and a white wood and painted clay stove. Near the window, a clay water filter and clay pot sat at the top of a long, tall wooden stool. It was from a reserve of freshwater to the heart of the north and was the tastiest water I've ever had in my life. There was a small table with four chairs, and when leaving the house, there was a very tall tree with excellent shade on the left. Under the tree that was the end of the day's meeting. There was no television or electricity yet, so we had plenty of time to talk. I didn't because I was the youngest, and where adults spoke, kids had to be quiet. For a long time, it was a reign of peace until the "friends" appeared. "Parents should be aware that, in most cases of sexual abuse involving children, the abuser is someone the child knows,"[169] states Blanchard.

There was a family of a very humble widow in the town house who, if I'm not mistaken, had eight children and five women living with her. Being a back neighbor with my grandmother, they ended up becoming friends. My grandmother was the godmother of the widow's granddaughter that she raised. Sometimes my grandmother would take one of the two daughters of this widow to the farm with us. One of the oldest daughters ended up dating my father, but he left her because she drank too much. Another one was enjoyable. When she came to the farm, she used to steal the birds that our cat killed to make very tasty farofa;[170] my youngest aunt and I loved her.

The widow's penultimate daughter took great care of me. She combed my hair, bathed me, put food on my plate, told stories, and slept with me on the sofa bed. I was supposed to sleep with my aunts, but she took great care of me and asked me to sleep with her in the living room. I must have been around six years old because I remember that I still didn't go to school. I started going to school when I was seven. According to Herrera and McCloskey, "Abused children can stray into a dysfunctional direction…Abused children can become prematurely sexually active or promiscuous in adolescence and adulthood."[171]

I'm not sure how it started or how long it lasted, but I know it wasn't just once. This girl who took care of me touched me and made me suck her breasts and feel her up. She kissed my lips and told me that this was our little joke. She must have been under twenty; I don't remember exactly. She started dating, and my grandmother no longer brought her with us to the farm. Not to mention that I began to understand a little more, and she must have been afraid of me talking to someone.

[169] Blanchard R. "The DSM Diagnostic Criteria for Pedophilia," Archives of Sexual Behavior (April 2010): Vol. 39, No. 2, P. 3 July 2010. Psychiatry.org

[170] Farofa: mix with fry birds, (meat or eggs) onions, and yuca flour. The base is yuca flour with anything.

[171] Nevis, Rathaus, Greene. *Abnormal Psychology in a Changing World.* P.381. 7th ed. Pearson Prentice Hall. Saddle River, NJ 2008.

My town was tiny and had two pharmacies. One of them was on the main street and was called First of May. When something happened, my grandparents took us to the pharmacist. The pharmacist applied medicine, bandages, and sometimes even acted as a nurse. When I was nine years old, I had a boil on the inside of my leg, and I could barely walk. Before I went to school, my grandmother told me to stop by the pharmacy. I went to the pharmacy alone, as he was a respectable man. "Frotteurism [is] a type of paraphilia that involves sexual impulses or sexual fantasies that involve rubbing and rubbing people who do not consent to sexual gratification,"[172] wrote Nevis, Rathaus, and Greene.

I put on my navy pleated skirt and a white T-shirt with my school emblem. My grandmother gathered my almost white-blond hair into a ponytail to avoid getting lice at school. On the fourth block in the corner, straight from my street, was the only movie theater in town. I turned to my left; the ice cream shop was also the only one in town. After a few stores was the pharmacy, down the avenue. I just had to walk a little more, turn right, and go straight until I got to my school.

When I arrived at the pharmacy, I asked for the owner and said that my grandparents sent me to speak with him. He came in and took me to the back of the pharmacy to give the treatment. He pierced the boil and bandaged it. As he cleaned the blood from my legs, he swiped and touched my girl parts. I remembered when it happened back then. I couldn't understand it, and I felt wrong, but he was a respectable man who my grandparents trusted. Later, in my teen years, I was terrified of that man, and when my grandmother sent me to the pharmacy, I never looked for him. I felt disgusted every time I encountered him, but I didn't have to deal with him anymore. When I was at the pharmacy and he saw me, he always tried to say something related to sex to make sure I could hear. Whenever I saw him, I left as fast as I could. I often got tired of going through the purchase halfway through and would come back another day. Then I started calling my friend and asking if he was around so I wouldn't have to see him.

Unfortunately, my sexuality was awake too early. In my mind, I hid these memories apart from those I didn't remember, especially what happened when I was six years old. It was always like a shadow. The abuser has generally abused before or is pure evil. They spend their whole lives sick and without knowing the freedom of healing. I feel sorry for those who abused me because I released that anchor, and it is is no longer in me. That little girl grew up and became a woman who didn't stop experiencing full joy.

Early childhood abandonment gave me a hidden trauma that led me to many others. Asking my mother for forgiveness and forgiving her made me free from the trauma I carried for four decades. She lived her nightmares and suffered unimaginable pain. My mother was a victim of her story. She did what was in her power at that moment. That was the first load of weight that I carried on my shoulders for a long period. I forgave someone who unintentionally caused me harm.

[172] Jeffrey Nevis, Spencer Rathaus. *Beverly Greene Abnormal Psychology in a Changing World p380. 7th ed. Pearson Prentice Hall. Saddle River, NJ 2008.*

The first step was my self-analysis of the millions of mistakes I made and how I had repeated almost the same thing that my mother did to me. Then, I analyzed Felipe's betrayals, the domestic violence by the father of my second child, and the sexual abuse in my childhood. My lack of self-love formed links of contempt and abuse. As much as I tried to move forward, my unconscious held me back. It forced me to believe that they let this happen to me because I wasn't worthy. I was trapped in memories with deep emotional wounds. I didn't want this anchor to do me more harm, nor would it bind me to receive what is good in life, much less deprive me of receiving the crown of life because of the damage others have done to me. May God judge all the acts I want to forget that I need to get out of my present. This chapter was the confirmation of the cure. I wrote this without feeling angry or disgusted. I didn't cry, it didn't hurt me anymore, and it didn't belong to me anymore. I told the story of a person who no longer exists.

Domestic violence

To hurt someone who swears to love you is not simply evil; it's a disease. Each person comes with their story; some hurt themselves, and others hurt those they love. Because they feel deep down that they don't deserve to be loved, love hurts them even more; they're sick, and even if they repent and swear not to do it anymore, they can't. They cannot stop because they are emotionally ill and need help. The spouse can never help and will be permanently harmed. The only love that heals is God's, and we are not God! Person-to-person love simply makes the disease take root. Emotional illnesses caused by trauma needs professional help.

My history of domestic violence started in my third month of pregnancy with my second child. Since the beginning, the relationship gave a red signal, but unfortunately, I didn't know how to see it. He started every fight, and we fought over things that didn't matter. We started dating when I was seventeen years old, and at nineteen and a half, our son was born. He wanted one child and always spoke the baby's name years before he was born. In the third month, in the middle of the night, he started hitting me because of an argument. The next morning, he didn't know how to apologize. Those episodes happened at least four times a month.

The seventh month of my pregnancy was the worst; he woke up in the middle of the night and threw me out of bed onto the floor. He was already hitting me and saying horrible things, and when I got up, he continued to hit me. A few weeks later, we went to his parent's farm. The whole family of more than forty people gathered. He locked me in a room and started hitting me. I was pregnant and needed to urinate almost every half hour, and I spent over four hours stuck with him in this room as he beat me and threatened me. When he managed to calm down, his mother told me, "What a cardboard box, your whole family is here to see you and you keep bringing it up." She tried to blame this on me. I was enduring the beatings of my then-husband, ashamed to expose what happened. His claim was, "You already have a nasty son of yours; who's going to want you now with two?" My self-love was already so destroyed that I believed it.

"One issue is that it is not just violence per se that is abhorrent in such relationships, but also the generally abusive and controlling nature of relationships. Even when physical violence does not occur, the woman's behavior, speech, and thinking are control by the man,"[173] wrote Guerin and Ortolan. After that, I would be humiliated by my family if I came home and was accompanied by all sorts of insults. Another time, we were returning from my father's house from my little brother's birthday party. When we got close to the house, he started arguing about something. He said my family should be ashamed of me for having two children before I was nineteen. There was a sewer ditch near the house, and he threw me into the ditch and said that that was my place. He started kicking me in the back. And that was until my delivery.

Fifteen days after the birth of our son, we went to our house, as I stayed at his parents' house after leaving the hospital. He woke and started hitting me worse than ever before with his belt. I spent all night being beaten, and in the morning when he was sleeping, I took the baby and left the house. As the gate made a lot of noise, I was afraid to wake him up. The wood gate was partly rotted away. By coincidence, on the other side of the gate I passed a little girl, the neighbor's daughter. She was my xará[174] and must have been about five years old when this happened. I pushed my baby under the hole of the broken gate, and I jumped over to the brick side where it was low, not to risk making noise to wake him up. I went to the bus stop to go to my grandfather's farm. It was still very early, and there was hardly anyone in town. I don't even know how that little girl was already awake. So much was going through my mind, but I couldn't be there anymore. Halfway there, I passed by his parents' house, and his mother was sweeping the sidewalk. She called me, "Where are you going so soon?" I froze and started to cry. She crossed the street, and when she got close, she was the one who cried. She took me into the house; then my father-in-law saw my black and blue face, and he couldn't believe it. He wanted to call the police so that his son would not be allowed to stay in public. His grandmother showed up and started putting herbs on my body to help me recover. "However, these women cannot share their problems for various reasons, such as shame in front of health professionals, fear of the person who committed the violence and fault,"[175] said Jane Vieira.

I was bruised all over; they looked like tattoos. My face was all purple, even my eyes. My biggest fear was that my family would know, especially my father. My family is from the northeast land of strong and protective men. And I know it wouldn't just be a beating on him, it would be death. His parents sent someone to tell him not to go near their house or they would call the police. I spent a fortnight in hiding until my face returned to normal. My family was looking for me, and I couldn't hide anymore. After two weeks, they saw me, and I still had some bruises; however, I denied everything. I never went

[173] Guerin, Bernard. Ortolan, Marcela. *Analyzing Domestic Violence Behaviors in their Contexts: Violence as A Continuation of Social Strategies by other means Behavior and Social Issues,* 10.5210/bsi.v.26i0.6804 5 P. 6. 26, 5-26 (2017). ©

[174] Xará: Brazilian term used between two people that have the same name. Example: If I refer to another Monica, I can say, "She is my xará."

[175] Vieira, Jane. BRAZIL. Ministry of Health. Comprehensive care for women and adolescents in situations of domestic and sexual violence. Brasília, DF, 2006aa, www.scielo.com.br. September 2008.

back to my house, and I stayed with his parents. We stayed there with so many promises of change because I felt safer. When something happened, I said I would scream, and he calmed down so as not to wake up his parents.

One day I went with a friend to the house of someone who would say a prayer for her. This lady looked at me and said she saw two rings without two hands separating. A few months later, I went to spend time with my mom, and there I started going to church with her and my sisters. In prayer, I asked God not to let this happen. We were alone in the house, and I cried out to my God in silence, and my husband lowered his hand and never hit me again. Soon after, he arranged a trip here to the United States, and it was the last time I saw him. I spent two and a half years putting up with the swearing through the phone. Since he couldn't have agreed anymore, he started mentally dating another person, the same woman he's with today. After more than ten years of living here in the US, I learned that he still beats up his wife. Two mutual friends who rented a room in the house commented on their desperation to hear what had happened. One of them said it was one of the reasons he moved there. The other said that he even talked to him after seeing his wife with a blue face, and then they started an argument because he said it was none of his business. I don't know if he has changed. I believe he has because they are still together today, but that is their business. "Violence often experienced causes a feeling of helplessness and hopelessness in individuals who experience violence and often don't see a chance to stop it or get out of the very unfavorable situation."[176]

This account took me to the past and gave me anguish for that nineteen-year-old girl. But when I accepted what happened and what hurt me, I left it in the past, and it no longer stayed with me. I started to feel nervous, like I was her mother; my two kids are older than her now. She spent so much time trapped in an abusive relationship thinking that no one would want her because she has two kids, that the family would despise her, and that she was ugly. I felt so sorry for her for being so young to live in this situation. If only I could whisper in her ear how beautiful and smart she was, and that she never needed to live all those traumas. Today I am twice her size and have three children and a husband a hundred times better than hers. And she, not knowing that, suffered so much. Today I don't feel angry at him; I feel sorry for her. But thanks to her, I am who I am, and God fulfilled her promise. No one ever raised a hand to me again. My second husband cheated on me until I walked away, but he never even thought about hitting me. He was totally against it. I believe that at that point, she allowed the codependency to come to be stronger until it got to her.

I have a strong relationship with dreams, as I have already mentioned in chapter 15. Less than four years ago, I dreamed about my first husband. I dreamed that he would enter through a white gate, and I held his hand; he could not enter. He was always looking towards the entrance. Every time he wanted to go; I held his hand. When I let go of his hand, he could enter. Upon waking up, I felt my love for him when I met him. I remembered

[176] Tsirigotis, Konstantinos Łuczak, Joanna. *Psychiatric Quarterly. Indirect Self-Destructiveness in Women who Experience Domestic Violence* Vol. 89 Issue 3, P. 521-532. 12p. September 2018.

what he told me about how his mother had many problems with his father when he was a child. Because she was so nervous, she would hit him a lot and trap him in the bathroom for hours. His uncle's wife, who lived nearby, would hear him cry and let him go and take care of him. He spent those hours hungry, scared, and sometimes tired of crying and sleeping on the floor. I felt the wind like an embrace and a dome of peace at that moment. Melody Beattie says, "Acceptance brings peace. And often the tipping point for change."[177] I feel like I talk to myself. I heard in my mind, "He is also my son, and I love him as I love you." I thought I needed to let him go, and my unforgiveness made him stay with me, reminding me of my pain. Forgiveness sets me free from the tormentors of the past. When you forgive everything wrong, it remains in the past, and the marks are tattoos of resilience. When advising someone who is going through the same thing, he remembers, but it doesn't hurt anymore. Forgiveness frees me from its oppressor, and its lack makes me consistent with the past evil in my present life. That morning, I forgave him for everything. My acceptance brought me peace. I closed my account with the harm he caused. He had not only abused me with violence. It was the marks that caused my emotions for years. Writing this chapter and reporting things inside the drawer made public has freed me. Finishing today's closing of accounts with past abuse only makes me love myself even more.

When I think about this part of my life, I remember an old song by Zé Ramalho.[178]

> *"Hey mister, I come from far away*
> *I don't know where I'm going*
> *I'm not afraid to forward*
> *But I'm terrified to go back*
> *Planting, planting because I am a man*
> *Planted, harvest for those who never did*
> *love, loving who never loved me*
> *Being more enslaved person than I am today*
> *When the going isn't good*
> *The return should be the worst*
> *I'm not afraid to forward*
> *But I'm terrified to go back*
> *Believe what I believed,*
> *And work for who I worked*
> *Love, love who I've ever loved*
> *Going back in paths I've already walked…"*

[177] Beattie, Melody *Codependent no more. P. 129.* Harper San Francisco. New York. 1987.

[178] Zé Ramalho Performer and Composer. Amar quem eu ja amei- Love that I've already loved. Brazilian Popular Music.

Forgiving small and big betrayals

It is natural for human beings to betray, lie, and deceive. What makes us different from the wild is our moral conscience. This awareness has been developing since the first "no" we received from our parents, the first punishment for hiding things we shouldn't have, or even a good spanking for a big lie or small breach of trust. All are taught to make us better, according to the community's moral and social standards in which we will live. Be it small or big, betrayals always hurt deeply. Of course, you and I already know why. Betrayal doesn't come from a stranger, co-worker, or even from that gossipy aunt no one talks to anymore. Betrayal comes from the one you love. Even criminal investigations start with the people around the victims. They start with family members, friends, colleagues, employees, bosses, and the people with whom the victim had developed relationships with. Most of the time, the criminal is just someone from that circle. When you're younger, you believe that whoever betrays you isn't the one who knows you and isn't your friend. It can easily trigger envy because the colleague does not always understand you well enough to develop admiration and love for you. The betrayal would've been expected but is not what usually happens. And when does the unexpected happen? Who are the people who love me? What do I do after the betrayal is discovered?

First comes the surprise; I can't believe it. In this first period, I want to lie to myself so as not to face the fact that someone who loves me so much might be able to betray me.

Second is anger—the desire to get revenge and hurt the person physically or verbally when it comes to those ideas that make me like them. I think that everything was a lie and nothing I lived with the person was real.

Third is mourning. This part is when I need to let go or keep it with me. Grief is, in all respects, the acceptance of what can no longer be changed. Like any loss, broken trust brings pain. And the transition from surviving that period is like any other loss. Here comes the decision to live free or hold on until bitterness takes root.

Fourth is forgiveness. I started this chapter talking about the anchor, and that's when I decided to cut the anchor. I can cut the anchor if my self-love is greater than the love I feel for this person, and it should be. When he learns to love himself, his dome is created, and his system of boundaries is created after that. This system I made for my life allows me to protect my emotions and keep myself free from anything that might affect them.

I lived through small and big betrayals of friends I love who are still my friends. I understood what they did was to survive or maybe because they thought they wouldn't hurt me. Maturity and self-love made me keep their friendships. Did I forget? No, I learned to love myself above all that. I understand that each has their demons behind traumas that can unconsciously lead to such attitudes. Today I remember without pain because I cut the anchor, and because it's in the abyss of the seas, it doesn't bother me anymore. I know them and their weaknesses, which is why I can guide myself even better. I love myself and do not allow myself to be hurt anymore because I keep my most precious secrets to my God. I don't expect anything that God doesn't provide. If it must be mine, it will come to me one way or another. It doesn't matter how much the betrayal will come, big or small.

What matters is how I will let her stay and be the weight this anchor will have on my boat. And as for those who do not believe what I believe, speak in the mirror when you are sure no one can hear you.

Psychology has a perfect exercise; it is visualization. I need to visualize the scene or act that hurt me with precision and detail, as if it were a painting, like the ones I do. After you envision it, your image starts to fade in your mind until it becomes smaller than a mustard seed. It becomes so small that you can't see what you visualized anymore, and it disappears. Whenever my "fleas" start to torment me, I have the power to make them so insignificant that they no longer exist. I did the same thing in my story with Felipe: I cut the anchor, and today I have a good relationship with him. I pray for his life and salvation. Also, because he is the father of my last child, I don't want my child to suffer.

In my case, as I have already reported, the gift of painting was my path to healing. My unconscious dreams project everything about me that I don't understand, don't know, or let go unnoticed. In my grieving process and after healing, I painted my dreams. With everything I dreamed of, I took a fragment and tried to put it on the canvas as best I could. I forced myself to believe that it wouldn't torment me anymore once it was on canvas. Of course, sometimes it came back because I didn't resolve it. I repeated it by painting another fragment of the dream that I had always written down. The other alternative is to write down the name of what is ailing you on a piece of paper after taking notes, then tear or burn it. Then repeat this on a smaller paper with a smaller print and shrink it until it's so tiny it's unreadable—like a cheating note that we write to help in the test at school, which could be so small that it looked like a secret code. Drawing is also another option. This is a message to my subconscious that I am greater than what takes away my peace and can destroy it. These exercises work on the unconscious, whether spiritual or not. Of course, I was taught that God is bigger than any problem for those who believe in God, and He made me strong enough to overcome them all.

Self-pity vs. Self-compassion.

In my self-acceptance to finding my complete joy, I faced my past. In the past, there were things that others did that caused me pain that became trauma. My traumas led me to a decision, and life demands every decision we make. Each of our choices comes with a future consequence. When I carry traumas as an anchor, I can go to two extremes: self-pity or self-compassion.

Self-pity is in a position far from forgiveness and healing. I will always be brooding over what I suffered and hurting myself, not allowing old wounds to heal that should have been forgotten. And I have much less love for myself, even though I've been through things that nearly killed me. I can't change what they did to me and the pain that my choices sometimes led me to. My pity for myself for what I suffered makes me a prisoner of the past. The sorrier I am, the more helpless I will be. The stronger I allow the experience to weigh on me, the easier it is to take me to the bottom. I will be empowering my tormentor to continue holding me captive to something that has already passed. I'm someone else,

and what brought me down then won't do it again today. I need to live what I have to live, leaving behind paths I've already gone through. The car's windshield is big because I need to look straight ahead to get where I want to go. If I keep looking through that small mirror in the rearview, I won't get where I want, and I will certainly cause an accident. It's much better to look through the open widow than to stare into a small mirror that isn't my future. I've passed it, gone through it, and it doesn't hurt me anymore. He arrives!

On the other hand, self-compassion or self-acceptance goes hand in hand with self-love. I learned to embrace my self-worthiness, show generosity, not express carotids, and be my best self. I feel compassion for my weaknesses and will regroup for another achievement in my own time. I don't force myself more than I should to love myself and don't exhaust myself by pushing myself to achieve what I want by going over my strengths. A feeling that enables me is accepting that the failures of what I went through make me more resistant. I'm careful with my emotions that are not to be compromised and with my body that also needs rest. Showing love to the healed soul, I end up reflecting from the inside out. Self-compassion will extend to others, for when I love myself, I will certainly love my neighbor.

Forgiving myself.

At one point in my life, I achieved the triumph of self-acceptance and self-esteem. The knowledge of love in early childhood is maternal, but your self-love must be first as you grow. Above all, I had to accept the discovery that I was real to God even before being projected and dreamed of by someone. Greater is the importance of having been designed by God, and every day that I was and am and will be loved by Him made me accept myself.

To be free is not only forgiving those who have wronged me, but also forgiving myself. I need to forgive myself for my bad decisions that led to even more painful consequences. Painful consequences cause regret and frustrations, and frustrations lead to more trauma. Traumas still generate low self-esteem. Since I cannot fix the past, I must accept and forgive myself for living at peace. Most of the time, it's easier to forgive someone who has wronged me than it is when I sabotage myself. And we do sabotage ourselves, don't we? All this was caused by not being more benevolent to myself. I need to learn to accept that even my wrong ways made me the beautiful person I am. I could never have become that strong and bold person without these paths. According to Don Miguel Ruiz, "Self-acceptance begins, and self-love will grow so strong that you finally accept yourself the way you are. This is the beginning of the free human being. Forgiveness is the key."[179]

To mature is to reach the point where the past no longer holds sway over me. The links were difficult to break because of my wrong decisions, forming chains of mistakes. My low self-esteem made me look for people with traumas even worse than mine; this resulted from unstable relationships that could no longer be undone. No one enters a relationship thinking it will go wrong. It is an old story that only time reveals. I revealed my frustrations and insecurities, and other people revealed theirs. Having three children

[179] Don Miguel Ruiz, MD. *The Four Agreements. Breaking old agreements*. P. 115. Amber-Allen Publishing Inc. San Rafael CA. 1997.

in three separate relationships caused me an even worse trauma. I couldn't forgive myself for not having that dream family. I wanted a husband and his kids, but instead, I had one with kids by three different parents. That was my biggest shame. For forty-four years, I couldn't forgive myself. I tried to put up with neglect and a lack of love, domestic violence, betrayals, and humiliation to keep our unions. As a result, I have only one father for my three children. But as I held it to my limit, I had to move from these relationships. I wasn't healthy, so I ended up looking for someone. If it was today, I would never choose.

As I felt that what I found was the best I deserved according to the level of my emotions, I didn't heal myself. I simply looked for my happiness in my relationships. That was my share of the ruin of my past relationships and the codependence I reported in chapters eleven and twelve. From the moment I could find my first love, the love for myself, I could forgive myself. Loving myself with my imperfections made me realize that I needed to go through what I went through to be what I am. If my choices were different, maybe I could have a more stable life. Without the traumas of my early life, I wouldn't be the person I am today. My three beautiful children are mine and God's. I am the mother, and God is the father, and that's what matters to me.

My trauma formed in people's opinions concerning the traditional family. I would love to have this conventional family, even though I fought for one I didn't have. But the most precious thing I have is my family. Learning not to take personal things that came from outside my dome, I was no longer interested in this type of judgment. As the opinion of others about my life no longer affected me, this was no longer a heavy anchor. I forgave myself for taking this path. Countless times I lied, saying that my children were from the same father, especially the older ones out of shame. The important thing is that I had three children, and they are mine. They are created and are exceptional people. Life is beautiful from birth to the end.

In the beauty of seeing that even my life has become a tangle of chains, I've freed myself. I have removed the heavy anchor I carried for decades. I had time to find out what was wrong with me and get rid of it; I had time to close many accounts with the past and have a peaceful present. And if I have a future, I will be living my last years as the best ones of my life. Not everything that starts badly must end badly. Life gave me time to grow and transform, although many people haven't had time to come this far. My gratitude means that I have enough time to close the accounts with the living and pay the bills with the dead. I can find the root of my past traumas and have a healthy present. I am leaving my future to He who is already there: God.

Happiness has enough time to close the tab with the living and pay the old bills to the dead.

Chapter 18
No

The no is the cauterization of a lot of blood that will spurt through a yes.

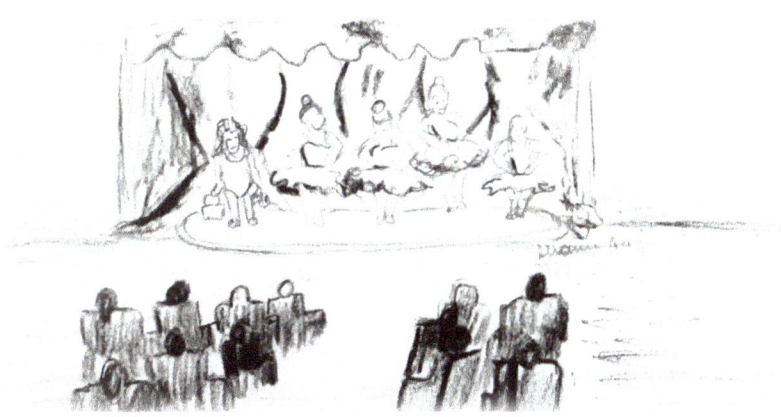

The importance of no

A single word is so small, but it is more effective than many others. It doesn't carry the weight of security even when I'm more insecure than ever. It has no strength when I can barely stand up. The biggest problem that seems simple enough, to say no to others, is one of the trickiest parts. There are three simple letters in Portuguese and two in the other two languages I speak, Spanish and English. Small words can be hard to get out. The denial itself is the challenge. Saying no and executing it is like my daily fight, as everything from birth is learning according to what we live. The practice of saying no has not been straightforward with the application. Saying no was one of the lessons I learned from Joy in my emotional healing process.

We receive it countless times in our life, especially when we are children. There is even a phase when the child says "NO" to have more individuality. It can start around fifteen months of life, when children begin to experiment, provoke situations to see what happens, and put their parents to the test. It's not about doing the opposite for fun. They certainly learned it from someone because everything is new to us since we don't know anything when we are born. What do we learn from the no we received from our parents or caregivers? The negative is to protect us by getting rid of situations that could cause us danger. We accept no for almost everything when we are children because we constantly discover. Then we learn from listening so much, and when we grow up, we don't like that word. Especially in adolescence, if we receive this word, it seems more like a curse. After all, in youth, we know everything. When we become adults, we are afraid to say no, and it

still hurts when we receive it. I insist to my children that if I receive a no at first, I'll fight for the possibility of the yes.

The rejection of receiving a no is what moves us all to do hidden things. It has always been and always will be since childhood. Who has never done something hidden for fear of receiving a no? Who hasn't already bought something hidden from her husband? Why do I do this? I know that what I'm going to buy is unnecessary, and I'm going to take a big no unless my husband is a miser. It makes me lie to get something that I imagine will get a no. Most importantly, I don't take the risk because I already imagine the answer will be no. The husband stops at a friend's and says he got stuck at work, knowing he's not going to have to listen to his wife's mouth. If I train my brain to imagine the possibility of yes or no, it will cause me so much fear. My self-empowerment or self-confidence shouldn't be afraid of receiving a no. The confidence and support of the parents or partner makes them choose dialogue instead of cutting denial. Most of the denial I get can make me resilient and stubborn. The no can also be a half-word, or "in little while." When my oldest son doesn't want to do something, he says no right away. When this kind of slurry happens, it's already clear.

The no received today can be my peace tomorrow. I invited some people over who have a certain kind of approach and are professionally qualified in some areas. I wanted them to exercise a certain point of reference by giving their opinion on one of the themes important in my emotional healing in this book. My thoughts were that they would be happy to be a part of something that will possibly stay after us: this book. Some of the invited happily accepted, and they sent me quotes. In several chapters, I expose professionals' opinions, most of whom are people I will never meet. Just one said, "I'll ask God about it." I finished the book, and still no answer. No answer? Well, that was a no disguised as a yes. Another very dear friend sometimes has her peculiar way of giving opinions that I respect even if I disagree. Her answer was a surprising no, and she was the only one who ignored the invitation. I'm plodding to process certain things, but as I said, I'm learning to relate to NO. For the first forty minutes, I was sad; for an hour, I felt snubbed, and in the end, I took the no as an escape from something.

Perhaps because I don't have these kinds of opportunities, I think they are essential; however, she may be in her dome, and I must respect and understand the position I occupy in the fence of her protection. Possibly I am on one side of her protective wall, a little farther away from what I projected to be. I can make a mistake stressing a place in a person's life, and she has another position for me. Her answer was a surprising silence, ignoring the invitation. I'm still learning to relate to no. That word is not my enemy; it is not a weapon of defense, protection, and escape, both given and received. It is used daily as a dome, a border, for the past, for people, for the present, and most importantly, for accepting and understanding God's no.

##

A famous Brazilian says, "A scalded cat is afraid of rain." Having spent so much time trying to let go of emotional currents when I got out of them, I couldn't risk it. In order not to take the risk, I developed a dome system. My healing process took so long because

I didn't want to risk getting infected. I kept myself in a kind of emotional anti-toxic bell. My personal space was invasion-proof; the dome was my immediate defense to others and myself. I held out the evil thoughts that were not good company for me. My dome protected me from blurting out words I didn't want to go far and offend someone, and it protected me from sabotaging thoughts that say I wouldn't be able to carry out my plans. Even though I had God's yes, I needed to put myself in a dome so as not to hear my pessimism. I kept away from things or people that could harm me and whatever it is that can influence me to move away from the path that I managed to tread hard on. I suffered a lot. I don't want to feel a bit of what I felt. It was tough to get rid of what was holding me, so my dome kept me safe. Inside my dome, I protected myself from hearing what put me down. I mentally created a block with words that I didn't want to hear, such as: brutal, impossible, not to be done.

As a hairdresser, I had to develop an effective dome system. Since the story began, I went into deafness autopilot mode. I learned how to do this in my seventeen years as a hairdresser. When someone sits in your chair in the hall, they automatically feel comfortable to vent their frustrations. Sometimes the chemical processes are lengthy; they have enough time for their therapy. As a Christian, I must console those who cry, but some bring toxicity; with Joy, I learned to lend my ear to tears. Most of these people will whine and vent to feel a little lighter. They even ask for advice, but they don't want to resolve anything; they want to talk about it. Or they want to do something wrong, like stay with their lover and complain about their husband. This person needs acceptance and solidarity to continue to do wrong and have someone else's approval to make him feel less guilty. The "I won't absorb this" autopilot frees me from storing things what won't be beneficial to me and that won't change in the other person.

To avoid fights with my clients, I only gave opinions when asked and never expected them to be followed. In my opinion, 99% of the time will be for the other to justify their mistake. The man does not like to fix mistakes, but God is master fixer of everything, and women love to talk without solving anything. According to John Gray, "When a woman looks upset and wants to talk about problems, it's not time to offer a solution; instead, she needs to be listened to and will gradually feel better alone. It doesn't need to be fixed."[180]

As a woman, I turn on my autopilot when I feel that what is coming out of the other may not just be a sigh of relief, but emotional rubbish that could run the risk of affecting me. As for men, they do not confide in people until they already have their decision defined. Most men don't like to expose their weaknesses, much less when they're insecure, so what I say and what side I take in the matter will be a waste of time. The only help is that when people talk, they rarely hear the nonsense they are talking about. When this self-analysis happens, it may even be that something is productive, not because I spoke, but because she listened.

[180] Gray, John Ph.D. Men *are from Mars, Women are from Venus*. P. 24. Harper Perennial. El Segundo California. 1998.

God created this dome system around us when he gave the rules or prohibitions. These domes are the Ten Commandments, or laws from the Old Testament. In the New Testament, Jesus added two new laws: to love one another as ourselves. The dome of God does not leave us out of everything, but saves us from problems. Also, by loving the other so little, we will go beyond the limits of the other's dome.

Domes[181] keep us away from confusion, gossip, mockery, and disappointment, keeping us safe emotionally. In my dome, people can enter, go near, reach the middle, keep their distance, stay away, or be eliminated. The no as the dome protects me from this type of situation. I live in a society that could be dark, although I must keep trying to bring light. But that doesn't mean sitting at the table with him and having his constant presence in what concerns me. Everyone wants to be loved and respected. My dome protects me from discrimination. Whoever I allow in my dome, in addition to having affinity, must bring me peace no matter how much it will cost. A toxic person doesn't care how much I prevail them from contaminating me, so my dome frees me from emotional rubbish. The emotional garbage and the poisons were sadly deposited in my life even though I didn't want them because I didn't know how to prevent it. The no is a dome that protects my emotions. In addition to being protection for me, the dome system is a filter through which I let the things that make me grow and inspire me to leave and enter. As I have more years living without the dome than with it, I still fail a lot; however, I continue to practice.

No, as a border

I spent over fourteen years sympathizing with many people I couldn't stand. With no boundaries, these people were inside my dome. My house was always full of people I didn't want to have. They mostly talked badly of me and supported my ex-husband's betrayals, although they sat at my table. I had to listen to gossip, submissive and wanting to please the world and be accepted in this community. Jamaica Kincaid wrote, "But the banality of your own life is very real to you; directed your extreme, expanding your days and nights in the company of people you don't like."[182] The biggest waste we make in our lives is dividing the time that God allows us and wasting time with those who don't miss us when we're gone. If one leaves, they make a bad comment about that person. People who cheat on their mate enjoy criticizing and laughing at each other's weaknesses. Unfortunately, I wasted my precious time with people who shouldn't even be around me. Vomiting their garbage, even unintentionally, will affect me. Joy showed me that my omission was one of the characteristics of codependency; I had to learn to establish boundaries, pushing away in groups not only people but also situations that shouldn't be around me. I only have one life, and I'm unsure of how long I still have. I wouldn't share what is blessed to me in days with toxic people and unpleasant situations. After meeting Joy, I started my border system.

[181] Some dome "advice" - Proverbs 10;19, 1 Corinthians 3:18-20, Colossians 2:18-23, Romans 11:25, Proverbs 23:4, Proverbs 25:16-17, Ecclesiastes 7:16. Psalm 1.

[182] Kincaid, Jamaica. *A Small Place*. P18. Fartar, Straus and Giroux. New York.1988.

No is a boundary that keeps the unwanted away from me. My mother used to say, "no one is an island to live alone." But I need to establish my boundaries. The borders are to pick and choose who will sit at my table with my family, listen to my problems, come to my house in a small group, come to my house in a larger group, or stay away from me. I know we're created to live in society. Moreover, I have control and protection for my emotions. I establish my fences with various groups that will deprive me of problems that I don't need to add to my life. Fences keep the peace and protect my emotions. A group sits at my table in my house. One group sits at my table in my backyard at a barbecue, and another group I only sit with at a large table in the community. "The truth is, for many of us, saying No is difficult! We want others to like us and accept us; we want to appear to them, meet their expectations and please them,"[183] states Alena Gers. The first love is the self, and if I love myself, I will also love the other. Love never comes without respect and companionship.

Unfortunately, even those who love us get used to never hearing no. To not hurt them, I want to keep them happy and close to me, saying yes to everything. This one can spurt a lot of blood, but a simple one cannot permanently be cauterized. In antiquity, cities were surrounded by a high wall, which had a watchtower that warned the community of any sign of danger from people or tribes constantly seeking domination. Those outsiders invaded their city, took their goods, and enslaved those who survived. The first sign of danger was warned with any movement. We always see high fences around cities, high walls, and the most primitive high fences in medieval movies, which were the reality of the fifth to the fifteenth century in feudalism. "The term personal space refers to the invisible boundary around each person. A boundary that other people shouldn't invade during ordinary social interactions,"[184] says to Margaret Matlin.

My fence imposes boundaries and security to protect me and limits things I must keep away from me. Surrounding my emotions ensures my peace. On the other side of the fence is what doesn't belong to me. I protect myself by putting limits on what will harm me. All the unwanted must remain on the other side of my fence. I'm the one who must take care and value what I have on my side of the fence. My fence will keep me safe. What lurks outside will try to invade, so I must be vigilant; after all, my peace is at risk.

The world is big enough with room for everyone to grow and bear fruit without it destroying me, although it isn't the reality. If you gave the benefit of the doubt, and your suspicion is clear like you already suspected, this person must be at a border; don't expect too much. At signs of transformation, move the fences, but never inside your dome. Unfortunately, it must be remembered that there is a different worldview in every mind called cosmovision. What's inside me is how I see the world, remember? Sometimes I believe other people have a perspective like mine. What I'm incapable of doing, so are the others. These are terrible lies; miserable people will always bring their interior hell. My fences

[183] Gerst, Alena. LCSW Psychotherapist. *You Know Saying 'No' Is Important for A Healthy Life*. midnodygreem.com. June 2020.

[184] Matlin, W, Margaret. *The psychology of Women. Nonverbal communication.* p180. 7ed. Wadsworth. Belmont- CA. 2012.

are for myself and the others. Everything I wish for me, I want for others; not all will be like me.

Unfortunately, those who don't have limits will never respect each other's borders; that's why I must keep my fences solid. The boundaries of my emotions will be guarded by barriers, which will separate the groups. My emotions are my city strengthened; the more I protect it, the stronger it will remain. The vast majority of saying yes ends up bypassing me to satisfy the other. If I'm not happy, I can't share my happiness with another person. Repeating this will indeed compromise my emotions. In the long run, it will turn into anxiety or depression. If I leave a faucet running, even if it's dripping, the sink will overflow. The use of no exercises my self-love. I must set my boundaries to have my personal space. Borders aren't just for strangers, but also for my children, spouses, friends, leaders, kin, and acquaintances.

No, for peace

The boundary and dome keep me protected not only from the bad vibes and acridity of some people, but also from my traumas both of hurting the other and of expression and judgment. I want to protect her from my projection on them and them on me. This is not isolation; instead, the right word for it is maturity. Yes! Between things that have hurt me or gave me joy, now that I am mature, I can discern what can be close to me and what cannot. Not only that, but I can discern the level of closeness you must have with me. I've positioned everything as a chess game—not that I know how to play chess, but it's a fantastic game that needs a lot of analysis. Even mature people have their emotional slips, turning after sighing, analyzing, and deciding. Like a game of chess, you must be prepared.

I will analyze such reports by representing how I am the player, and the parts are my friend or family cycles. We usually say "my king" or "queen" to spouses, parents or children, and so on. The game has its king, queen, rooks, bishops, knights, and pawns. According to the game, removing pawns are the most significant number of details on the opponent's front line. The pawns are also in the position furthest away from me. There are two of every other piece, except for the king and queen. Each one has its square, and each one of these pieces has its function.

Just like the people we relate to, those who can stay close have their part in the game of my life. I have a small group of friends that I talk to about personal things, and each of them can absorb a subject. I know the characteristics and maturity of each one. With some, I have learned about their weaknesses and continue to love them, so I already know that certain subjects aren't appropriate for them to be a part of. I had a friend for over twenty years; we love each other. She has her friendship group who doesn't leave her house, and they are always at the same events, but I'm the only one she trusts for her most intimate issues. I have another friend that I can count on for everything, but there are some topics I know that she isn't the person for. Another one is the same way. I go to her to see everything with a lot of spirituality rather than for matters that need natural analysis.

Certainly, you have friends in squares and functions, like in the chess game. Even in my immediate family, my children, my husband, and my secondary family have their spot. I can give an example with my primary family; each has their function and privileges. My oldest son is my biggest supporter, since we grew up together and he knows all my life plans. The middle one is my adoration. I'm so proud of him. My youngest gives me the strength to continue; he's my last mission. Besides being my best friend and my fundamental pillar, my husband is my king. Maturity taught me that I always have something secret. Not everything can be said, not even to the most trusted people. Whoever believes in God can relinquish their secrets to Him.

No, for the past

Like people, situations will also have to be placed in fences, establish borders with cases that we already know, and will unfortunately repeat. These situations always come back like a boomerang and end up taking me by surprise. "Out of guilt or fear of confrontation, we take on more projects; we invest in someone else's priorities. In the process, we squander our most valuable personal resources,"[185] states Michael Hyatt.

It seems that such situations have never been experienced because when they are repeated, they end up doing nothing. In these situations, they will not cut them permanently. The past cannot be changed, but it trains me to improve my future. I can break a vicious cycle by saying no to the past in my mind or to situations that recur. I won't be remiss in allowing it the next time. I was codependent for several years without even knowing it. After being healed, I needed to say no to the past by keeping an eye out. I was codependent, the yes-person, omitted. I was the famous ostrich stomach that supports and consents to everything. The one who has a history of codependency must have the no as a sharp sword ready to cut off every threat of the possibility of returning to his prison. No is your shield in the emotional area. The codependent, dependent, chemically dependent, depressive, bipolar, and so on must use no as a weapon, like they do with their borders and dome. All care is too little for those who lived in darkness. The victory of living in the light cannot possibly be threatened. The no closes the hole, saving me from the unseeing and forming a bridge to a better unknown path.

No, to people

When you learn the power of no, it excludes the no to people who must stay in the past. For some reason, the life course has given a no to any relationship whatsoever, be it friendship, romance, or even that toxic relative. Keep the person there in her fence, far away from you, where life has designated her to remain. I need to stop saying yes to those who deserve a no. "Learn to say no without resentment or guilt, no is liberating,"[186] says Fernanda Cardoso. No will save me a lot of headaches. If it's part of my gift and violates

[185] Michael Hyatt. journalist/author/financial coach. CEO of Michael Hyatt.com. Tennessee, 2 December, 2019.

[186] Cardoso. Fernanda. Missionary. Waltham, MA. July 2020.

the benefit of the doubt, then it becomes a threat to my dome system, and I will have to go to the fence. Do you know the expression of each one in their place? So, each person occupies a place designated by me for the general protection of my emotions. The more damaging it can be, the further away from my dome it should be. I also must know my place, so I don't go over the other's protection fence. I can project myself onto the other person and end up attacking them. If I'm aware that I'm the wrong one, that's the point I'll possibly deny, not putting up with nonsense or not empathizing with the same boundary must be ensured.

I worked part-time in a very nice bakery for several years, and I had to use my borders to defend against some annoying customers. The customers buy and leave, but there was one manager who was my most significant reason for prayer for a long time. Countless times, I stayed in my car fifteen minutes before going inside, praying and asking God to make me invisible to her. I asked God to help me control it because I needed the job. This manager had already given me countless reasons to walk away. I stopped working on the days she worked; I hid in my dome, working to avoid confrontation. She was my analogy for self-control. I treated her very politely in any situation. I felt she would start growling; I did my best before the bark. I wouldn't work most days in order to make her stay in the fence far away from me.

The first year, she caused me a lot of agony over not knowing how she would arrive. If she was going to come in possessed or expected, I was the focus of her discharge. There was an occasion on which she began to torment me since she arrived. The same situation has occurred with my coworkers, and she made people cry or quit. She didn't respect my fence and still invaded my dome, fences and all. I had to tell her to leave me alone or fire me. Then I got a little break. As a Brazilian, I could use the expressions "go to search for one goat," "go check out if I'm on the other corner," "go plant bananas three," and "go brush a monkey."[187] I would clock out and use one of my grandmother's sayings, like "may they see my behind as my answer." She would have said something heavier and northeastern. As the years passed, my manager had more fresh meat to torment and rarely focused on me. To say no is for me to be inside my fence in a situation like this. When someone is miserable, they'll invade my barriers to hurt me; one just shows what one has inside, right? Once I saw her from my dome, I wondered if she saw what she was doing. Nowadays, I even like her. I tried to focus on her good qualities. "It's important to be able to say No so that you feel empowered while maintaining your relationships with others. Saying No helps set healthy boundaries and allows others to be clear about what they can expect from you,"[188] says Laurie Leinwand. The power of No challenges what I want to do so that I don't upset anyone. When I'm concerned about not making people sad and saying yes, I can be frustrated. My frustration can develop into two different sides: depression or codependency.

On both sides, I am the one who'll lose, and I always end up doing the other's will and hiding my own. Anyway, I'm going to be sad and lose my shine to make others happy. When I say no, a person will show their true feelings towards me or vice versa. Of course,

[187] All these expressions in Portuguese means go to hell, leave me alone.

[188] Leinwand, Laurie. MA LPC. *Why Is Saying 'No' So Important?* GoodTherapy.org. New York- NY. November 10, 2016.

life in society is an exchange, and I love to see each other grow and be happy. Clearly, I want my dear ones to be happy, so I can share the happiness with them. When I meet someone who carries a little black cloud, like in cartoons, loaded with bad vibes, I would put up my fence by using no. If I open to help, I'll bring this person closer. Time and energy are wasted on toxic people. There is nothing to gain with someone who doesn't think there's anything wrong with their attitude, like my manager's example. They'll continue to intoxicate what they can. To others, the cloud is so dark that they don't see the way they are. Or it's like I used to be, so trapped that I had to descend to the last level to get the impulse to rise or die at the bottom. When I'm in one of these situations, I can't see the harm I suffer or cause. Prayer is the best thing you can do most of the time, besides keeping your dome clear.

I find it exciting when people give bad reviews of places. The vast majority are people with emotional problems. This is very telling, and I had to stop myself many times so as not to do the same and not to waste my time writing about horrible experiences with people in certain places. Like my husband used to say, "What is bad doesn't need our help to fall, they'll fall on their own." If I don't like it, I won't go back or recommend it either. I let everyone decide their own opinion because what can be bad for me maybe will be different for other people.

I remember my teenage years when someone new arrived in the tiny town I lived in. According to their experience, one person knew them, and consecutively, they all had the same opinion. They were manipulated by the vision of the first person who knew the newcomer. It wasn't just in my town; I think most communities are like that. Five years ago, when I just arrived at my current local church, I knew a handful of people already there. These people gave me their vision of some people I had just met. The result was like when I was a teenager. My vision related to some people was the same as the group before I even met them. After my healing process, I started give the benefit from the doubt to several of them. To some, I changed my opinion, and others I kept out with my fence system. This was not because I agreed with the shared vision, but because I didn't have enough chemistry to pull us closer. Saying no is an endpoint in a story of misfortune for me and others.

No, to the present

I am like every good Brazilian. I only do things under pressure, at the last minute. The more time I have, the later I do things. Moreover, maturity teaches us to re-educate ourselves for the things we want to get. I am concerned about foods that will no longer benefit me, especially at my age. When I want to watch a movie, I have my schoolwork. Putting boards in useless things is complicated, especially in negativity and pleasure. Saying no to what makes me waste my time in my present will save me time for the real opportunities in my future. The past just came to my present, and it will come to the future if I bring it. I know my past made me the person that I am today. So, this person couldn't allow the past to manipulate my future. By not giving into the bad experiences and people who belong to my past, I'll free my present and future from them. The no I say today will allow me a peaceful future.

No. for words

The most effective defense against words is not giving them importance, even if they come from people who matter to me. I know that words are more harmful than a venomous snake bite. Words are sharp one-way arrows. Once they are released, you cannot go back. The terrible damage that one word can wreak is more significant than you can imagine. For the most part, a word may have no weight when I cast it; however, when it reaches the other side, it may find a soul that is already wounded. When feelings are already out of balance, a small word can be thrown without any weight, but it can be the last ounce that will tip the scales towards something terrible. Care in turning something simple into a catastrophe is a thread.

It is the same that separates death from life. A powerful being created us, and with one word, He created everything. We have, like Him, the power of the word. What we say can make it bloom as well as make it wither. May I not weaken because of everything I do one day; I will have to give an account. Everything I said brought life, and everything I sowed caused death from the best to the worst. Everything that comes out of my lips has significant weight. Before I get it out of my mind, I must know if you're going to condemn me. Perhaps you will not condemn me today, but you will blame me later when I am asked to account for what I have done. And to those who do not believe this, I leave another simpler message that is no less important: everything that goes away will soon come back to me.

In English, we say, "What goes around comes around." If something is democratic, it is karma. Karma treats everyone equally without any discrimination. The Bible does not speak of Karma, but Galatians[189] says that I can choose my seed, but the seed I choose will be born. God may even forgive me in His infinite mercy; however, I will reap exactly what I sowed. The bill always arrives! The Bible[190] also speaks about the power of the word very clearly through several books.

We know the damage words can do, and we must defend ourselves against them. The words that cause us pain are from people who carry some weight in our lives. What can we do to dodge these arrows called words? Dodge them! Do not let them pierce you. Words only have weight when we take ownership for our lives. As soon as I hear something and want it for myself, I take ownership by absorbing it, inspiring myself, and making a reference point. From this moment, they become powerful, as I call them to exist in my life. As I said in chapter 16, I call into existence what does not yet exist. I project with my words the longing for what I dreamed until it becomes natural. I cast into the sea of faith to expect those nets to become complete, using my words like a fishing net. In chapter 14, I talked about many of my wishes on canvas, including the sleeping dream and the waking dream. At least in my paintings, I made reality. However, if I just let go, it will evaporate; the same thing is true with words. Some words came back from the past. The words

[189] Galatians 6:7. "Do not be deceived: God is not mocked. For what a man sows, that he will also reap."

[190] The power of the word in the Bible- Romans 10:9-10, Hebrews 11:3, Matthew 12:34 and 12:36-37, Proverbs 18:20-21, Proverbs 2:3, Proverbs 12:25, Psalm 3: 13 and 34:12-13, James 3:13 and much more.

I listen to in my present, if they are good, I must register. To words that will put me down, I have to say no! Those words I won't call to existence.

I will not receive them by giving them power. I am the one who empowers the words thrown into my life. True, when I was a child, the words of significant people were powerful. Now I understand that I am coordinating the power of words in my life. I will not allow any comments that are not of blessing to remain upon me. Everyone is free to say what they want and absorb what they want. I refer to the act of rejecting what will not do me good as an FTW—fighting thoughts of words. I created some FTW's, and if I can babble when these words come out of someone's mouth, I say, "I don't receive this! This has nothing to do with me! That's what you're thinking! This is not about me!" That's what she or he is feeling.

For a long time, I received countless words about my life without fighting them, but later I understood that only what I permit to stay remains in my life. I have the power to determine what will remain and what will not even be visited. I am the greatest blessing of everything related to me. I received from my creator the power of the word and the power to decide what to do with these situations. I can determine what grows and withers in my life.

No. from God

For years, I believed that if I placed myself at the center of God's will and corrected my ways by looking for what was not pleasing to God, I would live in constant prayer, like waking up at 3:00 am to pray, making promises,[191] fasting,[192] and offering tithe. Seeking the fruits of the Spirit,[193] supporting that person that no one wants around, and enduring shouting and insults would make God consent to my heart's desire. For many years, I got used to doing wrong and then asking for forgiveness and asking God in prayer. According to Cartiane Oliveira, "God's no is more precious than anyone's yes, as it keeps us safe and free from adversity."[194] He always grants me. I believed He would never say no to his little girl. I firmly believed that God would always give to those who serve Him in spirit and truth, but nothing is guaranteed.

If I believe, serve, and do everything in my power to be close to God, He will be good to me. Even I remembered God, saying, "Look Lord, it's in your word!" as if He didn't know. God doesn't give because He can. It doesn't matter how I look for holiness and fidelity when He gives nothing and no end. I will cry like a child who receives a father's no and retreat to my insignificance. My anger at God is only harmful to me, and it doesn't change. And what can we do to make sure God hears us? How do I know if God will give me what I ask?

[191] Purpose (vote, promise) to abstain or promise to do something to obtain blessings. (Daniel 10:2-3, I Cor 7:5)

[192] Fasting: not eating to kill the flesh as sin entered through food, sin through food weakens because the flesh is weak, and the spirit is strengthened in God. (Esther 4:16-16, Matthew 4; 1-2, 2Cor 12:10)

[193] But the fruit of the Spirit is love, joy, peace, patience, kindness, goodness, faithfulness, gentleness, and self-control. Against these things there is no law. (Galatians 5:22-23)

[194] Oliveira, Cartiane. Reverend. Preacher. Stoneham, Massachusetts. December 2020. Oliveira, Cartiane. Reverend. Preacher. Stoneham, Massachusetts. December 2020.

According to T. D. Jakes, "We don't know, because life is a mystery, if we knew things would work out, we didn't need to have faith."[195] In an interview with Steve Harvey, he says that faith is stronger when we don't know what God has prepared for us. The uncertainty makes us more dependent on God. God will always make us a little shaky to stop thinking we know everything. The more life is unstable, the more I must go inside myself to stabilize myself. We are strong enough to withstand the instability of life. If we know everything, we leave faith uncovered.

Innovations for creativity appear in times of adversity and chaos. God's no changed the course of my life. His no made me an overnight painter. From the paintings emerged children's books. The collection of the no's God gave me wrote the pages that are being flipped by your hands. Without God's no, I had stalled on my satiating bliss that had stopped me. But God's no made me know paths I never thought of treading. He activated a gift in creativity and inexhaustible inspirations arising in times of pain in the time of grace and of abundance from His hands. When I know what will happen, I stop living as the best version of myself. I don't find out who I am if I stay in the same place. God's breaking comes with his no. According to Flávia Gomes, "When you decide to hear God's no for a certain situation in your life, this doesn't become an impenetrable wall. However, this same No, will open other paths even better than those you insisted on remaining."[196]

God's no is for our growth in discovering qualities we would never know if He gave us a yes. Situations that occur with God's no are aimed to transform us, teaching us who we are and who we are for God. Most of the time, we are broken into little pieces or even turned to dust. After these breaks, He remakes us according to our permission. If we resist the pain, it will be greater, and if it hardens, we will be crooked. We must trust that He knows how to fix or remake us. We are a vase in the potter's hand. God's no remakes all the concepts we acquired up until then. As we process the no we take, we create guidelines for a new time. Maturity is the time to know that I've survived a lot and I'm still here—time to be more balanced in adversity in a world that is unbalanced, and time to be grateful for the no we receive, give, and especially for the no from God, which is usually a deliverance.

God's no is a dome that protects me against the destruction from others, the spiritual evil, and from myself.

[195] TD Jakes. Rev. Preacher. *Crushing God Turns Pressure into Power.* Interview with Steve Harvey. August 24, 2012.

[196] Gomes, Flavia. Reverend. Preacher. Norwood MA. June 2020.

Chapter 19
The reflection

I am growing my branches. I will blossom, and the wind will spread the joyful scent of my self-love.

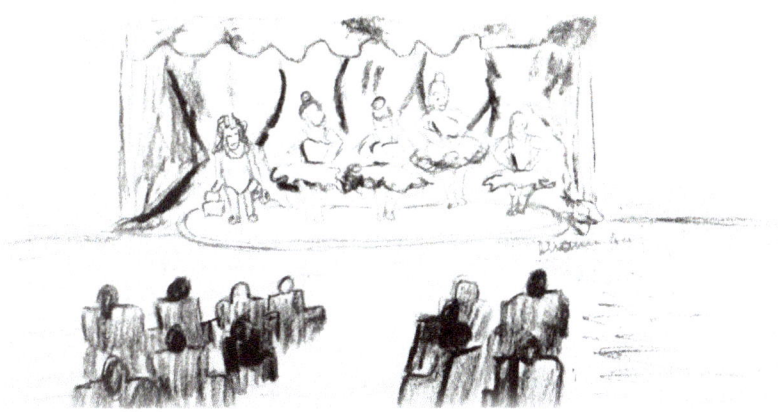

The reflection

The mirror shows me something, and quickly looking, I believe it. A superficial view of something is much more airtight than what is reflected. I am not just what I see in the mirror; I'm more than a reflection. I am profoundly more complex than a reflected image. And sometimes an image, like the mirror, can see everything outside my dome. But what is it that I reflect on? Is it an opposite image of myself? Or is it me the world doesn't, see? I must know myself, love myself, and find my peace inside my dome. Starting from this principle, I begin to calm down with what others see through my reflection. My intellectuality, dynamics, and goals are apparent to those who can recognize themselves in my adjectives. Those who don't cannot realize what they don't have. I cannot demand that the "world" know me in my essence. Will what I see only be my passing in front of a mirror or reflection of myself? Is my reflection the opposite of what I show? Or is what I see in others so critical to what I am? It is hard to accept what we keep secret and what we cannot show!

When I was a child, I loved Monica de Sousa's comic books.[197] One of the stories that most impacted me was the one about the mirror. Some of the characters do not remember who entered the mirror, persuaded by their mother or another. Everything was upside down, including Monica's name, Acinôm. Monica was strong, and everyone on the other side of the mirror was like a banana. One character-shell didn't like to bathe, and the other was clean and fragrant. Could it be that those days when my reflection attacked me wasn't

[197] Mauricio de Sousa. Turma da Mônica. Publisher April. Mônica is an old comic book character in Brazil.

really what was in my personal shadow? And what do I see in people, and am I seeing it from the inside of the mirror? It it from my bad side, or is it who I am?

Every attitude and position someone takes towards me is their reflection. It's not about me, but themselves. On the other side, I too can project onto someone what is in me. One of Carl Jung's concepts is the personal shadow and shadow projection. The personal shadow is a defense we create as children to escape shame. Defending against risks, I put everything I'm ashamed of in my personal shadow and pretend it doesn't exist; this is the part where I learn moral values, and what is outside of these values shouldn't go into the personal shadow. What is contradictory to what I believe to be good and do not approve of is in my personal shadow. I must confine it and in it put all of myself that I do not agree with. The problem is that when we become adults, this shadow becomes an obstacle. When I meet a person who projects what I own onto my personal shadow, I end up casting on it what I try to hide. My judgment of someone who shows what I hide out of shame will be pity. I end up hating someone who has done absolutely nothing against me for seeing my own reflection in. Now that I see my reflection, I have the authority to judge another person because I recognized myself. This person has done nothing to me, but they expose what I put in my personal shadow, revealing them as the scum of the Earth. She is no worse; she just doesn't have the same moral values as me. I hide, and she doesn't mind showing it.

Before projecting my anger and condemning, I need to empathize, knowing that in my personal shadow, I am not different. Sometimes, I am the same, I just don't show it. If I see myself with envy disguised as anger at someone's behavior, it's my unconscious revealing my dissatisfaction. Here is the point where I must begin to self-observe the need for change. It starts with my desire to be a better human being and focus on my personal shadow. The more I watch it, the more I will master it. I will have more power over this person; I will have less fear and less anger when I encounter difficult people who I will not shake.

Reflection of judgment or interpretation

The view of my reflection is quite challenging to accept; it can be aggressive or hypocritical. If you confront me, I will feel ashamed of being recognized in someone else's attitude. Or if I don't accept that I'm like that, I keep deceiving myself and being a hypocrite in judging what I am. It is complicated to see what I am and what I hide. I judge myself and then think that the other feels the same as me. I can also project my judgment based on who I am. Everything is a matter of worldview; I reveal myself by projecting onto another. Each life has a story with its projections and interpretations, and I empathize with others as I would like them to do to me. My judgment, in turn, will make me cynical to the point of pointing out something that I am as much as the other. According to Taize Figueiredo, "Never take a criticism received as true; they are often a reflection of the person who criticized you."[198]

[198] Figueiredo, Taiza. Ph.D. Graduated in Psychology from the University of São Paulo. Rockville-Maryland, USA. December 15, 2020.

In the same way, I can criticize someone I don't even know, just as strangers can criticize me. In my day-to-day life, I end up facing enigmatic and analytical situations. In such situations, I witness both known and unknown attitudes in people that reflect what I'm hiding. They require much more than my emotional interpretation. When I arrive at a place, and people who know me stop talking, what do I think? That they stopped talking because they were talking about me? Did they drop the subject because they didn't trust me, and didn't want me to hear it?

The truth is, the most likely option would be the worst, wouldn't it? This is judgment, and I base myself on what I project from my emotional self. The truth should be interpreted and not judged. And in my interpretation, I think that they must have stopped talking to honor me with their attention. I think coming will be a priority. They need to stop the subject for their attention to come back to me. Or even, more sensible, I can say, "It's not all about me!" Are you smiling with me or at me? I will judge rather than interpret. The interpretation should be, "They're smiling, good." It's not about me if they smile at me either, because I'm a funny and charismatic person. What others project on me isn't about me; it's the reflection of themselves.

When we know someone in general, we can have immediate thoughts about this person. I have my "feelings" about someone I just met. Most of the time it isn't a rash judgment; I am referring to my intuition. Many times, what I thought a person would be like ended up surprising me when I met them. My first thought was that I was an obnoxious person out to be someone different. Has this ever happened to you? For me, it was more common before Joy. Now I have the benefit of the doubt and the border system. Now with Joy, I just cut and walk away. There is a Brazilian saying: "My saint didn't face that person!" And it was a full stop. Are you like I was? Or do you know someone like that? Well, what happens is that my psychic learns to function with the immediate projection of my story. I unintentionally project what I have lived whenever I encounter a new situation. I end up depositing in someone I just met a load of psychological stories about what is in me and not in them.

Psychological projections come from my unconsciousness trying to protect me from what I've lived. Projection is a technique that my unconscious automatically uses out on impulse. I project onto the other what I see in myself. As a matter of defense and self-prevention of my subconscious, it ends up putting people and situations in a specific place that they shouldn't be in. The attitude is always one of retreating or attacking to defend against the pain that afflicts me. When I'm too critical of people for just being themselves, and I end up taking someone's personality personally, maybe I see my reflection. When I judge another, I have the power to make them feel inferior; however, due to how I think and for fear of being attacked, I automatically move forward first. A year before I met my husband, I met someone at my university, where people usually socialize on the last day of the semester. One of my classmates invited him. He would go back to his house when he had finished his course. After a while, he found me on social media through a friend we had in common. We ended up exchanging phone numbers and getting to know each other a little more. He had some characteristics of what I wanted, and I decided to give him the

benefit of the doubt. As the conversation unfolded, someone would have to move closer to the other if something more significant happened. Since I had my kids here, it would probably be him. I don't think I was ready for a relationship at the time.

I ended up projecting all my distrust into the course of the story. I didn't realize that what I was doing was involuntary. My subconscious defended me from my past pains. I thought it was him, but my psychic story ended up projected, and nothing went well. If we don't observe our projection to others, especially in romantic relationships, the cycle will repeat itself. I was already working on this conversion for my entire life, and I noticed my significant lack. I had to guard against projecting the old me since I wanted to be like Joy; everything had to reset. Too much projection becomes paranoid and dangerous for me and those around me.

No matter how much I believe in God or go through years of therapy, it won't help me if I don't learn to love myself. I stress this a lot in this book because I didn't remember to love myself until I was forty years old—when I was dying, surrendered by own my torn soul. Learning how to love myself saved my own life. The snap came from the thought, "What does such a great God see in a person like me?" If He and the most crucial love me, I should get to know myself better. Knowing myself better, I fell in love with myself. In the letter to the Corinthians,[199] Paul talks about the importance of love. This is called the Love Chapter and written by Paul in the Greek language. Love is divided into four kinds: affection,[200] which is simple love without reward, friendship,[201] romantic love, and the mercy or love of God for us.

Encompassing all types of love in its entirety, Paulo emphasizes that without "love, everything is nothing":

> Love never gives up.
>
> Love cares more about others than about itself.
>
> Love doesn't want what it doesn't have.
>
> Love is not snobbish,
>
> You don't have a superb mind,
>
> It doesn't impose itself on others,
>
> Do not act based on "me first,"
>
> Don't lose your temper,
>
> It doesn't count the sins of others,
>
> Don't party when others crawl,
>
> It takes pleasure in the unfolding of the truth,

[199] 1 Corinthians 13:4-7. The message. Bible in contemporary language. Trad: Eugene Peterson. Publisher Life Vol. São Paulo-BR May 2015.

[200] Greek: affection- storgé, romantic love- eros

[201] Greek: friendship - filia, love of God - agape

> Tolerates anything,
>
> Always trust in God,
>
> Always looking for the best,
>
> It never looks back but continues to the end.
>
> Love never dies.

Many love each other a little, and others love each other too much. Moderation is the key to balancing being in harmony with others and myself. Unfortunately, before I met Joy, I thought I was at the center of all my evil. I took everything personally and punished myself for all the evil around me. I am part of the world and not the other way around. I am not the center of the world; it's not all about me. If I realize that, I'll be in balance. Those who love each other very much will not be proud if they face the truth that the sun does not revolve around them, and selfishness will not be part of them. I will be more compassionate and enjoy the gap between life and death without hurting another person. I will be able to accomplish my goals without going over another person's goals. Likewise, the one who loves himself the least thinks that everything is personal. I fit into this group and had to learn one of Joy's life principles to understand that. If someone mistreated me, it was my fault, and I should have done something to avoid it. If my friend said something about me, I felt sore and frustrated, and I wanted to improve. But everything changed in the last betrayal, which was an exchange, a perfect one.

Felipe told me that the woman he was leaving home to build his life with was the woman he had dreamed of all his life. The poor end of his relationship was contrary to what he thought and what everyone already knew would happen. Only those who go through this know the pain of being changed. At that time, I thought I was horrible; old, fat, nasty, vile. I believed it was all my fault. It should have been better; caring for me more would have been nicer. Then Joy screamed at me, it made me realize that this was all an exchange, and it could be good for me. Because if someone doesn't want to be with me, this person is missing out on being part of the life of an exceptional person. But that thought took years to come to fruition; it was not an easy exchange. I was starting with my previous relationship and extending it to the rest of the world.

I always worked half the week in a beauty salon and the other half in cafes. Since I arrived here in the United States, my mentality has always been to have two jobs. When one starts to stress me out, it's already the day of changing the environment and going to the other job. How completely different they are. Besides, if I don't have work on one, I can always count on the other. The worst part of the two is the miserable and bitter people, or the ones who are not so sour, yet have a terrible day and spill on the person who does not work for them. When I started seeing through my dome and not taking it personally, I started not to contaminate myself. People's attitude toward me 95% of the time were not about me; they were about how they feel.

I became more tolerant and empathetic. I know each person has their own world with their own wars. Things don't bother me as much as before. I look at the attitudes that once bothered me as if I were just watching movies. Or, as if I were an extra in the scene I entered, and I'm already leaving. The whole process started with the disappointment of the exchange made by my ex-husband. He told me a couple of times that she was the woman of his dreams; I guess they deserved each other. In the beginning, I still wanted the crumbs, then later, for moral and spiritual value, I made a list and placed it in front of my bed. This list was the first thing I saw when I woke up.

1. It's not worth it!

2. You deserve more!

3. You need to move forward!

4. It wasn't your fault!

5. Don't take it personally!

It started to get into my mind, and I started practicing what I read every morning. Because when someone despises me and doesn't value what I am and what I have to offer, it's not my fault. My ex's decision has nothing to do with me; what he felt about me is not what I am or how I live. "Even when a situation seems so personal, even if other people insult you directly, it has nothing to do with you,"[202] says Don Miguel Ruiz.

Each person has their own traumas and frustrations, and their opinion of the world revolves around what they bring with them. She brings her load of emotions accumulated throughout her life. In chapter 3, I talked about a chain of decisions. From link to link, generating like a chain, the cosmovision of each one brings in its center what fills it. If I am full of good things, no matter how much I've suffered, I'll see from the outside how I feel inside. I project my interior to the world. If he has a psychological history and I don't seek help to transform him, it will certainly never end. To find my peace, I need to pay attention to what I am projecting from myself and around myself. By taking the other person's opinion personally, I will be agreeing with it. If I do not take it personally, I don't bring a sad link to my life anymore because her opinion will be out of my dome. Remember the dome? I need to create a dome to insulate my emotions as the other's worldview spills over me. To protect my feelings, I need to know that the emotional garbage someone else collects cannot be dumped on me. I have my own demons to deal with, and I don't need more. This thought will free me from conflicts with the other by having mercy on him. Remember that each one brings with them a story that made them what they are.

That continued thought will save me from disappointment. Giving the other the benefit of the doubt is letting time unfold a new story. I have my projections of what the other is, but it is just about to myself. Many times, I think about doing something for someone, and

[202] Don Miguel Ruiz, MD. The Four Agreements. Breaking old agreements. P. 49. Amber-Allen Publishing Inc. San Rafael CA. 1997.

then I just leave it undone. As a distraction, I end up forgetting; this does not just happen to me. It can happen to others, and I think they do not do something because they do not care about me. If I project my ailments onto the other person in the same way, this person can project onto me. Everything will be different if you and I do not have attitudes and situations like personal attacks.

When we are children, we are born with empathy, but we learn to be selfish like most of the world as we grow up. According to Daniel Coleman, "Development psychologists have found that babies experience sympathetic distress before they fully realize that they exist apart from other people[203]." After birth, babies start to react according to what happens around them. Everything you perceive will be relatively personal. If you see another baby crying, you will probably start crying. If you see another in pain, you will surely share your mother to comfort the other child. I remember I was at the water park with my youngest son, and he fell. He scraped his knee while I was on the other side, and I didn't see him fall. He simply went to the nearest mother and showed her his bruise. For him, mothers were all the same. When I saw her, she was already taking care of him. When we were in places and something happened to another child, he wanted me to put them in my lap and asked me to kiss their wounds as I did with him. Empathy and purity we already inherited from God when we were born. It's what we learn during our lives that make us what we are. It takes us out of our original and pure form.

The same way I see myself, I need to empathize with the world and the current that the other person has about them. In this way, I will be living the love of Paul's letter to the Corinthians. Compliments and favors alike will not just become a part of me. People like me can also be in a bad mood, talk too much, and get it wrong. Not considering that it concerns me, I will be at peace and keep social peace. Mainly I cannot resolve the other's life and feelings towards me, just as the other cannot do the same for me.

A few years ago, when my oldest son arrived from Brazil, he worked in a dog salon, as he had taken a course before coming to the USA. In this room, a lady chased him, gossiping and putting a bad taste in everything he did. She was afraid he would take her spot. What I taught him was that that lady must have severe personal problems to be acting like this. All this would pass, as he was in that job to pay for his education and support the family. A year later, he worked in a bakery and had two ladies who unfortunately pursued him even more than the first person. I told him to look at the target, which was his education. Let them say what they wanted, because their worldview was spilling out. He would have his master's degree in a few years, and they would still be walking in the same cycle.

Last year, a teenager came into the bakery where I still work for a few days. The same manager from the previous chapter was giving hell to young coworker. I ached as I did with my son, and I remembered the same thing with this boy. He was just passing by, and she was pouring out all her frustration on him because she was never going to get where he possibly could. I told him not to take for himself the poison she drooled around the

[203] Coleman, Daniel PHD. *Emotional Intelligence*. P. 98. Bantam Books. New York- NY. 2005.

world, because everyone gives what they have. "But if your eyes are evil, your body will be dark. If, therefore, the light that is in you is darkness, how great is that darkness!"[204]

In order not to show so much of how I feel and to avoid disapproving of what I see in people who try to spill their hurt emotions on me, I should exercise patience. I'm still halfway, there, but I'm learning the unimportance of people's opinions about me. When we find full happiness, we are very busy being happy and have little time to look at what bothers us in others. When this happens in my life, I see the difference between loneliness and aloneness.

Reflection of loneliness & reflection of aloneness

Before I met Joy, I couldn't stand myself. I couldn't be alone, and I missed people, always calling someone or another. I hated crying; I felt abandoned. If some friends got together and didn't invite me, I would be sore for years. Loneliness is accompanied by an emptiness that I did not fill. I needed others to be with me. I could see that I look for meetings or parties to be frequent or buy more than I need. Here is the first signal that I must pay attention to and seek help. My dreams will alert me that it will be great to pay attention to them. This emptiness accompanies anxiety, and here we distort the saying "better in bad company than alone." The feeling of nothingness that brings loneliness consumes the ability to decide and dream. Solitude, on the other hand, is accompanied by self-love, security, and empowerment.

When I learned to love myself, being alone was a state of grace. I plan to do things I enjoy doing when I'm alone, like walking, writing in a daily journal, learning new recipes, cleaning up messes, reading something, or inventing a new recipe. Every day, I make an appointment with myself. Having alone time is essential for my emotional development. It's a unique moment where I listen to myself, analyze, and program things I can control. I hear thoughts that hide when I'm with many people, and I end up destroying myself. If you don't invite me to a meeting, I'll use my time alone for more important things. Here is the famous saying, at its very essence: "Better be alone than in bad company." When I exercise self-love, loneliness isn't displaced by the invasion of solitude.

After discovering who I am and coming into the world, no small thing moves me from my inner peace. I love spending time with myself. Every day my presence enchants me more. I spend hours with my thoughts, even if it's when I'm washing dishes. I make my list of new goals I want to achieve. I write my ideas so I don't forget them. Being alone with the person God calls a daughter is spectacular.

Things often make you twist your face, close your hands, or rub your neck as I do. I am giving the impression that I'm not in the mood to be in the presence of this individual. How should I not take personally what the other is trying to do to me if they show it clearly in their expressions? In the same way, I let people read me because of my bodily expressions.

[204] Matthew 6:23

I can handle what I'm going to say, but my body doesn't hide it most of the time. What can we do to not let this happen? Since I don't want to take it personally by holding myself back with my opinions, however, I am floored by my body. How can I change this? I asked my family, who knows me best. I wondered what common expressions were giving me away. And I made a list to start working on them: the non-raising of the eyebrows, rolling of the eyes, the twisting of the mouth, the big sigh, touching the neck, and so on. I am practicing controlling my bodily expressions and practicing my self-control when the feeling is most potent. And my opinion of despicable, silly people who don't know what they're talking about isn't going to make them change. And much less, their opinion of me won't make me change. Controlling my response and my bodily expressions will keep me in my dome. I'm not letting it affect me. Should I just pretend it's not real, or should I call it into existence? As I'm not that person yet, I need to train until I am.

Amy Cuddy said, "Fake it until you are," in her speech about non-verbal communication, known as body language. This is how our body expressions reveal our emotions. Even if we don't speak, our bodies will speak for us. She explained how universal the beginning is in the animal kingdom when the animal feels the power it expends. In the same way, humans, whatever we've fallen into, extend our arms and confidently show that we're in control of the situation. Likewise, there are people who, with a physical or even visual disability, when they win a physical competition, open their arms in a V shape; this posture shows their pride and how proud they are of themselves.

However, when animals become powerless, they curl up and shrink. The same goes for humans, too, when we are not in control and become suspicious of our situation. So, what should we do when we need a position and don't want to show that we're insecure? Even then, we must fake it until we get it. Cuddy says, "Our body can change its mind in our mind, and our mind can change our behavior, and our behavior can change our results."[205]

In general, we will not be false, but in order to practice until we become what we want to be, we sometimes need to impose on ourselves a condition that we want until we're ready. Changing my behavior makes me happier because I'm not adding another's emotional garbage to my life. Then everything around me will be more pleasant. I do not take it for myself, and neither do I pass from one to the other. I am forcing my body to press my mind and practice hiding what I don't need to show: my fear and my insecurity. I practice exposing what I force myself to be: confident, arrogant, and full of self-esteem. I am moving on to people who rely on me for more security and not allowing those who root against me in a situation that could be seen as my weakness. Margaret Matlin states, "The non-verbal aspects of conversations are fundamental in conveying social messages."[206] That way, I won't throw my frustrations at the other person. I won't bring to my life what he tries to pass on to me, practicing love and being tolerant and merciful. I will not always

[205] Cuddy, Amy, Ph.D. Psychologies social, *Fake till you make*. Ted Talk show" October 1, 2012.

[206] Matlin, W, Margaret. *The psychology of Women. Nonverbal communication. p180.* 7ed. Wadsworth. Belmont- CA. 2012.

make it, but I will die practicing. I have a break until my death, and I don't know if it will be long, but if it is in my presence, it won't be as unpleasant as it once was.

In the morning, I have a blank page, and how I think and act during my day will be essential at the end of it. It will either end in peace or bring more trouble. My ability to see my surroundings is based on my maturity. What have I learned in this interval between my birth and death? I can be a guide for people who went through what I lived, or I can suffer again, as if my problem were the first in my life. I was a pessimist for a long time, yet my thinking now is that you can do what you can do. Each person brings in their own world perspective. David Wallace said, "The same experience can mean different things to two people because of the way they think."[207] Those who have closed minds imprison to the point of not letting anyone see that they are trapped. They think they are at their center, and nothing they can say will make them know what I see. I don't blow up with someone who takes my time when I have little to give after a tiring day, understanding that this person has his way of seeing the world. Science proves that we can all change our personality by working to make it happen. Everything is possible for those who believe and strive to achieve it. God is a great partner for change, but 85% depends exclusively on me.

The truth is in getting back to the way I was raised. I didn't have any limitations; I learned as I grew up. Today I want to change, and what should I do? I need to practice acting like the person I want to be consistently. Whatever part of me I want to transform, I need to act until it becomes natural in me. As stated by Albert Mehrabian, "Postural relaxation conveys power or status and increases implicit activity, such as facial or vocal responsiveness expressed to another person."[208] Even without using words, I leave when I'm feeling vulnerable. I must work more during situations when I am taken by surprise, as they are unavoidable. However, it's worth trying to correct the body language we can hold back. Who has never rolled their eyes when someone bothered them or spoke nonsense? What about the lowering of the eyes, the hands clenched in sadness or anger, or holding hands when you're insecure or anxious? Training my movements and expressions as loud, intense signs that reveal what I don't speak can free me from a lot of conflict.

If I want to hear more, I need to let people talk and keep quiet even when I want to talk. What I want to talk about, I write in my diary/newspaper or talk to a person or professional who I know will not spread the subject. If I want to be more economical, I start to cut what I want from what I really need. Being more sociable, I similarly start with small openings with people I like and haven't seen for a while. Reviewing and catching up on life with one person prevents me from doing so with others. Being more physically active, I start by taking two days and committing myself to keep them, then adding more, even if it's just a walk. Little by little, I get used to it, and without realizing it, I will be walking towards what I want to be as a person.

[207] Wallace, David Foster. Speech Kenyon college graduation. Gambier, OH. May 2005.

[208] Mehrabian, albert. Ph.D. Psychology. *Nonverbal communication* p8. Aldine& Atherton. Chicago IL. 1972

Açaí palm of the Surubiju

I spent most of my childhood on my grandfather's farm. It is located thirteen kilometers from Rondon do Pará, in the southwest of Pará, in Brazil. Today it belongs to my uncle Ailton and aunts Zinha and Vana. My father, Francisco, and uncle Valter sold their part of the inheritance. Before there was electricity on the farm and everyone watched TV at night, we had an engine that gave us electricity for a few hours. It was a ritual that we gathered for at the end of the day and night. We would gather on the vast porch around the house, drinking coffee with fresh milk or lemonade from our lemon tree in our backyard. My aunts made fresh gummy biscuits of tapioca called puba[209] cake. We shared watermelon, cashew juice, guava, jackfruit, and mango, which were native fruits. Some of us sat on the huge and extremely heavy benches in the Camaru, others on chairs made of tires and ropes, handcrafted by our cousin Jorge. Some rested in a hammock, like my grandfather, and others on the floor. In these meetings, my grandfather was told what had happened during the day in various parts of the farm. We would talk about the plans for the next day. In the evening after dinner, when the engine was turned off and we were in the light of lamps, we would meet again. This was my first favorite time of day, followed by the mornings, when I went to fetch fresh milk from the corral for breakfast with my aunt Vana.

This was a time for tales and legends to be passed. My father always told of his wonderful adventures in vaquejada[210] competitions and of the countless times he's won by being a puchador,[211] which was almost always. He told us of the times he was esteira[212] with his famous friends at vaquejada parties. Workers' stories came out of fishermen's tales at times of abundant fishing. Those who liked to hunt remembered and shared their experiences, like how they set the traps and when they fled from a jaguar while hunting. It was also the time of the old legends of the mula-sem-cabeca[213] and the sacipererê,[214] boiencantado,[215] and curupira,[216] among other legends and many stories that were left to our imagination. Whether it was just tales or truth, we would never know.

One of the nights, a man who worked for my grandfather told a story about when he went fishing in Surubiju and, of course, took açaí from the marsh with a friend. The açaí

[209] Puba: flour made with fermented (or pubada) and sieved cassava mass. Dry, crunchy and acidic, it is used in cakes, cookies, and couscous.

[210] Vaquejada: a cultural activity in northeastern Brazil, cited by some as a sport, in which two cowboys on horseback knock down an ox, pulling it by the tail between two lime strips on the sand track.

[211] Puller: the vaquejada pulls the ox by the tail and drops in between the lane.

[212] Mat: the assistant rider of the puller who takes the ox by the tail and delivers it to the one who will drop in the lines.

[213] The headless mule: the legend of tells the story of a black or brown donkey, which has a fire torch in place of its head.

[214] Saci-pererêa: a mischievous little Black boy who smokes a pipe and carries a red cap that grants him magical powers. He has only one leg. Saci-pererê is a very mischievous character who enjoys playing with animals and with people. His main antics are braiding animals' hair at night, making objects disappear (such as seamstresses' thimbles), whistling very shrilly to scare travelers, and disturbing the work of the cooks by changing the salt and sugar containers or making them burn the food.

[215] Enchanted ox: from the legend of a mysterious and indomitable ox, which appears to teach northeastern cowboys to lose their fear in taming the ox.

[216] Curupira: a Brazilian folk character who has red hair and backwards feet to confuse hunters. Protector of the forest.

palm is thin and, in most cases, very tall, and it wraps itself around the vines taken from the trees or ropes. They saw it very close to the Surubiju River, in one of its parts with a lot of currents, and the water was very dark, which meant that it was possibly too deep. Distracted, they were in the middle of the forest where there was no one, only wild animals. The rivers of Pará, primarily Amazon's tributaries, always have surprises, such as big carnivorous fish, anacondas, and alligators. He heard his friend say, "I was worth my baby Jesus!" And he walked towards his friend's voice and was faced with the scene: the friend was on top of the açaí palm tree; it was the tallest palm tree he had seen in his life.

It was heavily laden with açaí coconuts. When the friend reached halfway, the palm tree bent over, and his friend's position was halfway up the river. The palm tree began to crack as if it were going to break in the middle of the river. To top it off, on the other side of the river was a very thin anaconda sticking its tongue out. When they're chubby, it sometimes means they've already eaten. Its belly gets stretched out from swallowing its prey. Currently, it doesn't move and doesn't pose much danger. And under his friend appeared half a dozen alligators, with their giant mouths patiently waiting for the palm tree to break. Suddenly, his friend stopped praying, and he curiously thought he should have seen another solution. His friend reached out one of his arms and grabbed a skinny branch of a tree; he thought his friend was trying to hold onto this branch to save his life. But suddenly, he took his hand off this branch and took very yellow cashew into his mouth and began to savor it slowly. When he finished eating, he said from the depths of his soul, "This was the most delicious fruit I've ever eaten in my life!"

Once we are born, we start to die, and that's the only certainty we have: that death is inevitable. Sooner or later, my number will be called; the big question is, how will I get through this range? I must decide. It's no use spending this interval between the beginning and the end in pity. I was playing poorly, blaming myself for my reverses on the other. It is even worse to think the worst of myself and ache for unusual things. I was feeling wrong about those who tend to point out my downfalls and failures. I was denying that all my thoughts were my own. I can't change anything that isn't in me. I cannot change what is in the other, in his mind and emotions. I need to understand that I need to get through the interval between my birth and death as best I can. And the first rule to be okay in this range is to be at peace with myself. One of the tips that I received from Joy and passed on is not taking what is not in me. When I started to think this way, I realized that there was peace inside my dome, and it triggered my search for complete happiness. This separation from the things that have nothing to do with me brings me continued peace. When the disturbance starts to invade my dome of peace, I remember that it's not my respect. It's not about me, and I relax again.

My complete happiness is my sword and my answer of peace, my shield.

The real me

Clinging to my host as if he couldn't swim!

Having been generated and created in the ocean.

Going down a path I didn't choose.

For not wanting to let go of the old, the known, the pleasant.

As a breaker in other people's history, I accommodate myself, so I don't have to move.

A ride to a destination that the other has chosen to live the dreams of others.

Remorse, eating the rest, living the rest, and dreaming the rest.

For not wanting the warm one to leave.

Out of fear, I stuck to my cozy home and adapted to the situation.

I think I'm not a burden, I believe I'm not seen as a burden, I'll stay here.

And passing in front of a mirror, the real me appeared! I got scared. I didn't really recognize myself, had never seen me and thought it was someone else.

That's big! Huge teeth! A phenomenal musculature!

Astonished, I asked: what does someone, so proviso do below another, eating the crumbs?

When I started to move, I saw that that mighty shark was copying me. In the first few minutes, I thought it was funny. Soon after, it started to irritate me. When my chip dropped, I was even more scared!

It was someone who didn't recognize what he was living.

No, I didn't know the real me.

For what was I created?

For what I was designed to be.

What could I do?

A shark.

I was born a shark and became a remora for not wanting to break my limits.

For convenience, I preferred not to see my potential.

Living a life of remorse in the shadows, being a shark.

I could go to unfamiliar places on my own.

Choose what to feed me.

I did not need to hide below others.

I never took a place that was not meant for me.

Seeing what I was and how far I could go.

The real me was not afraid. Who should I fear?

It was unrestricted.

It was without limits.

Audacious.

I did not accept the impossible.

Shark is what I am.

I am making my dreams come true.

I am outlining, spreading, and conducting what I propose to do.

Chapter 20
Identity

Lifting someone who is down and applauding when he remains standing is a sign of strength.

The train of life

We are a blank card when we are born—the first car of a train, a new unpainted canvas. We learn from others to eat, talk, walk, go to the bathroom alone. We copy everything we've heard and seen. Teenagers think they know something; we look for a way to express the identity we don't yet have. Looking for a place in the sun, I'm the one who dazzles the sun shining on me most of the time. We try to be happy on someone's tab because we don't have our own identity. We think that what others do has a purpose more remarkable than ours. Maturity comes with the question of who I am and what my role is in this world. I know I don't biologically have so much time to waste. What will I leave when I go? What have I done with the time I have so far? What can I still do? What is my talent? What causes me complete happiness? Am I happy with myself? Do I like my presence? What is my identity? Who am I? The way to find my identity is when I find my purpose as a person. I will only live once, and I need to make my way here. I am marking my presence to those around me, especially to my primary family. Life is a train, and we get into the first car and move on to the last one.

The first wagons don't know anything; everything is unprecedented. After passing through a few cars, we already know something about the train of life. The last ones already know that it is complicated to reach the old age car. This wagon so dreams, and few conquer, and most are forgotten wagons. However, the last car has a lot of wisdom gained from having gone through several stages. He is always alone with so much to talk about without an audience. Many had the opportunity to live a long time and decided to get off the train of life. Some wished for this but have been removed earlier. So many are

struggling to get to the last cars, and health doesn't keep up. And the saddest thing is that some people pass the train without realizing they are alive and without taking advantage of the gift given to them by the train of life.

I had two dreams that I was in a hole, and I got stuck not breathing. I woke up, unable to breathe. When my breathing returned to normal, I dropped to my knees on the floor beside my bed, thanking God for the gift of waking up. After this, I have knelt in prayer three times a day. I talk to God each day, but I always thank Him first. At least that's my daily intention. Sometimes, I forget and send the request and redo it in gratitude. I learned something wonderful from my husband when I made my prayer request list. I asked him what he wanted me to intercede. He replied, "Health." "Just this?" I asked. He embarrassed me by saying, "God has already given me everything. I just need him to give me health so I can go get it."

Looking for my identity

Those outside my dome don't need to know my weaknesses and failures unless it's after a victory or for me to say that I failed first. The don't need to know my financial life, my fears, and especially my plans and dreams. During my separation, I went through almost five years of great financial difficulty. There was abundance, and I had what it took to live in peace with the problem and in harmony. During this time, I tried to live with dignity with little and make this little enough. Because of the lack of money to put oil in the house heater, I used electric heaters—which, by the way, are expensive in winter. And before the summer of 2016, I had a $2,500 debt on my electricity bill. I made a payment plan and paid late, which resulted in my electricity being cut off for two days. I felt like a failure. Not even in Brazil did I have my electricity cut off.

My stepdaughter and youngest son cheered me up with table games between the three of us. My oldest son had just finished college and moved back in with us. With his coming, his support with the younger ones, and his financial help, we lived in great peace. I'm not in favor of asking favors from friends and the church unless it's a case of life or death. People who help you think they have power over you. Help those who you can and help yourself, because you want to do something good for someone. My opinion in life is that while I'm breathing underwater with a straw, I'm still living. For the first six months, I separated. I needed government help with food, which was another humiliation. The vision of the Brazilian when he leaves his homeland is for a better change of life. We are very proud to pay for all needs and to achieve goals without begging. After years of living in the United States, and I barely had money to survive, as if my work and sacrifices of all these years were wasted. All my friends who came at almost the same time were incomparably better off than me.

But I remembered who I am, the King's daughter. Being a King's daughter, I took my cause straight to Him. I didn't want to be supported by the government, but by Him. He opens doors and blesses paths. In my prayer, I remembered who my provider was. My faith, along with my two works, was put into action. At this time, even the jobs started to

fall apart, and I had to change salons. The cafe where I worked for nine years failed, and they had to close their doors. Everything was going financially and emotionally terrible. But I showed people only what they needed to see. They saw what came out of my dome.

The only place outside of my dome that I could pour myself into was at the altar of God in the church, and I was criticized a lot. I was going through a process, and I didn't understand. I started to despair. I felt like I would die, and I let it all out when I was in church. I learned that this church held the world for those who looked for it. We don't go out to clubs, so my growth must be within the church. Somehow, I must become better as a person. And what will make me better or worse are my experiences with people. If I don't go to clubs and parties, then the church is where I will mold myself. There are people there who need God like me. Of course, some think they are cherubs. Everything about them is better and holy, and whoever goes through that will never go to her spiritual level because she arrived first. I always had little conversations with my inner crybaby. To this day, I am remembered by many as the person who exposed pain more than I felt so that people would feel sorry for me. Some see it as personal and Christian learning and transformation.

But most see me as if I'm their miracle and not God's. I've heard so many comments, and they're hiding pain from what I've exposed. I can't even imagine what it would be like if I had presented all my problems and asked the community for money. It would be even more teasing than I am now because of my whining. Most people can't stand people who constantly complain, as I found out myself. They support you for a month, but the talk begins when you don't change as expected. I begin to bother many and turn into the subject of small meetings among healed people. And the worst thing is the innuendo every time they pick up the microphone or preach. In the hall, it was no different, but there I couldn't open myself up like in church. During my time between one client and another I read, wrote, and drew the paintings I had in my mind. Outside the church, it's easier to defend yourself, but in the Christian community, it's complicated. And it is these situations that make many feel disappointed and like I want to give up, others become bitter, and some remain constant. After all, it's not God's fault; it's my fault and the fault of all those whose need Him. We all mess up, and some abandon their faith.

With all this, I learned with Joy to create my dome. I didn't have an identity, and many of these horrible things have stayed with me. However, discovering my identity became an experience for today, so I could write to whoever is going through this. It doesn't matter who doesn't need it. Start making fences outside and divide the groups, as in chapter 18. Protect your emotions from them as much as you can, depending on how you're going to conduct your day. With feelings protected and safe inside the dome, we will be vital and strong emotionally, and we can help those who need us and rejoice that we are already well. I know that when I'm emotionally out of balance, I can't help anyone. I only get in the way with my bitterness. And I can't applaud and rejoice that I can win. The most significant victory gained was having my emotions in balance. With my feelings balanced, I can use what I went through to help those who are still down. And I'm thrilled with whoever gets up, because I know how difficult it is to get up.

The winner admires and values the other's victory because he knows how difficult it is to achieve.

Finding my identity

Joy taught me that I am a child of God and seek holiness to be close to him. I am not perfect or self-righteous. I am weak and fail and depend on His mercy in all areas of my life. I don't need to be afraid to assume what little I am. I am small and flawed, the daughter of someone without limits, and invincible.

In my dome, I let out only what I want others to know about me. Today, with all the accessibility of the internet, I end up connecting with many people who I never thought of connecting with. According to T. D. Jakes, "For the reason that we only show the beautiful moments, haters are born."[217] Because we only show the beautiful things, haters think we never have problems and live victory after victory. Because I exhibit the best photographs, my family is very happy with me, although, I don't use a filter for anything. I show my victories, and my life seeming hassle-free. Because they don't accept that I have a miserable job and a miserable life, I'm just throwing out books one after the other. I'm exhibiting paintings like I do or buying a new car and always smiling. What is not seen is the rush to do all this.

Having to read, going to school after a tiring day at work. Cooking, cleaning, washing, or walking with a dog that never obeyed me, even as a baby. There are people who see my life and their life outside of the dome and think we are different. They believe that we don't have problems and bad times. It's not fair that they go through so much trouble, and I'm just happy day in and day out. Social media presents my best angle and the best moments, as if I live like this. We all go through agonizing days, we get depressed, and most of the time, we want to give up. How many times this year have you and I thought about canceling this blessed project that gave us a headache? But we are persistent, and we end up looking for a better way to get it done. You and I have something that won't let us stop; it always moves us, even when we are repeating to ourselves that it is no longer possible. But that's the contrast we make; it makes us different, and it seems like we always get what we want. What I let out of the dome is what I got and not how much I had to lash out against myself to do it. I found identity and learned to retain what will not make my God glorified. I believe in my strength to persist where I wanted to stop. In my faith, God's no is to teach me or deliver me. I believe in myself and in the power of what I can achieve.

Persistence is the essence of a fighter who, in his pain, bleeding, continues walking on thorny paths.

[217] T. D. Jakes. Rev. *Crushing God Turns Pressure into Power.* Interview with Steve Harvey. August 24, 2012.

Identity of daughter

In searching for my identity, I found my spirituality and searched for the meaning of my existence. The purpose of my existence is in tune with a force greater than I had. I have to get close to what I can't get. Spirituality, for many, is the quest to transcend the tangible. In my search, I also found my religion. And my faith claims that I am not only created by a supreme and powerful being, but I am also His daughter. When I believe that the sacrifice of His son Jesus Christ is accepted, I am adopted and co-heir with God. As a daughter and heir, I have duties and rights as any daughter has.

My duties as a daughter are obedience, fidelity, respect, honor, love, dialogue, giving continuity to my name, and so on. My rights as a daughter, among many, are a father's protection, fidelity, honor, unconditional love, dialogue, and so on. The daughter's identity teaches me that the dialogue with the father is the opening for both duties and rights. In the dialogue, I speak with the Father, and He speaks with me. Dialogue is nothing but prayer. The book of James talks about the power of prayer. God, in His mercy, blesses us regardless of prayer. In the same way, we can pray until we lose our memory, but if He doesn't want to grant what was asked in prayer, it won't do any good. The right as a daughter is asked; however, the answer can be silence or a no.

God's silence can also be the time to see what I ask for that I no longer clearly want. Who among us has not prayed and waited a long time until He changed His mind? We receive a no or a yes right away, and we wait for the "son" of God. I often think God has forgotten about my prayers, but it is the logic of God that His time is not the same as mine. I make an annual list of the things I hope God will do for me. The same things are repeated for years and years. The Father waits, ready to receive or make me understand, hoping that what I asked is not for me. One crucial thing is for me to be grateful for everything He has given me so far, which makes me satisfied, and if what I ask comes true, it will be an extra. As much as it seems my prayers are forgotten, if what I prayed for is in my heart, or I still need what I asked for, I need to trust. I need to trust in the Father's fidelity and provision, as He knows all the daughter's needs. Remember that if men say no, even though it seems impossible, the last word comes from the Father. Even today, I received the answer to a request that I had been repeating for over fifteen years. The daily and continuous dialogue with the Father will give me peace to wait and see that what I sin is not for me. After all, which father does not always give the best to his beloved children?

Exercising my identity

On the 22nd of November in 2015, I made my first live painting presentation at an event; it was a women's congress in Framingham, Massachusetts. I painted according to the theme of the event, and after this day, I have performed at teas, concerts, and conferences ranging from more than a thousand people to thirty people. I usually start with the main speaker and finish before him.

On October 2, 2019, I was invited to a tea party, and the topic caught my attention. I decided to research more about the subject. The chosen theme was the dandelion flower. To paint live, I must be emotionally within the matter, studying what I can on the subject, artistically seeing shapes, and studying what I'm going to paint. Of course, when I'm working on the canvas, I create more than I thought or take some things away to make the theme more evident.

On the same day, I had a themed painting group in my studio already booked for six people right after the performance. Paintings From the Soul worked with the dandelion theme because I had already done my study and written my metaphor to apply on canvas inspired by the theme. It was a success, as the results of these groups always are. All participants leave liking their paintings more than they expect to and marvel at the theme. That night, by the way, was super busy for me but very gratifying. They relaxed, chatted, drank my tea, and, in addition to having painted for the first time, like me, they began to see this flower as a synonym for identity. The dandelion is commonly known as Tapak Randa in Bahasa. It is included in the genus Taraxacum of the Asteraceae family. Dandelion flowers can live anywhere in the world wherever the winds carry them. The dandelion will grow wherever the seed stops.

The flower is like you and me, huh? It's also known as a "fairy clock" because its flowers periodically close and open at certain times. Like us again, we close but re-open. The dandelion does not look attractive because of its peculiar shape with its fragile stem. The dandelion was devalued as a weed that grows in the way and adorns the other flowers. However, the dandelion is very advanced for the human being through its philosophy of "the true meaning of life." I had already cursed and docked this flower when it appeared in my garden. With the other flowers, even with great care, it is still challenging to keep them beautiful. A dandelion, even in the ugliest place, is born beautiful. This brightly colored little flower can grow almost anywhere there is a hint of soil or a crack in the sidewalk. Even though I think of the plant as nothing more than a pest, understanding part of its use as a symbol can give it a new appreciation.

The dandelion name first developed in the fifteenth century from the medieval Latin phrase *dens lions*, which refers to the irregular shape of the leaves. Later, this became "dandelion" in French, and then in Middle English. We still use the same name today because it's easy to remember and still applies to describe what the plant looks like.

Since dandelions can thrive under challenging conditions, it's no wonder why people say that the flower symbolizes the ability to overcome life's challenges. Although it looks very fragile, it is powerful, beautiful, and has deep meaning. It is strong against the wind, soaring high and exploring the sky, and finally getting somewhere to grow into a new life. Like the dandelion, which is always tricky yet fragile, we keep trying to pursue and achieve our ideals that can be difficult on the streets but don't stop chasing dreams because falling into one place will lead to a new life. This symbolizes my identity—that even going through terrifying moments, I remained firm. I grew up where many flowers withered away with the terror of adversity. Like a common weed, the dandelion and

I remain beautiful regardless of the situation. The dandelion doesn't even deserve mention in the Victorian language of flowers. The philosophy of the dandelion did not stop medieval peasants and modern spiritualists from considering it a symbolic flower. Most modern admirers consider it a symbol of fighting life's challenges and gaining victory. Others use it as a visual reminder of the sun's power, especially when depression or pain makes it challenging to stay in the sun. Of course, a long-held popular belief is that blowing the white ball of seeds into which flowers grow grants you a wish. Others use it as a symbology to use intelligence when dealing with all sorts of situations. One thing we must agree on is that this flower looks so cheerful and happy, even when it's blooming on a sidewalk or invading the grass on a lawn. All dandelions are yellow, so they share a standard color. It means it doesn't matter what specific attributes you have. We are all equal, and we have the right to grow and strengthen ourselves by discovering our identity and allowing it to flourish and take our place in this vast world. And if I wasn't offered to grow up in the middle of a beautiful green field to the sound of water, I would still grow.

> I will grow up in the dry valley.
>
> In the shadow, throw a stone that steals my view of the sun.
>
> I will grow up in the high, cold mountains.
>
> Between the closed and suffocating bush.
>
> I will grow in a crack in a sidewalk or wall.
>
> Where many flowers would not grow, I will persevere with my tireless warrior identity.
>
> I fall, cry, bleed, grieve, and regret, but I will grow.

Persevering where doors close, persevering where dreams are frustrated. It is persevering on the path of faith.

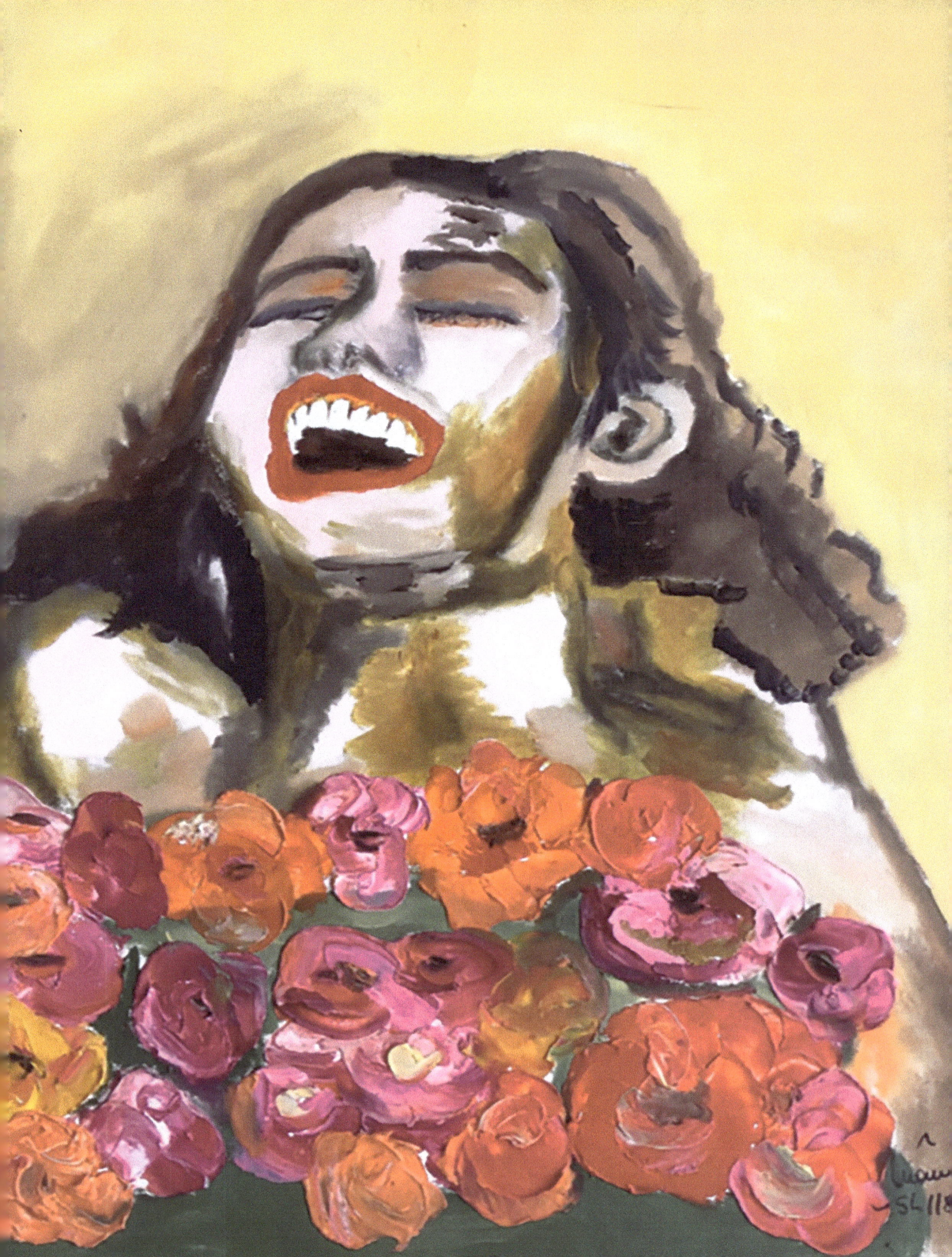

Chapter 21
Choosing a King
Humility is a leveled ground for infinite constructions.

The empty throne

Five years of walking with Joy and mirroring her attitudes were beneficial in my emotional healing. I could never have walked with her without healing myself. She has inspired me since the first day I saw her. When my rug was pulled out from under me, I visualized an emotional mess that I lived with without knowing it. Having to face this dirt created by the past, I had to relive pains that went back to where I didn't want to step anymore: my past, the root of all the evils reinforced by wrong choices. My false favorites formed strong chains with almost unbreakable links; the process took nearly five years, and a few people were of great help. After almost two years of therapy, these chains were broken with the help of two people: God and Joy. I had to look in the mirror and face what I think of myself, what God thinks of me, and what the rest of the world thinks. My God-given gift took a new direction and helped me a bit in the healing process. The inspiration delivered by dreams empowered me to bring reality in the form of canvases and books. I had to learn to float along with my tough financial life.

I had to forgive those who caused me trauma. I had to forgive myself for things I didn't enjoy, things I chose and brought to my disgrace. With my heart flattened, I learned to say no, learned its importance, and received God's no. I saw that I was not the center of the world and that the sun didn't revolve around me. Most of the things outside my dome are not about me. The process of smiling, crying, learning, and persisting gave me my warrior identity. Now I'm in love with the person God created. I did an excellent job of messing up God's beautiful work and sabotaging my own life. He showed the way of healing with a gift and how to love my own company and live in harmony with myself. Since I can be happy alone, I don't depend on someone else to do the work that is uniquely mine. My

happiness and inner peace are my responsibility to create and maintain. With this plot leveled out, I'm ready to build a relationship that will add to my happiness rather than its foundation. It was time to choose a new king to sit by my side in the reign of my life. This was a challenging task, as my reign is full of peace, and I live in my real happiness. I've found my "bliss," and I don't want troublemakers to mess up what I've worked so hard to achieve.

I was talking to my oldest son about wealth, and we talked about how rich we are. We remembered the two days without electricity, when we played table games by candlelight and smiled after I cried in frustration. Our memory was of the peace we had being united as a family once again. On Sundays we would get together, talking about our week and laughing at each other's follies. The reminder was that the only thing we didn't have was money, but we swam in peace, love, and unity. The most incredible wealth was having what was necessary provided by God and by our health to work. We walked into the house, and it felt like we were on another planet. I didn't want someone to come in as a spy for the enemy, cause discord, and destroy it all.

My son was almost thirty. He was dating already, intending to get married; however, he didn't want to get married and leave me alone with his little brother. When things are out of control, I surrender everything to God. I went back to what I do most: listening. In chapter 2, I talk about using lists for the common good, purpose, and self-commitment. The list here was praying and asking God to help me find a person I would write on my list. As He raised us all, He knew where this person was and how He would bring him to me. I wanted more faith and consistency in my life. But the identity issue helped a lot because I would continue to accept whatever came up without it. For the five years I was alone, I had to keep to my lists so as to not sabotage myself. I committed myself not to accept less than what I asked God for on my list. This reminded me of my petition, because when you depend on God, it is "August of God," as He is eternal. Sometimes, I think He thinks I have all the time in the world like Him. The goddess, little me, is thinking with the head of God. But I only know one person who knows everything and has power over everything, so let's relax and wait for God's August.[218]

To understand the king's choice to reign with me, I must mention some things about the medieval period and feudal times. Feudalism was born in the fifth century after Christ in the medieval period, divided into the High Medieval Period from the fifth to ninth century, and the Lower Medieval Period from the ninth to the fifteenth century. After the Enlightenment, people would refer to this period as the Dark Ages because it was a time when there was no growth, in their view. The feudal formation arose with the fall of the Roman Empire after it was invaded by the Germanic peoples, and it had the synergy of a new society. The context was one of economic ruralization in the transition from slave labor to servile labor. Societies began creating laws for the scarcity of slaves, creating a new type of work. Village life, as was the custom of the Romans, became less popular

[218] Since in Portuguese the month of August is Agosto, almost the same word for like, the Brazilians use the expression "a gosto de Deus." To God's liking, it means that it will take time to happen.

because of the many invasions of Muslims looking for better land to live on. The Germans had a king, and those who lived in the king's land influenced the fief.

Land was the main source of wealth and was the basis of subsistence agriculture more than exchange and sales. Feudal society was an estate divided between nobles and serfs. Unlike today, where you can change your social position, in the medieval period, if you were born a servant, you could never be noble. And with the help of the church that took the place of God, claiming that what they dictated was God's will, no one could fight back.

In the medieval period, the average person didn't have access to many sources of information,[219] such as manuscripts, documents, or evidence. There was no evidence; you had to believe what you were told. Because of the synergy between the Roman and Germanic peoples, the culture was of the Roman settlement and the bond of Germanic loyalty. The social relationship between them was that the lord should provide land and military protection. The manor was an agrarian subsistence unit protected by walls and administered by the feudal lord. On the other hand, the servant had multiple obligations; he would have to exercise the corvee, which was free half-week work on his lord's land. The carving was the delivery of 20% of what he produced to his master as well. The rate was called banality when it was necessary to use something from his master. If he was in the war, the servant would give shelter and supplies for the troops.

This was also the time when the tithe, or Peter's Penny, was invented. It is a gift of 10% of your income to the church, something still practiced today. At the death of a feudal lord, one more fee for the renewal of the contract with the heirs would have to be paid: the so-called dead hand. It almost seems fine with our days of paying for everything. The relationship between the nobles, however, was one of loyalty. Inspired by the German comitato,[220] the nobles were overlords and vassals. And here came the point of my allegory to explain this point in my life. I was electing a vassal king.

Vassal king

The noble or vassal king received from the overlord king an estate or title in exchange for his absolute loyalty. He managed this property with full power. The king reigned but did not rule; this was the position of the vassal king. If you still don't understand what I'm getting at with this introduction from the medieval period, I'm going to have to go to the beginning. In Genesis 1, the supreme king, God, gave the vassal king, Adam, the fief for him to reign above all. In the manor, Eden, he was made the absolute king. From the vassal king, he passed on to his descendants the autonomy over everything in their lives. When everything was given to us, the only thing demanded was our loyalty.

[219] This is contrary to today, when we have several ways to inform ourselves, so we cannot stay with what is said in churches and online affirmed by the point of view of those who swear to be "representatives" of God. We must study more we can access the information that is within our reach. Only in God can we blindly believe each person distorts according to their objective, so we must study and research.

[220] Comitatus: the Germanic organizational system that generated the fief. Property surrounded by walls was surrounded by serfs and the palace or house of the feudal lord or king.

Unfortunately, to this day, we haven't fulfilled our part of the agreement. Fortunately, the overlord king recognizes our weaknesses and lifts us up. Powers were given directly from the king, like the physical power to rule physical things by ourselves. We live in a physical kingdom, and all that is spiritual does not come from God. We are more powerful in the name of the overlord king. We represent the supreme king, and everything that tries to break that harmony must be stopped. In the name of the king, we can maintain that balance. Evidently, whoever tries to violate the order will only respect my authority.[221] I am loyal to the High King. The king's personal guard, the angels, serve the king. They will do things for me at the king's command and not mine. I have been empowered in the name of the king to maintain spiritual order in my manor. I represent the Supreme King, and if I am under His protection, I am empowered by Him for that matter. The physical kingdom is invaded by the spiritual. We have the power in the name of the king to fight. After all, being in the physical realm, we dominate, and whoever invades this plane needs other people physically for that invasion. Otherwise, it will only be an influence. "Most people think that Satan is an important force to consider. He does exist and you can't just ignore that fact... He's someone who needs to be recognized and resisted, but Satan can't do anything without your consent and cooperation,"[222] says Andrew Wommack.

The High King's seal is upon my kingdom, and with His protection through my loyalty, I cannot be attained. The biggest problem is that when I'm disloyal, the High King lets the enemy show me who really rules everything. I use an illustration that the devil is the sheepherder's dog. Once the sheep go the other way, he lets the dog put them in the path again. Afraid of the dog because they are without the shepherd's protection, they run to the shepherd. The shepherd will tell the dog to stop chasing them. We do this when we leave the protection of the High King by being disloyal to Him.

The other power that was given to us as vassal kings was the power of the word.[223] This is clearly for those who believe that everything we call to exist is both evil and good. I can't practice and live what I don't believe, and neither can I force someone to believe what I believe. The truth is the truth, but it is absolute according to what I believe. "His word is a gift that comes directly from God,"[224] said Don Miguel Ruiz. What's true for me may not even make sense to someone who doesn't think like me. Everything I share in this book I have lived. I open myself to those who have an open heart and mind to receive my truth.

Overlord king

[221] Power of the Overlord King to the vassal king. (Genesis 1:26, Luke 10:16, Isaiah 11:8, Ezekiel 2:6, Psalm 91:13, Mark 16:18, Romans 8:31, Philippians 4:13.)

[222] Andrew Wommack, The *Believer's Authority*, p62, Harrison House Publisher, Colorado Springs, CO. 2009.

[223] Power of the Word (Proverb 18:21, James 3:2-9, Ephesians 4:29, Matthew 12:37)

[224] Don Miguel Ruiz, MD. *The Four Agreements. Breaking old agreements* p26. Amber-Allen Publishing Inc. San Rafael CA. 1997.

In both medieval times and in Eden, the overlord or supreme king is the king who stands above all other kings. He was watching, and when needed, He intervened; however, He did not move on to something the vassal king could solve. The higher king gave the vassal king power here on Earth, because He had to reign. The suzerain king intervenes only in what escapes from the hands of the vassal king. If the vassal king can do it, the overlord king will not do it for him. He delivers to the vassal king because He knows his potential and expects His loyalty; clearly, the vassal king will not always be completely loyal. He will lie, disobey, hide, and so on. If it were really like this in the medieval period, mercy was far from being exercised, yet the supreme king, God, has mercy that has no end. The power of the word reaches its natural reign when I believe what I say, and that has to do with me. If I say things about growth, I will undoubtedly grow; the same goes if I say something that will be of destruction.

The letter to the Overlord King

In the medieval period, marriages were arranged between nobles. Indeed, the king knew more nobles than the nobles themselves who sought to marry off their children. Nobles chose matches that strengthened a political alliance. In my allegory, I knew that the High King knew all the other kings. As I always chose wrong, this time, I let the overlord king choose my vassal king. He would understand within what I wanted the exact king who would be mine. He would know the king in His essence for having created him. Given this, I resolved to write a letter to the High King with my petition. My list was a commitment to myself to continue waiting until my prayer was fulfilled.

I wanted my king on Earth to love and fear the overlord king above all. I wanted a man who knew how to be a good father and a good reference to my teenager. I wanted a tall, hard-working man who would love me and respect me as if I was everything to him. I wanted him to know how to deal with finances better than I did. I wanted someone calm who didn't like shouting; someone whose family was his priority; someone determined who knew what he wanted for his life. I wanted a man without a rude mother, one that already had his children and didn't want any more children. And I wanted a king who would understand not to oppose my call to be loyal to the overlord king and work for his kingdom.

And besides having these characteristics, the confirmation would be that when I found him, he would say this to me: I don't want to be your boyfriend, not even your fiancé; I want to marry you because you are the woman, I asked God for. It sounds hopeless on my part, but I've decided to live a life loyal to my overlord king. Since I was alone for many years, dating the man of my dreams wouldn't be just kissing, right?

Candidate for king

When you ask the overlord king for something, you must trust Him to do it. He is sovereign and knows how and when to do it. Going back to the goddess expression, I made it clear that I would help God. It started well. The king he chose no longer had a mother,

and he was a Black man who feared and loved God. He was a worker and managed his finances well. Many things were on my list; however, some weren't. He loved me and acknowledged that I was what he asked of God, too. In contrast to my list, he had never had children, so he was not a father. And he wasn't the height I wanted, either. He was ten years younger than me, and men are usually more immature; he couldn't possibly be sure what he wanted. As I thought it was about time, I decided to make sure he was what I wanted.

For the first few months, I was his queen. We connected online through the intermediary of one common friend. We talked every day and tried to get to know each other before we had our first date. I was left with doubt because I didn't have the signal. He didn't say how he had asked God for me, yet I let him go ahead. Because of the pleasantness, it made me go above what I had stipulated as important. Unsure, I started to pray to ask God if he was my king. When I started to pray, I noticed that he started to change his behavior towards me; he answered me rudely, and he didn't call with the same frequency; however, I thought it was too demanding of me, but the more I prayed, the worse he got. I continued to pray and pay attention to these attitudes, as the time for us to meet in person was approaching.

One night, I attended a service at my friend's church; when the service finished, I went to the preacher and showed her a picture of him, asking her to pray for both of us. I didn't mention my doubts and much less that I would still meet him. When she saw the photograph, she smirked and shook her head. She said, "That's not your husband. Your husband is closer than you think. You asked God for something and are negotiating the bargain. Your husband will give you so much peace that you won't even remember how much you've suffered, and your marriage will never be a problem again. You will be thrilled, but he is not that young man. If you don't believe, make a 21-day prayer purpose, and God will show you that what I say is true."

Sarah Arthur wrote something about faith: "Leaping is not necessarily leaping into the dark, although it may seem like it. It's leaping into the light."[225] Believing in God is like entering a door, knowing that God is already on the other side of the door. This man was so different that we didn't even exchange messages anymore. In my stubbornness, I commented that he had changed, and he was furious. He wrote me almost a page of insults. These problems all happened because I thought the world revolved around me. I remembered the list I made, asking that I was to be the center of everything in my future husband's life. What was I accepting? Since I was happy with myself, I shouldn't spoil what I already had. As the priest in the church said, I was bargaining for what I asked God for. Because I didn't want to wait any longer, was I getting something in between? After a month without talking, I broke it off. And yet I hoped it would be him so I wouldn't have to wait any longer. The signs that he was not what I had asked of God were more

[225] Arthur, Sarah. *Walking through the Wardrobe*. P46. Tyndale House Publisher. Wheaton IL. 2005.

than explicit. God always gives us more than we ask or imagine. Because I always underestimate God halfway through the process, I think it's good, and I become easily satisfied. I'm notorious for not wanting to wait for things. I always say that since He is eternal, He is not in the same hurry as I am. But does my God not know how long it will take until He can give me what will be useful to me?

He does; however, in my impatience, I end up taking what is not what God has prepared for me. Lucky for me, I was educated to never again make any decision in my life without asking God. And that's what happened with this theme. I made sure every day that this was the vassal king who would reign in my manor. I didn't know His intentions and if they were what He tried to show me at the beginning. If at some point that wasn't so, He was unhappy to approach the daughter of a sovereign king who knows all things are under his protection. Yes, God has taken care of me in every area of my life. He takes care of everyone; there are many who do not want His care and move away or do not accept that He takes care of them. They decide their wrong ways and when the result comes, they blame God for their setbacks. The world blames God for ecological disasters, but we are the ones who threw plastic on the beach. Rich countries like the one I live in have places that throw a horror of food away. Even I throw enough food away to feed a hungry family. And because few have much and many have nothing, it is not God's fault but ours. I watched a movie called *The Platform*[226] about a vertical prison that maintains numerous floors with two prisoners on each. A platform offers food to the prisoners, but it starts on the first floor and goes down. Anyone on floors below the fifth or sixth picks up mostly leftovers, and those below the hundredth floor pick up nothing but feces and urine. The comparison of a capitalist society was quite clear, with the rich wasting while the less fortunate had nothing. The film is about showing the confrontation of what really happens in our midst, and we don't do anything to change it. By activating the sensibility of the public, obviously, there will be no change. This is the reality because all of us act according to our interests.

Lack is the biggest blindness a person can have. Where you see a bat as a butterfly and a snake as a fish, however, emotional healing creates a dome that makes you see even what is hidden. Evidently, my connection to God wouldn't let me down. I always told suitors that I didn't want anyone because I was already married to Christ. I was convinced that if He didn't have someone for me like I wanted, I would be with Him as a husband. Do you have a better husband than Christ? While I was alone, He was my provider in all things, and I lived well according to my needs. He never misses anything!

Once in my youth, I heard a joke I never forgot. It is about a man who lived in a small town who loved to exalt himself. Everything about him was better than everyone else. One afternoon, he sat in a bar with several people, and he poured himself into counting the advantages. Beside him, a person listened and watched on, annoyed. The sentence he said

[226] The Platform. Desol, David. Gazetulu-Urrutia. tv-MA.1h,34m. 2019.

ended with his expression "It's your weak friend!" Referring to itself, the expression "I am very powerful" is implied. One of his friends looked at his string and said, "How beautiful your necklaces are!" He replied, "My gold chain has thirty grams of solid gold and is three carats. Is it weak your friend! Hm?" Then another one who didn't know his way of aggrandizing himself, accompanying a friend, said, "What a nice shirt!" He said, "My Louis Vuitton shirt I paid three thousand for, weak your friend, hm?!" Another unprepared person asked if he wanted a ride. He said yes, as he had borrowed his car. Forgetting how much he liked to get carried away, he asked, "What car do you have?" He replied, "I have a Lamborghini Diablo. Weak your friend, hm?!"

Eventually, the annoyed man had listened to the man brag enough. He thought of putting him to shame and asked, "What about your sister, that whore? Is she still stitching in the same place? The man looked surprised but didn't let his fascination fall and replied, "My sister became a nun; she married Christ! Weak my brother-in-law, hm?!"

According to the joke, I had God as the husband of the helpless; imagine being the brother-in-law of Jesus. And what about the wife? "Is my husband weak!?" Son or daughter? God as the father of orphans; "Is my father weak!?" Although I must be in a relationship with God, the relation of others with Him will never benefit me, just their prayers. Anyway, I must decide to accept one relationship with Him. After the veil is broken, there are no intermediaries. Of course, intercession prayer has power, but if the person who has received grace through prayer does not change, He will always need intercessors. Until when? What if He said I could also do things as big as Him? It's time for you and me to take the place we inherited.

When I felt the power of being God's daughter, my life started to flow; in three years, I turned from hairdresser to visual artist, published two books here in the United States, and had three art exhibitions that were very positive. I went back to college to finish all my academic English. God and I already had plans, and what I needed was someone to share the reign of peace that God and I built. In this reign, I am the warrior queen. I'm no a princess in a white dress, I'm a queen in leather. I didn't need a husband because I was already complete with myself, my children, and my calling. I had my goals set to follow persistently. My king must be equally brave must have spent his life at war, seeking peace. I prayed to find a strong king who appreciates and deserves a queen like me, and who has the High King sitting in his heart, never stopping me in my quest to spread the perpetual reign of the High King. I am a queen and I wear the sword of faith, the breastplate of justice, and the shield of peace. I let my voice ring in this generation through my book's words, and the dreams exposed in my paintings. The kings and queens that descend from me will know that I was a queen forged in the war of healing and transformed through art and the power of the High King.

Walking with God never leaves me in the dark because He is my light.

Autumn and the king

Seasons passed, and I was waiting for my half.

Winters, springs, summers, and autumns are gone, and nothing from you.

What season will the king bring?

Darkness came, the cold came from winter, and his embrace did not warm me.

The spring glow, the green of the plants sprouting everywhere, flowers in spring, and I am still waiting for you...

At peace with myself, I followed, waiting for my half. What season will it come in?

Another lovely sizzling summer came, but in our bed you're missing. I have not met you yet.

Will my life be complete with my unfinished cake? Where is my cherry on top?

How many times in the parking lot in prayer have I asked for you?

The time was not ours; we were not ready for this encounter.

Let us flatten our hearts for the day we meet. What season will it be?

In my favorite season, the yellow-orange, wine, and brow foliage of God's painting.

A perfect meeting day, not cold or raining, just blessed!

My other chance to be even happier; autumn brought my king.

The beauty I dreamed of never came close to what you are. A king loved me like a queen.

What happened and hurt us also forged us for that time.

A couple of days were all we needed to simply decide to love!

A new opportunity for two wounded souls, healed and ready to live a dream.

The reality is that when you are joyful alone, everything else comes like a waterfall, pouring out increased harmony.

Hands that touch, hands that build a new story across several seasons.

The king and I transformed a plain Tuesday into a sunny wedding day.

Chapter 22
The King and I
God doesn't give a glass just full.
It always overflows!

Finding the king

The process that life imposes is like a test given at school. There are different disciplines to be tested in my learning. Each one has its difficulties, and when I learn, my growth will depend on me. If I don't do well in one of them, it will undoubtedly delay the preparation process. I must repeat the text with the same theme, only with tricky questions that seem different. If I pay attention, I have already seen these questions with other words, and possibly, if I don't recognize them, I will repeat the text. Here came one of the tests in subjects that only life can teach. I messed up countless times by repeating the tests. I became more attentive, trying to observe where the footprint was. Where will I fool myself? And how can I avoid tripping over the same rock? I got a king as a gift, and now I need to keep him. Relationships don't come with manuals, but understanding how to better deal with certain temperaments, not taking things too personally, and understanding that each one brings their worldview, help a lot.

In the meantime, we were an hour apart; he was living in Seabrook, New Hampshire, and I was living in Waltham, Massachusetts. Many times, he must have passed through here, not knowing I was close by. I always said in my prayers, "God, you know where he is." Sometimes we talk, and I say how I wish I had met him when I arrived and had a long life with him. And we agreed that it would not have been the way it is now. Because everything we went through made us sure that I was perfect for him, and he was the same for me. He suffered on one side and I on the other, and we found peace together. The sign that the king would not be an imposter would be something I spoke to God about. My king would tell me this when he recognized me as his queen, "I don't want to be your fiancé, I don't want to be your boyfriend. I want you as a wife! I waited for you." I may

sound crazy, but whoever believes God as I do knows that many crazy things to others are miracles for us.

Currently, I oversaw a church job leading the children's ministry. After nearly five years alone and now with the man I had asked God to show to me, it would be complicated to control my hormones. So, I didn't ask God for a boyfriend or fiancé; I went straight to the point. Well, I wasn't desperate for a husband, but if he showed up, he had to be the one to stay. I came out of my moorings at the age of forty and had a lot to do. I didn't have time to waste on the wrong person. It's also a part of the process of getting to know the person who doesn't really know anyone. At some point, when an unexpected attitude happens, I will see that I have never met him. Only time and coexistence reveal the person. The decision to stay with him knowing him imperfections is the choice to love. I didn't want to keep choosing and having fun with the wrong person until I found the right one. How did I know it was right? I could never know which was right, so I trusted God. He did know. So, one secret phrase I expected as a sign would define the person who would come to stay in my life. Of course, they had to have all the features I put on the list, or I wouldn't pay attention. It was exceedingly difficult to find this person. I didn't go out much, and when I did, I went to church. There I had no option. In my work, it was no different from the church. Those who showed up were junk, and the best were already married.

In the salon, I met a friend of my boss who got tired of frustratingly relating to people who were friends of her friends. She wanted to remake her life away from those who always had something to say. She tried to find someone other than her companionship, and as it was not possible, she signed up on a social networking site. She was criticized a lot, even by me. After six months, she informed us that she would marry someone she had met on this site. He was a man who had children, including a baby abandoned by his mother. This man's wife simply disappeared after postpartum depression. The comments from the salon were that she was crazy, that the man might have killed his wife, and the same would happen to her. That future husband was a doctor, and to everyone, it was a very dubious story, like a trap. Besides, they were going to live in New Hampshire, away from everyone she knew. After more than five years, they are together, married, and seem to prove the opposite of all speculations.

I have three friends who have always told me about joining dating sites. The first one found her husband on a website, and they married more than twelve years ago and had a daughter. I met her through a referral to do her waxing. I did her hair many times, and being very friendly people, we always talked. The two others are also in happy relationships that have been going for more than three years. My friend Luziane always pointed out that she had already witnessed several long-lasting relationships through websites; she always told me the same about the others.

That was a vast place for me to find people listing my search within what I wanted. The biggest challenge was my prejudice. I thought it was a horror that social networking sites, like Facebook, were less harmful. They always mentioned the same thing when they met me. Now and then, a suitor, usually younger than my eldest son, would come along

and fall apart. The ones that were in my age group were not on my list. It may sound like a list obsession, but that's just my temper. I made such a list because God has two causes: the first is the power of lists, but the main one is my faith. All my choices had gone from bad to worse. It was brighter on my side to ask God to choose.

Then another friend came to the salon who was is also an artist. Her name was Rê. She appeared all satisfied that she had found someone who made her incredibly happy. Through a website, she found several exciting people. She even went out to dinner a few times with people who caught her eye, but this was what felt best. They had been dating for six months, and the relationship was serious. So, as they are tough bread, I went to a not-so-expensive site that one of the three had coincidentally referred to me. Michael Rosenfeld states, "Finding your partner online indicates that you are much more likely to marry him. This is probably since you know a lot about your partner before you meet him, thanks to his profile, and because you can select people who share your interests, thus increasing compatibility."[227]

I paid $45 and spent half the day organizing my profile, writing what was important about myself, like whom I was, what I was looking for, what I believed, and what I did. For the options of what the person I was looking for should be, I basically wrote everything that was on my list. That was the second of October 2018. On the fourth, I received a message from a very up-front man who called me "babe." I didn't pay much attention to that moment. At the end of the day, I decided to look at his profile. He had information that I wanted to respond to. And then we started talking. I never told that to anyone, not even my kids. I talked about him, but I was lying about how we knew each other, which is such a common thing these days. My prejudice made me hide. My children will know, as you will be reading this book now. In my opinion, I put it in my personal shadow. I asked him not to speak, as no one knew how he had met me. But as this book is a clean mirror of my image, it was necessary to expose this.

According to Monica Anderson, "When asked to share their relationships that start through online dating, just over half of American adults agree that these relationships are as successful as those that started offline."[228] The new research center also conducted interviews with several Americans and found that 22% of responses were that online relationships are very positive. It opened more options to meet people outside my social circle, expanding the possibility of finding someone who I could not possibly find in the environment where I used to be. And that's exactly what these people told me when they insisted I give a social networking site an opportunity. The places I frequented were totally limited. 26% of people interviewed said that their relationship through websites was totally negative. They believe that they have more ways of lying online in order to be more efficient. When you don't know any people who have contact with your possible partner, they can

[227] Rosenfeld, Michael, Ph.D. of Sociology at Stanford, Magazine. Relationship adviser online. Nov. 8, 2019.

[228] Anderson, Monica. Internet & Technology. New Research center. February 2020.

invent everything about your life. I don't think it is smart for people to forget that this style of dating can also be dangerous. That's the way I saw this issue, especially since I had never met anyone whose relationship had worked through social networking sites.

All the relationships that were in the news were traditional. Already 50% of respondents thought it was normal and had neither a negative nor a positive opinion. After I started to open my mind about trying to get into a dating site, I coincidentally started researching more about it. I had heard of lasting and positive experiences from four people close to me, and there was much more to hear. It's challenging to let the new in, as the new confronts everything I'm used. Now I was at a point where I would have to try different things to get different results. I dreamed of a new visitor coming to my church, and he would be what I was waiting for. Or I would go to the grocery store, and a tall, athletic man would help me pick something off the shelf and would fall in love with me. Why not at the gas station or something like that?

I didn't want to use a dating site and to look for a husband. I was too happy with myself to be looking for trouble. I'm not saying it's the best way, but after hearing several testimonies and meeting four people who it worked for, it inspired me to open my archaic mind. The significant increase in encounters through this medium had seen considerable growth. They were satisfied with their choices and that this way would have been better than the traditional way. It gave me the breadth to select data that I want in a person. And it certainly wasn't like how I thought I'd be pushing the envelope on looking for a partner but helping him find me. Someone who had been hurt like me should be looking for a Christian who is faithful, caring, and a dedicated companion woman willing to share her life. It was a barrier of mine to enter this new experience. The dating site provided me with this. Even having found it and having worked so well, I can't say that it's right for everyone. What worked for me might be a nightmare for others, but it's an option.

After two years and already being married, I was still prejudiced and a little ashamed of having done it. I didn't want to give in to cheering, claiming that I found my king on a social networking site. If I said that, maybe I would be taking credit off my list to God. The truth is that God always uses new things in every situation to bless those He loves. Isaac went to drink water at the well and found Rebekah. The stories in the Bible were set a long time ago. The core message is applied today. God is not stagnant in the past; He is in this age of today and in the future. Times change, and we must evolve together. For example, I'm taking my university classes online, but I love going to school and interacting with teachers and classmates. I must evolve so that I don't get stuck in the past. I know that everything I asked for came, but it's been years since I've had to wait for him to be ready to meet me. The second he wrote to me about not even having the chance to select more people made me see that he was waiting for me, as I expected him. It was blunt, like how I wanted it to be. He saw me and knew I was for him, and I believed what I asked of God. It was confirmed by what he told me on our first date. Among other people who encouraged me to take this step, I was startled by four positive experiences.

Betty and Ed

Betty is a neuroscientist who came from Brazil to do her doctorate at Harvard. As she did not know many people, she was encouraged to look for what she wanted in her future partner on a social networking site. She has been now married for fourteen years and has a beautiful eleven-year-old daughter. She met me after being recommended by a friend that I do her hair and waxing. Since my first exhibition, she has been my client, has supported my events, and is a friendly, humble person. She saw in me the need to find someone to share her life with and did not hesitate to tell me her story of how she met her beloved husband. They both live in Newton, Massachusetts, with their beautiful daughter.

Rejane and Thomas

A very talented plastic artist from the Rio Grande do Sul came from Brazil to stay with her son in the USA. She had a relationship where she and her partner met traditionally, and their relationship was miserable. So, she decided to join a social networking site, where she said she had met charming people and had a few dates in restaurants and other public places. Finally, she found her partner, sharing her life pleasantly for almost three years now. She is sixty-two years old, and he is sixty-eight years old, and they live in Fall River, Massachusetts.

Regina and Darin

Regina[229] came to the United States in May 2015. In addition to seeking improvement for her family and her life, her wish was to find her soul mate and a companion to share her life with. She said she believes that when you want something deep in your heart, the soul projects out, and it ends up happening. She thinks our feeling is strong enough to pull close to us what we truly want to reach. After some time, she noticed that there weren't any options in her social life, and a friend prompted her to sign up on a social networking site. She met nice people, going out to dinner and having breakfast with a few. Staying on the site for three months, she met Darin. They started talking to each other more often. For a month, they exchanged messages, as both had met someone and decided to give these people an opportunity. These attempts lasted thirty days and failed. They returned to talking and shared their experiences and became friends to the point of exchanging phone numbers. They finally met up in person, and that was when they stopped looking. On her birthday, he surprised her with a trip for four days, which enchanted her. Since he already knew she was the perfect woman for him, he invited her to live with him. Regina found it very strange but decided to try it based on the wonderful four days. And it was no different. He was very patient and loving.

[229] Marano, Regina. Artistaplastica—Darin Business sales management. West Warwick, Rhode Island. 2020.

Six months later, when Regina's family was reunited for Christmas through a video call, Darin asked Regina's mother for permission to marry Regina. And in May 2019, they got married and now have a full relationship. She says she went to the site with a plan and with an intention in her heart to find a person who wanted what she wanted. When she made her profile, it was noticeably clear that she wanted a serious relationship. She spoke about what she believed and what her vision was of a union and the importance of God in her life. She was a mother whose children had grown up, now it was her time to live hand in hand with someone who would receive all the affection she had to dedicate to this person she was waiting for. She strongly encourages people to look at social networking sites as another option in finding what her heart desires. If you believe in what she found for her life, you will surely find it. Regina and Darin live a dream; they are to each other more than they wanted, and they feel so blessed by God for hearing their prayers and giving them both this perfect gift.

Lila and Julio Guerra

Lila[230] got married for the first time at age twenty and separated at twenty-four with the responsibility of raising two young daughters. She didn't want to get involved with anyone because her daughters might be vulnerable to a man living with them. Twenty years after her divorce, her daughters finished college and were independent; Lila had empty nest. At this time, she began to feel the need to have a mate. She used to live in Coaraci, Bahia, which is an exceedingly small town. She didn't see the possibility of finding anyone there who fit the profile she wanted. She met people who, over time, were eliminated from the profile of the man she was looking for. She met a man named Julio, and although his personality was respectful and considerate, he was the only one who didn't want to get involved. Julio had a lot of tattoos, and being from a very traditional family, she got a bad impression. But the city he lived in was a tourist town and was known for being very liberal. He didn't give up on her. His gallantry, wit, and insistence convinced her.

They decided to go on their first date in a nearby town, Ilhéus. She began to see that her prejudice had no purpose when it came to Julio. He was even more charming and attentive in person. They had several encounters. After a while, he invited her to spend the carnival at his house to meet his children. When it was time to go home, Lila received an offer from Julio to live with him. Now the difficulty was that they lived in different cities. But nothing is impossible for anyone who decides to love. It is more than a passion that is decided in youth. Lila and Julio's love was a decision of two people who looked to each other for a partner to grow old together. On May 16, 2009, they started living together and never parted again. They have a solid relationship and are committed to the common good of both. Realizing that Julio was her half, Lila became the half of Julio. They both claim that it was the best decision of their lives.

[230] Lila-Iraci Silva master's in physical education and Educational Sciences. Julio Guerra Marinheiro and Advertiser.

The choice to love (The king and I)

It was all swift. Twenty-one days was enough to decide to love someone for the rest of my life. So, were we without contours? We meet and stop, analyze, and decide to love. It's been just over two years; however, we've created a reign of peace, dialogue, understanding, companionship, sensuality, and love. When we met, we texted all day, talking about how we were. And I exposed everything I was and what I expected in someone. I talked about my calling by asking a question to guide me on what to expect. Soon he found me on Facebook, and we continued the conversation on Messenger. As a result, I only spent two days on the site. This was what I wanted.

And so we decided to meet as soon as he returned, as he was traveling for his work. That same week, he introduced me to his son, who was traveling in his truck with him. On the twelfth of October, we made a date to meet each other. He came to Waltham, and we walked to the public square. Until that moment, I had only seen him via video call. The day was wonderful, neither hot nor cold. It was autumn, and anyone who lives in this part of New England knows how beautiful it is. It looks like a painting with colored leaves on the floor. The trees had leaves in shades of orange, burgundy, yellow, brown, and green. It was a perfect day for both me and him to receive as a gift.

I parked far from the square where he said we were going to eat first. We were going to talk and possibly have dinner somewhere in downtown Waltham. I was sitting on one of the benches when he called me to find out where I was. I got up and went in the direction that he said he was coming from. I adjusted my hair, added a little mascara, and put on red lipstick to seal the deal. I was still wearing braces and had no idea when I was going to get them off. I wore a sundress with a black print and sunflowers, along with the tallest wedge-heeled sandal I owned. I had asked God for a big man, and I didn't want him to be so disproportionate. The sun was blurring my vision; in the middle of the square was a man under a tree.

The tree was on the right side of the square near the town hall. He was tall and Black, and I thought he was my suitor when I saw him from afar. I was like a chipmunk, wasting a smile with my huge mouth. The guy took his hands off the tree and started walking towards me. I found him a little shorter and stronger than me, and I wondered if he had lied about his height. It sounds futile, but it was tremendously important that everything I put on my list agreed. If it weren't like I listed, I wouldn't even go for dinner. As they say in Brazil, I was giving him "um perdido[231]" and disappeared. On the other side of the square, my proposed boyfriend suddenly appeared.

I came to a stop so suddenly that I looked more like a car that slams on its brakes when it's almost past the entrance. That's how it went—I think if I had been wearing a thin heel, it would have broken, and I nearly turned my foot. The one in the shade of the tree made a sign of disappointment, dropping his hands. I made a shadowy face like I hadn't even

[231] Dar um perdido: just walk away and disappear.

seen him. Then my date and I went to sit on one of the benches far away from the other man. We walked around the bank of the Charles River, where I heard him repeating my prayer: "I'm not looking for a girlfriend. I am not looking for a fiancé. I came here because you are the wife my mother would choose for me. If that's not what you want, tell me and this will be our first and last date. I want you to grow old with me. I want you for my wife." And then we kissed for the first time. The autumn leaves continued their spectacle.

Here in New England, it was beautiful. Everything was like a gift to us. After we had dinner, we each went to our cars and were supposed to meet a week later. This next week, we talked about getting married in April 2019. On the thirteenth of October, I had dinner to celebrate my oldest son's birthday, and we took the opportunity for him to come and meet my two children who lived with me. When he sat on the couch, and my dog, Slash, lay at his feet. At dinner he asked my son for permission to marry me. We started planning our spring wedding. One week he dreamed that we were getting married on my birthday in January. A week later, I went to New Jersey with him to meet his family. His eldest daughter came there to meet me, and I had the same conversation that he had had with my son.

When we arrived in Massachusetts, we decided to get married the next week. Only my children and my mother knew. I called the bakery and asked for Tuesday off. Everyone was worried that something had happened, because it is rare for me not to go to work. On Tuesday morning, he brought his things. We went to Waltham City Hall with the justice of the peace and my son, who gave the apostolic blessing as an evangelist. We spent a simple day. My youngest son arrived from school and already knew the news; he congratulated us. In the evening, there would be a service at my church, and I would ask my son to accompany us. Before going, I asked my pastor for the opportunity to give a testimony. I arrived with him and my son at the church; everyone was super excited. They thought that I would introduce him as a boyfriend. When it came time for the witness, I reminded everyone that I was waiting for someone that God would send me. Some people knew that I wanted a man like him and have been happy since I started talking to him. So, I created quite a controversy by almost giving my pastors a heart attack. I told everyone that I got married in the morning, and no one even knew I had a boyfriend. It was a blast, as they say in Brazil. Some people were angry because I didn't say anything. Most were very happy and very afraid of my decision.

When I showed up with him on Wednesday at the bakery, everyone was worried that something had happened. I said yes and that I would talk to everyone at once. They were already expecting the worst, thinking I must be seriously ill. I gathered everyone who worked that day in the back, and I told them what had happened. It was the week's topic, and they created a phrase for when someone asked what day it was: "Tuesday wedding day." I already had the sign of God and the blessing of my eldest son, who is my priest, and we decided to write a story together. My husband and I asked God for the same thing: someone to grow old together with and someone who would be a blessing. In the beginning, it was just a decision to love each other. Two years later, we cannot imagine one without the other. I have that old grandma's recipe that says, "There are two paths to a

good man's heart. One is through the kitchen and the other through the bedroom." So, if the man is good, the queen will remain queen, and he the king. The queen will keep control of everything, especially the king. It cures all bad moods; the old man said, "Fill your belly and empty your bag." It sounds grotesque, but it works! Unless he's already a man with no character, if he's going to cheat, he's going to cheat no matter what I do. My king is enormously happy and gained a full pound from my Brazilian food.

Sometimes I find myself crying with gratitude. I look to my king with admiration and gratitude, for he is everything I put on my list, and God gave him to me. When I look at him, I don't just see a husband and partner, but a yes from God. Our decision came from a lot of attraction. I was so lucky that I still got a husband with a six-pack on his stomach after I was forty-four. I am blessed that my High King[232] gave me the perfect Vassal King,[233] and not just because I have a husband who is the biggest hottie. He is the visible proof of my prayer being heard and given in all areas.

A king's temper

Now with the husband I always wanted, I couldn't risk making mistakes on purpose. To make mistakes accidentally is something inevitable; however, something that can be avoided is already stupid. I watch my partner's temper to avoid clashing with mine. I was totally ignorant about what temperaments were, and I only learned about it through Joy. My first therapist talked to me at the beginning of my visits, discovering my temperament. She showed the worst side of being melancholy. I was horrified by everything she told me about myself. From there, I started researching everything about my temperament. And I saw that the good side is wonderful. I had already received the gift of the will and inspiration to paint. I only came to pay more attention after I got to know Joy. There's no way to get to know Joy and not delve into the human psyche.

I confess that I was already curious about temperaments, and I read some articles about it. I only went deeper into the subject after my friend Flávia made me wake up even more after she revealed to me that one of the answers to the relationship issue is the reading of temperaments. She helps many women, especially in marital crises. She revealed to me that after she came to understand her and her husband's temperament, their relationship improved by 80%. And even more, she said that if it weren't for that, maybe her relationship, which has lasted more than fourteen years, would not have reached this point. She strongly advises people who come to her to know more about her and her spouse's temperament.

From this point, I looked for more articles in my university library and the library in the city where I live. I also looked in the psychology books I inherited from my son's college, and some of my own. Temperament is our original form, uninfluenced by what we

[232] Higher king: God

[233] Vassal king: my husband

learn. The physiological state characterizes the individual; the psychological condition is the general basis of emotions. I can genetically inherit from my parents or ancestors, but the family, in general, has different types of temperaments. According to Helen Neville and Diane Johnson, "Understanding your child's innate temperament makes your job as a parent easier."[234] Temperament can be observed in the first years of life and has a genetic influence.

Compare the baby to a mysterious island. You need a map to get to them. Knowledge about temperament makes it possible to read the map of this island, making the expedition not only possible, but when you arrive on the island, you will know how to direct yourself to go to the most beautiful places and prepare for the worst side of the island. There are better sides to the island than others. If you can expect the differences, you will be able to navigate these temperaments. Temperament is determined by brain stem processes. Every person has a unique brain stem that cannot change over a lifetime. Temperaments can be controlled, but not changed.

Many scholars have discovered that there is a difference between personality and temperament. Personality is formed by the way one lives and experiences absorbed. Temperament is formed from an exceedingly early age. According to Elaine Fox, "The notion of traits is important in the contemporary science of emotions because it suggests that people have a number of essential aspects of their personality that can influence how a particular situation can be perceived or evaluated and, therefore, can result in behavior."[235] If we observe each other's temperament and our own, we will avoid many disagreements.

When I became more comfortable with my temperament, I came to understand many of my attitudes. Since everything has two sides, the temperament issue is no different. You can't change tempers when you discover the worst of them, but you can build on the best of them to make up for it. As all temperaments have two sides, the good is the not-so-good. As I strongly recommend, you should strengthen your good side to fight your weakness and have no problem winning. Speaking of this battle, knowing my enemy's weaknesses, which are the weaknesses of my temper, I prepare myself to fight them. And on the other hand, enjoying the best part is understanding your weaknesses.

I thought my biggest enemy was outside of my dome; however, with my self-responsibility, I saw differently. Outside my dome, there is a danger, I agree. The worst side of my temper is scary, but I put boundary fences on it when I sense danger. Unless it's an accident, no one is unchanged. The vision that opened to me after meeting Joy was frightening. I saw that I am the greatest saboteur of my achievements.

Temperament is a quality of the human personality that refers to the particularities of our behavior. The concept of temperament is nothing new and has been studied since ancient Greece. Temperament comes the Latin word *temperare*, which means "balance." To study the complexity among human beings, psychologists, neuroscientists, and

[234] Helen Neville and Diane Clark Johnson. *Temperaments Tools*. P.12. Parenting Press Inc. Seattle, WA. 1998.

[235] Fox, Elaine. *Emotion Science*. P.56 Palgrave Macmillan. New York. 2008.

philosophers resort to the theme of temperament. In 287 BC, the Greek philosopher Theophrastus discovered many types of people. He argued that people can use their powers of persuasion to discover their character. After 500 years, in 201 AD, the philosopher and physician Galen developed the idea of nine temperament types, which was followed by many others, even long after in Jung's theory. Today psychology recognizes four types of temperaments with multiple divergences among psychologists regarding the definition and use of this theory. According to psychology, temperaments are melancholic, phlegmatic, sanguine, and choleric.

My temperament is melancholic, and because of my downside, I started researching characters. That way I would know not only the worst, but also what would raise me to the best of my temper. Melancholic characteristics include being fearful, anxious, and worried about the future and what others think. They tend to be highly guilty individuals, worrying about how things might have been done differently in the past. They rarely live in the present. It takes a long time to decide, but when they do, they execute. They are very suspicious, so it takes a long time to trust, despite being loyal. People with a melancholic temperament are oriented towards detail and quality. They are obsessed with finding what's right, and they are careful and work to ensure that every detail is as perfect as possible. They are rule followers, intellectual, loving, empathetic, shy, artistic, and lonely.

Melancholics have the most sensitive sensibility and are deep, detail-oriented, perfectionistic, and introverted people with difficulty expressing their feelings. They tend to choose professions that they can pursue on their own. Melancholy can be highly manipulative and selfish. Melancholics find it very hard to believe in themselves, and they can be highly pessimistic. Their stubbornness goes beyond narrow bounds, and what they say becomes law. They can become aggressive when faced with an unfavorable situation; they are private and introverted grudge-bearers and self-judgmental judges. They measure all the possibilities of what could go wrong and then never leave something undone, as they are persistent and obstinate. Their significant colors are black and gray, and they are moved by emotion. Their related season is autumn.

Looking at the temperament book as a tool to get to know my children, I began to remember my children's attitudes. My middle child is sanguine. From an early age, his aggressiveness and annoyance could be observed when he was frustrated. A little more prepared, I met another sanguine: my husband. A sanguine can never hide their temper and will never allow themselves to be overshadowed. They are extroverted and sensitive, communicative, optimistic, resilient, adaptable, and enthusiastic. They are fun, expressive, and affectionate. They build relationships easily and trust others because they are spontaneous and like to interact. Sanguine people usually make large gestures and speak well in public. They are very sure of themselves. Most sanguines don't have much of a problem with self-esteem and depression. They are always innovating and making plans, although they seldom finish executing them. They are enthusiastic and start and end things with about the same speed. he sanguine will always come up with ideas but don't count on themselves to execute them. They have a forgiving heart that both explodes quickly and forgets quickly. They always tend to act with impulsiveness, a lack of attention,

superficiality, and exaggeration. Their significant color, red, is powered by power. Their related season is spring.

My eldest son is phlegmatic; he is dreamy, peaceful, docile, loyal, methodical, and calmer than he should be. He loves to be comfortable and puts off everything for later, except for eating. Phlegmatic people value routine and silence and rarely lose control, as they tend to assess the entire situation before reacting. They are patient, diplomatic, stubborn, observant, disciplined, and do not hold grudges. There's just nothing the phlegmatic loves more than sleeping and eating. They prefer not to express their opinions in public and tend not to react well to criticism. They seem lazy, but the temperament's downside that needs to be watched is slowness, resistance to change, and indecision. It is the most stable of all temperaments. They are incredibly explosive and angry when frustrated, but it is their only temper to control anger.

The world may never know all the brilliant thoughts, great books, spectacular artwork, or wonderful ministries that are buried with phlegmatic people. They rarely, if ever, use these ideas and talents, because it would take a lot of energy and effort to put them into practice. They love to inspire others with big plans, since they don't need them to execute them. The phlegmatic, as the excellent observer, perceives the injustice but will never rise to fight it. They look at the wrong things in the world and see it as a waste of energy to go against them. Their significant color is white, and they are moved by peace. Their related season is winter.

Who hasn't been manipulated by a choleric? This temperament is explosive, ambitious, and authoritative. They are determined and have a great capacity for planning, in addition to a lot of energy and impulsiveness. Highly narcissistic, their ideas and projects will always be for their own benefit. They are self-centered, intolerant, and impatient, and they rarely forgive, which is their downside. They always start with a plan and finish executing it. They are cheerful, flashy, inspiring, intellectual, organized, and loving, and they always find a solution for everything. It's okay to innovate and living in large groups will lead the way. They are resilient and never fall for too long on the ground. They are highly resilient and great leaders. Practicality is their most incredible skill, as they are tremendously strong and stubborn. Their significant color is yellow, and they are moved by joy. Their related season is summer.

I'm trapped in my dome of protection with my greatest enemy, myself. As Paul [236]said, who can keep me away from myself? I do what I don't want to do, and what I know is right I don't do, even if I want to do it. After the test with the would-be king, I needed to pay more attention to who I was as a person and to police myself by knowing the bad side of my temper. I always say that preparation keeps its promise. With my husband and my different temperaments, it is a constant dynamic of control and learning. Consequently, when I learn about my temperament and I learn about his temperament, I can establish the ground I walk on and how I should tread.

[236] Letter from the Apostle Paul to the Romans 7:12-25

The story behind the king.

I have already reported my side of the story. Meanwhile, there was someone I didn't know was right for me to meet after a lot of frustration and zeroing in on our past. He left behind his misfortunes, creating a beautiful rest of his life. He is the fifth of a family of seven children, including five men and two women. His Christian-principled mother forced him to go to church every Sunday in a bowtie. His baptism was in the icy sea of New Hampshire with and the choirs of the most beautiful African American voices. He is a basketball lover who practiced for indefinite hours. Despite trying football, his passion for basketball made him the best in high school, giving him free education for his ability to play. Despite the scholarship, he would still have to buy books and pay for other college expenses. With an extended family at home, he chose to enlist in the army so as not to be a burden to his mother. He once was in an accident where his friend died, and his brother remained in a coma for days. He took two shots to the chin, and there is still a bullet in his jaw after all these years. After the incident, he was honorably discharged.

In a past relationship, he had his first child, and the mother had to raise their child alone. He got married and was imprisoned for twenty-three years, enslaved and unhappy. He didn't have a life of his own, and he only lived for his three children. Out of perspective and embittered, he broke into a depressive crisis. Just as I was exhausted, so he found himself. He no longer had the strength and had to stop. Then he remembered a God who works miracles. He got divorced and left everything behind, including a marriage that only sank him. He needed peace; he didn't fight for anything financial, he just wanted to live what was left of his life, not knowing that in less than two years, he would get refunded everything. He did more in two years than he sorely tried and couldn't accomplish before. After some time, he started asking God for someone, if God had her for him. And I was already waiting for him without knowing he existed. However, God already had a second chance for both of us to be happy.

A king of vision

Like any good melancholic, I love to plan, make lists, explore possibilities, and make them happen. My king came with this vision at the beginning of the relationship; he said he didn't like to make plans because he was very untimely. However subtle and observant he is, he has been targeting his projects and walking towards what we want. I think it's incredible that what he says he wants, little by little, is becoming a reality. He is highly patient and controlled with it, and everything comes to him like magic. He has a very positive vision of the future. He treads with firm steps as if he knows the lot. He believes in his resourcefulness and in achieving his goals daily. When I met him, he already had a vision of a relationship based entirely on trust and companionship, and that's how we live. We only had one stormy moment once in two years. Your people-reading qualification alerts you to the firm ground on which you must continue. I always tell my kids that we go for the yes, and I already have.

The king's vision is that yes happens when you dare to take the step to possess it. I am highly insecure and in constant war with my pessimism. The king's vision does not exist; pessimism is not in question. We start a decision-based relationship. I was scared to death but believed in a promise and walked totally on the spiritual side. The king already had a vision of the beauty that was about to happen. He and I did not love each other as we do today; knowing him made us decide to proceed into something solid and mature. Today the king's vision makes me clear despite being afraid. I see His trust, and we trust in the king who united us. I trust that He opens paths when we decide to pass. He already has a vision of what will always be open, and the High King will make it come to be. Recognizing the worldview of each one, I leave my egoism and become empathetic.

A reign of peace

The vassal king reigned in a reign that had torn his crown. The only power he had was to provide. The bitterness of others overshadowed his peace. He did not know that the High King had already prepared a dense reign for him. He would have to recognize his queen. His chair was empty for five years, as she was still in dungeons. His queen awaited him without knowing, but in her dreams, she found him. She painted her stories and what she dreamed of him.

He was born in snowy mountains near an icy sea, where nights come early and take a while to finish. The sun fights almost without strength, still shining; it doesn't heat up by the biting cold that confronts it. The earth freezes for six months, and plants dry as if they were dead. Animals disappear, hidden from the cold expanse of the king's land. It pretended to shine its glamor in spring, followed by a robust and dry summer and refreshed by the even more beautiful and vivid autumn season.

People are chasing the most talked about currency in the world. You don't have time to lose, or you lose money. Most die without seeing their homes paid off. They kick their teens out of the house and forget them when they are old. Cars and houses are left open, and parcels left at the doors are received. Manual work is gold, and good gold is 10 karats. Anyone who wants to work always finds work, and opportunities are open to those who seek them.

The queen came from the land of the forty-degree sun cut by the equator. The rivers she used to bathe in are tributaries of the muddy Amazon River and the pink dolphin. The days are long, and the moon must fight to appear. All kinds of plants grow in the rich land and bear fruit throughout the year. Its wealth was smuggled and taken from its people. Dense forests are full of exotic animals. The sea is brave and warm, even when it should be cold. People waste time on football, politics, and the lives of others. Adult children do not want to leave the house, and grandparents die telling old stories. They pay for the place still alive, or they live their entire lives without a roof. You can never trust anything open; everything is stolen. Gold is very pure, but it goes with the country's wealth to those who do not belong here.

The king and queen suffered, struggled, and stayed apart, only for one day to meet. Now, they are together and living in a simple reign of peace in a kingdom where the High King controls everything and blesses the two of them with what He once dreamed. A good husband should be treated like a king, and wife like a queen.

In a little over two years, I have learned many beautiful things from my king. The most beautiful of all was when we talked about the strength that life has given us. That after having faced, fought, and won, we are no longer afraid. I said the only thing I feared was God. He answered me, "I'm not afraid of my father! And because I'm His son and I trust Him, I'm not afraid of anything."

The worst thing about a promise is not to wait: it is not training in the waiting time to be worthy of keeping it.

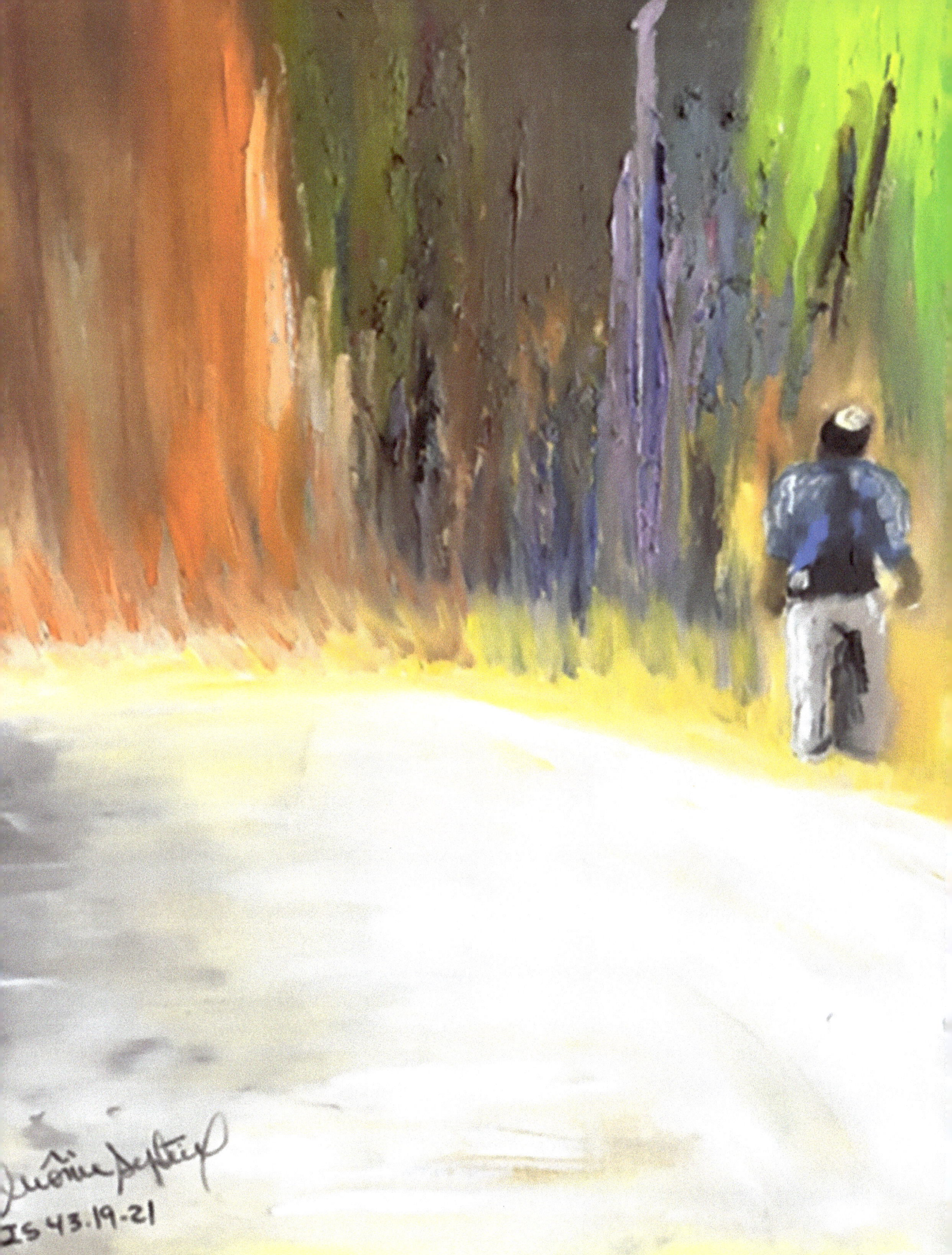
IS 43.19-21

Chapter 23
180 degrees

Chaos brings destruction; destruction brings silence.
Silence brings strength; strength makes a 180-degree turn.

Alchemy

Alchemy is the mystical chemistry of the medieval period, and it combined various fields, such as art, physics, chemistry, astrology, philosophy, metallurgy, medicine, mysticism, and religion. Alchemy sought to discover the cure for all physical ailments and improve bodies with the help of nature. It is aimed at transforming a subject that combines different sciences, with the processing from one element to the other. The best-known example of alchemy is the act of turning copper into gold. Even with countless trials and studies synchronizing various sciences, it never got results, as opposed to mental alchemy, which is common and depends on the desire of each person. The first change is always in the mind. The transformed mind enables a 180-degree conversion at all angles relating to me. The alchemy within me started after my dream, and my first process was mental alchemy. That was my greatest difficulty in transforming my mind.

Since this point, my evolution has been happening consecutively. When my intellect went through the alteration, it impacted everything related to me. Remember the popular saying, "Nothing changes if I don't." Well then, all angles will sync around my conversions. It won't be necessary for those who can't see it, because my vision will be so different that I'll know everything differently. My plan was to release my fourth book on the second of May 2020, but due to the pandemic, I had to postpone the exhibition and launch party.

I finished the book, but everything around us was shut down. I used my time writing and illustrating another children's book that I will undoubtedly publish soon. My husband and I had talked about a longer book, and my eldest son is suggesting something deeper—something that could inspire and strengthen people who have lived what I lived. Thus, you can get a sense of how what you discovered today begins to change. Remember

that everything has a cure before death. Then the idea came to me to open my codependency story. What happened was that I found out I was codependent, and I had to go back to the root of my traumas. Because I was safely locked up in my castle during this time of the pandemic, in addition to painting and taking care of the chores of a mother and wife, I started writing *Joy*.

Countless times in my life, when I no longer had a door, I had to break through a wall and make one. When the house fell on me, inspiration came from something new in time to get out of the rubble. It's like that old saying, "What doesn't kill you makes you stronger." So, the period that started in February 2020 was one of destruction and fear. It was the period of our common and invisible enemy, COVID-19. Today I told my oldest son that at the beginning of the city where he was born, the one I grew up in, Rondon do Pará, there was a very bumpy street. The name of this street was Bahia. The potholes on this street were so big, and some were more than half a meter deep. This street was halfway in the middle of the city, and when it rained in Pará, it completely flooded the street. The constant rain caused huge torrents that looked more like a river. I must have been eight years old, and I loved taking a shower in the rain, and I still love it—especially in Pará, when the rain comes down in the middle of a forty-degree Centigrade heat. When these rainstorms occurred, children my age would put out paper boats or wooden boats in in flood. When the rain was not so terrifying, we entered the dirty waters from all over the city. If it was too strong, it was possible for the flood to carry people to the end of the Bahia River. There was even a sad episode where a person fell at night, and there was no one around to help him. The flood carried him away and took him to the mouth of the Bahia River, where he was found dead. The Bahia River was on the lower side of the city, and the street ended in a precipice caused by corrosion.

The phenomenon descending from this precipice looked like a black waterfall. I swam with all sorts of viruses in those floods, hidden from my grandmother. If I had the same immunity as I did at eight years old, I would be immune to COVID-19. But as I'm already forty-six years old, it's better not to give my face to the virus to hit. And with less than two months to the end of 2020, on the fourth of November, on a Wednesday, I started to feel like I had the flu. I was at the bakery, and I was afraid my immunity was low. I asked for a few days to recover. It was the best thing I did, not allowing the virus spread through me. The other day, I got a message from someone at my church who tested positive for COVID-19. Unlike me, this person felt flu symptoms and still attended church meetings, spreading the virus to nearly fifteen people. Since then, I have entered a door I have never experienced.

I started to have a constant fever, severe headaches that hurt the bones of the whole head, and nausea, and I felt very cold; I lost my sense of smell; my taste buds disappeared. I could barely walk. I felt so tired. As I was unable to eat solid food, my youngest son made fruit and vegetable shakes. I isolated myself from him, but unfortunately, he seemed to have contracted the virus, too. I took the test, which took more than five days to confirm the certainty that my body was already saying. My son had mild symptoms, like a cough and a slight fever. Because he is young and strong, I believe that he was not overwhelmed

by the virus like I was. On November 12, 2020, despite being very tired, I woke up with no fever and a slight headache. My sixteen-year-old son helped me more than I expected, even vacuuming the underside of the house. After four days of me simply eating fresh rice, two people from my church decided to make food for the pastors who had also contracted the virus. One of them decided to bring some for me, and I asked for some fresh rice, which I managed to eat. I asked my oldest son to buy bean broth at a Brazilian bakery. He brought it, and I managed to eat some, too. And my friend Cecy cooked for me, too. I had to cook the only thing I could eat: fresh rice.

Besides the terrible symptoms that made me suffer, the worst thing about the disease was the lack of family in my country. I missed someone to make at least cheap and straightforward fresh rice. I have many acquaintances, but as everyone is so busy in this country, they couldn't do anything. My friend Gislaine and Cecilia took the time to send homemade things. Unfortunately, I couldn't taste anything. Some even knew that I was extremely sick and could not stop because life here is not easy. But thank God, He never left me alone; He also made my husband come back a little earlier to help my son and me. After seven days, some people started asking if I wanted something to eat or if I needed help in any way. Besides completely losing my hunger, I didn't have the strength to cook when I want something homemade. Eight days after the onset of the illness was the first day I got up without a fever, and even though I was exhausted and weak, I can say that God's mercy had reached me, and I was recovering. My husband did not have any symptoms; even so, he and my son took the test, and the result came on the twelfth. My husband did not catch the virus; however, my son did, although he had no more symptoms. Even on November 15, I was still very weak and did not have my sense of taste or smell; I felt headaches.

Nothing is inevitable when you are alive except for death. I am so grateful to God that he has spared me once more. I am happy to have finished this book and still have more time to finish raising my youngest son to follow the development of the other two. I have time to love my vassal king and adore my Sovereign King if He gives me life. I can grab what he proposes and make small changes, however they appear.

Needed to change

When I wait for opportunities for change, I always remain alert, as the moment for change can occur even in a time of pandemic. When I finished my first book, I didn't know how to navigate book publishing. My oldest son, who is kind of crazy like me, followed my vision, even though it seemed impossible. I don't know if it's because we grew up together or because he's seen a lot of my "crazy" come true. He already knows that there is nothing impossible for a believer. I found a way to publish, and on the eve of publication, the worst president[234] in recent history was elected. Hearing on the radio that he was the new president, I cried because his threats were so great for an immigrant like myself. I talked to God, and He didn't give me any sign for me to stop, so I went on. Soon after, my book was a reality, and on top of that, it was registered at the US Library of Congress. I called

my pastor and said, "Pastor, my book was published in this actual Us president[237]!." He then replied, "No, my dear, you have published your book in the country of our God." I may be in a pandemic, disaster, and depression, but my God is unscathed. As they say in Brazil, "There is no bad weather for God."

We are in a time of many people falling down; the invisible enemy mowed down rich, poor, Black, white, Latino, and more. A democratic virus is neither racist nor homophobic and takes everyone without any discrimination. I heard a song at the time when this whole pandemic started that goes like this: "Where are you now when the darkness seems to win? Where are you now when the world is falling apart? Oh, I heard you saying look up my child[238]."

God is not trapped in pandemics that we humans create. Even in unhealthy times, God changes lives. At that time, when I had to cancel all the events of my fourth book launch and exhibition, I started authoring this book. I found out that my other books are on bookstore websites in over a hundred countries, like Norway, Japan, Australia, Korea, France, and others that I'll never go to. At this time, I started doing the Arte e Vida interview channel on specific subjects for a practical life. It was during this time that I was forced to abandon my dream of being a hairdresser to dream God's dream for me. If I don't stop, God stops me! Or, for those who do not believe, I can say that there is no set time for a change. It all depends on my vision and willpower to want a better life. Changes come soft like a late afternoon breeze or fierce like a storm, but it's up to me to take advantage and change. There is no change without conflict. Conflict is the beginning of the changing process.

My struggle is not coming from anyone else. When change comes, I must do something with what has been placed in my hands. And in this, I draw attention to the diverse types of people who are on my side on this new path. In this group, there are positive and negative sides. The positive side has two types of people. There is one who doesn't believe in my goals or dreams but likes me and so will be supporting and helping me at times. The other one believes in me will support me, and even when I tell her absurd ideas, she will still add things to make them possible. The negative side, in turn, also has two types of people: the first doesn't believe in me and therefore won't help me, but they won't do anything to harm me, either. The second person will be the one who believes in me and knows I'm likely to make it, but since she's on the negative side, she doesn't like me or has become bitter over her traumas. It's because you believe in me and don't want me to do what I decide to do that you're going to do something that won't become possible.

It reminded me of the book of Nehemiah, when someone spoke of what he wanted to do in Judah. Tobias knew what he could do and rose to criticize. Since mocking Nehemiah wasn't enough, Tobias began to devise plans, but he used the SAD technique—he sighed, analyzed, and decided in his heart that no one could stop him. And the rest of the story was that he had to fight with one hand to fend off attacks while the other was restoring

[237] The American president of 2019.

238 Daigle, Lauren. Singer. *Look up, child*. Sep 2018.

the wall. His great achievement came after fifty-two days with the building of the wall of Judah. The saying "A tree that does not bear fruit does not take a stone" fits here. If the attacks on me have started, it is because I am on the right path, both in the natural and spiritual world. Anyone who doesn't believe in my potential won't worry about me stopping. 2020 was the year I realized the power of God's mercy.

What separates me from going through a momentous change is me or the other person. Most of the time, the dispute is with me. My inner self is not being happy with how I'm living and what's happening around me. I'm starting to realize that I'm sabotaging myself, and if I don't act, it will be like a snowball. The endpoint in this situation needs to have the first step. The famous Brazilian saying goes, "The annoyed let them move!" Referring to this topic, it would be, "It's the annoyed who needs to change!" If I am dissatisfied with the confrontation, then I'm the one who needs to change. The biggest problem with not changing my thinking is that others need to change because they are bothering me, but I can't change a person who doesn't want to change. Whether my happiness or peace of mind is at stake is the point that brings me to the conflict that comes from switching to a different life. I need to make my life the best life I can because I only have one. And I'm the only one who can do something.

Forced to change

As I'm acting with the people I care about and making them suffer, I'm forced to change. My metamorphosis from caterpillar to butterfly depends on the need to be better with myself and the people I love. Interestingly, if I transform myself and am driven by being better, everyone will also change with me. Maybe it's because I'm different and no longer bothered with things that would surely piss me off before my changes. Here, a dome is created. Changes can be forced by a stormy situation where I will have no choice but to change. You don't want a door to be destroyed, and I would be forced to enter another one that I don't want to. This new door might be all I needed to transform everything in me and around me, even if I didn't mean to. It is tough to adapt to new situations; however, they tend to be beneficial to a different life and much more enjoyable. What I need is to be open to how life will surprise me and take advantage of them.

Unfortunately, to start a new trip, I can't take everything with me. Every big transformation requires significant losses. I thought I had lost people at first, but it turned out to be my deliverance. It's not that I will become their enemy, but some people will trap me in a place or situation that will influence my growth. Here, the protection fences are created. I am making boundaries with people who must be kept at a distance. For me to change, in some cases, I need to leave behind people who can't accompany me, no matter how much I love them.

The Alchemist

God changes situations through a conflagration and is not always calm. Why? We are very accommodating when we are in times of peace. Very few decide to move by a gentle

wind; my oldest son was one of the few I've ever seen do that. The vast majority, starting with me, only change in big storms. When instability enters my life, it is a sign that I was called to attend to something I am not seeing. If I alert myself by reflecting on what is causing this, I can get rid of the clash that will knock me down so I can see that I need to do something. I would love to skip a lot of the processes I've gone through to get this far; however, these have trained me to be what I am now.

I think back to the kintsukuroi, the broken vase soldered with gold. Before, despite however beautiful it was, it was not admired as something magnificent. Its pieces turned it into a work of art. My wounds and harrowing experiences make me bring out the shine of my achievements won by tribulation. What doesn't kill me makes me more attractive, sexy, and beautiful. God sends us warnings before changes arrive, yet sometimes I do not see them, and I think they come suddenly. He always gives signs, such as nature's storms followed by winds or a lack of them. Like storms and life changes, it is hard to see what is happening when I am in the middle of them. Best of all, storms don't last forever. It's better if I use the changes from God to transform my life and my personality into something higher than where I found myself.

We also go in and out of storms without taking advantage of them, and we remain the same. The changes that come from God involve a call to a specific mission. Most biblical characters were doing something very carefree, and a lull came, calling them to something that God had for them. My calling was never for my benefit, but for the kingdom that God founded for us all. However, I'll be blessed if I accept the call. That's what I believe, and I respect the opinion of those who don't think like me. Following biblical events, the calls were never for one person to benefit himself, but for an entire people. Regardless of whether God told him to leave his kin behind and go to an unknown place, like Abraham; or to the middle of a war where he fell for joy and acted, like David. All change in preparation and after the call. Preparation comes with the decision, and halfway through, the ideas will come.

It's been more than five years since I decided to change forcefully, even though my calling was when I was nine years old. All my changes came when I decided to embrace the cause, and all He gave me were tools for me to heal and show who changed me. And if they happened to me, things started to happen because I was scared and finding it impossible to continue. I didn't think about writing, let alone being selected for the Brazilian Literature Award for Brazilian Writers Outside Brazil. I never thought that I would have more than 400 painted canvases, with more than sixty sold and many donated. I didn't believe I would have four large exhibitions and several small ones in a foreign country. I couldn't believe I would have become a person who left her second year of college, unable to continue, and would teach herself. Not to boast, but to say that everything I've been called to, and every door that opened for me, has only one vision. My goal is, above all, to spread the love of God. He is the alchemist who takes raw metal like you and me and begins to develop something new. It proceeds from my crude form to something

unique. It doesn't have to be anything special or big. The 180-degree turn is because I have changed my mind and can experience this turn when it presents itself.

180 degrees

There is something called a reboliço[239] by Brazilians. That's God's specialty. When no one else waits, He makes a 180-degree change in the life of the one who is expecting something from Him. Everything in my life was changing drastically. When I was twenty-four years old, I had a fight with a cousin, and I had to move out of my grandmother's house. I went to live in a shack at the back of a dentist's building, which was owned by the husband of a friend. From my bed, I saw the stars through holes in the eternit[240] roof. My fridge was tied shut with a rubber band. My friend Iva built a tile shelf and some boards she found in the backyard. She found me after my disagreement with my cousin. I was always on the alert to move to this place, where she had lived before. My bathroom was outside the shack, and I didn't have a front door for almost a week before I could put it on. I closed the bedroom door with my oldest son to sleep. I refused to take my youngest to live there in that poverty with me. He stayed with my ex-mother-in-law in a much better life than ours. I always brought him to stay with us, and it was difficult. He was petite and didn't understand the division of almost anything because before, he had lived better. My eldest, poor thing had no option but to share what I could do.

That was a short time, as nothing leaves the one that God calls to stand on solid ground. Even if we fall, we will always get up. My paternal grandfather always helped me by bringing something from the farm and even bringing gas for my kitchen. Soon I bought another fridge and started moving. I had some cattle on my grandfather's farm and some money I had asked my father to keep. All this time, the only thing I spent money on besides renting the shack was on food. Then, for eight months, I had the opportunity to buy the house I dreamed of. Since I had my first child, I prayed for a house that I could afford. At that time, I had a company that messaged people through a special day service connected to the computer about making breakfast baskets and flower arrangements. In my city twenty-three years ago, few people had a computer, scanner, or printer, so I used mine to work. I made copies, faxed, scanned documents to be sent online, personalized birthday cards, and made business cards. The house-buying deal seemed terrific and was everything I asked of God. It cost all the money I had. When everything was ready to sign the papers and I was dreaming of the house, the house owner sold it to someone else who offered more. I was so devastated that I cried with disappointment. Well, I had to accept.

A month later, a house appeared on the last street in town called Rua das Mangueiras. A colossal erosion caused by the floods created a massive cliff on that street just a few steps away. But the house was everything I ever thought of having. It also seemed dangerous to

[239] Reboliço: Stir. Brazilian term used when unexpected devasting change happens.

[240] Eternit tiles: in addition to being cheap, their main advantage is their installation and practicality. Since the tiles have a larger dimension, they do not require a reinforced structure. Reinforced Cement of Synthetic Threads uses polypropylene threads to reinforce the fiber cement structure.

live so isolated with children. At that time, I was dating a military police lieutenant who was the best person I ever had in my life before my current husband. He always kept the soldiers on the alert to pay attention to the children and me, as he was the city's police commander. The other giant problem was that I didn't even have half the money to buy it. My boyfriend sold an automatic pistol to another officer, and he was able to help me with the purchase. I am forever thankful for so many kinds of gestures of care from him. I told the owner of the house that I could pay for the rest of it after four months, and we closed the deal. A woman came to me who wanted to put a brothel in the place I wanted to buy. She tried to exchange with me to stay at her house in the center, which was a little better, and I could give mine to her. The other house needed some repairs, but the location favored it. Then I tidied up little by little. I remember a lady who came to my shack and asked me how I could pay rent on that house if she saw me living in a shack.

I used to live in the shadows, thinking it was my identity to be a remora. I would hitch a ride in other people's dreams, going only to places I could go as baggage. After the healing process and discovering my identity, I found that I had lived for forty years as a remora, although I had been born a shark. I'm the one who chooses my path, and I don't hitch a ride on someone else's path. I'm the scared one, and yet I don't stop. I get frustrated when I can't complete a task and don't move forward. Even stopping for another idea or after recovering in a long pause brought on by COVID-19, I get up. Even if I'm slow because I'm fragile, I continue because God gave me time in His mercy. I must do something with that time. I was created to be free and choose my destiny. I'm the one who says what I can't do; no one can say no to what I believe. Like a shark, I have my place in the world, and I don't live off the rest due to cowardice.

My God created me to be brave, not cowardly. Like a shark, I fear only my creator because He is the only one above me. We are created to be sharks, to reign over the sea of our lives, and not live off of the other sharks. Like a shark, we cannot stop even in calm seas, much less in rough seas. The worse the storm, the more our muscles are strengthened. Even resting in the calm sea, we are still alert. In the sea of my life, the sharks are just waiting for me to bleed to devour me. Remember the dome? I can't let my blood out, or the other sharks will eat me. Some shark's "friends," as much as they rejoice in my victory, don't want me to be any happier than they are. If I eat small fish, that's fine, but if I eat a fish bigger than theirs, it starts to tease them. List your dreams and commit to them. You will soon begin to mark off those that have begun to happen. Being ready to dream, you must be prepared to live. After all, everything starts from a dream; even if it's absurd, it can be real. They are fantastic for you and me, the God who allows us to dream is the God of absurdity, of the impossible, of going 180 degrees around. From ordinary metal, the great alchemist creates precision. Believing the great alchemist and in myself, I can do the unattainable.

Mental alchemy enables a 180-degree conversion at all angles related to me.

Dancing the music of life

I should always dance the same way as when I was a kid.

I also suggest that you dance like in the early childhood years.

Just a tap, and the little uncoordinated feet began to move.

I was swinging one limb at a time so as not to lose balance and fall.

I was babbling a song of my own, and I stirred "like a calango[241] in the hot sun."

Already speaking the language of the big ones with the wrong letters, I copied complicated steps.

I danced, expressing the complete joy that came with me when I was born.

I was learning to be ashamed of exacerbating what was inside of me.

I was taught to be sad. I wasn't born that way.

Understanding that no more dancing for everything, but now choose the rhythm.

I choose music.

If it's not my favorite song, I don't dance.

An adult who doesn't dare dance, no longer sings.

Feet that only move after money and disillusionment.

Never applauds!

Neither hums.

Life is a continuous dance; even with songs I don't even want to dance to.

I criticize everything, and nothing brings me contentment.

Bitterness soured my waddle.

[241] Calango: a popular term to refer to some reptiles, especially small ones. The expression of comparison is very popular in Northeast Brazil. A calango is already very agile and moves faster and more often when the sun is burning hot. It is worth remembering that the sun in the North and Northeast of Brazil is even more intense than in the rest of the country.

My heart follows ingratitude. No longer continues with beats rejoicing in the simple.

I won't dance when the weather closes, but I dance in the mud formed by the rain. I don't want to sweat in the heat, but I loved dancing in the burning sun, thinking it would make it rain.

I danced of gratitude; I dance when my food is ready.

If it were samba, I would samba.[242]

Forró[243] *would drag my feet.*

Vanerão[244] *would run with long strides.*

Xaxado[245] *raises dust. Until it was rock, I jumped and shook my head.*

Without fear of ridicule, I expressed myself.

Or even dizzier from twirling to the beats of the carimbó.

I stopped dancing! I stopped singing! I stopped being what I was created. Original and happy.

I should always dance the same way as when I was a kid.

I am letting go of what comes from outside and pouring the beauty that I have inside.

I was turning my thoughts like a string guitar and leaving the heart as light as a violin.

My feet are as agile as a cuica, and a genuine smile as an accordion.

Following the dance of life to the full, even if it's a languid waltz. Even it's as painful as a funeral march, I was dancing and reinventing until the excellent music played, breaking me up with joy.

I was supposed to dance the same way when I was a kid.

[242] Samba originated from the old drums brought by Africans who came to Brazil as slaves. These drums were generally associated with religious elements that instituted among Black people a kind of ritual communication through music, dance, percussion, and body movements. The rhythms of the batuque gradually incorporated elements from other types of music, especially in the Rio de Janeiro scene in the nineteenth century.

[243] Forró: a dance that began in Northeast Brazil. People used to dance by dragging their feet in order to prevent the dust from rising, hence the term rastapé, or shuffle. Nowadays it is appreciated throughout Brazil and celebrated on December 13, the birth date of accordion player Luiz Gonzaga.

[244] Vanerão: traditional Brazilian dance originating in southern Brazil that is based on a musical style in this region.

[245] Xaxado: traditional Brazilian dance originating in a musical style in the Northeast of Brazil, as well as forró and catira.

Chapter 24
Joy

I decree my manumission when I take full responsibility for my actions and their consequences in my life.

SAD—Stop, analyze, and decide

At the beginning of 2020, a year plagued by pain and uncertainty, people began to self-isolate and stayed in their homes. Almost everything was closed; it felt like the apocalypse, with deserted towns, no music, and no people, just fear. I just had published my book, but the painting exhibition I scheduled for the second of May had to be canceled, like the plans of billions of others. The wrong side of my temper soon came to haunt me: pessimism. With a book just published in the early days of the pandemic came the sadness of not promoting it as I had done to the others. And after rereading what I had written in this book that I had just published, there was a snap. I was inspired by my sadness, and I created *SAD*, which means stop, analyze, and decide. The book is about a girl who stops for several pending questions in her life.

I decided to put into practice what I had written and to conquer all that I wanted. I sighed in dismay as everything I had planned sadly dissolved. I analyzed that I would stay at home for a long time and that my temper gets very discouraged when it doesn't get a result. But through Joy, I'm learning to strengthen my virtues to fight when I'm weak. I decided on the idea of learning to paint with watercolors. And when I started painting, I looked like someone else. If you ever want to ask me for advice, find out when I'm painting, and you'll have the best of me. I believe it's because I disconnect from myself and the world and live at my best. Painting with watercolors, I created a whole story for my following bilingual children's book, and of course, I was painting where the idea came from, so I had all the illustrations ready. My son and husband had already pressured me to write a book for adults. With all this demand, I was dismayed at all the other things that were canceled. I sighed with all my frustration for not doing anything with my time

like everyone else who was quarantined at home. I analyzed everything I did three years and three books ago, and it had already arrived. I decided to write this book, *Joy*. I took advantage of accessing the faculty library to assist me with several types of research since the public library was closed by the pandemic. The books I have at home helped me a lot, expanding the topics that I lived through. It's not enough just to stop and analyze; you must decide and make it happen, or everything will remain as it is. The same attitudes will always give the same results; just looking is no good, and closing your eyes is even worse.

I went a long way in my life and ran over many processes. My desire to live and discover new things often caused me harm. On the other hand, they also made me what I am today. Joy is the last chapter in this book, despite being the first part of the biggest change in my life. My metamorphosis started when I met Joy. The impact of disappointment knocked the rug out from under my feet. The frightening discovery of what had been held under the same carpet was even worse. It came like solid waves that break when you are unprepared at sea. A wave throws you to the bottom, followed by another, and others are unable to get up. Taking strength when the water enters the mouth, there are only two options: fight for life or surrender to the fury of the sea that at this moment has already taken you deeper. I opted for life, and it lifts me after so many waves and wounds from sand and rocks. I was bruised and dizzy and knew that life would be difficult to go through alone. I sought professional help and confronted what I needed to change. Learning how to understand my dreams helped me self-analyze, but the gift of painting was the most incredible tool of healing and transformation. The whole process had already started; however, the milestone was through a dream. It's no use dreaming and not deciphering, nor understanding and not deciding to act towards change. The foundation of meaningful change comes from someone who is self-responsible. Such a person will unquestionably be endowed with faith in himself. And if you have faith in God, the walk will have a beautiful purpose. The twist I saved for last was a dessert.

When I think back, I can't believe that I learned to float amid despair and got here. Some parts were a self-examination of my healing, others a confession. I would like to imagine this story and write it; however, I had to live to tell it. Between the cold of a broken heart and the heat of the desert, I had to survive. I'm not sure which was the longest, whether it was the cold of lack of love, disappointment and neglect, or the difficulty of changing one's life. I was facing my self-responsibility to be happy with myself. I had to try different strategies to find happiness. When happiness is expected in things and people, I am always at their mercy, but I am free when I take responsibility for being the center of my well-being. It doesn't matter if I'm alone or accompanied, my own company accompanies me. "Being self-responsible and living free without blaming the other,[246]" says Cleria Marcal.

I was tired of blaming my past and everyone who made my most effective downfall possible. People who are in my downfall will hardly help me to get up. If they stay, it

[246] Markal, Cleria. Master Coach. Pastor Cathedral of Adoration Somerville - MA - Revere MA, August 2020.

will only be to make sure I stay where they helped me fall. Tired of giving half a smile, I decided to have the genuine one. For a genuine smile, you must be happy, not just satisfied. Happiness always comes with a spontaneous smile and is reflected within my body. A face that conveys joy cannot be forced, let alone hold a smile of total joy. Scientifically speaking, the muscles around the eyes contract by lifting the cheeks if pushing the skin towards the nose. It is tough to control this involuntary muscle action when you are happy. French neurologist Duchenne Boulogne made a remarkable discovery of the difference between forced and natural smiles. Successively, in her honor, this smile provoked by joy was named the Duchenne Smile. In this smile, so little acquired by me is so desired. I believe that not only for me, but for many others. My smile was codependent, always conditioned to situations and people. For years, this is how I lived. Upon meeting Joy, I learned from her that my smile would only depend on me.

Self-responsibility brings peace, followed by happiness, which opens countless experiences related to resilience and persistence in achieving goals. I must start the projects and finish them. I was feeling good about myself, renewing myself for adversity in a positive way. The biggest gain in life is discovering that I am the only one who can make myself happy. What comes after that is just the add-on or addition to my process. Everything that comes with acquiring self-responsibility is a surprise. I rely on myself to be happy and keep myself happy by being aware that it all starts with me. I am creating my dome and borders for possible threats that could destabilize this harmony.

The moment I assume that the only fault for not having full happiness is mine, it will arrive. Blaming people for my misfortunes and lack of peace tired me. The analysis started from the fact that if I continued to wait for others to find my happiness, I would still be living in moments. Self-responsibility brings the key to open the door I want to enter from the hands of others. I can't enter this door because it's waiting for the other to open, and I'm the one who wants to join and not the other. Funny how we wait on each other for something. It took me so long to realize that I never had to wait!

According to Raquel Santangelo, "Self-Responsibility is to honor attitude, movement, action and word. Bearing with its consequences, whether they are good or bad, depending exclusively on you and freeing yourself from everything and everyone."[247] The power to change the picture to one of happiness is mine alone. And the power to stay happy is, too. So, if this person is not there, I will continue with my full happiness unconditionally and independently. People pay a lot to have what I get for free. It pays to hear that the fault of your evil is not someone else's, but yours alone. God gave me Joy, and she always made it clear to me that I would feel the crying and smile. I would be waiting outside to provide myself with something I already had inside of me.

The clarity you see after taking self-responsibility for your life is like darkness and light. It's no use having my eyes open if everything around me is dark. Much less will it matter if it is light, and I close my eyes. Taking my total share in my own life will open paths that

[247] Santangelo, Raquel. Empresária. Master Coach. Newton - MA September 19, 2020.

no one can shut. That's why life coaches are on the rise, and that's good. I was taught to have the networks of my life in my hands! My coach was and will always be Joy. Talking is very easy for those who have self-esteem. It is more achievable for those who have their identity defined. Know your purpose for existing and the importance of the no. Forgive in order to be freed from the shackles that are left through stored grievances. It is complicated to be happy alone if you never allow yourself to know yourself alone. I needed to have a date with myself to assume my role as single and sufficient for myself. Without it, I end up blaming God for something He has set me up to do. God has enabled me to take care of myself from the temple of his spirit. I am the abode of the Highest. His love must be manifested in me, because this is His address where love, empathy, gratitude, and mercy must be seen through the eyes of the blind. How can I have such a unique force live in me and not find it? How come the prince of peace is inside me, and I live at war with myself? If he has his grace, it's enough for me. I must be one with him; I must be happy with myself! And why can't I? Because I don't allow myself to! I'm tired of living theories, and I'm taking my self-responsibility to accomplish this once and for all. That alone seemed impossible, but I could count on a big push from Joy to make it happen.

Facing my self-responsibility

It all started as a light, fresh rain on a hot, exhausting day. Today I live in balance between the hot and the cold; I live in the present; I live my bliss. Even though life's downfalls come, I continue with my plan of not allowing myself to rely on the outside to make me happy. Much less than the outside steals my absolute peace that was so hard to get. In Brazil, they say that "life is compared to the echo; if we don't like what we hear, we have to change what we shout." The key is to do something we want to listen to the echo of. To be able to change the message or keyword that we keep repeating like a vicious cycle, to change the cycle, something must be different from the usual. I didn't understand this and had no idea how I should start to change.

In the beginning, I paid attention to the people around me and to how I had the habit of observing the obnoxiousness of others for the sake of self-recognition. I immediately saw the worst of others for recognizing that in me. I couldn't see the good in people because my best was too buried to come out. So, I started to use that vision and reflect on what I had and what I didn't want anymore. I started to correct myself from this point on, seeing the worst in myself and in others, and setting goals for a transformation.

When I was in therapy, we always made lists to check for changes, and one of the things I didn't change was my group of friends and my hobby. It was hard to make friendships when I had such a low self-esteem. It started with my family changing their habits and hanging out a little more, doing things they enjoyed and that could please me. I complained a lot at first, but then I started to like it. It allowed me to give myself a chance to live new experiences with my family. At first, I did it for their love, because seeing myself sad and always alone was not good for them. Afterward, I felt comfortable being with their craziness and even forgot my age. I began to see that if I tried hard, I would

make changes. I realized that my thoughts were inspiring and creative when I was alone. The friendships were the same ones I've had for years, and because I was hurt, I couldn't open up anymore. After learning the boundary system, I significantly expanded my friendship group.

Feeling more secure with myself, I was no longer afraid to enable people to approach me and aim and vice versa. I have a very long friendship with a person who loves to set an example in the lives of others because he wants to show perfection on his own. When I didn't have self-esteem, I thought his self-esteem was very high. After studying a lot about it, now I know that it was narcissism. Nothing about him is ugly, and his family is perfect; his is always better than the others, and he doesn't like to listen; he always has more important things to talk about. I was his focus on his life lesson for the people he wanted to counsel. There was a period when I realized that what was happening irritated me, but today I keep him close but with a border, and I watch to make sure I don't become the same way. After all, the bogeyman that doesn't eat you strengthens his legs during the race. We all are full of flaws, but we'll be alone if we isolate others for their shortcomings. Furthermore, when I learn to love myself, things that have nothing to do with me don't bother me, and my peace will be more difficult to compromise.

On the other hand, a hobby has to do with self-esteem; that was another thing that came with time. Today, I'm an artist and author, but I had to find love for myself before that happened. My quality time with myself helped me find out what I enjoyed doing. What if you didn't love me? I couldn't stand being alone. There was nothing about myself that I liked. I didn't think that everyone hated me, but that everyone was more likable than me. And being with someone else was better than being alone. I needed to practice self-love until it came true. I started seeing things I didn't like about myself, things that I recognized in others that drove me mad. After hearing gossip about how annoying I was and crying about my troubles to everyone I knew, I took a few steps from my list.

First - stop complaining. Answer "how are you?" with a very positive response, as if I am living the life I dreamed of. Remember calling into existence what does not yet exist? Practice makes perfect and ends up convincing the mind and the body. Do math until it becomes natural. At first, it was difficult because I was addicted to complaining. And always cried with pity for the misadventures of my trajectory. Even though I stopped doing it for others, I always did it for myself and those closest to me. I got used to telling people I was "great." I didn't even know if I was great or if it was because I got used to talking like that. I talk a lot about practicing. If I'm bad, I don't intend to stay bad long, and besides, not everyone needs to know. I heard a comment about me that made me reflect: "She loves complaining about life." The situation I was in was ugly, but it wasn't anyone's fault. I was living something that was provided by my decisions, not because people heard my cry. Why should I be crying for others? Besides being boring, no one was going to change anything. I had to accept that my absolute responsibility for my happiness was mine alone.

Second - make lists of targets. I'm suspicious of lists, as I have adopted a system with priority lists, dreams, and daily, weekly, and yearly projects. Remember the importance of the list and the commitment you must make to yourself when making a list of tasks.

Third - strong messages for myself. The Bible speaks of teaching things to remember in the day of adversity. Our minds are influenced by repetition. I put messages of optimism at various strategic points in my house so I wouldn't forget, even on days I when I don't want to get out of bed.

Fourth - start writing a diary. Instead of telling your problems to others, start writing. Mark what was done wrong from all sides. Since I cannot change others, I select what I did wrong, and in a line, I write what I can do to improve in this aspect. The good thing about the diary is that when you read it after a while, you can see how much you've improved.

Fifth - strengthen your strong side. We all have a strong side and, undoubtedly, several weaknesses. What you think is your best part is likely to get better. The compensation system on the firmer side will help me to excel at what I am weak at.

Sixth - acknowledge your faults. By acknowledging my flaws and seeking to be better at them, I will admire myself more. Become a better person to get along with others. I will recognize that I need to change and notice what may be inconvenient to my family. What's holding me back from growing will be my first target for transformation.

Seventh - face your fears. I ran from a lot, putting off the confrontation out of fear. After I learned to love myself, the fear was halved. Do you know that meeting where you make excuses for yourself for not wanting to see certain people? This happened to me many times. Once I started to face my fear, it began to disappear. Today, no matter how much I don't have an affinity with someone, it never deprives me of living my life. I don't think it's bothering anyone anymore, but I won't lose anything for not facing my ghosts if it is. I made peace with all of them.

Eighth - give people the right to doubt. The weather and situations change people. Things that were once uncomfortable now go unnoticed. So, I can also spend time with people who sometimes do not suit me. If I'm different, maybe they will be too, and those who already receive judgment from the eyes and opinions of others may not be who they told you they are. Give new people the right to prove that what directs them—this could simply be a matter of projecting the speaker.

Ninth - have a hobby. When I'm alone after doing my chores, I spend the day jumping from hobby to hobby and filling my soul with satisfaction. This recharges my batteries to do what I'm required to do in one way or another. As stated by Maria Cannon, "Hobbies play an important role in mitigating some of this unavoidable stress, as they provide an outlet for creativity, distraction is something to look forward to. Hobbies bring a sense of fun and freedom to life that can help minimize the impact of chronic stress."[248] The hobby will be the time to please yourself; it doesn't have to be something challenging,

[248] Connon, Maria. The Importance of Hobbies. C&T Publishing. Feb 28, 2018.

but something that gives you peace and disconnects you from the world. Although lately, I do everything so gratefully that even washing dishes doesn't bother me anymore. What would give you peace and contentment? To sew? Cook? To plant? Read? Write? To draw? Crochet? To walk? Embroidery? Pray? To fish? Whatever you do, may it rejoice in your soul.

Tenth - don't accept anything. I'm very immediate. I don't have the patience to wait. When I had to wait, and it still didn't work out at several essential points of my life, I changed my mind about staying. Since I must wait, I want the best. Too much has already been invested in you to get the quick fix of lack of patience in waiting—materially, spiritually, and lovingly speaking. Waiting is the time of improvement to maintain what I hope will last once it's in my hands. I will be more careful. I will be more cautious and more grateful, because I know how difficult it was to acquire. I want to get in shape, but I also would love to have plastic surgery, too. I understand that the procedure is not only painful and very expensive, but I would also definitely appreciate it more. I know myself; if I reach a goal by self-sacrifice and not at the expense of a scalpel, I will be even happier and prouder. By taking care of myself more, besides being better for my physical shape, I could publish more books with that money. The books will stay, and in a few years, everything in my body will drop. So far, I don't know for sure, but I'm trying to live longer, diet, and exercise.

Eleventh - believe in yourself. We have the habit of thinking that the other can do it, but we can't. If someone succeeds, I, as a human, can also make everything that I propose to do possible. Remember the remora and the shark. I must take my place in the world. I was discovering my identity, my strength, and my purpose. Nothing is impossible when I believe in myself. To those like me who believe in God, He already knows my potential, so He opens paths, betting that I'll make it. Only two people can keep me from achieving what I long for: God and me! I'm the one who stops my victory process. God has already given his approval, and I must go get it.

Twelfth - value your roots. It's great to go through everything on this list and feel good. Having assumed my self-responsibility to have a full life, it was all me who got it. At this point, I will be empowered and see how strong I am. Not forgetting my roots will make me even nobler. I must remember where I came from and everything I went through to get here. I am proud of my metamorphosis. I rejoice and honor the people who played a part in this path: those who supported me and believed in me, and those stones that wanted to stop me. I forgave them—some because they are more emotionally sick than I am, and others who were allowed to torment me and ended up strengthening me. Anything or anyone that tries to stop what I build will only serve to get more consolidated in my purpose. My roots have infinitely enriched my soul.

Thirteenth - look for a point of reference. As much as you read all these tips, advice, or suggestions, your acceptance takes more work. I like to receive tips because advice doesn't sound acceptable to me, and the direction seems to me like I'm already criticized. So, if none of them work because you are like me and have been codependent for years, the

biggest solution is the most effective: the reference point. To assume my self-responsibility, I had to have a point of reference. This point must be something strong enough that it attracts you like a magnet, not allowing you to deviate to one side until you can move out of the comfort zone that you are in. The artist needs a reference point to guide his entire canvas. Everything taught to your children will be based on the reference point.

My point of reference must be the point of attraction for everything I do. If I deviate from this point, I will put all my work to waste. Could it be God? Because, after all, he is the most fantastic reference point for those who believe in him. Of course, He is the beginning and the end; without Him, there is nothing in my view, but I am talking about something natural and psychological that I must use to train myself to get out of a vicious stage and find my natural, permanent inspiration. It could be a lifestyle, a hobby, or a reference person. We always ask children, "What do you want to be when you grow up?" Since I've grown up and I'm still lost and don't know how to change, I should ask myself this question in another way. The question now is, "What do you want to be for the rest of your life?" Your answer will be your point of reference. My point of reference is Joy.

One way

Everything looked good. I had my dream home in Brazil, with a boyfriend who was more than I asked for. My business had multiple contracts and many clients, and it seemed to be going well. Then everything started to go down. The groom's mother started teasing me more than ever after he was held hostage by a robber; she said I was not good enough for the captain of the military police. And I was only in my second year of philosophy. It was my second choice, followed by math. My job was facing a lot of competition. With all of that and my kids growing up, what I had wasn't enough for the three of us. I needed to make sure they had a better future than mine. A single, unaided mother didn't see many alternatives. I started to think about how I would send them to the university if I could barely pay for my own education. A friend came to the United States and started saying how good it was there while she was making money. I started to analyze whether I could come and spend a couple of years and buy a small apartment in the capital to live with them. I filed taxes and had my own house, a motorbike, and a not-so-bad bank account. So, I started planning the trip and selling everything that could be sold. The most interesting thing was that my fiancé did everything possible to make everything work out. And even more impressive was his mother's enthusiasm. She was helping me as much as she could to get rid of me. I rented my house and painfully left one child with my father and the other with my ex-mother-in-law.

I remember the day as if I were living now. That was nineteen years ago, and the memory still hurts. I didn't have the full amount of money, and my dad loaned me $10,000 at 10% monthly interest. Having to make a document that was registered at the registry, he would keep my house if I didn't pay the money. Many were desperate for a better life as I was; it was already customary. Two evenings before my trip, I received a request from a friend to bring his brother with me, who was coming anyway. He needed someone to come

as an escort, as he was just a few days away from turning twenty-one. He was a complete man, used to traveling alone across the country, but he couldn't leave the country without an escort yet by protocol. So, his parents went with me to the registry office and authorized him to come with me.

We left the country on the thirteenth of June, 2001. Everything seemed to be going well, except for Marco's boredom, which disturbed me the whole way through all the stops that we had to make. For him, it was more of an adventure; for me, it was a path of no return. I couldn't afford to go back. I pledged the only things I had with my kids and my house. His pranks had gone beyond irritating. I couldn't wait to get there so he would go with his family. When we came to the US, I felt that I left everything I loved the most behind; I lacked air, lost balance, and fell. I couldn't breathe through the weighty air. I sat down and let the group go. Marcos was always around, but as we walked into a group, we ended up in front of each other. He missed me and came back when they departed for Boston. I was exhausted; I couldn't move anymore or talk. I was in shock. Nobody saw us, but he came back and saved me. He said, "We've come this far together, giving up is not an option!" He put me on his back and made sure I was on my feet again. That's the last time I saw him. I have immense gratitude for that young man; I always pray for his life. I still hope I can thank him personally. I heard that he returned to Brazil very well financially. If not for him, maybe I wouldn't be telling this story.

After some time, my entire immigration status was regularized. There are many anxieties in the immigrant's life who leaves his land for a better life, but God delivers us from them all. Almost two years later, I managed to pay my father, and my house is still there today. With God's help, my oldest son came five years later. He studied and, with his efforts, managed to finish his bachelor's and then his master's degree. With the help of God and my ex-in-laws, my middle son graduated in law and passed the Bar exam after he graduated. I started a family, but once again, after fifteen years of living in this country, I was lost. I was abandoned, betrayed, and raising a teenage stepdaughter who never listened. Add in my ten-year-old son, and my heart felt like it was in pieces. I was exhausted, couldn't breathe, wanted to quit, and wanted to stop as I stopped back there in the desert. Not that I would commit suicide, as I'm too much of a coward for that. But there was no more air; I couldn't move. Joy was my Marcos at this time; she was not giving me the option to stop. They both put me on their backs when I couldn't walk anymore.

The only difference between them is that I never saw him again, and Joy sees me every day. Both were put into my life by God to save me when my hopes and strength had run out. But one thing they made sure I understood was that the path I was following had no turning back. Going back is not for cowards; whoever returns along routes that have already been consecrated has the strength to suffer the same scourge twice. I prefer to take the risk in my cowardice of encountering what I don't know. The fear of repeating

my mistakes is greater than the fear of going to the uncertain. The path I'm following has no return.

An old memory of my life in Brazil was walking barefoot on my grandfather's farm. Sometimes I went to the corral or the house, where the pump that drew water from the artesian port was. In April, the temperature is thirty degrees centigrade at the lowest, and to reach or exceed forty is nothing new for those who live in Pará. The summer months are sweltering. We decided to walk barefoot during this part of the day, and the sand seemed to be on fire. Near the capital of Pará, in Belém, the city of Mango trees has a stunning beach, Salinas. Salinas is one of the best-known beaches with the biggest tourist movement among the state's beaches. Tourists know it as the place where you can be served food and drinks while sitting at a table in the beach waters.

Another popular spot for its exotic beauty is Coca-Cola [249] Lake. This lake is behind some giant dunes between the sea and the lake. To get to this lake, you must cross the dunes. The big problem is the sun, which makes the sand unbearably hot. When the decision is made to go barefoot, less than halfway over the dune, the feet are already on fire. With the unbearable pain, a decision must be made. Some options must be found urgently, or I'm going to make my feet raw from the burns caused by the hot sand. I could go back and give up without ever knowing the greatness of the lake; go back and get a shoe that will lighten up very little as your feet sink into the scalding dunes anyway and repeat the little path that has already been gone; or do what I did. I started running like crazy and slid on the sand, falling and burning my hand from touching the sand to get up. From the top of the dune, you can see the black lake, like the Coca-Cola drink.

As we descend towards the water we say, "Every saint helps."[250] When getting to the lake, it's like heaven, not only for the beauty, but also for the icy water. The feeling is so wonderful that you forget that the lake possibly has piranhas. The pain of burning both in the sand of the farm or the dunes and the emotional pain will make me stop and never experience post-healing. I can retreat to protect myself better, losing the first attempt and getting hurt on the way to the other side. Or I'm going to stare at what I can get when I get to the other side, and nothing will stop me. I don't have a lot of time to waste getting ready for life, at least from my point of view. I got prepared by living it! Pain is a significant influencer. Pain is the greatest motivation for growth and achievement. With the pain, I must run to get to the other side.

The strength to continue depends on the intensity of my desire to reach the other side.

[249] The lake is dark like Coca-Cola is due to the chemical composition of the soil rich in iodine and mineral coal, in addition to the pigmentation of the roots of the trees around it.

[250] A popular saying in Brazil is that every saint helps when descending, as it is easier to descend than to climb—both in the literal sense and in one's personal and financial life.

Joy

My first art show was just around the corner, and I asked my boss in the salon to highlight my hair, which she gladly did. She ended up getting distracted by her client and let my hair pass by. I should have kept an eye out, since I was a hairdresser, too. As she was doing her work, I was waiting for the time. When she went to wash my hair, it melted like plastic. I cried like a child, and she didn't even apologize. You know the saying about the child's personal shadow? That pretending it doesn't exist makes it disappear? I think that's what happened. There were four days to go before the exhibition. I didn't feel good about myself, and even half of my hair felt worse. And I was only four days away from turning forty-two.

This was the beginning of my story; I got lost, and I started doing my walking routine to distract myself. I always walk the same path because my distraction ends up on an unfamiliar side of the trail. I came across a field with very dry weeds, and all the sides that my eyes could see were just weeds so dry they creaked. Amazingly, in January, the sun was so intense that it burned my skin. Sunshine and dry grass gave the impression that everything was yellow. I started walking toward the exit, even though I had no idea where it would be. I kept walking for a while longer and couldn't find the exit, but I was already getting worried and nervous until, from a distance, I saw something moving. Because of the sun in my eyes, I couldn't make out what it was, so I walked a little further and saw a female figure.

The sun was so intense; it blinded me with its glow. I couldn't define what it was! Still, I continued towards that figure, maybe because it moved out of place. I went towards that figure and walked for more than thirty minutes. That felt like hours. I yelled, "Hey!" but as the wind didn't favor me, she didn't hear me and continually moved away. Indeed, it was a woman wearing a red dress. I moved a little closer and saw that she was so distracted that she didn't notice or hear me coming. I was thirsty and exhausted, but insistently, I didn't stop. Finally, I think she listened to me but for some reason stopped. But she was still dancing with a bush clasp in one hand.

Then I touched her shoulder, and she turned in her dance, showing me what she held in her hands; she didn't have dry weeds, but a ripe wheat clasp that she had harvested, and she danced as if celebrating what she harvested. And at that moment, I looked at all the yellow and saw that the whole field was ripe wheat like the clasp she had in her hands. In my agony to reach the end of the area, I couldn't see that it wasn't just dry grass. When I returned my eyes to her face, she smiled, but I couldn't see her face. As she moved, dancing, she turned her back. I asked how I could get out of that place. She didn't answer me, just smiled. Turning from the coast to the sun, I could see her smile. Her smile made me stop and look at her; it felt like freshwater that quenched my thirst at that exact moment.

She smiled in a way I could never smile in my life. Due to the reflection of the yellow colors of the forest and the sun's glare, I couldn't see her face properly. The smell that came from her was comforting, like wet earth. When she moved in her dance, her feet

were so steady that she sounded like she weighed tons. Her rising hands were movements of adoration. I gaped, not being able to speak. It seemed like spending hours watching that woman dance made me lose track of everything, but I knew it was just a few minutes. Her dancing was like she said, "Don't worry, your dad never lost control of anything!" She emanated peace. Today, I understand how I understood everything she wanted to give me, even without saying anything to me. Her joy was highly touching. In addition to taking my breath away, I had no attitude, but she needed to go back to my house. So, I got close to her. Although I had never seen her, she gave me a lot of confidence.

She didn't seem strange to me; maybe I'd already seen her somewhere? Perhaps she didn't recognize me. I moved a little closer to see her face. She had a dome of self-love that seemed to protect her from everything outside. Interestingly, I belonged to this dome. I held out my left hand instead of my right, and I had a ring, but it wasn't the same old ring I had from my ex-marriage. Even so, I couldn't touch her shoulder. I held out my right hand and had another ring that I didn't know about, either. She turned around again and stopped dancing so I could see her face. Her deep gaze was like arrows striking straight into my soul; her expression was that of such a self-assured person. She looked familiar to me, and I stared into her face. I wanted to ask a lot of questions about who she was, what her name was, where she lived, and what the reason was for being so joyful and dancing like that in the middle of that field on such a hot day. She smiled again, passing the wheat mill to her left hand, and with her right, she touched my shoulder. She had a ring on her right hand, just like the one I had. Her soft touch was like a warm embrace on the day of despair.

Then a gentle wind whipped the wheat around us. From this wind came a very familiar smell. I closed my eyes and took a deep breath of the scent that came from her in the wind. Her scent made it clear to me that I didn't understand. Joy smelled like that little girl who was abused and couldn't defend herself. Like a teenager who gave birth to a boy as a fifteen-year-old. The scent of that young woman she'd picked up throughout her pregnancy. The woman that crossed an ocean to give her children a better future. From the immigrant who arrived alone and penniless in this country. From the woman who spawned without horns, from the woman who in the middle of her life was without direction, from the woman who was terribly betrayed, abandoned, and tired of so many misadventures. Her teeth no longer had the flaws she had before putting on braces. She had fewer curves than I have now and a lot more wrinkles. Then I saw myself! I recognized myself. I was Joy!

Though I had wished to many times, I couldn't go back there. I told myself that I couldn't go back every time I needed someone like Joy. In my childhood, I wanted to tell myself that I would be fine. During my teenage pregnancy, I would have loved to have been told that my son would only make me proud. Every moment I thought it was the end. But Joy became powerful enough to come to me; she knew I was exhausted that after so many misfortunes that I had been through. Without her, I would never move from the desert. I had already been too hurt; I needed to become her. If Joy hadn't introduced herself to me, she would never have had the chance to be real. She needed to show me her immense harvest by giving me hope. She needed to show me that the crying would cease.

I was the one who had to put a stop to so many tears. The night could be immensely long but not eternal. And if I took responsibility for my own happiness, it would be a reality. And by my decision, she would dance at harvest time on sunny days.

She was supposed to use my gift of painting to cure me. She was putting vibrant colors into my gray life by metamorphosing me into it. Dancing in adoration in sad moments and painting my bliss, I will work towards being her. She hugged me so tight that it went inside me. So, I woke up from the dream and woke up to another possibility of life. Here, my alliance to my self-responsibility was generated. I would march non-stop on a single track with no turning back. Joy showed me who I could be. However, it's up to me to become Joy. Without her, I could never have made a 180-degree turn. God did his part by giving me the gift of the desire to paint and the inexhaustible inspiration. Of course, without Joy, I would never have come out of the cocoon and become who I'm projecting myself to be. I realized that with each canvas I paint or book I publish, I'm closer.

Every person I inspire with my transformation is a step toward her. Longing to become Joy, I struggled against what I was until the day I met her. After five years since our first meeting, I look in the mirror, and I can start to recognize her. In every time-gifted expression on my face, every new gray hair, every mature attitude, every learning, and every new achievement, I can see Joy. I know she is me; however, I am not her yet. From that day on, Joy became the inspiration of my life. But what did Joy show me? Who allowed her to come to me? Who let me meet her? Whoever did it know that I would fall in love with her. Becoming her would be my life goal.

For someone who doesn't believe in God like I do, Joy is simply a projection of my unconscious that yearned to save me. She was the psychic hologram of everything I wished to be. She was released by analysis after the dream once more. This is a scientifically logical fact. What I believe is that God has given me another alternative. You can continue if you are mediocre, or you can become Joy. When I woke up, the first thing I did was to paint something like what I had just seen, which today became the cover of this book. But this painting is a little bit of what I saw, just as I try to illustrate my dreams in my paintings. My dream of myself being older and healed also became paintings and now this book. The first painting of my encounter with Joy I hung across my bed to be my first vision of the day. I am remembering the covenant of commitment to becoming Joy. I painted her dancing with her harvest. I took the totally wet painting to the exhibition, and my son, after being alerted more than fifty times, still smeared the painting all over his shirt. Several people wanted to buy the painting during the exhibition, but we didn't have time to catalog it or put a price on it, and we didn't sell it. Today, this painting is priceless. It is the visualization of the beginning of my transformation into Joy. Two years later, I made a bigger painting with both of us in it. It is the forty-year-old version of me looking at myself as the woman I will become. I believe this second painting has another mission. Maybe you don't have a dream that makes you wake up and go through a metamorphosis like me. But surely this story will sharpen the doubt about what you will be in a few more years as a person.

What commitment do you have today with the older you? The ring on my left hand was my upcoming engagement. The right-hand ring represented my commitment and responsibility to become Joy and bear the weight of my happiness alone. Five years passed, and during this time, I had to make a concert of who I was and who I wanted to become. As a storyteller, I relate why Joy had to come and what happened after she came. Some parts are so dire, it feels like I just wrote them and didn't live them, because I can't believe I managed to get out of such situations. I know they all contributed to being here as I am.

Joy is someone who only looks in the rearview mirror to provide examples and propel those without a sense of direction to find their Joy. Her eyes are always on the windshield, looking forward, knowing that she is the daughter of an innovative father. This part is already acting on me to look for the new. When it happens, I can keep up the good work? If my father works non-stop, how can I stay still as a daughter? That's why I don't stop with pandemics, happy days, cold winter days, or scorching hot days. She needs my strength to be what I saw.

On the twenty-third of May 2017, I was pregnant in my dream and always looked out the window in front of a building. This building would be my home, and my father was building it for me to live in when the baby was born. I looked at my belly, and it was already full, as if I was about to give birth. I would look out the window early in the morning, and while my father was working, He would give me a smile and keep on working until night came. He lifted me, waking me up with the noise of the construction saws. My dad would see my light on, give me a smile, and continue to work so that when the baby came home, it would be ready. My father didn't stop working for me to live everything He dreamed of for me. And I, as a daughter, can't stop working to become what He showed me I would be if I want to be, either.

Everything is my choice. He showed me who I would be if I liked His work to become Joy. I believe that my first dream at age nine and every other dream has a purpose of driving down a path that I have been lost on for many years. I've been lost with my emotions for forty years, and the dream of my future self-made me wake up, be self-responsible, and fix the mess I managed to create on my own. God didn't mess anything up; I did. Why does He have to fix the chaos I've caused in my life with my wrong decisions? And for those who do not believe that God showed me, let's go to the rational side, because faith is not convinced or proven; this book is not only for those who believe. It's also for those who believe that dreams, as psychology explains, and the projection of my unconscious show me what's wrong with me and give me tips on how to fix them.

Let's say I dreamed of older version, and it projected everything I wasn't. So, I started to blame myself for my misfortunes. I looked for the roots of bitterness and trauma. I started looking in the mirror and getting to know myself. I used my desire to paint as a gift for my occupational self-therapy. I learned to discern my dreams and to analyze them. I learned to survive so as not to drown. I was forced to forgive my tormentors who still

walked with me. I had to learn the importance of not giving as much as accepting. I had to recognize my projection reflection and let go of my personal shadow, to find my identity and assume my role as a shark. I am learning to love myself enough not to get involved with a person who would only delay my target. I keep believing in my vision even in the pandemic and report my path to overcome it. It doesn't matter if my account is natural or has many spiritual fragments. What matters is that even if God shows me or sends chariots and fire riders, if I don't take charge of my life, I will not survive to live a full and happy life, and I will always be miserable.

Believe it or not, my eldest son called himself an atheist and an evangelist for seeing impossible things happen. He saw the paintings' messages come to life. And all the most absurd projects happen without explanation. I dream a lot, and half of the things I can present may sound absurd; however, I know who inspires me and makes everything cooperate to make them happen. I try to paint fragments of my dreams on many of my canvases, bringing them as illustrations. My dreams are messages from my unconscious to myself. But if these messages can influence others as I have come to do over these five years since I started illustrating my dreams, it could be because we have similar traumas, conflicts, and pains. What if it's not just that? A dream transformed my life. Perhaps a dream or the illustrated message of a dream can also change someone else's life. And I know that each of my dreams has its mission, even if it's coloring someone's wall. Just like my books, it has its message for both children and adults. They will go where I can never go, express what I will never be allowed to express, clarify what I don't even imagine it to be. My part in all of this? Only dreaming, discerning, listening, feeling, writing, and painting.

Since I saw Joy, I found my bliss. I'm living my full joy, and it's up to me. I can feel sad, express myself, and even get depressed. However, as the guardian of this complete peace, I don't depend on anyone to keep it. Since I started to love myself, I discovered at first how interesting and difficult it is to deal with myself. I fell in love with Joy, and as she is, I strive to be her. This allowed me to open up more to people, giving me the right to doubt, as I have my limits.

After Joy, I had the most significant turning point of my entire life. When I try to improve as a mother, wife, friend, daughter, and person, I come close to being what I saw in my dream. In my second exhibition, I presented this painting as the central theme. This year, I just focused on reaping a better life. I called the painting called "Harvest." Right now, my biggest target is to become Joy and get close to my original created form. I kill countless monsters in my saga, but I will continue my hero's journey to become Joy. I know that as Joy, I will reap everything I am planting today. She wants to take care of her dreams because she took care of me, introducing herself and being my estrus for everything I wanted to achieve. I do not need to dream about Joy, as I become more characteristic of her every day. My life was dry and wasting away to death. And overnight, God changed my luck.

"When the Lord brought those who returned to Zion from captivity, we were like those who dream.

Then our mouths filled with laughter and our tongues with song; then it was said among the Gentiles: Great things the Lord hath done to these.

Great things the Lord has done for us, for which we are glad.

Bring us again, O Lord, from captivity, like the streams of the waters in the south."[251]

Those who sow in tears will reap with joy."[252]

"He who carries the precious seed, walking and weeping, will no doubt return with joy, bringing his sheaves with him."

[251] Negeb Currents or Southern Torrents: Negeb in Hebrew means dry. This is a desert region south of Hebron, southwest of the Dead Sea. A phenomenon occurs in a fraction of minutes before what seemed like death becomes a lot of life. Melting snow on the mountains floods the land that seemed unproductive, and everything starts to come alive.

[252] Psalm 126. Song of Pilgrimage - the experience of joy caused by the restoration. It highlights the joy that has already been experienced. Version NVI. Zondervan Publishing House. Michigan MI. EUA. 1995-2000.

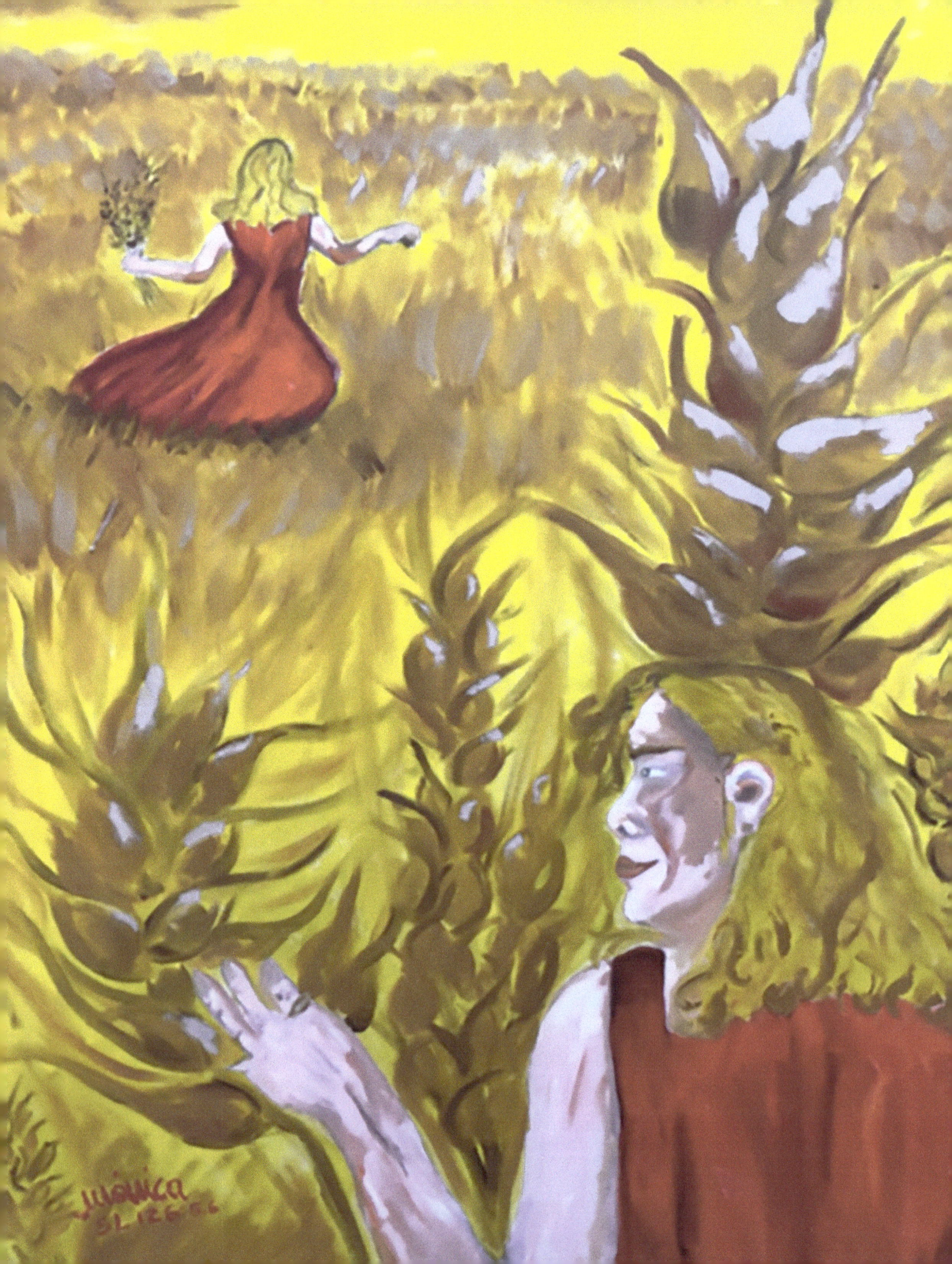

About the Author

Monica with her 110lb dog, Slash, who is the protagonist of her first two books. Slash is currently 10 years old and is a very loved, active, smart, and sweet companion.

On the night of August 23, 2015, Brazilian author and visual artist Monica Septimio had an impactful dream. The next morning, she tried to illustrate the dream message to herself, even though she had never painted before. Since then, when she had inspirational dreams, she tried to illustrate them. These paintings had deep meanings that impacted many people, eventually leading to an exhibition six months after her first painting. At the event, she noticed a collection of sequential paintings forming a story. This collection of paintings gave life to her first book, published a year later. The paintings transformed darkness into light, directing the author to study art and psychology.

When her youngest son was little, she wished for bilingual books for their bedtime stories. At the time, there were not many bilingual Portuguese/English children's books around. This became a strong influence on her work as a writer.

Septimio would go on to create her own bilingual books, which she illustrated with her paintings. In her second year after becoming a writer, she became a children's ministry leader at Waltham Cathedral of Worship, her local church, for over 3 years, further encouraging her to write more children's books. She was a seminarian for four years at Christian Preaching College in Framingham, MA. She studied philosophy for two years at the University of Philosophy of Maranhão in Rondon do Pará, Brazil, before immigrating to the US. She is a 003 member of the International Academy of Brazilian Literature. She has held four major painting exhibitions and has participated in many fairs and festivals and numerous small exhibitions around Boston. She has participated many times in conferences by presenting live paintings.

In 2017 she created a class called "Paintings From the Soul" based on her own experience with art as a healing medium. This work consists of people who paint from a message

following a specific theme. The effect of this group's paintings resulted in an exhibition at the Brazilian Consulate in Boston on the night of October 20, 2017. One of the most outstanding achievements of "Paintings From the Soul" was volunteering at MAPS, a volunteer group for survivors of domestic violence.

Septimio has three sons. She lives in Waltham, MA, with her husband and youngest son. She currently attends a program at Massachusetts State Community University.

Her published works include the following:

*Nothing Is Impossible -
Nada é impossível*
ISBN Paperback:
978-1-61244-509-0

*Be Thankful, Be thankful –
Seja Agradecido*
ISBN Paperback:
978-1-61244-602-8

*White Dresses –
Vestes Brancas*
ISBN Paperback:
978-1-61244-698-1

Sad
ISBN Paperback:
978-1-61244-826-8

www.ingramcontent.com/pod-product-compliance
Lightning Source LLC
Chambersburg PA
CBHW041918180526
45172CB00013B/1329